Medieval Art

Oxford History of Art

Veronica Sekules is Head of Education at the Sainsbury Centre, University of East Anglia, and was formerly exhibitions and collections curator. Her original research interests were in the fields of sculpture and liturgical furnishings in England and Europe from the thirteenth to the fifteenth centuries. She has also written about the art patronage and consumption of art by medieval women, and continues to work on these themes. She has published regularly in the fields of visual arts and museum education and modern art.

Oxford History of Art

Titles in the Oxford History of Art series are up-to-date, fully illustrated introductions to a wide variety of subjects written by leading experts in their field. They will appear regularly, building into an interlocking and comprehensive series. Published titles are in bold.

WESTERN ART

Archaic and Classical Greek Art
Robin Osborne

Classical Art from Greece to Rome
Mary Beard & John Henderson

Imperial Rome and Christian Triumph
Jaś Elsner

Early Medieval Art
Lawrence Nees

Medieval Art
Veronica Sekules

Art in Renaissance Italy
Evelyn Welch

Northern European Art
Susie Nash

Art in Europe 1500–1750
Nigel Llewellyn

Art in Europe 1700–1830
Matthew Craske

Art in Europe and the United States 1815–70
Ann Bermingham

Modern Art 1851–1929
Richard Brettell

After Modern Art 1945–2000
David Hopkins

WESTERN ARCHITECTURE

Greek Architecture
David Small

Roman Architecture
Janet Delaine

Early Medieval Architecture
Roger Stalley

Medieval Architecture
Nicola Coldstream

Renaissance Architecture
Christy Anderson

Baroque and Rococo Architecture 1600–1750
Hilary Ballon

European Architecture 1750–1890
Barry Bergdoll

Modern Architecture
Alan Colquhoun

Contemporary Architecture
Anthony Vidler

Architecture in the United States
Dell Upton

WORLD ART

Aegean Art and Architecture
Donald Preziosi & Louise Hitchcock

Early Art and Architecture in Africa
Peter Garlake

African Art
John Picton

Contemporary African Art
Olu Oguibe

African-American Art
Sharon F. Patton

Nineteenth-Century American Art
Barbara Groseclose

Twentieth-Century American Art
Erika Doss

Australian Art
Andrew Sayers

Byzantine Art
Robin Cormack

Art in China
Craig Clunas

East European Art
Jeremy Howard

Ancient Egyptian Art
Marianne Eaton-Krauss

Indian Art
Partha Mitter

Islamic Art
Irene Bierman

Japanese Art
Karen Brock

Melanesian Art
Michael O'Hanlon

Mesoamerican Art
Cecelia Klein

Native North American Art
Janet Berlo & Ruth Phillips

Polynesian and Micronesian Art
Adrienne Kaeppler

South-East Asian Art
John Guy

WESTERN DESIGN

Twentieth-Century Design
Jonathan M. Woodham

American Design
Jeffrey Meikle

Nineteenth-Century Design
Gillian Naylor

Fashion
Christopher Breward

WESTERN SCULPTURE

Sculpture 1900–1945
Penelope Curtis

Sculpture Since 1945
Andrew Causey

PHOTOGRAPHY

The Photograph
Graham Clarke

Photography in the United States
Miles Orvell

Contemporary Photography

THEMES AND GENRES

Landscape and Western Art
Malcolm Andrews

Portraiture
Shearer West

Art and the New Technology

Art and Film

Art and Science

Women in Art

REFERENCE BOOKS

The Art of Art History: A Critical Anthology
Donald Preziosi (ed.)

Oxford History of Art

Medieval Art

Veronica Sekules

OXFORD
UNIVERSITY PRESS

OXFORD
UNIVERSITY PRESS

Great Clarendon Street, Oxford OX2 6DP

Oxford New York

Athens Auckland Bangkok Bombay Calcutta
Cape Town Dar es Salaam Delhi Florence Hong Kong Istanbul
Karachi Kuala Lumpur Madras Madrid Melbourne Mexico City Mumbai
Nairobi Paris São Paulo Singapore Taipei Tokyo Toronto Warsaw
and associated companies in Berlin Ibadan

Oxford is a registered trade mark of Oxford University Press
in the UK and in certain other countries

0-19-284241 2

10 9 8 7 6 5 4 3 2 1

British Library Cataloguing in Publication Data
Data available

Library of Congress Cataloguing in Publication Data
Data available

Picture research by Elisabeth Agate
Typeset by Paul Manning
Design by Oxford Designers and Illustrators
Printed in Hong Kong on acid-free paper by C&C Offset Printing Co. Ltd

*The web sites referred to in the list on pages 213–218 of this book are in the public domain and
the addresses are provided by Oxford University Press in good faith and for information
only. Oxford University Press disclaims any responsibility for their content.*

Contents

	Acknowledgements	vii
	Map 1: Medieval Europe, showing cultural centres and principal trade routes	viii
	Map 2: Europe in the High Middle Ages – the main political divisions	x
	Introduction: The Realms of Art	1
Chapter 1	A Sense of Place	7
Chapter 2	Artists	35
Chapter 3	Art and Power in the Latin Church from the Eleventh to the Thirteenth Century	61
Chapter 4	Design and Devotion 1200–1500	87
Chapter 5	Image and Learning	119
Chapter 6	Art and War	147
Chapter 7	Pleasures	169
	Notes	190
	Timeline	198
	Further Reading	205
	Museums and Websites	213
	List of Illustrations	219
	Index	225

Acknowledgements

First of all, I would like to thank all my former teachers and fellow students for inspiring me to pursue researches into medieval art. For commissioning this book, nursing it through the early stages and being unfailingly supportive throughout, I would like to thank Simon Mason. Many friends and colleagues have shown consistent interest, and I have fond memories of particularly helpful conversations with Jane Beckett, Elisabeth de Bièvre, Sebastian Birch, Tom Burke, David Cannadine, Deborah Cherry, Linda Colley, Amanda Daly, Roberta Gilchrist, Lee and Kate Grandjean, Richard Halsey, Nichola Johnson, Ludmilla Jordanova, Janet Mayo, John Mitchell, John Onians, David Park, Nicholas Pickwoad, and Cesare Poppi. Thanks to John Allan and Elena da Luca for helping me with a number of specific references, and to Åke Wikhet for helping to track down the image on page 161. I am immensely grateful to Dolors Lamarca for many bibliographical and picture references sought out for me when I know she was extremely busy. For constructive criticism of specific chapters I would like to thank Frances Barasch and Nicholas Hall. The whole text was read through by Valentina Vulpi and I am very grateful for her comments. The production team at Oxford University Press did an admirable job in keeping to a punishing publication schedule and I am grateful to Katharine Reeve and Ali Chivers, and particularly to Paul Manning and Lisa Agate, whose good humour and enthusiasm made meeting the deadlines a pleasure. For copyediting beyond the call of duty during a very difficult time, warm thanks to my friend Susan Haskins. My immediate family have helped me the most. My sister Kate has been an inspiration and mentor. Without the practical and moral support of my mother, Marianne, I could not have done any of this work. My children, Clio and Jack, have joined field trips with enthusiasm and have patiently endured my obsessive attention to work at the computer. My husband, Sandy Heslop, has been my greatest supporter and both my sternest and most creative critic. My debt to him is beyond words.

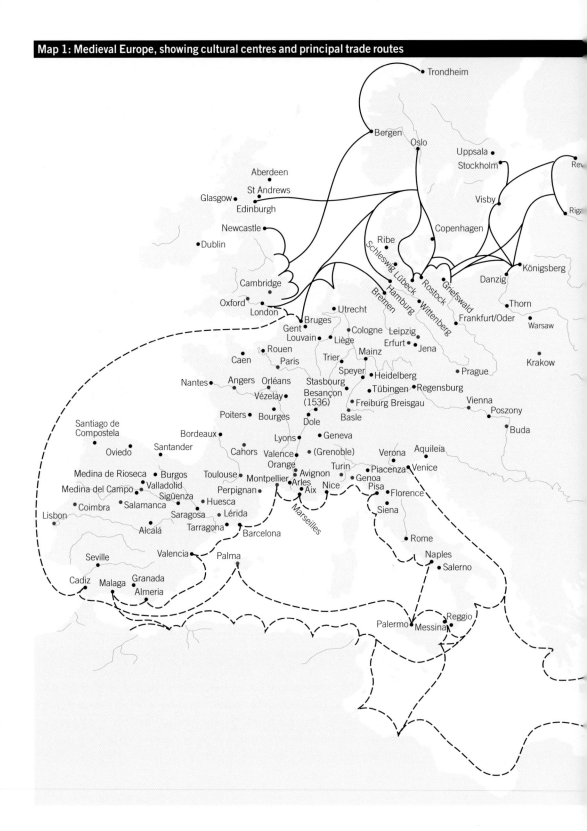

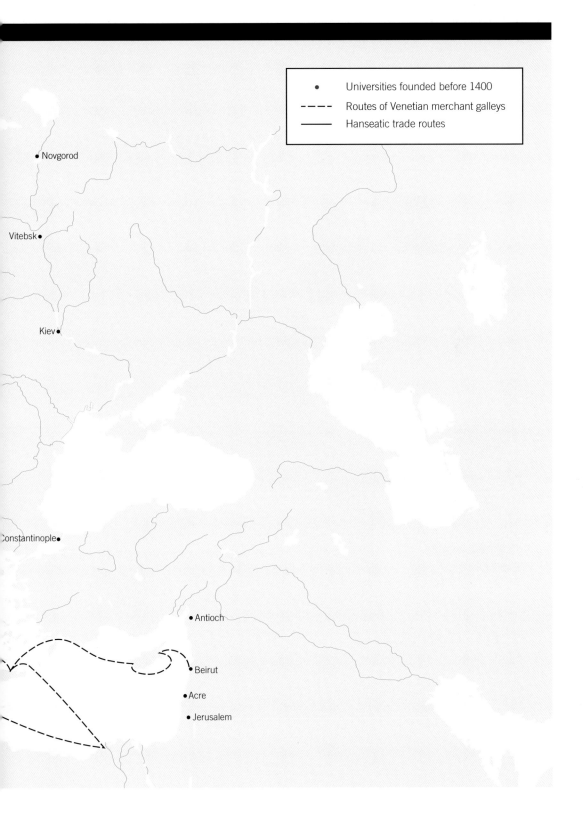

Universities founded before 1400
Routes of Venetian merchant galleys
Hanseatic trade routes

Novgorod

Vitebsk

Kiev

Constantinople

Antioch

Beirut

Acre

Jerusalem

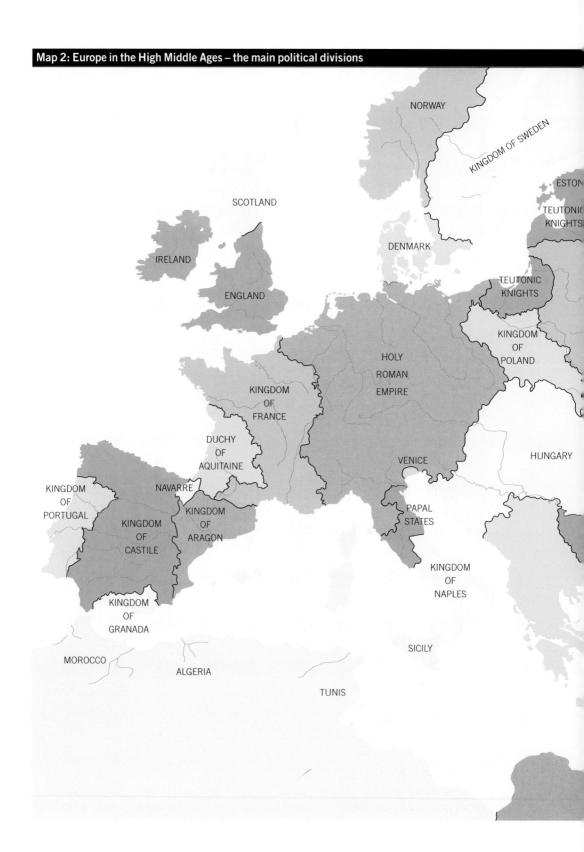

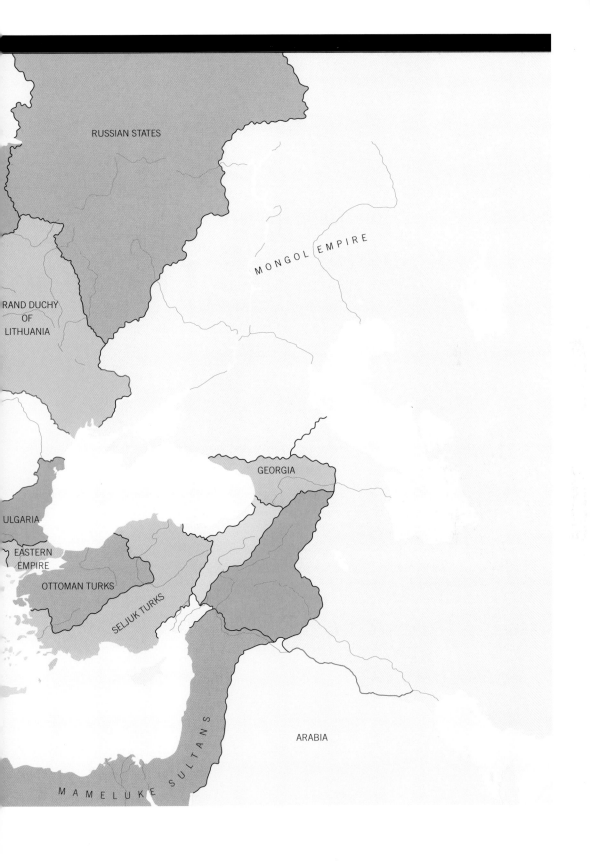

RUSSIAN STATES

MONGOL EMPIRE

RAND DUCHY
OF
LITHUANIA

GEORGIA

ULGARIA

EASTERN
EMPIRE

OTTOMAN TURKS

SELJUK TURKS

ARABIA

MAMELUKE SULTANS

Introduction:
The Realms of Art

The travel writer Sir John Mandeville discussed the journey he supposedly undertook from England to Constantinople in the prologue to his book written in the mid-fourteenth century. He explained that he would not be describing the route in minute detail as that would make too long a tale, but rather he would select the most important places.[1] This he went on to do, stopping every so often to describe a noted feature or to relate a story that lent atmosphere and veracity to his account. Although his book is enormously entertaining, it is also notoriously inaccurate, so I hesitate before making too close an analogy between his work and mine. But his description of the perils and enormity of the task, and his sensibility to the need to keep the reader interested, struck a chord. Like him, having undertaken a very long journey, I have chosen to record a selected and abbreviated path, sparing the reader its minute details and potential digressions. But, in a sense, the medieval past is just as much an elaborate fiction now as was the world described by Sir John Mandeville. Most of the places of which he wrote he had never visited, so he had to exercise his imagination in order to convey his impressions. I read many books, I undertook real journeys to specific places to see the landscape, the monuments, and the remains of material culture. But the medieval past is not a specific and visitable destination and no medievalist can do more than make informed judgements and imaginative suggestions about wider cultural aspects of the life and art of the period.

Discussing the art of some 500 years and some 12 countries in one book is a daunting task. I have aimed to trace a number of distinctive paths through the material to tell stories and pursue lines of argument. I have tried to maintain a tension between ideas and questions that have relevance for us now and responses and reflections that come from the medieval past. My aim has also been to be vigilant about commonalities, idiosyncracies, issues of identity, and cultural difference. Incidents and phenomena that apply to one situation are not necessarily applicable to another in other circumstances. I am acutely conscious of the specificity of historical accident and the relevance of the particular in environment, events, and personal

Detail of 98

'Gothic' was a pejorative term for medieval architecture current in Italian art-historical writings around 1500. Basically applying to the fashion for the pointed arch, it was denigrated, inaccurately, as deriving from the barbaric tendencies of the Goths. It persisted as a style name, gradually acquiring a defined period of development, starting around 1150, and a set of characteristic attributes:

- slender and attenuated pier and arcade forms and an increase in linear pattern;
- canopy-work proliferates, decorated by leafy crockets, fleurons, buttresses, small gabled roofs, and pinnacles;
- increasingly varied and complex window tracery, with its forms being used as surface patterning on walls;
- figurative arts acquire some of these influences from the beginning of the thirteenth century.

These characteristics and effects are discussed in the present book, but without reference to 'Gothic'. It is potentially misleading to adopt an anachronistic style name as a shorthand for a whole range of assumptions about the spread and consumption of ideas, or modes of behaviour. A persistent expectation until recently that the main changes in forms of art are centred in the development of the Gothic has meant that continuities of ideas over the whole period of the Middle Ages have been ignored.

experience. It is largely for this reason that I have avoided all use of retrospective style terms such as 'Romanesque' and 'Gothic'. Instead I have used style diagnostically, looking for characteristics that reveal attitudes, genres, modes of reception, and influences. As an historian and an educationalist (but this approach would also work for a novelist) I am interested in exploring what it is that a work of art allows one to say, the realms within which it can operate. These will not always be the same as those that the artist intended or thought were related, but then artists are often surprised at what their work communicates to a dispassionate observer once it is out of their control and viewed within the context of other lives and agendas.

This book is about the conjunction of art and life. In the medieval period there was no argument about what art was and precious little definition or discussion either. Art was not an isolated phenomenon, but was integrated in all forms of visual display and associated with numerous aspects of cultural behaviour, custom, and communication. Worship, learning, building, domestic life, warfare, trade, and gift exchange—each had its range of appropriate arts. As communications media, of service in evangelizing or socializing, or for moral or philosophical instruction for widely scattered populations, the visual arts were highly developed. Architecture is beyond the scope of this book, but every part of a church from the floor to the roof could be used for public display, to illustrate Christian philosophy and dogma, its literature, and its hierarchy of revered saints and heroes. In the secular world, the learning that gave access to a cultured and civilized

life left its traces through sculpture, paintings and tapestries, as part of hall and palace decoration, or, in the case of a civic building, by the very vision of grandeur and importance its dignitaries chose for it.

For a culture that was largely illiterate, memory and imagination had to play a large part in the transactions of daily life. St Gregory the Great's assertion, written in the sixth century, that pictures were the books of the unlettered, was quoted again and again until well into the fourteenth century as a justification for the arts of painting in churches. Pictures and sculptures in public places also reflected literature or history, sometimes as a demonstration of great erudition, or to deepen spiritual experience. The most detailed visual narratives of the lives and miracles of local saints were often to be found precisely in the localities where they were celebrated, such as, for example, on the capitals around the apse in the church of Saint-Hilaire at Poitiers. Tapestries, embroideries, or paintings, often hung in palace halls, as, for example, the embroidered Bayeux 'tapestry', told great tales of battles and conquests, and it was often relatives or descendants of the battle heroes that commissioned them.

Even though texts are relatively mute about the interpretation of imagery, most medieval art is readily open to a range of interpretations. Images appear to be simple and communicative, but are often more complex than they seem. Puzzling over things, enjoyment of anomalies, and playing around with layers of meaning, all these were medieval practices and delights and the modern viewer can quickly pick up a taste for this. But one of the more puzzling facts about the arts of the Middle Ages is that the ways in which works came into being and were transformed from conception to realization varied a great deal according to particular local conditions and influences. The creation of art was often collaborative, either more so than it is now or more openly acknowledged than it is now. It was not unusual for works to be created through the amalgamation of the skills of artists and teachers, thinkers, and theologians.

There was also a perverse tendency among artists and patrons to overturn the rules and confound expectations in order to keep viewers thinking hard about the possibilities of single meaning, multiple meanings, or lack of meaning. Within the context of a manuscript, the placing of an image on the page, its prominence, its mode of framing, and its physical relationship to the text may have signalled its mode of reception. A full-page, fully coloured, and framed picture of a saint or religious scene will inevitably inspire reverence through its subject matter, but also through its imposing scale. It supplants written text, so is viewed in sequence by a mind set on reading. Marginalia or images bordering text will be read in a more dynamic fashion, drawing the eye to and from the text via a less predictable pace of narrative. Artists understood and played with these conven-

tions, which fundamentally affected the genres of imagery in each context.

Sensibilities to cultural difference were also acute. This subject is explored to some extent in the first chapter. Where and how did people get their sense of place and environment, and how was it expressed visually? The two issues were interrelated. International contact was dependent on direct personal experience. Whereas now when we import foreign goods we can simply buy them impersonally in supermarkets, in the Middle Ages the merchants came too, so that buyers had to purchase from people whose language they did not understand and who were perhaps dressed in different fashions. Trading enterprises of merchants led to constant travel and exchange of goods among European markets along the arterial rivers—the Rhine, Danube, Meuse, Seine, Thames, Elbe, and Rhone—and to and from strategic ports of the Baltic, the Mediterranean, and the North Sea. The importation of luxury goods such as ivories and precious metalwork, silks, and textiles in themselves had an impact on the sense of place in many ways in that they brought a refreshing foreignness and exoticism. An object such as the Dune cup from Gotland (discussed in Chapter 7) is a case in point [135]. As an exotic import from a faraway land, its rich animal and foliage decoration would have given its owner a sense of another place, bringing with it an aura of rare luxury, perhaps stimulating his imagination to roam a little beyond his familiar realms. Such goods were in limited use in wealthy households and in the Christian church, but there is growing evidence, especially from the eleventh to the thirteenth century, that the colours, patterns, and motifs of Eastern textiles were widely influential throughout western and central Europe over a range of other media, incorporated into ecclesiastical vestments, informing taste in aristrocratic apparel, and inspiring derivations in other media and contexts from the Mediterranean to France and England.

The spread of Christianity throughout Europe in the Middle Ages gave new impetus to travel for all kinds of ordinary people as well as for clerics. Throughout the later Middle Ages, the many disparate powers of Latin Christendom were held together by successive edicts, councils, synods, and military enterprise, all requiring numbers of people to be in international transit. The very fact of establishing and maintaining a common religion across most of Europe required assiduous evangelism, and constant administrative, spiritual, and sometimes military support. One of the factors that gave rise to the Crusades between the end of the eleventh and the fourteenth centuries was a perceived need by Christians for protection of monuments and sites in the Holy Land that were sacred to their religion. This led to the movement of great armies of Christians against Muslims and the 'just war', justified by Christians as a defence

of their territory. But there was also a less belligerent desire for authentic spirituality that grew as a mass movement, which inspired a regular traffic of people, a cross-section of society from kings to peasants, that travelled across the whole of central and eastern Europe to experience the sites of the Holy Land as well as to liberate them.

This book begins and ends in very different worlds. The generally accepted view is that the first half of the period, until about 1250, was a time of broad economic growth and political expansionism. It saw the beginnings of the Holy Roman Empire, an increasingly powerful and rapidly expanding Catholic Church, the growth of pilgrimage and Crusades, a dominant aristocracy, and a strong rurally based society. At the end, we have a wealthy and numerous bourgeois class with more and larger urban centres, declining rural economy, and a dramatically weakening Catholic Church. While Arabs and Jews were systematically driven from Latin Europe between the thirteenth and fifteenth centuries, in the world beyond, frontiers and aspirations were expanding with the explorations of the New World and Africa. A good deal of what happens represents change and development, not progress, and that applies as much to the history of art as to events and politics.

Looking back from an age of escalating scientific and technological experiment, it is easy to view the medieval past as bound by limitations and constraints. It is perhaps hard to see the relevance to modern societies, driven by the need constantly to push forward the boundaries of knowledge, of an age whose restraints represented security, whose certainties were accepted unquestioningly, and in which the past had more authority than the temporal future. Yet we still owe debts to the medieval view of the world. The attitudes and images of 500 to 1,000 years ago are the roots of many contemporary beliefs and prejudices. Western societies still express fears, fantasies, knowledge, and discoveries about the world, space, the environment, and creation in various forms of art. We may have turned increasingly to journalism, film, and multimedia, but our visual world contains many similar elements.

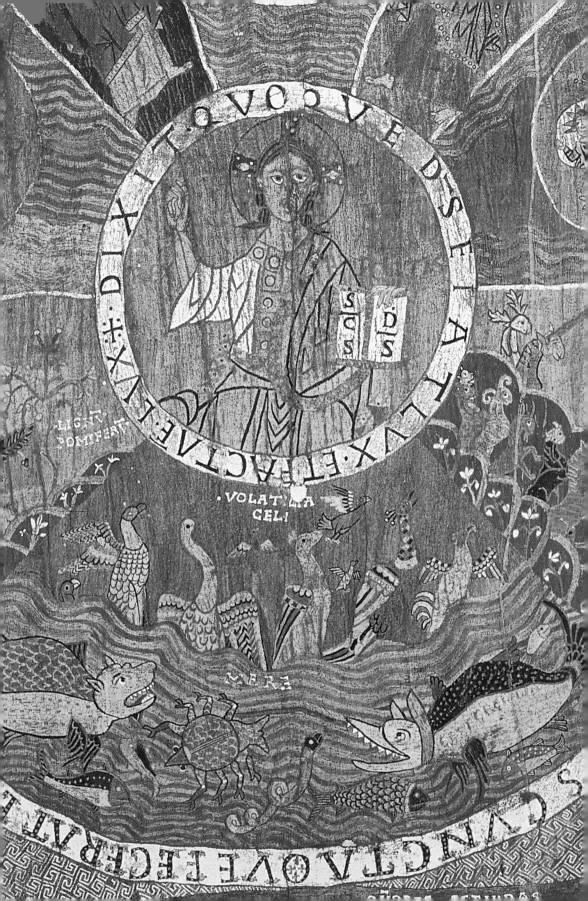

A Sense of Place

During the last 50 years it has become possible to travel the globe in the space of a day, view the planet from outer space, and commute a hundred miles daily between work and home. During the 500 years covered by this book, travel was confined to the hours of daylight and restricted daily by the distance a person could walk or ride on horseback. For most people, the village and fields in their vicinities were the only places they saw and their neighbours the only people they knew. Roads and paths, river bridges, and mountain passes were limited. Those who ventured abroad and experienced lands beyond their own were likely to have been either pious and travelling on pilgrimage, brave and preparing to fight, rich and engaged in a foreign marriage, or learned, required by their professions to travel. There was also a general issue of the triumph of faith over experience. The majority of the populace of western Europe understood the geography of the world in terms of the Judaeo-Christian Bible, and to them it was matter of certainty that God created the world in seven days and that the Garden of Eden existed somewhere in the East. Written accounts of the world by travellers and encyclopaedists reported that monstrous creatures inhabited the lesser-known regions of the world, and their exaggerated descriptions were widely believed. Only towards the end of the fifteenth century were some of the ordinary beliefs challenged as the real shape and contents of the world became more widely explored.

Communications media dominate modern society, making it hard to escape the daily information we have about the rest of the world. The effect has been to extend our horizons far beyond our homes, and the danger is that widening perspectives divert attention from our immediate localities. In particular, our visual sense of place, which ought to be determined by what we know and encounter locally, is unsettled by comparison or contrast with external stimuli. This sense of place may be governed not only by reality but by aspiration, for example towards ideas of ruralism in the city or a desire for exoticism in the West. In the Middle Ages, while perceptions of place were similarly conditioned by experience, communications were slower. People who travelled abroad were able to bring home a sense

of wider horizons through the tales they told, music they played, or goods they imported, but for those left at home there was more time for sharper reflection within a narrower band of locally accumulated knowledge. If anything, the imagination played a greater part then than it does now in defining the visual horizons of a particular place. As illustrations in this chapter will show, there are many ways in which works of art reflect a sense of place, in terms of celebration of the minutiae of daily incident, aspirations towards, or rejection of, the foreign and exotic, or the making of symbolic relationships between one environment and another.

Concepts of place

There is constant tension in western medieval images of the world between empirical observation and the symbolic representation of Christian ideology. Large tracts of the earth were as yet unexplored and uncharted terrain and yet, ideologically, the Christian world had to be accepted as entirely created by God and explained in terms of the Genesis account of its beginnings and its apocalyptic climax. Life was never-ending; death was a mere interruption to the continuum, after which the soul would await the Last Judgement, the blameless destined to join God in heaven, the wicked condemned to the fires of hell. Reconciliation of tensions between what was known, what was experienced and documented, what was unknown, what was dis-covered by science, and what was understood and accepted through faith was provided already in the fourth century largely by the writings of St Augustine, but these were the most debated issues in medieval philosophy for centuries thereafter. Concepts of the world were on the one hand impossibly complex, but in other terms could be summarily represented by very simple means. In the *Etymologiae*, the late Antique encyclopaedic text of Isidore of Seville that is at the core of much medieval knowledge, according to one typical formula the world was represented in the form of a circle divided by a 'T' into three parts to form the three continents of Asia, Africa, and Europe, one for each of the sons of Noah. In Spain, perhaps because the country was long faced with the political and military power of Muslim rule, a whole category of moralizing images of the world continued to establish the basic Christian ideology. Beatus of Liebana, a Benedictine abbot from Asturia, had written a commen-tary on the Apocalypse in the late eighth century as a means of strengthening the faith of a spiritually embattled Christian popula-tion. As well as multiple illustrations of the Apocalypse of St John, copies included Creation scenes and maps and diagrams of the world intended to demonstrate the extent of the territory to be evangelized by the apostles. Sometimes the world adopted the Isidorean T–O form, but also new types of diagrams invented for it included a

1

Creation tapestry, wool
embroidery, c.1100.

The Creation tapestry from
Girona, in its incomplete state
alone measuring 3.65 metres
high by 4.70 wide, is one of the
most important surviving
medieval visualizations of the
origins of the world. God
appears at the centre of a
segmented circle, surrounded
by Creation scenes and the
four winds. Above is the
creation of the firmament,
flanked by the division of night
and day, below is the
multiplication of creatures of
the earth and water, and to
either side is the creation of
Adam and Eve. Images
illustrating Christ's betrayal
and the finding of the True
Cross are at the bottom,
alluding to mortal weakness
and human salvation.

rounded rectangular shape with the Garden of Eden at the eastern
summit.[1]

Another, more complex pictorial tradition brought the origins of
the world into powerful vision. The Creation tapestry from Girona,
in Spain, dating from the late eleventh or early twelfth century, com-
bines a visualization of the Genesis account of the beginnings of the
world with a cosmological diagram [1].[2] The roots of its design can
be traced back to classical sources, through Christian art of the
Mediterranean, as well as to cosmological diagrams of both Jewish
and Arab origin. It is a large-scale, public work of art and, despite its
multicultural sources, it makes visible a rationale for the way the
world had been shaped according to an exclusively Christian ideology
as if it were acting as a piece of knowing propaganda for the
Christian religion.

Medieval images of the world have been described as 'moralized
geography', providing summary catalogues of the world's contents
and assemblages of information about peoples, places, geographical
features, and curiosities, for the purposes of instruction.[3] Large-scale
world maps, or *mappae mundi*—literally, 'cloths of the world'—were
religious documents but also courtly necessities, commissioned by

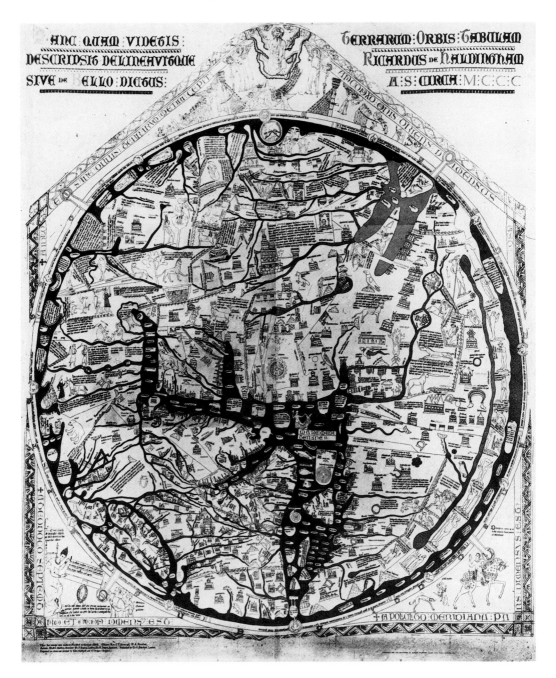

European rulers to hang in their palaces, for their information, for their obvious prestige, and for their strategic potential. The emperor Charlemagne had owned one such map in the early ninth century; Henry III and Edward I of England had each had one in the thirteenth century, and in 1375 Charles V of France requested a copy of the most up-to-date world map from Pedro IV, king of Aragon. The French king was sent the 'Catalan Atlas', which bears witness to the

2

The Hereford cathedral world
map (nineteenth-century
engraving), c.1230.

At the summit is the east with
Jesus Christ in judgement at
the edge of the world below
him. Jerusalem is at the centre
with the Mediterranean below
it to the west. England is
disproportionately large at the
lower left in the northern
region. In common with most
other *mappae mundi*, the
Monstrous Races appear at
the southern edges of Africa,
but a few are also scattered
like itinerant anti-pilgrims
throughout the world.

supreme skills of Jewish cartographers in Spain. This was not for display on a wall but was a folding parchment compendium. It included a combination of geographical, scientific, topographical, and cosmological information, deriving in great part from Greek, Roman, and Arab scholarship; it also took account of all the current navigational techniques for measuring coastlines and distances for ships undertaking mercantile and exploratory voyages. It also catalogued the relatively recent travels of Marco Polo and other records of real travel and exploration.[4]

At the lower left corner of the large world map made in Lincolnshire, England, in around 1280, probably for a canon of Hereford Cathedral, the Roman emperor Caesar Augustus is represented instructing his surveyors to measure the world [2]. At the lower right is a portrait of the map-maker, Richard of Holdingham and Lafford (Sleaford, Lincolnshire), setting out on horseback and greeting a hunter. At the summit, Christ presides in judgement, flanked by angels, while below him the saved souls are being separated from the damned. The Hereford map is one of a small group of *mappae mundi* with both English and German connections that make a particular feature of the Christian context for the world in that it is cradled by, or guarded by, the body of Christ. The largest of these included the thirteenth-century Ebsdorf map, which measures over three metres in diameter and is now known to be from Lüneburg, near Hamburg in northern Germany. Destroyed in a bombing raid in 1943, it originally had the head of Christ appearing at the top and his hands and feet at sides and bottom. The smallest versions feature as manuscript illuminations.[5] These visions of the world are highly complex documents with, depending on their scale, a public function as items for display and practical guidance. In Richard of Holdingham's words his purpose was to excite the curiosity of the viewer, 'giving directions for travellers and the things on the road that most freely delight the eye'. The compendium of information they contain is consistent with their multiple purposes, as universal symbols of current knowledge, as items for instruction, as plans for or records of itineraries, as aids to evangelism, and as warnings against the world's dangers and unknown forces. Topographical details were assembled in order to fulfil a number of these didactic and historical purposes, but they were also designed with specific patrons in mind.[6] For example, in the Hereford Cathedral map Lincolnshire occupies a disproportionately large area of England at the map's lower left. Religious symbolism also played a part in the moral geography of the map as Jerusalem is shown symbolically as a focal point at the centre of the world and all the Christian sites in the Holy Land appear nearby. The Monstrous Races are ranged, according to common belief, at the southern edge of Africa [3]. The skill of the map

3

Three inhabitants of Siberia, *Livre de Merveilles*, parchment, early fifteenth century.

The *Livre des Merveilles* is a manuscript compendium that includes the travels of Marco Polo and Sir John Mandeville. Inhabitants of Siberia were described in Polo's text simply as 'wild men', but were illustrated by the artist as representatives of the 'Marvels of the East': the Blemmye, with faces on their chests, the Sciapods, who were said to use their enormous feet to shade them from the sun, and a naked wild man.

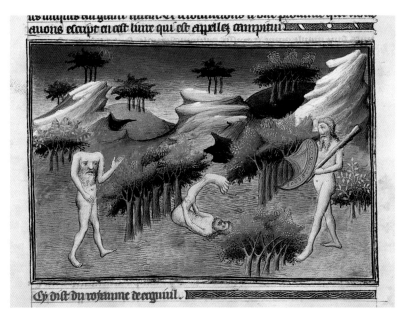

compiler, and indeed of this kind of map, was to centre a particular local history in the context of the rest of the world in such a way as to satisfy a need for both the general and the particular. The world is not merely recorded: it is orchestrated to convey a geographical sense of place within a political and religious context, in terms of past and present history, and within a clear overall ideological framework.

The Monstrous Races

Many sources contributed to the accounts of the Monstrous Races. They represented peoples encountered by Alexander the Great on his eastern journeys. According to information in the encyclopaedia of St Isidore of Seville, deriving from Pliny's *Natural History* and Solinus' *Collectanea*, which in turn had culled material from Greek accounts on the matter, the races of strange and unfamiliar beings mainly inhabited the extreme eastern or southern countries, at the edges of the known world. Here the climates were known to be excessively hot and dry and the peoples consequently deformed and without reason. As these regions of the world became more familiar, sightings of Monstrous Races shifted to the frozen north as well. Reports of their existence were enduring and varied from

the supposedly historical and scientific accounts of the encyclopaedists and, much later, the travel accounts of Marco Polo to the more dramatic fantasy of Sir John Mandeville's popular fictitious travelogues.

The accounts varied from the embellished descriptions of real peoples such as the Ethiopians and the Brahmins of India to fantastic accounts such as the 'Cynocephali' or dog-headed men who communicated by barking, the 'Blemmyae', whose faces were on their chests, the 'Anthropophagi', who drank from human skulls, and the 'Panotii', whose ears reached their feet. In the Middle Ages these peoples were ghettoised in travellers' accounts and on *mappae mundi* as the heathen 'other', representing the other side of the world.

Peoples as places and places as peoples

Personifications of places, whether cities or countries, especially as regal or armed women, are one of the oldest forms of power symbolism. The city of Rome, as the centre of Latin Christendom and the heart of the Holy Roman Empire, had to be reinvented as a Christian symbol and yet still appeared in the Middle Ages as an enthroned pagan goddess holding her attributes of control and rulership, a globe, spear, and shield. A ceremonial gospel book written and lavishly illustrated in *c.*1000 for the Holy Roman Emperor Otto III shows him enthroned and being approached by four queens bearing various attributes [**4**]. They make obeisance before him by inclining their heads: Roma takes the lead, followed by Gallia, Germania, and Sclavenia. The illustration represents the greatness of the emperor's power, the women symbolizing four provinces of his extensive empire, which extended from northern Germany to southern Italy and over to eastern Europe. It is a graphic demonstration of the ruler exercising power over his peoples, but it also serves a more particular political purpose. By having his artist identify the Italian province as Roma, as opposed to Italia as his predecessors had done, Otto was indicating his intention to centre his imperial power in Rome. Polish ruling families had been competing there for power, so by showing Sclavenia as his subject, behind Roma, Otto was making his strategic intentions towards the city very clear.[7]

Places were represented by the stereotypical personages, but people and their characteristics also represented the identity of places. Medieval commentators were sensitive to the particularities of both. They were also ready to categorize people according to race or class

4

The Holy Roman Emperor, Otto III, enthroned in majesty and approached by four queens, from the *Gospels of Otto III*, parchment, 998–1001.

Rulers are nearly always shown in some kind of architectural enclosure, and important pronouncements or presentations to patrons are always framed by architecture. In general terms, the representation of architecture, or of architectural features such as fictive niches or arcades as settings for images, suggests status and civilization.

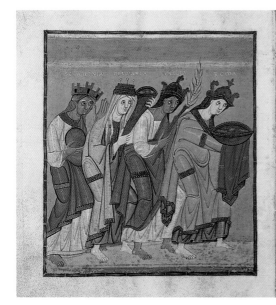
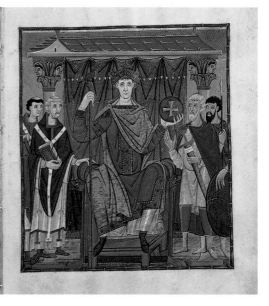

and were often critical or suspicious of national characteristics that were perceived as foreign or different from their own. For example, Guibert of Nogent, in coming across the Scots during a Crusade in the early twelfth century, wrote of them disparagingly as men who had been 'drawn from their native swamps with their bare legs, rough cloaks, purses hanging from their shoulders, hung about with arms, ridiculous enough in our eyes'.[8] Different appearance was one of the most obvious signs of foreignness. Description of place and sensibility to its atmosphere in medieval texts is often rendered in terms of vivid descriptions of unfamiliar-looking people exhibiting strange or barbaric behaviour.

Pilgrims travelling from northern Europe to the shrine of St James the Great at Compostela in Galicia had to journey through south-western France and northern Spain. While the journey entailed traversing spectacular scenery and the pilgrimage sites that exploited the scenery's natural beauty, a revealing account of the route concentrated more on the trials of travel. It appeared early in the twelfth century in a manuscript known as the *Liber Sancti Jacobi*, which is sometimes attributed to a Poitevin author, Aymery Picaud. Pilgrims were subject to widely varying standards of welcome and hospitality on their journeys. The inhabitants of Poitou are described as being generous in the rewards they bestowed and prodigal in the hospitality they offered. Passing through the Landes, in south-west France, pilgrims would find a barren and desolate region with few villages and many sandy swamps, bedevilled by wasps and horseflies. Gascony was said to be rich in white bread and excellent red wine and covered by forests, meadows, streams, and healthy springs, although its inhabitants were described as loquacious, libidinous drunkards, given to mockery, and were ill-dressed and rather careless in the ornaments they wore. Particular venom in the account was reserved for the Navarrese, who were declared to be distinct from all other nations in habits and character: they were malicious, ugly, debauched, perverse, perfidious, disloyal and corrupt, libidinous, drunken, and given to all kinds of violence. As if this were not enough, they were also ferocious, savage, impudent, false, impious and uncouth, cruel and quarrelsome, incapable of anything virtuous and 'well informed in all vices and iniquities'.[9] In the sense that it demonizes the foreign, the highly prejudiced description of the Navarrese in the *Liber Sancti Jacobi* is little different from the conventionalized medieval portrayals of unknown peoples as the Monstrous Races. These too were peoples who, reputedly, since the days of Alexander the Great had been encountered on real voyages undertaken by explorers to far-flung quarters of the earth. But occasionally they crept out of the scholarly world of manuscripts into wider circulation, impinging with a particular force on more popular local consciousness.[10]

In 1146 St Bernard of Clairvaux preached the Second Crusade at Vézelay, and in 1190 Richard 1 of England and Philip Augustus of France started their missions from there for the Third Crusade. Had there been mass media, the world's attention would have been directed here, but there was a real sense in which the world was already there. The church at Vézelay contained the relics of St Mary Magdalen and was itself an important centre of pilgrimage as well as a favoured stop en route to Compostela. Upon entering the church the main focus is the tympanum of the inner west doorway, carved in c.1130 [5]. It is dominated by a figure of Christ who, with pentecostal rays of power emanating from his fingers, is manifestly inspiring an agitated group of apostles to evangelize throughout the world. All around them are arranged the world's diverse peoples, ringed by a temporal and cosmological assembly of labours of the months and symbols of the zodiac. The Monstrous Races appear here as benign candidates for conversion. But they are also symbolic of the dangerous encounters beyond the known world. They perform a dual role, as 'Marvels of the East' to be puzzled and wondered at and as victimized foreigners pushed to the periphery of civilized society. Their liminal presence heightens the sense of this place as being driven by a mission to seek out cultural difference, encouraging a perception of foreigners as objects of derision while at the same time asserting its responsibility for their religious conversion.

Jerusalem everywhere

Today crowds of pilgrims still congregate at the *sancta sanctorum* near the basilica of S. Giovanni Laterano in Rome and prostrate themselves on the 'Scala Sancta', or 'Scala Pilati', the steps that once led to the Praetorium of Pilate in Jerusalem and which Christ is said to have mounted during his Passion. These steps have been sited here since they were brought to Rome by St Helena in the early fourth century, and whether or not one believes in their authenticity, to experience the power of association, and to witness the extreme manifestations of faith of those who do, is unforgettable. But contemporary touristic voyeurism is utterly foreign to medieval attitudes. Nobody in the Middle Ages would have been sceptical about the authenticity of a relic as important as the Scala Pilati and no one would have been immune from the extreme rush of devotional feeling and reinforcement of faith that making obeisance at these steps would have given them.

A modern pilgrim limits the experience to the geographical boundaries of Rome, but in the Middle Ages, when earthly identities were shifting and intangible, a pilgrim was effectively as good as visiting Jerusalem itself. The eleventh, twelfth, and thirteenth centuries saw a dramatic rise in the number of pilgrimage centres all

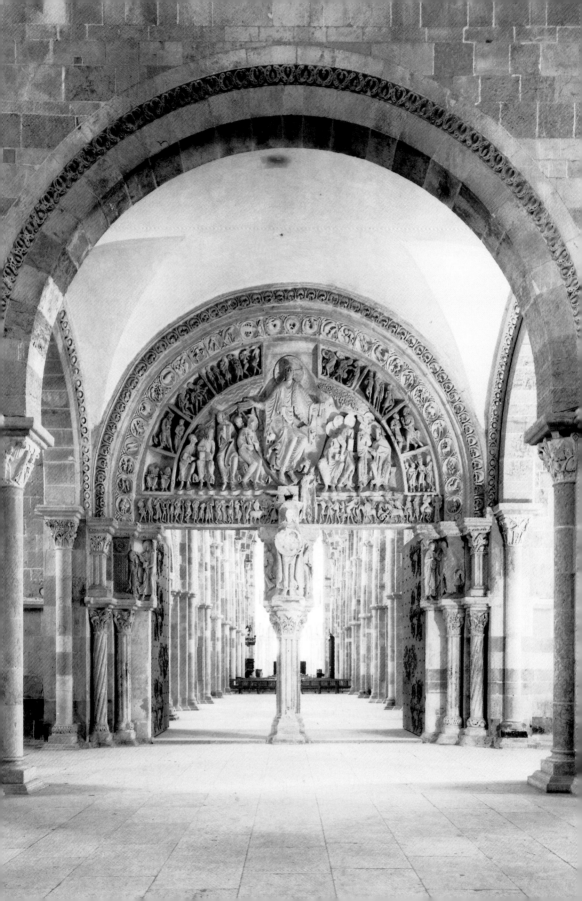

over Europe. This was partly a result of the Crusades, as returning crusaders and pilgrims from the Holy Land brought back relics that they wished to honour, but partly also a result of competition between regions and dioceses that vied with one another to acquire the most important saints' remains. Not only could these confer a holier status on their resting places, but they could also lead to the generation of considerable funds. No less a coup than the acquisition of the body of St James for Compostela, or that of Mary Magdalen for Vézelay, were those of St Nicholas at Bari, St Lazarus at Autun, or the relics of the Three Kings at Cologne.

The great crusading fervour of the eleventh, twelfth, and thirteenth centuries may have resulted in the temporary capture of Jerusalem in 1099 until its fall in 1187, but the Holy Land was never successfully colonized, so the conquest was incomplete [**6**]. The 'conquest' of Latin Christendom by Jerusalem, however, was much more striking, played out largely in the spread of its relics and the foundations and monuments that were created to honour them.[11] Because of the sanctity conferred on a place by a potent relic, and because of the system of indulgences granted to pilgrims who visited holy sites, there was an extent to which a really important but intangible centre, such as Jerusalem, could be strategically echoed and duplicated to make it more powerfully intelligible. More prosaically, the movement

Jerusalem

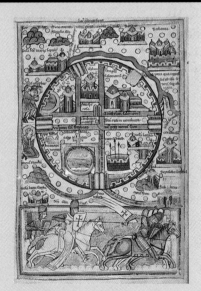

The city of Jerusalem was subtly reformulated through its visual images to present an acceptable picture of Christianized territory. Most maps of Jerusalem date from the 50-year period after its conquest in 1099. As in the tiny vision of the city at the centre of the Hereford map, Jerusalem is usually represented as a circle divided in four by a square, thus conflating the division of the world by Isidore of Seville into three, as represented in T–O maps with the Christian symbol of the cross, in an obvious symbol of ownership. The design of its topography is rationalized in the Hague map to produce an ordered symmetry consistent with medieval ideas of visual perfection, whilst also incorporating the range of sites that a traveller would expect to find. However, fighting crusaders at its base remind the viewer that this is contested territory, land that has been hard won and is worth defending.

of relics meant that extreme holiness could be disseminated to centres of local importance, so that pilgrims did not have so far to travel.

Throughout Europe, from at least the eighth century, replicas of the church of the Holy Sepulchre at Jerusalem and of Christ's place of burial were built in many forms, some of them incorporating relics from the Holy Land, but all of them reproducing in some significant way the associative power of the original site.[12] The most comprehensive evocation was built in Bologna in the twelfth century—a veritable 'new Jerusalem', comprising a complex of buildings that represented and were named as the church of the Holy Sepulchre, the mount of Calvary, and the courtyard of Pilate. Pilgrims would have been granted indulgences for journeying to worship there.[13] The appropriate sanctity could be transmitted even to outdoor locations. The carved rock chapel of the Tomb of Christ at Horn in Westphalia is a potent example of a phenomenon that was replicated extremely widely [**7**].

7

The 'Externsteine' stone, Horn, Westphalia, *c.*1115.

An outcrop of rock in Westphalia became the site for a magnificent twelfth-century carved Deposition of Christ, behind which, in a little rock-hewn chapel, is a version of the Tomb of Christ in Jerusalem—a tiny body-shaped cavity into which the Host, as the body of Christ, was ritually buried every Easter.

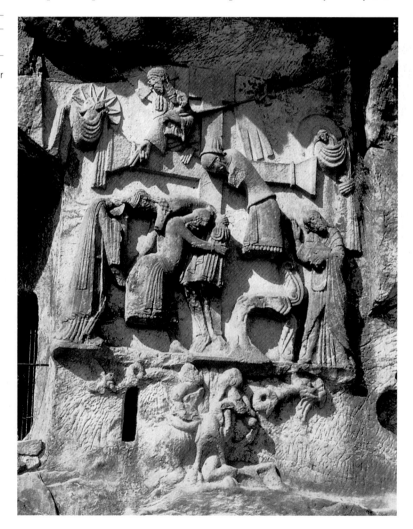

At a conceptually more complex level, Jerusalem could be everywhere, at the chancel of every church during the celebration of mass. Marking the entrance to the choir of Southwell Minster in Nottinghamshire in central England, a group of twelfth-century capitals high up on the crossing piers literally announces the space as an evocation of Jerusalem as they record the association between the entry of Christ into Jerusalem and the celebration of mass.

Rampant nature and the imagination

Artists had many devices and strategies for introducing a sense of atmosphere and were sensitive to the correct setting for a scene or figure that gave it a strong sense of identity and situation. As any gardener will be aware, given a mere single season's neglect a well-cultivated patch of land will be overtaken by weeds. Neglect weeding and all will be lost, advised medieval gardening manuals, nature was ever ready to reclaim its own. The inhabited scroll, a frequent phenomenon of manuscript decoration, and a persistent one in stone or ivory carving in northern Europe in the eleventh and twelfth centuries, is witness to the dominance of nature, ready to reclaim the civilized world at every turn. The symbolism of mortal struggles within or against rampant nature is ubiquitous as a metaphor for the triumph of order, or the dangers of its loss, or perhaps simply indicative of struggle with any adversarial force. Monsters, men, and animals writhe and grapple with whiplashes of leaf and stem tendrils on the wooden doorways of twelfth-century stave churches in Norway. In these images nature is represented as challenging the strength of mortals, ready to engulf and exert its stranglehold over civilization, which is, as it were, caught inescapably in its web.

But, as the French historians Jacques Le Goff and Marc Bloch both recognized, what might be thought of as rampant nature, the forest or the wilderness, was far from untamed.[14] Persistently adjacent to every settled urban or village community, the forest was not always a barren waste of impenetrable thicket, but was readily exploited as a potential and actual source of harvest for game keepers, carpenters working in furniture or building trades, charcoal burners, apiarists harvesting honey and wax, ashmen employed in the fabrication of glass and soap, and bark pullers finding materials for tanning leather and making rope. It was also a refuge for hermits, a hiding place for fugitives, a hunting ground for the nobility, and a place of trial and adventure in romances and legends. It is the last of these categories that is habitually represented in art, the forest as a fantastic refuge and a place of strange encounters. But these encounters are not always what they seem, and in religious art the sense of place is more likely to be allegorical than literal. The richly coloured forest at the border of the page for Psalm 1 of the Peterborough Psalter in Brussels

8

Psalm 1, Peterborough
Psalter, parchment, English,
c.1300.

The border design for the
Beatus page of the
Peterborough Psalter in
Brussels shows a hunting
scene in a forested landscape,
featuring at the top an
imaginary combat between an
ape with an owl upon its head
and an ass. The image is a
moralizing one, like many in
the Middle Ages, in the
context of religious art,
alluding to folly and vanity.

conceals skirmishes between animals and men that are as much moral
as sporting in their intent [**8**]. In contrast to the real world of forest
industry, their illustration could highlight time-wasting diversion.
Describing an image very similar to one at the top of the page—'an
ass upon which was an ape with, in turn, an owl upon its head'—the
Dominican preacher Robert of Basevorn used it in the early four-
teenth century as an example in a sermon on human vanity, making
it clear that this image was a play on nonsense.[15]

Box carved with wild folk in woodland scenes, boxwood, Upper/ Middle Rhineland, c.1460–70.

The carvings celebrate the pleasures of love-making, hunting, and child-rearing on the back and the threats and dangers on the front, all enacted by wildfolk in the forest. They portray a burlesque parody of sensual and familial realtionships unfettered by conventional society. The images relate to diverse other sources, such as prints, drawings, and tapestries, suggesting that the original designs were made by a group of artists producing a wide range of decorative arts.

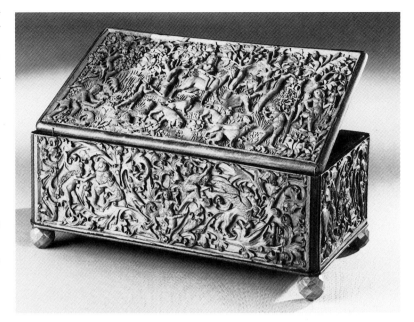

Similiar scenes of rich foliage encompassing tangled encounters between men and animals, wild men, scenes of falconry, and other country scenes and sports do, however, appear regularly as decoration on secular luxury goods, evoking pastoral idylls or fantastic or mythical encounters, depending on the context of their use. Carved leaves, beasts, and 'wild men' occur on a fourteenth-century boxwood gittern in the British Museum and on a mid-fifteenth-century Upper or Middle Rhenish so-called troubadour's box in Vienna, each redolent of the manuscript painting of the damply lush enchanted gardens of Guillaume de Machaut's poetry, and perhaps echoing the imagery of the songs and stories their owners were accustomed to relate [**9**].

The familiar landscape

Environment, climate, language, and custom differ widely in Europe from one country and one region to another. Each one of these factors, or several of them together, might contribute distinctively towards the special character of a place or its inhabitants. The rains and mountains of western Scotland give that country a particular landscape, vegetation, and quality of light that have consequences for its peoples in their types of housing, customs, diet, and habit of clothing, and these are, as they always have been, quite distinct from what one might find in the dry heat of southern Italy or Provence. Despite these wide variations, the life of the peasant varied little across Europe for the whole Middle Ages, and the social structure of peasant communities changed little from place to place. Geographically and demographically, they were probably the most settled

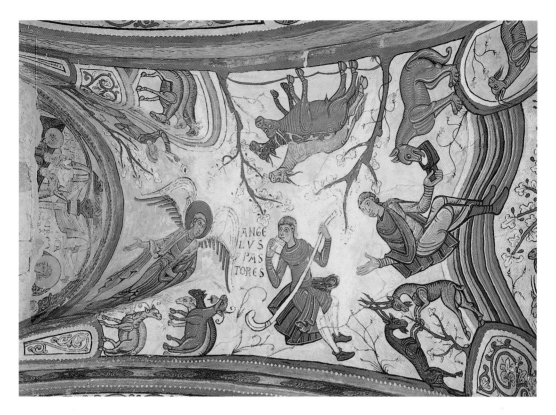

10

The Annunciation to the Shepherds, vault painting, Pantéon de los Reyes, Léon, c.1160.

The painting was added a century after the completion of the building. The Pantéon palace chapel dates from 1054 to 1067. The scene is set in the mountains, where a frisky collection of goats and sheep cavorts among the fig trees.

section of the population. Peasants were primary producers who necessarily developed an intimate relationship with the land, and whatever the particular local economic circumstances, peasant labour and peasant skill were the roots from which the whole of the rest of the economy grew.[16]

In medieval thinking, the peasant's destiny was derived from Adam, whose labours were at the foundation of man's escape from the sin committed by Eve. Piers Plowman, the hero of Langland's fourteenth-century poem, represents truth and virtue and shows how to work well so as to 'wende to heven'. The idea of noble toil is reflected in art, along with the distinctive environments of certain peasant communities and the settled nature of peasant life. Even though it shows an episode from biblical history, the scene of the Annunciation to the Shepherds in the vault of the Pantéon de los Reyes at Léon is depicted as a relatively unmediated image of mountain peasant life [**10**]. The oneness of man, beast, and soil is especially evident in the familiar terrain of rolling mountainsides, with goats locked by their horns in playful sparring, nibbling at leaves, or grazing. Touching details give it immediacy: one man feeds a dog from a dish, another winds his horn, calling all the shepherds to hear the angel's news. These men with their animals and families may have eked out a reasonably comfortable subsistence existence,

but we must remember that they are depicted here in a palace chapel where the kings and queens who ruled them would have been their primary audience. However noble or redemptory the toil, the sense of place of any peasant, in both the economic and social sense, was inexorably dependent on the lords whose land he or she worked.

After the peasant uprisings in England, Flanders, and France during the course of much of the fourteenth century, attitudes to the peasantry in northern Europe may have become more equivocal as they mobilized forces against the nobility. However, art continued as before to reflect an unchanging social order of serfdom, with the physical toil of the land-workers seen always in the shadow of their

11

Scene of harrowing, from the psalter of Geoffrey Luttrell, parchment, English, c.1335.

This page shows a scene of rural labour at the bottom and, at the top right, the mark of ownership, the heraldic shield of Sir Geoffrey Luttrell, who commissioned the manuscript, supported by a woman firmly lodged on the back of a bird.

Calendar illustration for September, from the *Très riches heures* of Jean, duc de Berry, parchment, 1413–16 and *c*.1485.

A scene of the harvesting of grapes takes place in the shadow of the enormous emblem of seigneurial power, the chateau of Saumur, which was built at the end of the fourteenth century for the duc d'Anjou, nephew of Jean, duc de Berry. The chateau was painted by the brothers Limbourg, and the harvest scene was completed 70 years later by Jean Colombe, who finished the manuscript after the brothers' deaths.

masters. Peasants shown in the borders of the Luttrell Psalter, or in the calendar pages of the *Très riches heures* of the duc de Berry, are bonded men and women whose labour benefited the great estates and who were depicted in their lord's most precious manuscripts as much to demonstrate their servility as to depict their rural attainments [11]. (In both cases, images are rich in double entendres and bawdy visual jokes, hinting at ribald humour at the expense of the ruder classes.) There was also an element of the fashionable pastoral conceit. On visiting the count of Foix in southern France in the early fifteenth century, King Charles VI of France was greeted by members of the local nobility picturesquely dressed as cowherds driving before them animals carrying silver bells. It is in this genre too that peasant labour is celebrated in rich tapestries and wall-paintings for great houses.[17]

The *Très riches heures* calendar images, which depict estates dominated by great palaces, show with particular clarity the extent to which the lordly residences were felt to dominate the landscape. It has been suggested that the remarkable effects of foreshortening and the close attention to detail in these pictures were achieved by the painters with the aid of an optical device, either a lens or a type of perspectival frame [12]. A great family would own numerous, scattered estates, and this manuscript is witness to the price of ownership. Jean, duc de Berry, owned 17 chateaux on his estates in the Limousin, Poitou, Berry, and the Auvergne, as well as a Paris mansion, the hôtel de Nèsle, where he died.[18] Typically, Mahaut d'Artois, a prominent member of the French royal family in the early fourteenth century, whose extensive domestic accounts survive, owned 10 chateaux in Artois and Picardy, as well as her grand house in Paris, and was constantly moving from one to the others.[19] Maintenance and defence of possessions and lands required noble households to be frequently on the move. Quite apart from the peasants working the land of the great estates, in the wake of such peripatetic wealth there followed a kind of roaming service industry of traders and pedlars and a wide range of entertainers—jugglers, storytellers, dancers, musicians, and other dramatic performers.

An idealized vision of the virtuous industry of agriculture appears in the frontispiece of a fifteenth-century Flemish manuscript edition of Virgil's *Georgics*, where farm buildings form the horizon and lend the picture much more of a rural atmosphere, coming very close to conveying a landscape [13]. While the scene is pure conceptual artifice, it manages to convey an impression nevertheless of having been grounded in experience and local observation.

Cultivated nature had many meanings in medieval art and literature, sometimes acting as a stage for formal narrative or a setting for romances. The entire narrative of the *Romance of the rose* takes place

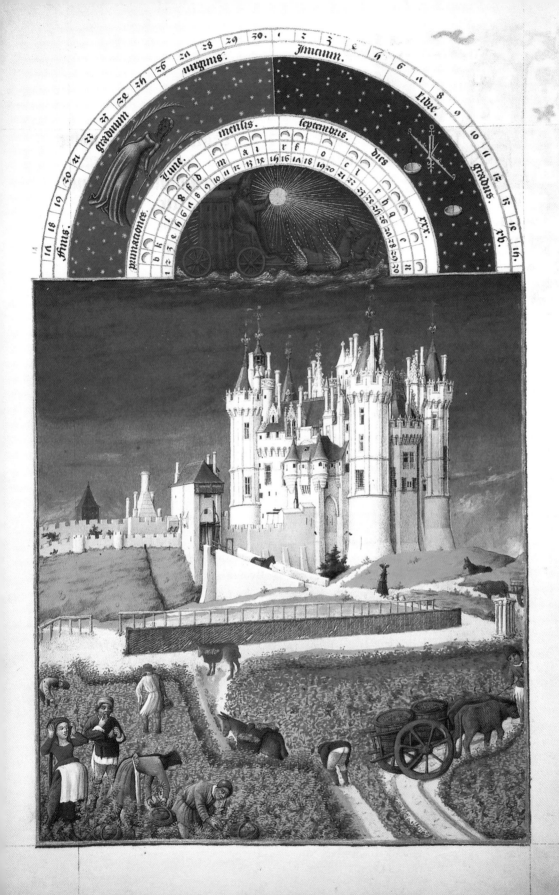

13

Winter scenes, Virgil's *Georgics*, Bruges 1473.

This visual catalogue of rural pursuits in winter shows ploughing with two kinds of plough, coppicing and tree pruning, and bee-keeping. These scenes are set at the edge of a village, the unlikely landscape feature of which is a precipitous outcrop of rock, ruling out its being anywhere near Bruges. However, the image brings a sense of contemporary life to animate an historical text that is entirely concerned with cultivation. The scene is therefore set for the book's continued relevance to a modern audience.

14 Jan van Eyck

The Virgin and Child and Chancellor Rolin, oil on panel, *c*.1435.

The familiar landscape appears in Flemish art as background vistas in images of the Virgin and Child, as a metaphor for comfort and refuge. In the foreground the Virgin and Child are the object of the chancellor's almost unnerving contemplation as he kneels at prayer. The twitching feet of the child draw attention to the garden beyond the loggia, while his raised hand points level with the landscape. Framed by the colonnade of the opening behind them is a pair of figures gazing over to a winding river as if they are viewing eternity.

in an enclosed garden, appearing in illustrations as a theatrical setting, entered and inhabited by the various allegorical characters. In fifteenth-century Flemish manuscripts intended for courtly patrons, the garden can be the setting for allegories such as 'The soul personified as a woman in dialogue with her heart' or 'Personifications of the twelve ladies of Rhetoric'. The *hortus conclusus,* or enclosed garden, had long been a metaphor for the beauty, wisdom, and chaste order of the life of the Virgin Mary. Such a garden can be glimpsed beyond the loggia in which she sits with the child Jesus on her lap in Jan van Eyck's painting *The Virgin and Child and Chancellor Rolin*, as a verdant extension of the geometric tile pattern of the foreground [**14**]. The central point of the whole scene, to which the eye is inexorably drawn, is a little pair of well-dressed people at the edge of the balcony beyond the garden, admiring the view. The vision spread before them of the roofs, towers, and bridges of the town intersected by a river that winds its way through fields and trees to the distant hills is indeed spectacular, but it is also curiously domestic, itself a yet further extension of the measured interior. The visual containment of the meandering river within the framework of the central arch of the loggia makes it appear both to recede into the distance and remain held in suspension, as if it is straining between the familiar and the unknown.

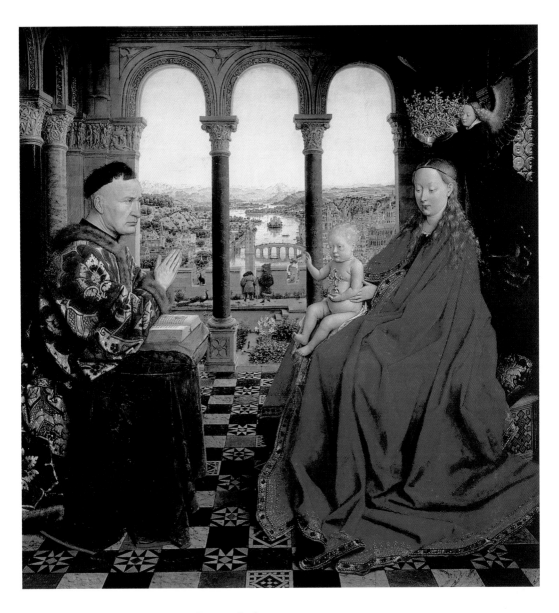

The culture of place

Medieval artists were more concerned with differentiating the visually represented world from the minutiae of lived experience than with devising a pictorial code that united them. In the period from 1000 to around 1350, evocative suggestions of a sense of place are everywhere, but the instances of detailed, accurate, and descriptive visual images of environments, countryside, towns, or even buildings can be counted on the fingers of one hand. The translation of empirical observation of nature or topography into illusionistic realism is very rare. But when it was important or relevant to record a place or a phenomenon of nature in accurate detail, it was done and could be

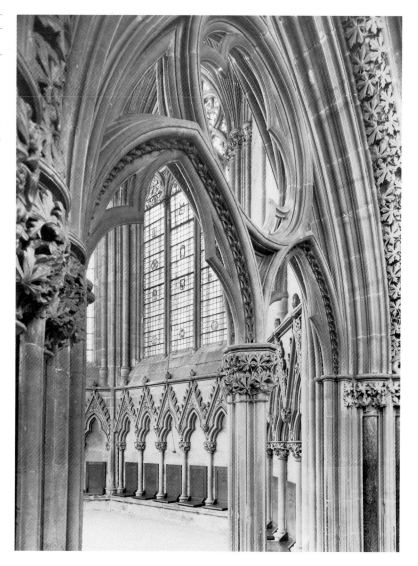

done at any date. Thus we have the mid-twelfth-century waterworks plans of Christ Church, Canterbury, in the context of the Eadwine Psalter or Villard de Honnecourt's records of architectural details dating from the early thirteenth century. Many examples of architectural or natural realism date from the thirteenth century. In the capitals of the chapter-house of Southwell Minster, or in the nave capitals of Reims Cathedral, a range of local vegetation and flora is most accurately transcribed into stone. The sacred potential of awesome nature had been long recognized by the Church.

Hovering metaphorically between nature and the built environment, the polygonal chapter-house of Southwell Minster is a symbolic hybrid between a celebration of earthly creation and an evocation of heavenly space [**15**]. Chapter-houses—the rooms where

The city of London

A remarkable view of the horizon of the city of London appears on the seal of the barons of London for 1219. It is much earlier than any of the known picture maps or dioramas, most of which are Italian and from at least a century later, and it also predates by a hundred years the supposed origins of interest in perspective. It demonstrates a highly developed skill in representing an illusion of real space, a sense of recession, and an interest in recording the built environment. St Paul's Cathedral is shown in the centre with the Tower of London and Baynard's Castle either side and many spires in between. The massive figure of St Paul, holding his sword and standard of the lions of England in either hand and firmly planted astride the city, dwarfs its scale and leaves no doubt as to the acknowledgement of his authority and protective power

the central business of an ecclesiastical organization was discussed—also have long associations with the Virgin Mary. The natural imagery of the famous leaves of the arches and capitals at Southwell relate closely to the idea of the Virgin's *hortus conclusus*. The extremely accurate depictions of identifiable species among the leaves make it appear as if the hedgerows themselves have bonded to this building, engulfing it in growth. This is not, however, the unruly nature of the inhabited scroll. The architecture of the building dominates and holds the natural world in check along a very prescriptive path. The hedgerows have been firmly tailored to its conventions as if they had been clipped into shape.

A most compellingly illusionistic miniature view of the city of London was made for the seal of the barons of London in 1219 [16]. By virtue of its use as an image to authenticate documents, it also establishes an image of civic responsibility, here overshadowed by the benevolent presence of St Paul as the city's protector.[20] Architecture can suggest the order and harmony of human agency. On a different scale entirely and, of course, for a different purpose is Ambrogio Lorenzetti's famous image of Good Government, made for the Palazzo Pubblico at Siena in 1338–9, which shows admirably the

intermingled harmonies of urban and rural life and the interdependence of urban and rural economies, both town and country being peopled by worthily industrious inhabitants [17]. The well-governed city is bustling with people who know what they are doing.

In the Middle Ages realism in the representation of places is most obviously apparent in Italy and in topographical illustration, appearing in images of buildings and towns that range from a detailed image of the buildings around St Peter's in Rome in the thirteenth century, painted high in the vault of the church of S. Francesco at Assisi, to vignettes of Genoa in Francesco Pizigano's atlas dating from 1373 or of Venice in Jacopo de' Barbari's woodcut panoramas of c.1500. More widespread in the fifteenth century are bird's-eye views and picture maps delivered with a considerable degree of detail, sometimes, as in the case of the view of the boundary of the duchy of Burgundy in 1460, now in the regional archives in Dijon, made for a particular purpose such as to settle legal disputes over land ownership.[21] Greater detail gave illustrations of places a more perceptible character and atmosphere and a sense of the enjoyment of individuality.

17 Ambrogio Lorenzetti
The Effects of Good Government, fresco, Sala del Nove, Palazzo Pubblico, Siena, 1338–40.

The fresco shows the interdependence of urban and rural economy, with traders, farmers, and gentry entering and leaving the city, and goods arriving from the country and being sold. Outside the city is a neatly organized productive landscape.

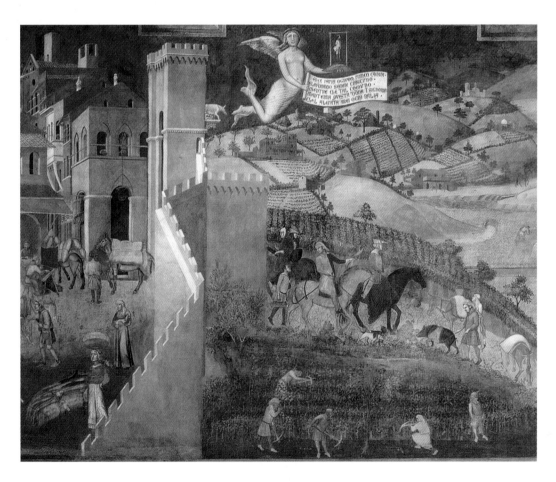

But however accurate representations become, they never escape the particular quirks of their illustrators or the agendas of the patrons who commissioned them. Realism was still more about evocation of atmosphere and the depiction of detail in order to stimulate memory and imagination than about the recording of minutiae. Experience could be contributed in a variety of ways. The detail of the best of the illustrations to Christoforo Buondelmonte's book of islands around Greece, dating from 1485, manages to convey a 'being there' quality, evoking an atmosphere of particular places [**18**]. Yet the authenticity, on closer inspection, is ersatz. Despite the wealth of incident in its surrounding walls and buildings, the view of Constantinople still includes elements of make-believe, picturesque embellishment, and pictorial licence. Far from representing the great trading city recently conquered by the Ottoman Turks, the misty blue aura of this image gives it a sense of the city being an imaginary place and yet it still manages to inspire confidence that it is an effective symbol for somewhere that really exists. In that tension between imagination and accuracy it follows and heralds the best qualities of all travel literature and imagery.

The impact of Andrea Mantegna's small painting of the *Descent into Limbo* is all the more powerful for its evocation of the mouth of hell as a specific locality [**19**]. Rather than the pit of fire, or seething mass of tormenting devils, hell is a dark cave issuing not flames but a wind that causes the garments to flutter. In contrast to the conventional medieval representation of Christ's Descent into Limbo, where

18

Picture map of Constantinople, from Christoforo Buondelmonte, *Liber insularum Cycladum atque aliarum in circuitu sparsarum*, tempera on parchment, Flemish, 1485.

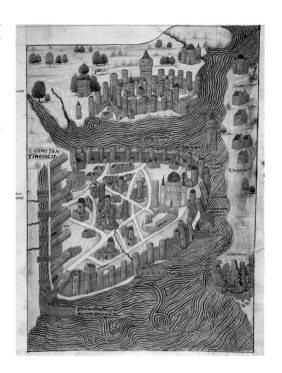

he is shown erect and determined with staff raised before him, here he is seen from behind, stooping to help the souls to escape. The image raises all our natural fears of dark places and caverns that lead we know not where, and, furthermore, as with many of the best new ideas in art, it draws upon the long-held belief that, like the Garden of Eden, hell existed somewhere on earth and could be found.[22]

By the end of the fifteenth century the world and its depiction had really changed. America had been discovered by the Spanish and Africa had been explored by the Portuguese. Ptolemy's *Geographia* had been translated and published, releasing long-hidden sources of classical scholarship. In terms of the way that the world was represented, experience triumphed over belief, and the emphasis in the art of map-making turned towards improved scientific measurement of lands and coastlines. Although the shape of the world had long been known, one of the earliest surviving representations of a world map

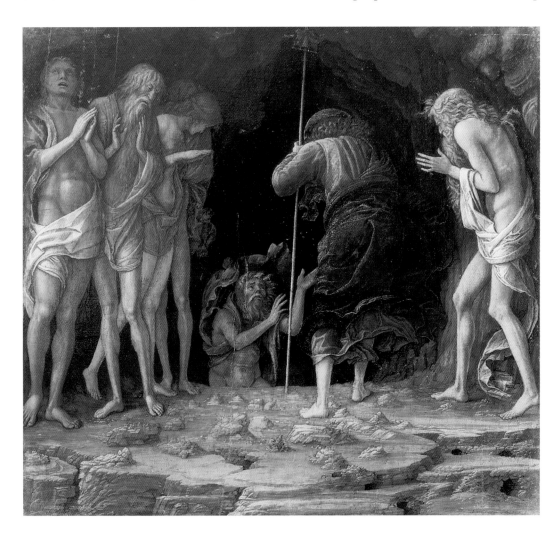

transferred on to a globe dates from the end of the fifteenth century. It was commissioned from Martin Behaim on behalf of a group of merchants of Nuremberg in order to demonstrate the prospects for exploring new voyages to the East Indies.[23] While the routes were plotted from Behaim's knowledge of Portuguese explorations of Africa, it is a very different piece of strategic mapping from earlier *mappae mundi*. Hopes of monetary gain from the lucrative spice trade have changed it into a very earthly world guided by profits rather than spiritual beliefs. Commerce has tamed the Monstrous Races and the world's unknown quarters represent opportunities, not threats.

20

World globe, lime cement, parchment, painted paper, Nuremberg, 1492–4.

Martin Behaim's globe misses out lines of longitude and latitude which map-makers had derived from Ptolemy's *Geographia*. In all other respects it incorporates the latest geographical and commercial information. It was commissioned in Nuremberg to raise finances for mercantile voyages to the Spice Islands.

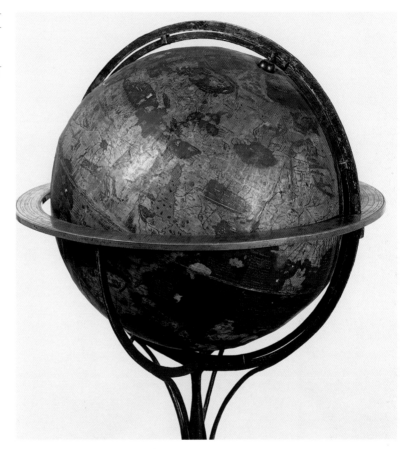

Labour

stays forever kneeling there, it could not be a more appropriate statement of his ownership in the most humble sense, his homage to his own skill and to his patrons, and his sense of onerous responsibility, both for the task and for the safety of the enormous construction above him. Like the Hildebertus image so much earlier, it manages to be both amusing and to the point, showing that serious creative work has its troubles.

The artist as loyal servant

At court or attached to the great houses, an artist may have lived a genteel existence. Furred robes were common gifts to the more important artists in the course of their commissions. Artists of great reputation were well looked after and given houses and lands, precious gifts, regular wages, and expenses. It is debatable, however, how ennobled an artist was ever allowed to become. At the French court, artists were given the title *valet de chambre*, equivalent perhaps to 'clerk of the wardrobe', a common title in England. Medieval society throughout Europe was highly conscious of title, and the appropriateness of certain behaviour, dress, and social aspiration to a person's 'degree of estate' applied to artists as to everyone else. An artist's social standing was likely to be derived from, and relative to, his patron's status but at several steps' remove.

In a tiny eleventh-century ivory panel from the shrine of St Emilianus, or San Millán de Cogolla, in the province of Logroño, in

23 Engelram and Redolpho

Panel, ivory, from the shrine of San Millán de Cogolla, Logroño, Spain, 1070–80.

The panel shows the carver Engelram with his son Redolpho. It is one of a series of panels from this shrine in various museum collections in New York, Florence, Berlin, and San Millán itself that uniquely demonstrate the community of interests in bringing the shrine into being. These include the man who travelled on horseback to collect the tusk, several of the royal patrons, members of the monastery, and the scribe who supplied the inscriptions.

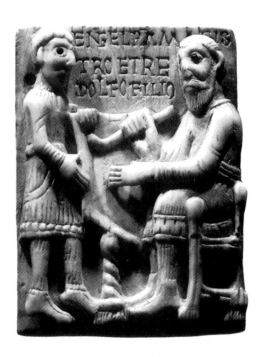

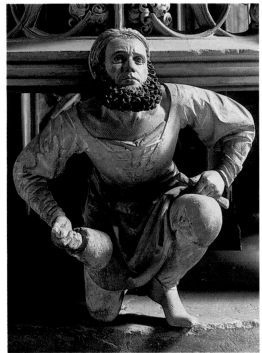

this scene demonstrating his fastidiousness. The combination of gentility and diligence is typical of the self-image of the artist in the Middle Ages, but so is the humour.

John of St Albans, an artist of Edward II of England, was paid to dance on the table for the king's amusement. The role of the artist as society's virtuoso entertainer is one that some artists in each age have adopted with alacrity. Antonio Averlino, known as Filarete (*c*.1400–*c*.1469), depicted his team of artists in a joyous dance, maybe celebrating the completion of their work, in their signature relief hidden at the rear of the bronze doors of St Peter's basilica in Rome (1433–45).[1]

Adam Kraft's image of himself in Nuremberg is a witty variation on the conventional combination of hubris and servility in artists' self-portraits [**22**]. Between 1493 and 1496 Kraft created one of the tallest and most magnificent sacrament houses ever made (about 15 metres tall) for the church of St Lorenz. A shrine for reserving the host (the body of Christ), it was one of such monuments that had become extremely popular and sacred, especially in the German provinces from the late fourteenth century onwards. Churches vied with one another to commission the tallest sacrament houses, and artists clearly used them to demonstrate their virtuosity. Adam Kraft depicted himself according to a well-known medieval burlesque tradition as a latter-day Atlas figure, mallet and chisel at the ready, crouching below as if supporting the whole towering structure. As he

The artist as entertainer

While author portraits occur relatively frequently in manuscripts, and names of artists and scribes are sometimes recorded in colophons (the inscriptions at the end of a book recording the date and other production details), it is unusual for two self-portraits to survive on two autographed works by the same artist, together with illustrations of working methods. It is even more rare to have images showing irritating distractions. The Bohemian artist Hildebertus drew himself with his assistant Everwinus twice, once writing an inscription scroll at the bottom of a dedication miniature of a manuscript and once again, in a now famous image, irritated by a 'wretched mouse' who attempts to steal his lunch and to distract him from work [21]. Hildebertus portrays himself as well-dressed in a long robe, cloak fastened at the shoulder with a brooch, and long pointed shoes. His intemperate mood in the St Augustine manuscript was no doubt occasioned as much by a concern with hygiene as by his desire to save his lunch and be left in peace to continue his work. It was almost certainly in that spirit, not only to amuse, that he chose to represent

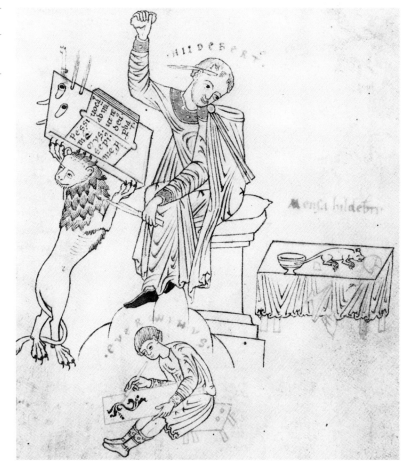

21 Hildebertus and assistant Everwinus

Self-portrait, from St Augustine, *Civitas dei*, ink on parchment, *c.*1150.

Hildebertus, who worked in Bohemia in the mid-twelfth century, left one of the most animated self-portraits from the entire Middle Ages in a copy of St Augustine's *Civitas dei*. Hilderbertus aims a missile at a 'wretched mouse', who in the course of trying to steal his lunch from the table, and knocking dishes to the floor, has distracted him so entirely that his text has also been invaded by the story— the words 'pessime mus' can be clearly read there. With exemplary duty his assistant Everwinus continues to concentrate hard on painting a section of decorative scrollwork.

Artists

2

Nowadays, people who describe themselves as artists might work in a whole variety of fields—illustrating books, designing advertising, teaching in schools, making videos, as well as exhibiting in art galleries, photographing, painting, and performing. Although the circumstances were quite different, the work an artist might undertake in the Middle Ages also involved a range of public and private situations and required many technical accomplishments. Just as would be the case now if one were aiming at as full as possible a picture, the study of artists, their status, and their working methods have to be pieced together and surmised from a patchwork of evidence. Medieval sources, of course, survive very unevenly and are widely scattered. Information has to be gleaned from the objects and monuments themselves, from documents detailing payments and finances, from sketchbooks and working manuals, and, for the later Middle Ages, from records of guilds and fraternities and contracts. While there is a persistent belief that artists worked anonymously, many names are known, and masters who worked in the great households, churches, and courts were sought after. Another popular misconception is that all artists were monks and nuns. While there was specialized artistic production in monasteries and nunneries and some artists in holy orders (such as the Dominican John Siferwas, discussed below), most of the practical execution was probably done by professional artists or by peripatetic laymen or journeymen working in association with them. In towns there were also family businesses and workshops, the equivalent of large studios, where a number of artists worked together, as goldsmiths, textile workers, masons, carpenters, painters and imagers, glass painters and stainers, and armourers. There were village craftsmen who might make one or two artefacts for a church or manor house or turn their hands to repairs. Then there was the whole back-up industry of ancillary workers providing and preparing materials, such as foundry-workers, glass manufacturers, parchment-makers, book-binders, quarry workers, spinsters, and hosts of assistants and apprentices grinding colours, tracing and measuring designs, planing wood, polishing metalwork and gems, and so forth, but all contributing in some vital way to the production of works of art.

Detail of 32

Spain, the artist Engelram is seated on a fine chair as he carves, assisted by his son Redolpho [**23**]. Both are dressed in short robes, the decorative borders of which show them to be more luxurious than ordinary, as well as demonstrating the artists' virtuosity in achieving such fine detail on a small scale. Engelram and Redolpho were probably court artists, working for King Ramiro i of Aragon, who is shown on the shrine carrying the money bag with which to pay them.[2]

The Dominican friar John Siferwas, active during the first quarter of the fifteenth century and the compiler, scribe, and illuminator of the Sherborne Missal and the Lovell Lectionary, was revealed by his work as a man of great learning and skill. The transaction between him and his patron, Lord Lovell, shown in his own dedication miniature, unreservedly represents Siferwas in the role of supplicant and Lord Lovell as wise beneficiary [**24**]. Both are shown in profile, in common with Dominican precedents in portraiture, and their eyes do not meet at the same level, although their smiling expressions indicate their friendly, even close, relationship.[3] The religious purpose of so much medieval art, and the fact that artists themselves or their patrons were sometimes members of religious orders, must have set

the tone for the climate of humility and subservience within which artists were working all over Latin Christendom. Fear of the deadly sin of pride meant that it was inappropriate to seek personal fame. It was also accepted, as artists were makers of things, that a work took primacy over its creator. Thomas Aquinas summarized this attitude:

The good of art is considered not in the artist himself, but in the product, because art is the correct concept of things made: for the activity which shapes outward matter is not perfection of the maker but perfection of the thing made. Art does not require the artist to proceed well, but to make good work.

It would appear that the artist usually offered his image or signature for the sake of the work itself and that the motive was not hubris but, more plausibly, a modest desire for his efforts in pursuit of perfection to be recognized and firmly bonded to the work. This is sometimes made explicit in dedicatory images or texts. The placing of an image or a text of a petition for an artist is often subordinate to the subject of the book or to the donor for whom the book was made.

Signatures and anonymity

The idea, commonly expressed, that the medieval artist worked anonymously is entirely erroneous, and in fact it was not at all uncommon for artists to be named and identified. To compound the difficulty, there are countless examples of names surviving only in documents with no works attributable to them. Many of these are tantalizing, such as 'Master Guzmin', a goldsmith from Cologne who is mentioned in Lorenzo Ghiberti's treatise of the 1450s as being internationally renowned and working in the service of Louis of Anjou. For all we know, many of his works may be extant, but no signature has survived, and the artist is therefore effectively anonymous. Certain documentary sources, such as building fabric accounts, contain names of craftsmen and details of their wages and working practices. Other kinds of document such as household and wardrobe accounts, charters, ecclesiastical and city archives, and wills, may associate names with information concerning the acquisition, building, and repair of property and possessions, workshops and materials, purchases and bequests, and sometimes the districts where artists lived.

It is rarely possible in the study of the Middle Ages to make the association between names, personalities, and reputations—the kinds of incidental biographical information that fascinate people and that in later centuries has, in one way or another, contributed to artists' reputations. However much artists would wish otherwise, curriculum vitae are as much essential tools for contemporary artists as their brushes, hammers, welders, and videos. But lacunae in sources of information do not necessarily distort the evidence that remains

25 Gislebertus

Tympanum, west door, Saint-Lazare, Autun, c.1120.

This famous pilgrimage church, literally the brother-church to La Madeleine at Vézelay nearby, is likely to have set out to attract a famous artist, although the fact that the artist Gislebertus signed the sculpture below Christ's feet is more likely to indicate a gesture of homage and thanksgiving than hubris.

concerning medieval attitudes to the identity and especially the personality of the artist, which in very many respects differed from those current today. The pattern of occurrence of names of artists and signed works is seemingly arbitrary, especially in the earlier part of the period. Only occasionally, as on Irish metalwork, or in Spanish Mozarabic manuscripts from the tenth to the thirteenth century, are names recorded as a matter of course. In the latter case, a rich series of conventions existed for artists' names, and sometimes images also, appearing in colophons, often together with those of their patrons, asking to be remembered for their labours, requesting prayers of the reader, or even, like Florentius and Sanctius of Léon, celebrating the end of their labours by raising a toast with a glass of wine.[4] More usually, a name is unexplained. The words 'Gislebertus me fecit' are inscribed at the bottom of the Judgement tympanum of the church of Saint-Lazare at Autun [25]. Why they are there is unknown. The inscription is appended to an astonishingly powerful piece of carving, and the fact of its being there, even though we know nothing else about the artist, has been enough in later centuries to increase the reputation and significance of the work. But reasons for identification of other artists, such as the words 'Unbertus me fecit' on a capital at

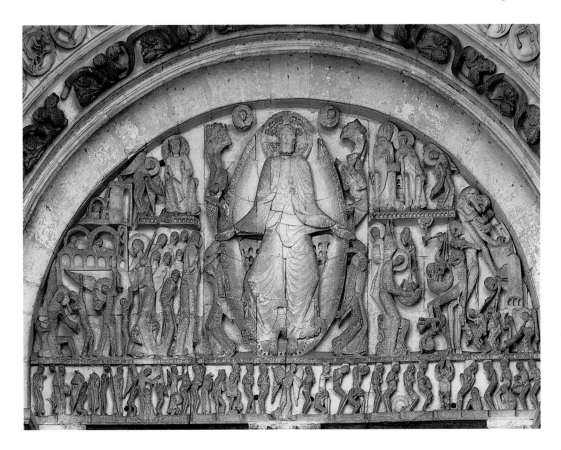

Saint-Benôit-sur-Loire in the eleventh century or 'Rodbertus me fecit' on a capital at Romsey in Hampshire in the twelfth century, are more puzzling, as they are clearly not in the same league as Gislebertus's typanum sculpture either in terms of scale or skill.[5]

Nicholas of Verdun, a goldsmith and enameller, signed two very different works, the famous pulpit at Klosterneuburg near Vienna, made at the beginning of his career and finished in 1181 [**26**], and a shrine to the Virgin at Tournai, dated 1205, which was presumably made towards its end. Nothing else is known about his life. By any standards, Nicholas's work on the pulpit (now refashioned into an altar) was remarkable and prestigious. For him to have been summoned across Europe suggests that he was well known and sought after, and indeed his work shows an incomparable technical proficiency and has been identified as contributing to the development of a new figure and drapery style. What is also noteworthy is the contrast between the two works known to be by him. The Tournai shrine has been much restored but retains his figures, which are vigorous and lively, modelled in the round in silver-gilt. The pulpit figures are dramatic, but more passive, and without prior knowledge it would not otherwise be easy to identify them as being by the same artist. This has increased Nicholas's modern fame as an artist who had a range of skills and whose work developed and changed. It is partly because of that range that other works, principally parts of the shrine for the relics of the Three Kings at Cologne, have been attributed to him [**53**].

26 Nicholas of Verdun

Panel from Klosterneuburg altar, bronze gilt, champlevé enamel, Stiftskirche, Klosterneuburg, c.1181.

This panel, originally part of a pulpit, is one of 45 bronze-gilt panels entirely decorated with champlevé enamel. It was made into an altar in 1331 after it had beén damaged in a fire. Recorded by inscription around the outer edge of the present arrangement is the name of Nicholas of Verdun, its maker, and the name of the patron, Provost Wernher, who, it can be assumed, determined the details of its complex typological programme.

Skill and reputation

Modern artists, bemused by the critical reception of their works once they go on display, have to accept that the works have to look after themselves once they have left their studios. In quite different circumstances, this also applied in the Middle Ages. Particularly in the case of altar images, shrines, reliquaries, or objects of liturgical importance, the finished works not only had to look after themselves, but were perceived as performing a distinctive didactic or spiritual role in communicating with the worshipper or enhancing devotional fervour. Accordingly, the role of the artist is written out of these objects, which are said to have appeared miraculously. The *Volto Santo* at Lucca, a cult crucifixion image much copied in the twelfth century, the original of which was said to have been carved by Nicodemus himself, was in this way given an assured status of holy witness that removed it from the more menial associations of manual labour. In quite a different way the labour proved its own reward to the sculptor Wiligelmus, whose work adorned the west façade and furnishings of Modena Cathedral in Emilia, northern Italy, at the beginning of the twelfth century [**27**]. Neatly avoiding potential accusations of pride, the sculptor's skill is attested by the work itself in an inscription tablet on the façade. It is held in place by figures of Old Testament prophets Enoch and Elijah: 'Your sculpture declares, Wiligelmo, how great should be your honour among sculptors.'

A greater number of examples of such praise for identified sculptors has survived in Italy than elsewhere in Europe [**28**]. This may be because there was more of an accepted tradition there for recording individual achievements. In the fourteenth century this fashion was extended to include painters.

'In the year 1260 Nicola Pisano carved this noble work. May so greatly gifted a hand be praised as it deserves', was the accolade inscribed for Nicola Pisano (working 1258–78), who carved the stone pulpit in the Baptistery at Pisa [**29**], while his son Giovanni (*c.*1248–post-1314) was 'blessed with higher skill' for his work on the

27 Wiligelmo

Dedication stone, façade, Modena Cathedral, *c.*1110.

The dedication stone bears the homage to the sculptor, Wiligelmo. Such plaques were conventional on north Italian façades. As if in justification for awarding public praise to the maker, the work itself was said to bear witness to his skills.

28

28
Cosmati pavement, limestone, marble, Westminster Abbey, 1268.

In the early thirteenth century the fame of the decorative mosaicists who worked around Rome, the Cosmati (named after one of the leading families), specialists in opus sectile pavements and tombs, spread throughout Europe. Some inscriptions on their work accord them the high honour of *Magistri doctissimi*, an unusual acknowledgement of learning for medieval artists, but perhaps explicable by the mathematical intricacy of their abstract patterns and the great precision with which they must have had to be measured and laid out.

pulpit at Pistoia and 'endowed with mastery greater than any seen before'.[6] These paeons of praise are witness not only to a desire for authenticity, but to an immediate attention to interpretation, setting the scene for their works to be admired and revered in a context of perceived 'progress'. Even more fulsome, and challenging to possible critics, is the testimonial on Giovanni's Pistoia pulpit: 'He would not know how to carve ugly or base things even if he wished to do so. There are many sculptors, but to Giovanni remain the honours of praise. He has made noble sculptures and diverse figures. Let any of you who wonders at them test them with the proper rules.'[7]

The painter Giotto was perceived, especially by Florentine writers in the fourteenth century, as having changed the culture of artistic taste and practice. Powerful supporters such as Boccaccio and Dante wrote admiringly of his work. Documentary sources provide information about his period of activity (*c.*1301–37), his family, property, and financial dealings. And yet, it is somewhat surprising to note, as a modern writer, John White, has remarked: 'although Giotto plays what is for an artist an uniquely prominent role in early chronicles and literary sources, our knowledge of his life is not commensurate with his fame. Not one of his surviving works is documented.'[8]

Knowledge of Giotto's career as an artist is dependent on attribution to his hand of the Bardi and Peruzzi chapels (before 1328) in S. Croce, Florence, the Arena Chapel at Padua, and several smaller works, and there is much disagreement about others, such as work in Assisi.

The Florentine historian Filippo Villani included painters among the great men of his city in his chronicle, *The Lives of Florentine Men* (*c.*1405). Painters feature as greater than masters of the liberal arts, superior to scientists, and as reviving an art that had become lifeless with new realism and lively expression. According to Villani, Cimabue was the first great artist in his skilful imitation of nature, but Giotto was superior to the ancient painters in talent, and elevated his art to new heights. At the end of the fourteenth century, Cennino

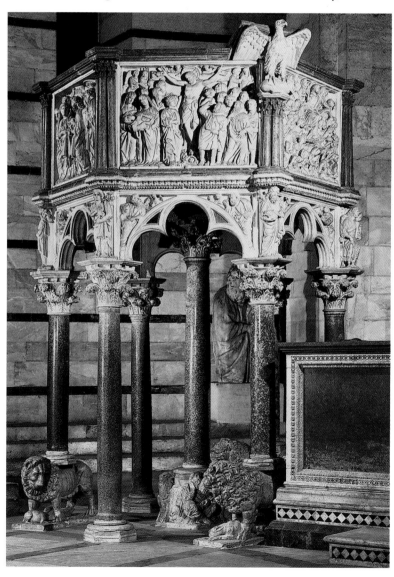

29 Nicola Pisano

Pulpit, marble, Baptistery, Pisa, 1260.

The artist had previously worked in Apulia in the circle of artists around Frederick II. This pulpit is the first in a series of four made by Nicola and his son Giovanni and their workshop assistants. Nicola carved another at Siena Cathedral (1265), and those made by Giovanni are at S. Andrea, Pistoia (1301) and Pisa Cathedral (1311).

Cennini also admired Giotto for his skill in drawing and subtlety of modelling, and for changing the art of painting and rendering it more modern. Giotto was undoubtedly deserving of the highest praise, but the way these texts promote his reputation with remarkable consistency had an enormous influence, especially in the way in which the art of the Florentines eclipsed that of other Italian centres, such as Siena and Venice, and fed directly into the beginnings of modern art history. Over a century later, an Umbrian painter, Giovanni Santi (d. 1494), singled out in a verse tribute the Flemish artists whose expertise with colour and illusionism appealed to Italian court taste: 'At Bruges most praised were great Jan van Eyck and his pupil Rogier van der Weyden with many others gifted with great excellence. In the art of painting and lofty mastery they were so excellent, they many times surpassed reality itself.' But in his zeal to praise the arts of his own time, Santi was also among those who began the process of denigrating the arts of the Middle Ages: 'In this splended noble art, so many have been famous in our century, they make any other age seem poor.'[9]

The artist's career

Artists were regarded socially as artisans, below the rank of merchants in the towns, and, depending on their precise skills, at the upper end of the rank of peasants in the countryside. Rodney Hilton has written of the artisan workshop as the most widespread unit of production in the medieval town.[10] His and other historians' studies of the economic and social structures of southern French towns in the later Middle Ages have shown relatively large concentrations of craftsmen and women practising as weavers, masons, and carpenters, and in addition engaging in multiple occupations as food retailers, market gardeners, or vintners in order to extend the household income. This evidence of diversification indicates that the production of art and artefacts was not sufficiently remunerative to support an entire extended household, and is common to other centres in Europe. In Paris in 1292 a woman book illustrator named Thomasse also ran an inn. This kind of dual career was known also in London, as for example in the cases of Matilda Weston, weaver, and Dionysia de la Longe, gilder, who both ran alehouses, and it was quite usual for female textile workers to run small breweries.[11] Avarice in William Langland's *Vision of Piers Plowman* describes his wife thus: 'My wife was a weaver, and woollen cloth made. She spake to the spinners to spinnen it out … I bought her barley malt—she brew it to sell—Rose the Regrater was her right name.'[12]

Typically, an urban workshop would be made up of members of a family, or extended family including apprentices and journeymen, hierarchically organized and controlled by the master-craftsman, who

30 Jean Bourdichon

Le Travail, from *Les Quatre États de la Société*, tempera on parchment, French, fifteenth century.

Jean Bourdichon's illustration, from a series about the four estates of society, shows a carpenter planing wood in his workshop while his wife spins with a distaff and a child plays at their feet. It represents a typical scene of family-based artistic industry.

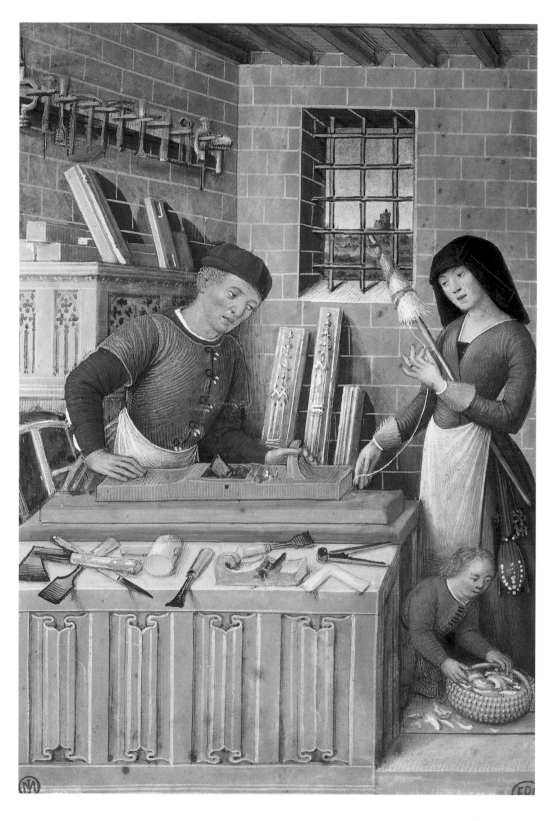

was also the head of the household. Women sometimes played a major part in the craft production, especially in the textile trades and crafts allied to the production of clothing, leather goods, and parchment [**30**]. Particularly within the context of a family business, women could play a full part, as did Bourgot, working as a professional illuminator in Paris in the fourteenth century alongside her father, Jean le Noir, or Katherine Lyghtefote, whose skill as a builders' merchant attracted her a husband, Henry Yevele, one of King Edward III's master masons in England in the late fourteenth century [**31**]. Silk spinning on large spindles was an exclusively female trade in Paris and spinsters had the right to take on apprentices and to employ their children.

From Paris in 1268, we have some of the earliest and one of the principal records of guild regulations in Etienne Boileau's *Livre des Metiers*, or book of trades, probably commissioned on the orders of King Louis IX, and which contains descriptions of the duties and rights of some 100 Parisian craft guilds. However, the situation in Paris was not typical of the whole of Europe. In Vienna at about this date, craft guilds were forbidden. Elsewhere, many guilds were charitable fraternities or trade associations rather than concerned with craft. Occupational craft guilds gradually became formalized and codified in towns in France, and in the Netherlands, the German

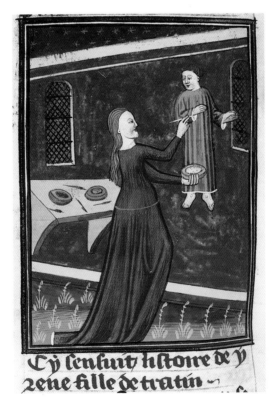

31

Irene, Pupil of Cratinus, Painting, from Giovanni Boccaccio, *De claris mulieribus,* tempera on vellum, French, mid-fifteenth century.

An illustration from Boccaccio's history of famous women, this is one of several rare images illustrating female artists at work. Irene's talents surpassed those of her teacher, Cratinus, to the extent that the Greeks had her likeness sculpted and put in a place of honour among figures of the great artists in history.

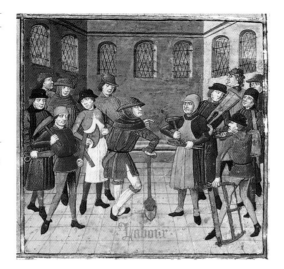

Various workmen carrying the tools of their trades, tempera on vellum, from French fifteenth-century edition of Boccaccio, *De cas des nobles malheureux hommes et femmes*. This copy was dedicated to Jean, duc de Berry.

Entitled 'Labour'. Although this illustration appears to be a piece of reportage, it was an imaginary scene made for a literary work and is one quarter of a full-page miniature representing the four estates of society.

provinces, England, and the Italian states. From the mid- to late thirteenth century, guilds began to ensure their own strict ordinances, controlling training, methods of work, hierarchy of organization, and wages [**32**].

In England, although there is evidence for a guild of London gold-smiths as early as the twelfth century, there is no consistent information on craft guilds until the guild returns of 1389. Early guild statutes in England seem to have been principally concerned with social, moral, and religious obligations between members who were associated with a particular religious foundation, and dedicated to a particular observance or saint. Craft guilds tended to be founded with an overtly religious purpose, such as the guild of the Assumption of Holbeach, in Lincolnshire, otherwise known as the tilers' guild, or to be superimposed on to some of the original fraternities, thus changing their character. Regulations for craft guilds varied in different parts of Europe. It was for example obligatory for German masons to spend a year travelling as part of their apprenticeships. This rule also applied to other crafts in other centres, such as the members of the guild of St Luke—the painters' guild in Prague. Secrets of the craft were fiercely protected and only available to members, which occasionally led to open dispute. A German congress at Regensburg in 1459 forbade a master, mason, warden, or any fellow from teaching anyone not of the craft how to set up an elevation from a ground-plan by geometrical projections. The rule was broken within a few years by Matthew Roritzer, master-mason of Regensburg Cathedral, who published a treatise explaining the technique 'to promote the common good', having sought special dispensation from the bishop.[13]

There is much evidence throughout medieval artistic production to suggest that artists were accustomed to collaborate and that artistic skills were interdependent. The production of tapestries was a

good example, as different artists were responsible for their design and execution and yet each contributed significantly to the quality of the end result. We know for example that for the remarkable series of Apocalypse tapestries commissioned in 1376 by Louis of Anjou for his palace at Angers, the count went to the workshop of Nicholas Bataille, a master-weaver who in turn ordered designs and cartoons from the king's painter, Jean Bandol of Bruges. It is apparent from many accounts for building projects that lodges were set up on site and that work was largely conducted *in situ*. It is increasingly emerging from painstaking studies of constructional techniques in various regions of Europe that as far as decorative carving and imagery are concerned masons worked side by side to the extent that they could even work together on different parts of the same figure. Evidence of this kind has been found, for example, on such disparate sites as the west front of Orvieto Cathedral, in Italy, and Ely Cathedral and Beverley Minster in eastern England [**66**].[14]

33

Effigy and tomb of Richard Beauchamp, earl of Warwick, bronze effigy and marble tomb chest carved by John Bourde of Corfe, Dorset, Beauchamp Chapel, St Mary's, Warwick, 1449–54.

Who was the artist?

In the Middle Ages, complex works of art involving several processes were often made collaboratively and sometimes it is necessary to be cautious in attributing works of art to single artists.

According to some of the literature discussing the making of the tomb of Richard Beauchamp, earl of Warwick, for St Mary's Warwick between 1449 and 1454, it is the founder, William Austen, who is attributed with much of the credit for its design. He was commissioned to cast the effigy of the earl and the weepers around him, and also supplied all the materials and labour for the tomb's installation.

Other authorities believe that the artist who should be credited with originating the design is the sculptor John Massingham (known works date 1438–49), who made the wooden moulds around which the effigies were cast.

The person who was paid the most by the executors commissioning the tomb was Bartholomew Lambespringe, a Dutch goldsmith who polished and gilded the entire monument and made the heads, hands, and all the unclothed parts of the figures of weepers and angels around the effigy.

In the end, therefore, it is not at all clear who the artist was, or rather it is perfectly clear that all these men contributed in some significant degree to the finished appearance of the tomb and that no single one of them had sole authorship or was given sole credit.

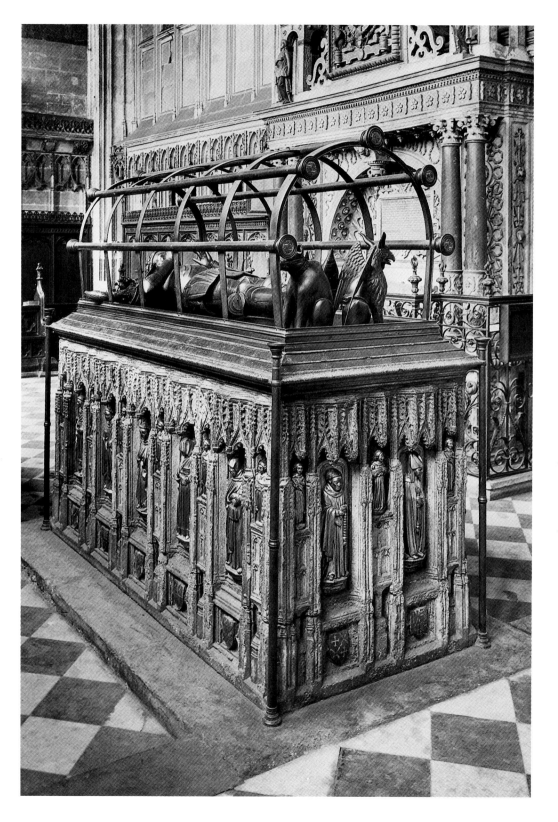

Writing about practice

The notion of an artist was a very wide and variable one in terms of the kinds of operation and skill required. The most common philosophical position understood the artist to be the agent by whom things were made and that the production of art was dependent on the knowledge of the rules for making things. Manual labour, skill, and dexterity were essential prerequisites for the creation of works of art. Art was perceived as dependent on nature, both imitating and enhancing it. According to Richard of St Victor, writing in Paris in the mid-twelfth century:

We can easily perceive the working of nature in such things as plants, trees, animals ... the work of art, that is, the work of diligence, is seen in sculpture, painting, writing, agriculture and other creations of man, in all of which we find innumerable reasons for which we should rightly admire and venerate this gracious gift of God. Thus, because the work of nature and the work of art co-operate, they are, as it were, joined closely together and united in mutual contemplation. At least it is certain that the work of diligence takes its origin from the working of nature, is based upon it, and derives its significance from it, and the working of nature draws on art to improve itself.

The *De diversibus artibus* (On the Various Arts), written by the self-confessedly 'almost anonymous' monk under the pseudonym Theophilus around 1100, was the first comprehensive record of techniques written for the benefit of all artists practising in painting, stained glass, and metalwork. On behalf of artists, he represents a community of interest and an international body of specialized knowledge:

whatever kinds of the different pigments Byzantium possesses and their mixtures; whatever Russia has learned in the working of enamels and variegation with niello; whatever Arab lands adorn with repoussé or casting or openwork; whatever decoration Italy applies to a variety of vessels in gold or by the carving of gems and ivories; whatever France loves in the costly variegation of windows; and whatever skillful Germany applauds in the fine working of gold, silver, copper and iron, and in wood and precious stones.[15]

While the main purpose of Theophilus's treatise is as a manual, it is full of useful recipes and instructions, and although the author leaves no doubt that the spirit of creativity is breathed into the artist by God, he also makes very clear what power the artist had at his disposal and how essential were his products: 'Henceforth be fired with greater ingenuity: with all the striving of your mind hasten to complete whatever is still lacking in the house of the Lord and without which the divine mysteries and the administering of the offices cannot continue.'

Glass workers in Bohemia, from the *Travels of Sir John Mandeville*, ink and tempera on parchment, Flemish, early fifteenth century.

The illustration shows the legendary pit of Memnon with its inexhaustible supply of sand. It also gives a plausible idea of how practitioners made effective use of natural resources, setting up workshops near their sources of supply of raw materials. All the processes of glass-making, down to the testing of the finished products, can be seen here.

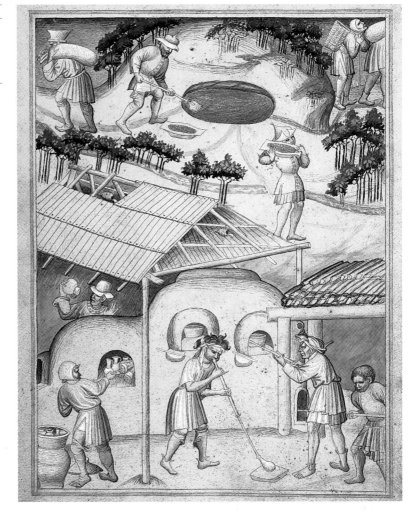

Two Florentine treatises for artists, respectively from the end of the fourteenth century and the mid-1450s by Cennino Cennini and Lorenzo Ghiberti, each added in its own way to the tradition of artists' literature, attempting to establish a more theoretical and intellectual framework for the practice of art and architecture and yet greater respect for a hierarchy of individual practitioners. Ghiberti (c.1378–1455) has been credited with the first piece of sustained art historical writing that engages in assessing reputations and criticism of works. Cennini's treatise (the earliest surviving copy is dated c.1435–7) was the more workmanlike, a practical manual of the same type as that by Theophilus, which gave a much stronger impression of artists participating in and representing a professional commmunity. Cennini (doc. 1398) came to painting 'through love and gentleness', an attitude that he advocated for others. Yet he aspired to success, with 'velvet on his back', and set down the recipes for professional skills for a com-

petitive market, seeing himself in a lineage of artists whose achievements help substantiate his own.[16] His culture was already one that latched on to names, promoted the individual, anticipated a tendency towards innovation, and attributed the values of artistic genius [**34**].

Sketchbooks

While the 'how to do it' manuals were rich in recipes and techniques that are still useful today, it is in sketchbooks and artists' notebooks that we can get closer to understanding an artist's processes of thinking. Adhémar de Chabannes, a monk from the abbey of Saint-Martial in Limoges, who died on a pilgrimage to the Holy Land in 1034, left behind him the earliest surviving example of what is in effect an artist's sketchbook [**35**]. It is a personal record of visual and literary notes from a variety of contemporary and earlier classical and eastern Mediterranean sources. Some relate to religious subjects—Adhémar included a Deposition scene and a reclining Virgin taken from a Nativity—others are classical or mythological, many of them copied in detail from earlier sources. In the thirteenth century the sketchbook was thought interesting enough to be of use to one Raimond de Bégonac, who stole it from the abbey.

Like Adhémar's sketchbook, Villhard de Honnecourt's collection of drawings, although probably also personal in origin, seems to have been of subsequent use to later artists who traced over, added to, and

35 Adhémar de Chabannes

Sketchbook pages, ink on parchment, Saint-Martial, Limoges, first quarter of eleventh century.

The illustrations show Adhémar to have been interested in ways of showing figures interacting in groups or gesturing in lively activity. They were obviously copied, as many are not drawn with great ease or fluidity but have the appearance of the artist having to check his source regularly, and they are informally and haphazardly arranged on the page, often accompanied by sketchy notes or longer pieces of text.

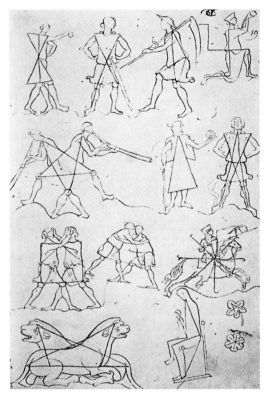

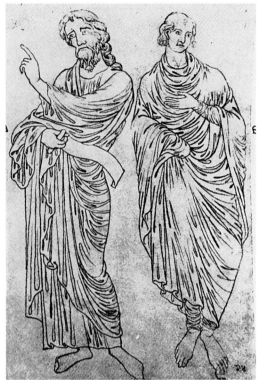

altered some of the images [**36**]. At a basic level it is a record of an artist's travels and sightseeing—there are works in it from places from France to Hungary. But it is much more importantly a portfolio cataloguing the varied interests of a practitioner in architecture and associated crafts. Far from being specialized and concentrated, it is enormously wide-ranging both in its geographical scope and in the range of techniques and genres to which he pays attention. Villhard was interested in the learned apparatus of his craft, declaring an interest in the use of geometry in portrayal, geometry being one of the Seven Liberal Arts (see Chapter 5). He recorded buildings, engines, methods of construction, ground-plans, and geometric projections, but he was clearly also professionally interested in the depiction of figures. He also included some drawings that are obviously made from life, such as a grasshopper, and others declared to be from life, such as his famous lion '*al vif*', which is not lifelike, but has been constructed according to geometrical principles in line with his stated interests. Whatever the intensity of the experience of viewing, and however immediate the impression created on him by his subject, it seems that the artist had to transform it methodically, using his training and professional techniques in drawing and geometry.

Another characteristic of medieval aesthetic attitudes that may puzzle modern observers is the predilection for copying from earlier

sources. There seems to have been little regard for originality, though this is entirely consistent with the Neoplatonic position that art was an approximation of an ideal that existed in the spirit, and that only God was capable of real originality. The Eadwine Psalter, discussed in Chapter 5 in regard to its famous author-portrait and waterworks plan [**99**], is not a completely original work but a version of a famous book made in the region of Reims in the ninth century, the Utrecht Psalter. The later psalter, although to the same scale, introduces innovations and is more imposing than its predecessor, and has additional texts and commentaries. The fact remains that it is strongly based on an earlier authority; and its relationship to that earlier source—the balance between careful adherence to it and development from it—was part of Eadwine and his artists' great skill. A later version of the same book, the Paris Psalter, made at the end of the twelfth century, transforms the illustrations into an entirely new style, highly and fully coloured. To us, these books appear to be extraordinary examples of artistic homage. But in the Middle Ages it was more common than not for an artist to look first to a prototype or series of examplars, to enter into a dialogue with his or her sources, and to innovate in terms of style or iconography by careful degrees of departure from tradition and authority. In art the achievements of the past were continually being consulted, absorbed, reinterpreted, and brought to new relevance in the works of the present.

Collaborative enterprise: artists and patrons

As significant as the maker of a work of art in the Middle Ages was the community of interests associated with its inception and its use. On the shrine of St Patrick's bell, inscriptions have incidentally allowed historians to reconstruct the date and place of its making—in Armagh (Northern Ireland) between 1094 and 1105—but what they actually record are details of the group of people through whose collective efforts it was created [**37**]. The litany of names includes the makers, the place of its making, the patron who commissioned it, and its custodian. Names here, and on other pieces of Irish metalwork such as the Lismore crozier or the 'Cumdach of the Cathach', the reliquary box for a treasured fragment of a psalter once belonging to St Columba, act somewhat like museum labels: they increase the veneration for the objects, and enhance their prestige and preciousness.[17]

Very often the benefactor or patron took as much credit as the artist, or more. Famously, Abbot Desiderius of Montecassino, in the course of enhancing the learning, culture, and environment of his monastery in the 1060–70s, employed mosaicists from Constantinople to revive their art in Italy and to teach his monks. As written about by Leo of Ostia, the principal and only really significant role in

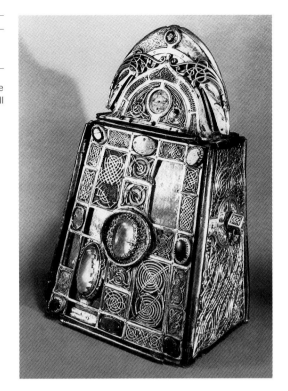

this enterprise was that played by the abbot in having conceived and orchestrated the entire exercise.

Only one name is associated with the rebuilding and embellishment of the abbey church of Saint-Denis, near Paris, in the 1140s. Introducing the first part of his account of the rebuilding and embellishment of the church in the 1140s, Abbot Suger wrote in the first person of his long-standing ambition to have the abbey walls repainted: 'We summoned the best painters I could find from different regions and reverently caused these walls to be repaired and becomingly painted with gold and precious colours ... I completed this all the more gladly because I had wished to do it, if ever I should have the opportunity, even while I was a pupil in school.' Abbot Suger's zeal was driven by a true belief in the power of art to elevate the spirit: 'The dull mind rises to truth through that which is material.' The artists themselves were his tools, and while he acknowledged the beauty of their work, never once did he mention any artist by name. He composed 13 verses for inscriptions throughout the new work and, like a great impresario, claimed all the credit for bringing the whole enterprise into being:

And bright is the noble edifice which is pervaded by the new light;
Which stands enlarged in our time,
I who was Suger, being the leader while it was being accomplished.

This stone graphically portrays
the relationship between the
patrons, Lutz Krafft and his
wife, and the architect in
terms similar to those
described by Boethius.
All three are supporting the
building, but the architect is
bent almost double bearing
the bulk of the burden.

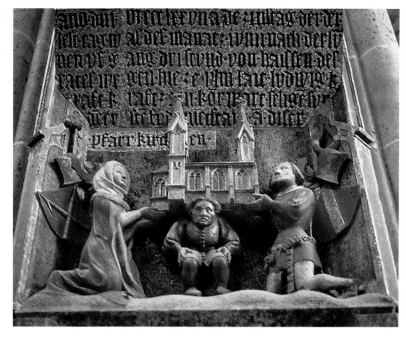

Suger regularly praised the skills of his artists above the preciousness
of the materials they used—'Whoever thou art, if thou seekest to
extol the glory of these doors marvel not at the gold and expense, but
at the craftsmanship of the work—and he further embellished the
altar frontal of Charles the Bald, 'so that certain people might be able
to say the workmanship surpassed the material'. The relative merits
of the skill of the artist and the preciousness of the materials con-
tinued to be weighed up throughout the Middle Ages, sharpening in
Italy and Flanders in the fifteenth century, when illusionism, in the
form of perspective, and the imitative skills of the great Flemish
colourists, who were able to evoke precious cloth and materials in
paint, became particularly valued.

Boethius (480–525), the Late Antique philosopher whose work
was very widely read throughout the Middle Ages, wrote: 'Buildings
are inscribed and triumphs held in the names of those by whose rule
and reason they were begun, not of those by whose labour and servi-
tude they were completed.' This, while striking a chord with the early
medieval practices, became less true as time went on and individual
artists rose to greater fame. But there seems to have been a general
acceptance of the convention that the patron's role in the conception
and realization of a work of art was seminal and at least equal in
status to the skill of the artist [**38**]. It is not possible to generalize
about procedure in drawing up and enacting the terms of a contract
as so few examples survive. In Italy, fifteenth-century contracts often
specified that the artist produced a drawing based on ideas given by

the patron and from which negotiations could begin between them about further details of the commission. Then, as in the case between Fra Angelico and the linen-makers' guild in Florence in 1433, there came a point when the design was agreed and the final drawing had to be faithfully followed.[18]

Commissions

It was more in the context of the secular world of patrician families, ducal courts, and princely palaces than within the Church that patrons and artists recognized the mutually beneficial effects of the marriage of skill and reputation. Great art could further ennoble great men and it was in their interests to seek the best artists and further their reputations. Andrea Mantegna (*c*.1431–1506) was employed in the service of the Gonzaga family, marquises of Mantua, for 45 years, during which time he completed not only the astonishing painted decoration of the Camera degli Sposi in the ducal palace, but carried out all kinds of artistic commissions, designing panels, tapestries, and metalwork. He also acted as a kind of resident artistic adviser to the Gonzaga's noble friends who would request to borrow the skills of Mantegna, 'the famous painter'. The arrangement apparently served the patrons better than it did the artist as Mantegna was, despite promises, not too regularly paid. The Gonzaga, however, gave him lodgings and land and titles and, most importantly, kept his name circulating in the best company.[19]

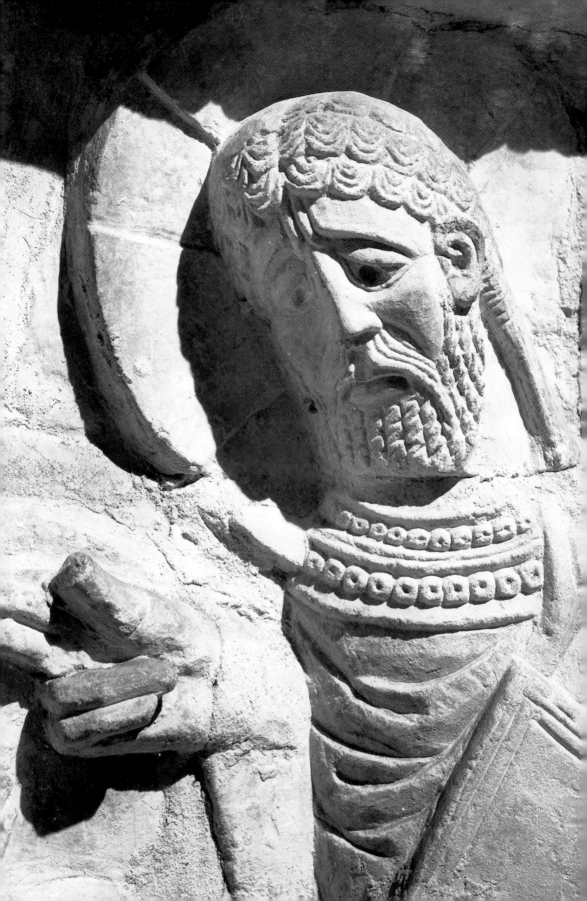

Art and Power in the Latin Church from the Eleventh to the Thirteenth Century

3

The Church of Latin Christendom came closer to European domination in the Middle Ages than any other power in history. As the earthly representative of the highest authority, the Church assumed a great mission, aiming to maintain order and, in addition, to provide spiritual comfort, solace, and security to society. The beginning of the second millennium inaugurated a period of two centuries of great expansion in the Latin-speaking Church of western Europe. Its political apogee was achieved during the incumbency of Pope Innocent III between 1198 and 1216, and not surprisingly, since he had announced grand ambitions at the outset of his reign, stating that he had 'not only the universal church but the whole world to govern'.[1] He was able to build upon the strong foundations laid by the eleventh-century reform movement of popes Leo IX and Gregory VII (see below, **Reform and authority**). But, while there was a centralizing force with expansive ambitions within the papacy in Rome at this period, there was only an extent to which the Church could be considered a monolithic institution. Bishoprics and, under them, the parish churches and their clergy came efficiently under the papal administration, largely through the administrative and legal reforms of the eleventh-century popes. Monasteries, however, had their own networks of governance and, while they derived their rights to hold office and to form new establishments from the pope, the Rule of St Benedict required them to withdraw from the world into a communal life organized around prayer, so that their spiritual inclinations were not directed to other types of conformity. The culture of expansion was thus driven by a complex interlocking and often competitive network of Church administration and secular patronage, all with different levels of vested interest in promoting growing numbers

of monastic foundations and an expanding network of parish churches. It was through these means that the visual arts were able to flourish. The Church's power was highly visible in many locations through an ever-increasing variety of types of building and decoration. A growth and elaboration of worship was supported by a vast and magnificent material culture of books, vessels, vestments, hangings, shrines, altars, and furnishings.

The eleventh and twelfth centuries also saw developments in certain types of beautification and embellishment of church buildings—with rapidly expanding numbers of historiated capitals, arcades, ambulatories, and radiating chapels, and of stained-glass windows. These phenomena grew partly as a cultural consequence of a general growth and spread of ideas and tastes, and the availability of funds. No directive from any central authority decreed that churches were to be built or decorated in particular ways, although the religious orders imposed their own rules. During the course of the twelfth century ascetic monastic reform movements, the Cistercians in particular, vetoed what they regarded as extravagance and excess in design and decoration.

Nevertheless, one may speculate about the nature of the issues that needed to be tackled by those who built churches, whether these were driven centrally or locally. What were the vested interests that needed to be satisfied, traditions to be observed, and influences at work that conspired to shape buildings and their decoration? Answers to these questions, and indeed the precise nature of the questions themselves, varied almost as much as the number of sites and situations through which they can be investigated.

Reform and authority

Cluny in Burgundy and Gorze near Metz were important among the newly founded monasteries of the tenth-century reform movement that was stimulated by a need to return to the Rule of St Benedict. Existing establishments were also affected by this movement. From them ideological and liturgical influences spread during the next century west into Aquitaine, south to Spain, and north up the Moselle valley and into the province of Cologne. Monastic reform was supported by the German rulers. This subsequently helped to bring about the election of a succession of German popes who pursued administrative and legal reform and took papal business out of the confines of Italian local politics. Leo IX (1049–54) was the first to make an impact on the reality of papal power. Opportunities were quickly turned into further ambitions, and in 1054 Leo's attempt to assert the authority of the papacy over the patriarchate of the Greek Church in Constantinople led to the irreconcilable breach between the two Churches. Under Gregory VII (1073–85), the administrative and legal efficiency of the papacy was strengthened. Relations also became critical between the popes and emperors over the rights to investiture of Church leaders, initiated by the dispute over the see of Milan in 1075. This marked the beginning of a major and enduring quarrel between successive popes and western emperors (styled 'Holy Roman Emperors' from the thirteenth century), which was ultimately over the balance between temporal and spiritual power.

Ambitious bishops and authoritative abbots

Bishops were very powerful in the Church as they controlled most of its local organisation both from a pastoral and legal point of view. Recent research has highlighted the extent to which the expansion of the frontiers of the Church between the eleventh and thirteenth centuries into southern Spain, Scandinavia, and eastern Europe can be charted and defined by the establishment of new bishoprics.[2] Individual bishops varied in their zeal for building and adorning churches. Exceptionally, active promoters of the Church's material culture were often noted in contemporary records and given almost sole credit for the patronage they exercised. Such a figure was St Bernward, bishop of Hildesheim from 992 to 1022, who was personally credited with the building and sumptuous adornment of churches within his diocese. According to his biographer, Thangmar, so seriously did he attend to the enrichment of his churches that he acquired many of the necessary skills himself and was an accomplished goldsmith and mosaicist as well as an assiduous collector and patron. The bishop encouraged the training of gifted artists in his service and provided 'bright and exquisite paintings' for the church of St Michael at Hildesheim, as well as many precious books, ornaments, and vessels for the elaboration of divine service.[3] This formation of a kind of art school was a significant artistic contribution. Another was his role in the encouragement of a revival of large-scale lost-wax bronze and silver casting on behalf of his own and other churches in his diocese. Most famous among his commissions, and probably devised by him, are the magnificent pair of bronze doors made for the abbey of St Michael at Hildesheim, each cast in a single piece between 1011 and 1015, and the bronze column, also cast in one piece, made for St Michael's in c.1000–10. The influence of Bishop Bernward's metalworkers spread widely, and it has been suggested that they were subsequently involved in prestigious work in Spain in the employ of Queen Sancha for the shrine of St Isidore of Léon, made in 1063.[4]

One of the most captivating pieces of metalwork was one of the first and one of the smallest, made in c.996—a silver crozier made for Bernward's kinsman, Erkenbald, abbot of Fulda [39]. It not only demonstrates an exquisite attention to technical detail, but also conveys a powerful and very complex message with great inventiveness and economy. The crozier was part of the abbot's paraphernalia.[5] It served both as an attribute of authority and a symbol of his holy office. At this period in German history, the crozier was formally handed to the abbot at his investiture by the emperor; later in the twelfth century the question of whether this should have been the specific and sole prerogative of the pope became a matter of dispute, not only in the empire but all over Europe. Abbot Erkenbald's crozier

39

Crozier head of Abbot
Erkenbald of Fulda, silver,
Hildesheim Cathedral,
treasury, 997–1011.

This crozier was made for
Erkenbald while he was abbot
of Fulda between 996 and
1011. The crook represents
the Tree of Knowledge arising
from the four rivers of
Paradise, shown as
personifications on the knob.
Adam and Eve are depicted at
first within paradise, Adam
with cocked head and erect
penis, defiantly sinful after the
Fall as he eats the apple. The
scene moves to a tiny space
outside the garden, where
even the branches of the tree
propping up his slumped body
appear to turn back to accuse
him. God has appeared in
person, handing him a book,
while Adam hangs his head,
visibly deflated in his remorse.

is one of those skilfully composed works of art through which several
ideas are communicated simultaneously—about man's Fall and even-
tual Redemption through the Word. Through its imagery, it
reminded the abbot of where the supreme authority lay—within
God—for his mission. More specifically, by analogy with God giving
the Word to Adam after the Fall, it emphasized both the abbot's duty
as an evangelist and his potential failings as a man.

As we have seen, mosaicists and painters from Greece were
famously brought to the abbey of Montecassino by Abbot Desiderius
to train his monks, with the express purpose of instigating a revival of
the craft. Like Bishop Bernward half a century earlier, Desiderius saw
the need to expand not only the fabric of his buildings but the
range of resources available. The encouragement of new skills
and techniques of painting with which he has been credited by his
biographer, Leo of Ostia, is more likely to have been about re-
launching and establishing new priorities than starting afresh. As
excavations of earlier monastic sites in southern Italy, such as at
S. Vincenzo, south of Rome, are demonstrating, there was a very rich
pre-existing culture of wall-painting of long standing.[6] What can
legitimately be claimed on Desiderius's behalf is his investment of
new energy in the programme of church building and decoration.
The involvement of artists from abroad and resulting ideas generated
locally led subtly to developments in the communicative power of the

40

Entombment of Christ, wall-paintings, S. Angelo in Formis, Campania, 1072–87.

The scene of Christ's entombment comes from the north wall of the nave and is part of an extensive christological cycle comprising some 60 episodes. A simple detail such as the emphasis of the mourning visage of the Virgin in the Entombment scene, which is turned slightly to show the viewer the depth of her feeling, transforms the image from a distant conventional representation to a dramatic and moving spectacle.

visual images in Desiderius's churches. From surviving paintings at the church of S. Angelo in Formis, for example, it is clear how figure compositions have been half turned towards the viewer, traditional poses varied, and details sharpened to enhance their emotional force and to give them a newly arresting theatricality [**40**].

The Word

The golden pulpit donated to the palace chapel at Aachen by the emperor Henry II between 1002 and 1014 was fashioned to resemble a panelled bookcover studded with jewels. It has been adapted to its function—the curved shape and size, just large enough to enfold the deacon in the act of reading the words of the Gospels, appropriate as a frame for the spoken word. Its size demanded that its glorious jewels be the size of dinner plates, and like the gems on many smaller contemporary bookcovers they are Antique [**41**]. Also from an Antique source are six large ivory panels on the sides, some showing aspects of secular rulership, but others strangely incongruous in their open pagan display of fecund sensuality. The pulpit was not an object for public consumption, however, but a piece of royal indulgence for an imperial palace chapel with a venerable history. Its founder, Charlemagne, was becoming increasingly a hero, not only for his

Pulpit of Henry II, silver, bronze-gilt, gems, ivory, enamel, Aachen, palace chapel, 1002–14.

Prominent among the prize collection of jewels and enamels studding its framework are onyx dishes, gadrooned gold bosses, and Fatimid crystal. Of the four metal repoussé panels of Evangelists framing the curved front, only St Matthew is original. Six large ivory panels dating from the sixth century and representing pagan subjects adorn the smaller curved panels at the sides.

imperial successors, but also in European popular culture [112]. The ancient plaques and jewels gave this new pulpit a window to a multicultural past, as well as establishing through these visual statements ambitions for future pronouncements.

The re-use of ancient art and the combination of tradition and innovation, pagan and Christian, and decoration and didacticism are characteristic of much of the art of the eleventh and twelfth centuries. It is interesting to see these artistic tensions played out at the political centre of the Latin Church in the course of forming an appropriate genre to promote religious messages. The great marble pulpit of S. Ambrogio in Milan was constructed, probably at the end of the eleventh century, on the foundations of two early Christian sarcophagi [42]. It was a crucial piece of church furnishing, with a clear practical purpose: it was used for reading the Gospels and, as a symbolic presence, it represented the importance of ritual and text in the services of the Church, at a time when the primacy of the see

Pulpit, marble, S. Ambrogio, Milan, late eleventh century. Built around a core of two Early Christian sarcophagi, only one complete scene, the Last Supper, remains from an eleventh-century cycle on the balustrade. Supporting it is an arcade rich in a combination of scrollwork inhabited by dragons and lion-like creatures entwined in playful and possibly dangerous combat, while trapped in the midst, almost hidden in the spandrels and lunettes, are the Journey of the Magi, eucharistic symbols, and Adam and Eve.

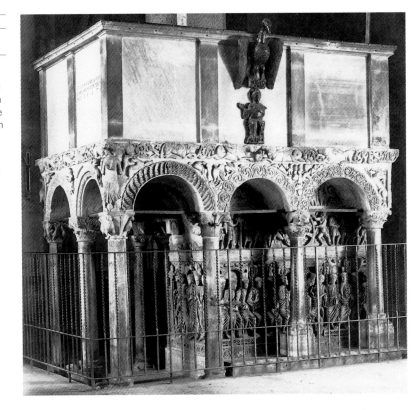

of Milan over that of Rome was a matter of dispute between Pope Gregory VII and the emperor, Henry IV (see **Reform and authority**). It is also crucial in that it is the first of such monuments to combine the decorative, foliate vine-scroll carving traditional in earlier Italian church art with figures in full relief, displaying a range of Christian iconography.

Visual communication

Cultural exchanges at the borders of Latin Europe highlight the tensions between the rapid growth of new forms of church art and the survival of earlier powerful artistic traditions. Norway came to Christianity during the reign of Olaf Haroldsson, who died in 1030, was buried at the cathedral of Trondheim, and was later canonized, becoming his country's patron saint. Highly sophisticated patterns of inextricably interwoven swirling foliage, animal, and humanoid forms, chilling in their eery anthropomorphism, characterize some of the earliest sculpture in a Christian context at the stave church of Urnes in the late eleventh century. The church door acts as a kind of frontier between the outside world and the holiness within, and this tradition of inhabited scrollwork became a visual metaphor not only for the struggle against evil but for growth and a celebration of nature. A century later, for example, at the churches of Ål, Hurum

Doorway, wood, Hurum Church, Valdres, Oppland, Norway, 1180s.

A runic inscription in the nave of the Hurum church records that the timber for the door was felled by the local lord in 1179. The door has been moved from its original position but is likely to have been an exterior door on the south side. Nature engulfs it in regular swirls of vine-scroll tendrils within which dragons are enmeshed. Each spiral has a clear centre, and although the wildness of nature has been controlled, it is still an impenetrable thicket strangulating anything in its path.

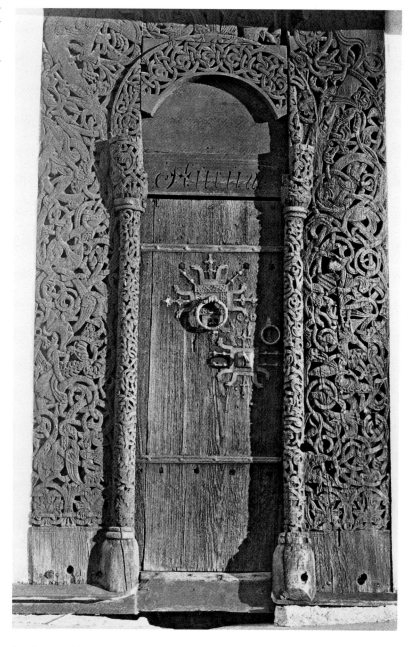

[**43**], and Torpo, a similar range of natural curling foliate motifs, deriving not so much from Viking origins as from the Mediterranean, has typically become gentler and more evenly decorative. The foliage scrolls, although they enmesh their victims more securely, adhere to the surface of the buildings as if nature is part of them rather than being an antagonistic force to be warded off.

Monumental art could be employed to enable parts of the buildings themselves to appear to communicate aspects of the Church's teach-

44

44

Crucifix, painted wood, Brunswick Cathedral, Lower Saxony, c.1150.

It was customary for the Crucifixion, flanked by Sts Mary and John in mourning, to be portrayed in churches as a three-dimensional image, sometimes life-size or larger, above the screen at the entrance to the choir and sanctuary. Post-medieval reforms and iconoclasm have caused most of these images to be destroyed, but in Germany, Italy, Spain, and France there are a number of examples from the ninth century onwards. Although it no longer stands at the crossing, this mid-twelfth-century wooden Christ on the Cross, signed 'Imervard me Fecit', and modelled after the miraculous *Volto Santo* at Lucca, is still preserved at the cathedral of Brunswick.

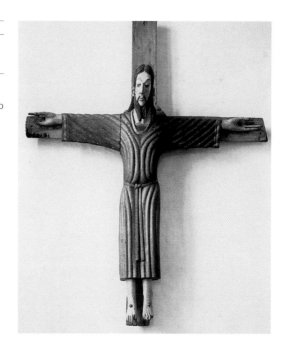

ing and liturgy [**44**]. Arcaded buildings with decorative capitals had been known since classical times and formed the basis of the early medieval basilica. In the eleventh century, however, they began to be increased in scale and complexity, with ambulatories and upper galleries affording more scope for decorative articulation and embellishment, notable examples being the French and Spanish pilgrimage churches such as Saint-Sernin at Toulouse and Santiago de Compostela. Reasons for elaboration might have ranged from a growth in a church community and increase in scale and modes of worship to technical and aesthetic experimentation on behalf of builders and artists and an expectation among the populace for an experience of awe, wonder, and spectacle. Decoration extended to all parts and surfaces of the church—the walls, floors, ceilings, and windows, and both interior and exterior. Historiated capitals, that is capitals incorporating figured scenes showing biblical episodes, saints' lives, fables, or scenes of physical or spiritual trial or prowess, became commonplace. From the middle of the eleventh century we also see the beginnings of the enhancement of façades and entrances with relief carving. These trends were well established by the beginning of the twelfth century, and increasingly thereafter sculpture, wall-painting, and stained-glass windows, and often the three together, were used to enrich and to give meaning to the most significant and holiest parts of the buildings.

It was in the orbit of the Cluniacs that some of the most significant early developments in a new didactic, communicative kind of church decoration took place. Musicians, angels, virtues, allegorical scenes, Adam and Eve, and the Sacrifice of Isaac inhabited capitals

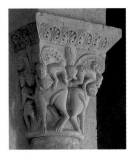

45

St Martin at Fromista, Castile, founded 1066 by Doña Munia, widow of Sancho el Major, king of Navarre. *Right*: the south nave; *Above*: detail of capital.

Strategically placed at the corners of a nave capital in the convent church are two bishops, one holding a crozier and one a tau cross. Here, as they preside over two scenes of concord between men and women and one of reconciliation between quarrelsome men, they stand for the forces of harmony: they represent the authority and hierarchy of the Church, while ingeniously performing a formal role in dividing the space. Other capitals echo the theme of discord and harmony among beasts and animals (*see above*), while towards the most sacred parts at the east end of the church, biblical episodes recall the Fall of Adam and Eve and the Redemption via scenes relating to the nativity of Christ.

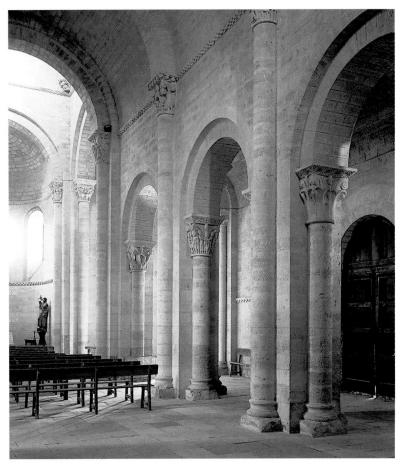

ringed around the ambulatory of the third church on the site of the mother house of the Cluniac order at Cluny in southern Burgundy. Begun in 1084, it probably did more than any other building to establish the fully fledged high-medieval type of great church. It survives only in fragments, but it is clear from these that sculpture was used in the sanctuary and on the main façades both to enrich a beautiful structure and to suggest the presence of a series of narratives interweaving with the fabric of the building.

Although the Cluniacs made lavish use of sculpture in their churches, it would be misleading to imply that they, or indeed any single source, were responsible for the increase in the appearance of figurative sculpture in church art. A number of factors were involved that varied from place to place. In Spain, where the Church had to define itself against the competing religions of both Arabs and Jews, it is possible that the introduction of figurative sculpture—the enhancement of the sense of presence of the holy narratives and personalities—was an especially powerful tool in the face of the iconophobia of the other religions. Recent research has indeed brought out

how sensitive a subject the figure was, in the extent to which both Christians and Jews engaged in aggressive dispute about the way the body was referred to or misrepresented in certain theological writings.[7]

By the second half of the eleventh century, a number of churches in northern Spain had developed the genre of sculpture, and the historiated capital in particular, in a way that integrated structural necessity with communicative power. The handsomely proportioned church of San Martin at Fromista (Castile) was founded in *c.*1066 by the widow of Sancho Garces III of Navarre, who had been instrumental in introducing the Cluniacs to Spain at the time when the papacy was attempting to use the order to assist in establishing the Roman rites of worship to supplant the old Mozarabic rites [**45**].

As attitudes to images and patterns of worship changed, many forms of medieval art were destroyed in succeeding centuries. Consciousness of the need for conservation has made people more cautious now, but the medieval Church was constantly subject to change and readily replaced obsolete features. Screen divisions were particularly vulnerable to being swept away, and twelfth-century examples were almost all replaced later. At Chichester Cathedral the

46

The Raising of Lazarus, stone relief, Chichester Cathedral, *c.*1108.

These emotional figures are likely to have been influenced by German workmanship, such as bronze casting made for Bernward of Hildesheim. It is probable that the German bishop of Chichester, Ralf de Luffa, commissioned them for the consecration of the cathedral in 1108.

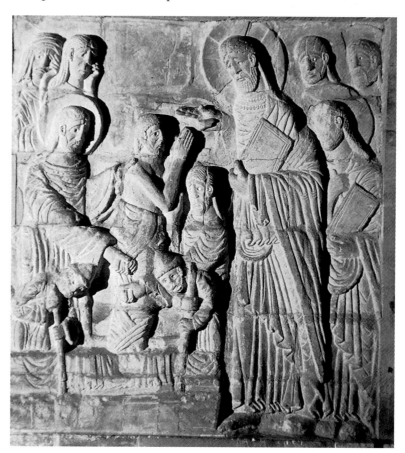

former choir enclosure between the area under the central crossing tower and the aisles was discovered in the nineteenth century behind the early fourteenth-century wooden stalls. These contained relief carvings of the Raising of Lazarus that had as much dramatic power as the wall-paintings from S. Angelo in Formis discussed earlier, although they have rather been compared to art in Germany, specifically the Hildesheim metalwork in the circle of Bernward [46].[8] The stalls that replaced them represented a practical change— they were needed to perform a different function as seats for the choir rather than as space divisions—but they also marked a strong change in aesthetic attitudes. These reliefs were situated in a part of the church reserved for clerics only, yet the tear-jerking emotional force of the Lazarus reliefs arrested attention, invited the viewer to stop and empathize with the plight of the weeping sisters who believed their brother was dead, and to marvel at the miracle wrought by the benign towering figure of Christ. No such distraction is afforded by the furniture that superseded them, which is not primarily figurative. This indicates perhaps that the need in the first arrangement of the church at Chichester for communicative decoration to stimulate reaction was thought superfluous as new fashions took over.

The parish church

By the twelfth century a network of parish churches was already established widely throughout Latin Europe, served by priests who were responsible for the care of souls in local communities. They were dependent on episcopal sees but, according to the terms of their foundations, could be subject to the authority of a local monastery or to the estate of a king or nobleman who would have rights of presentation of the priest to the living. Parish churches served as the spiritual and sometimes also the civil hearts of the local communities, and through them the arts of the Church flourished sometimes at a humble and modest level, but also with great richness and vigour. Economically, they relied for funds for building and decoration on their patrons, on their priests, and on local inhabitants. In the interests of providing for care of souls in a local community, rich benefactors could exploit the opportunity to found a church in order to pursue their own social and philanthropic purposes.

Occasionally an example survives of the use of imagery to promote some kind of moral or theological teaching. This seems to be the case in the parish church of Pürgg in Styria, which was founded jointly by the abbots of Admont, probably Abbot Gottfried (d. 1165), and Count Ottokar III of Traungau (d. 1163), a member of a powerful local family. The two benefactors are represented in the wall-paintings either side of the chancel arch directly below figures of Cain and Abel making their offerings to God above [47]. Research has shown that

47

Wall-paintings around chancel arch, chapel of St John, Pürgg, Styria, 1160s.

The two benefactors are depicted either side of the chancel arch below Cain and Abel and Christ in Majesty. Other scenes include, in the chancel: four atlantes, possibly the four nations supporting the Lamb of God, and personifications of Righteousness and Peace, and Mercy and Truth. In the nave are the Feeding of the Five Thousand, Annunciation and Nativity scenes, and the Wise and Foolish Virgins.

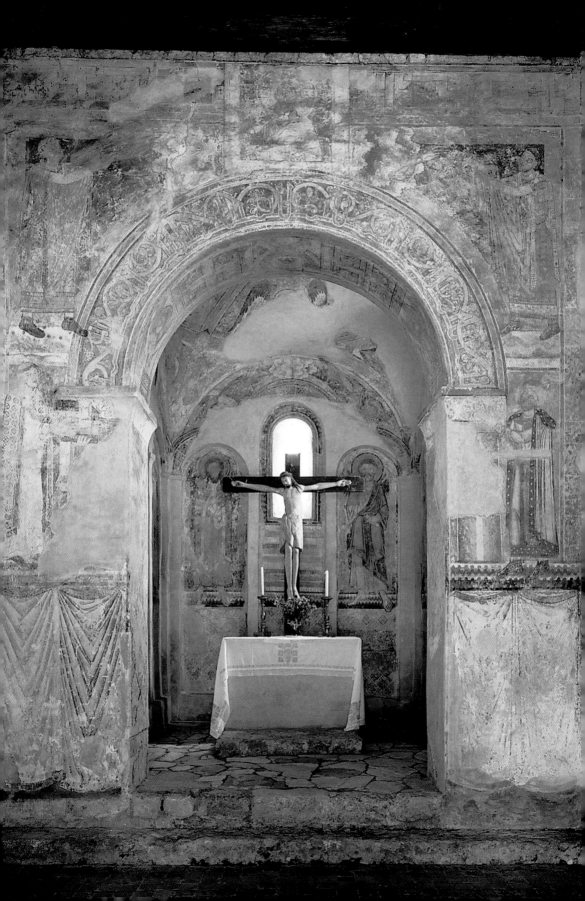

Abbot Gottfried wrote homilies about the Feeding of the Five Thousand, one of the scenes represented on the north wall of the nave, and it is possible that theological or moral themes are being explored at his instigation through these paintings. There is a marked emphasis on folly and wisdom and justice and argument in the other scenes painted in this very complete cycle.[9]

It is often the case that in parish churches in rural regions where there has been neither a history of iconoclasm nor destructive hazards there are remarkable survivals of altar furnishings and images. Some of the most vibrant examples of decorative painting and carving, brilliant with strong reds, greens, black, and ochre, and portrayed with simple, direct features, come from isolated villages and settlements in the mountain regions of the Pyrenees. Such artefacts also survive in relatively large numbers in Catalonia but have mostly been removed to the Museum of Catalan Art in Barcelona, where the scale of what once existed can best be appreciated. Now, standing in the empty churches overshadowed by scrub-covered rock, one can only imagine the impact on a little community of the comforting visions of beatification or terrifying scenes of martyrdom, the hypnotically powerful figure of the Christ in Majesty of the wall-paintings in Taull, or the direct appeal of the Virgin and Child altarpiece from Avia [**48**].

Through the networks of parish churches, we find local schools of carpenters, painters, and stonemasons, sometimes confining their work and influence to one or two centres, but in propitious economic circumstances their range could be extensive. Wall-paintings existed in almost every church, ranging from a favourite scheme at the most

48

Altar frontal (or retable), tempera on panel, Santa Maria d'Avia, Catalonia, c.1170–90.

A typically accomplished painted altar-piece from a Catalan parish church, and representative of the type and scale of such altar furnishings in parish churches all over Europe. It depicts the Incarnation of Christ, showing the Virgin and Child at the centre, with the Annunciation and Visitation and the Journey of the Magi to the Virgin's right and the Nativity and Presentation in the Temple to her left. Christ is gesturing towards the scenes announcing the Incarnation.

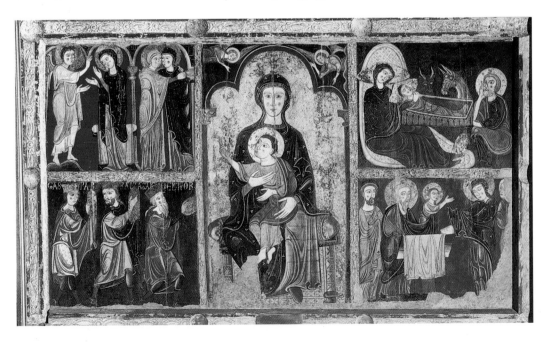

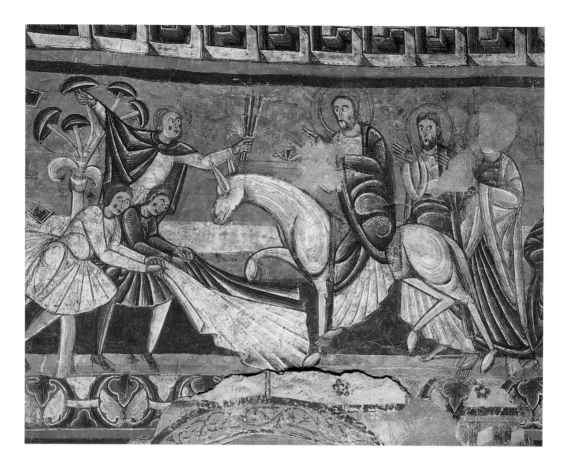

49

Wall-paintings, Saint-Martin, Nohant-Vicq, Indre, second quarter of the twelfth century. Paintings in the nave show Nativity scenes; on the chancel wall are the Crucifixion and Last Judgement. In the choir are images relating to the Last Supper and the Institution of the Eucharist. All the figures are shown in vigorous movement, garments flying. A joyously spirited version of Christ's Entry into Jerusalem, on the south wall, must have given the priest and his congregation a real sense of enthusiasm about being part of this place.

modest end of the scale—a limewash coat picked out with a black linear masonry pattern—to complete cycles following the life and miracles or the Passion of Christ.

A number of schemes of wall-painting exist in churches in the Berry region, around Bourges, in eastern France, but like many examples of regional work seem to have involved a number of painters who always produced variations on a range of themes, but never identical schemes. Principal among these is the church of Nohant-Vicq, a dependency of the abbey of Déols [**49**]. The whole scheme of painting is directed towards picturing the Incarnation and Passion and is remarkable for its liveliness and energy, to such an extent that one writer has criticized the artist's insensibility to the depth of the spiritual experience that he was required to expound.[10] At the tiny church of Brinay, a stylistically similar scheme of painting by a different artist concentrates more on the infancy of Christ and the Temptation.[11]

This Crucifixion window is
dramatically coloured on a red
background outlined in blue.
It occupies the most
prestigious position, being the
axial window of the choir, at
the east end of the church.
Above the crucified Christ is
an Ascension scene including
only ten apostles. The
remaining two apostles are
below in scenes of their own
martyrdoms—the crucifixion
of St Peter, patron saint of the
church, and a companion
image of the decapitation of
St Paul. Royal donor figures at
the bottom may represent the
Plantagenet king Henry II and
his queen, Eleanor of
Aquitaine.

Colour and light

Threading its way through philosophical and theoretical writings
by adherents of the visual arts throughout the Middle Ages was a
general belief in the efficacy of pictures and images in elevating the
human spirit and encouraging people to contemplate the lessons of
Christian life and destiny [50]. With an artist's eye for the impor-
tance of combining instruction with beauty and marvellous work-
manship, Theophilus summarized some of the main advantages of
pictures thus:

'By setting off the ceiling panels and walls with a variety of kinds of work and a
variety of pigments, you have shown the beholders something of the likeness
of the paradise of God, burgeoning with all kinds of flowers, verdant with
grass and foliage.'[12]

Describing the overwhelming effect of a church totally filled with
colour and light, he continued:

A human eye cannot decide on which work it should first fix its attention: if
it looks at the ceiling panels they bloom like tapestries; if it surveys the walls,
the likeness of paradise is there; if it gazes at the abundance of light from the
windows, it marvels at the inestimable beauty of the glass and the variety of
this most precious workmanship. But if a faithful soul should see the repre-
sentation of the Lord's Crucifixion expressed in strokes of an artist, it is itself
pierced.

For a medieval account and appreciation of the aesthetics of colour
and light in the church, nothing equals the passion and the vision of
the writings of Abbot Suger. He expressly wanted to accommodate the
great crowds visiting the church of Saint-Denis, trebling the entrance
doors and extending the east end to enable the reorganization of the
shrines and treasures so that they could be viewed in the choir and
chapels rather than in the crypt. Quantities of gold were procured
for altars and shrines. Donations 'from kings, princes and many
outstanding men' provided a

multifarious wealth of precious gems, hyacinths, rubies, sapphires, emeralds
and topazes, and also an array of different large pearls for setting in shrines
and altars. Sapphire glass was laid in stock for the windows. In honour of the
sacred bodies of the patron saints. The church shines with its middle part
brightened. For bright is that which is brightly couples with the bright, and
bright is the noble edifice which is pervaded by the new light.[13]

Asceticism versus aestheticism in the monastery

The monastery of Cîteaux had been founded in 1098, to set up a
reformed Benedictine house aiming to return to the simple values of
worship and manual labour without the ritual and ornament to which

the Cluniacs had become accustomed. St Bernard joined the monastery in 1112 at the age of 22 and was influential in establishing and spreading the values of the house, becoming its abbot after a few years. He inspired the foundation of four more colonies, among them Clairvaux, and a total of 68 by his death. He promoted the cause of the Knights Templars, one of the military orders dedicated to service in the Holy Land, and wrote their order for them. Cistercians abhorred ornament, believing, as St Bernard wrote, that 'inward beauty is more beautiful than all outward ornament'.[14]

Cistercian buildings are renowned for their simplicity and pure lines, echoing with prayer and liturgical chant and unadorned with colour and monuments. Ascetic writings emanated from the pens of their monks, excoriating just those riches in which Suger revelled and delighted. In the twelfth-century *Dialogue between a Cluniac and a Cistercian monk*, it is written:

Beautiful pictures and various sculptures, both adorned with gold, beautiful and costly coats, beautiful hangings tinted with different colours and beautiful costly windows, stained-glass windows tinted with sapphire, copes and chasubles interwoven with gold, golden chalices set with precious stones and gilded letters in books—all this is demanded not by necessity, but by the greed of the eyes.[15]

Some of the most impressive and extensive uses of historiated capitals are to be found in monastic cloisters. In these settings, such as the cloisters at the pilgrimage church of Saint-Sernin at Toulouse, the cathedral at Monreale, in Sicily [51], or the abbeys of Moissac and Santo Domingo at Silos, the pace of viewing is measured according to the intervals between arcades, and one can imagine the monks walking, pausing, and cogitating at each one. One of St Bernard's most famous writings, in a letter to William, abbot of Saint-Thierry, was an exasperated outburst at the 'amazing kind of deformed beauty and yet a beautiful deformity' of grotesque carvings proliferating in the cloister, not least because of the extravagance—'the church dresses its stones in gold, and turns its sons away naked'—but also because of the vanity implicit in the fact that these carvings elicited greater admiration than piety and were distracting, tempting the monks to read more in the marble than in their books.[16] The debate touched the core of what art in churches was there for. Seen from the point of view of lay benefactors, on which monasteries, even Cistercian ones, relied for their support, funds put towards the elaboration of churches marked an increase in their piety and facilitated their worship.[17] King William of Sicily's benefaction to the monastery at Monreale, where he intended to be buried, allowed him direct access, as it were, to the Virgin and Child to whom he pays homage in a mosaic inside the church as well as on one of the

51

King William II of Sicily presenting the church to the Virgin Mary, cloister capital, Monreale Cathedral, c.1180. Large schemes of sculpture such as appeared in monastic cloisters signify the presence of material and intellectual wealth. Monasteries normally had numerous lay benefactors. Here King William II of Sicily is represented on an historiated capital of his foundation at Monreale, offering a model of the building to the Virgin and Child. The columns are richly inlaid with mosaics, indicating that no expense was spared.

capitals in the cloister.[18] Such images of gifts of works of art, of which there are many in all media in the Middle Ages, set up their own system of validation and effectively place the benefactors beyond criticism, showing them already in the realms of heaven.

Relics

Canonizations of powerful new saints, or the aggrandizement of earlier ones, were among the factors that generated the most artistic activity and, ironically, led to the greatest enticements for the 'greed of the eyes'. Europe was effectively colonized by saints' relics and it would be hard to say whether the movement was driven more by the Church encouraging the aggrandizement of cults or a public expectation for ever more spectacular miracles and greater displays of magnificence. Whichever was the case, each party was prepared to spend money—the Church on pomp and display, the public on travel and offerings—and the economic and cultural phenomenon was propitious for the creation of considerable works of art. Income generated from the faithful allowed worship on an ever grander scale, including the elaborated settings for mass, which included liturgical

Sarcophagus for one of the children of the Castilian royal family, stone, Convent of Las Huelgas, Burgos, 1194.

This little stone sarcophagus, deriving from a classical type of pitched roof form, was made to commemorate one of the children of Alphonso VII of Castile and Eleanor Plantagenet, founders of the Cistercian convent of Las Huelgas at Burgos. It was possibly made for Prince Sancho, who was born in 1181. On the long side it represents the soul in a shroud being carried by angels from its bed to heaven. On either side of the bed are the weeping parents, their heads bent in grief. Flanking them are figures of abbots and bishops, and there are further mourning figures at the ends. This is probably the earliest surviving example of a tomb with weepers. The custom of decorating the tomb chest with mourning figures of relatives did not become fashionable on aristocratic tombs in England, France, and Spain until at least 50 years later. One of the earliest parallels is of a tomb of one of the royal children of St Louis of France, so the little Burgos tomb may have marked its beginning as a royal custom. The other innovative feature of the tomb is the memento mori inscription around the lid which predates the fashion for such things by some 200 years at least. This reads: 'Whoever you are you will fall into death, so take heed and weep for mine. I am what you will be and was what you are now; I beg you to pray for me. 1194. P. M. F.'

furnishings and precious vessels, and containers and surroundings for the remains themselves, such as gold and jewelled shrines and reliquaries and their bases and canopies [**53**].

One of the problems of relic display was that the more that relics were available to view, the more they were vulnerable to theft; another was that the more they were seen, the more familiar they became, and the less captivating to pilgrims. To address these issues,

Shrine of the Three Magi, gold, silver-gilt, bronze-gilt, gems, enamels, pearls, Cologne Cathedral, treasury, begun *c.*1182–90.

Relics of the Three Magi were given to Archbishop Reinald van Dassel of Cologne by Frederick Barbarossa after he had acquired them in Milan on conquering the city in 1162. Nicholas of Verdun was almost certainly among the team of craftsmen engaged to make the shrine for such prestigious relics. Designed like a roofed sarcophagus and almost the scale of a little building, the magnificence of its display was no doubt intentionally geared towards encouraging admiration as much as piety.

measures had to be taken on the one hand to provide security and on the other to renew interest. A slightly bizarre story attached to the relics of St Mark in Venice is concerned with both these problems [**54**].[19] With a degree of incompetence that is hard to credit, during the rebuilding of the church dedicated to him in Venice in the late eleventh century, it is said that the location of the saint's relics had been forgotten. They had been in Venice as some of the most venerated and important relics of the Christian Church since 828 and, yet, they had entirely disappeared. Miraculously, after three days of fasting and prayer by the whole population, the south-east pillar of the central dome opened miraculously to reveal the relics hidden inside. The scene of the discovery is recorded in a mosaic in the south transept opposite the pier where the miracle had occurred. The mosaic sets the scene in the thirteenth century rather than in the eleventh, and shows two pulpits brought to Venice after the Sack of Constantinople in 1204. The officiating priest is the patriarch of Grado, reigning in Venice in the thirteenth century, and the doge is likely to be Ranieri Zen (1253–68), who reintroduced the feast of the 'Apparitio', which celebrated the episode. This picture does more than record the happy resolution of an extraordinary lapse in mem-

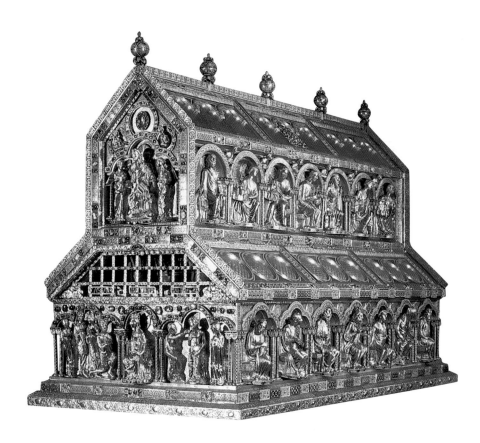

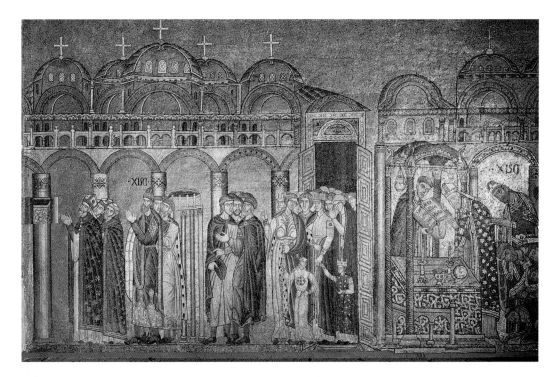

ory: it records the public witnessing by the greatest dignitaries in
Venice of the reaffirmation of the saint's physical presence. St Mark
was showing them, by his miraculous reappearance, that indeed his
body belonged there in Venice; the people had nearly lost it, but he
was not going to abandon his post. Whatever interpretation one puts
on the loss of the relics, the incident thus served to relaunch his
cult.[20]

The new entrance

Sculpture was employed in the interests of enhancing the corporeality
of parts of buildings, of bringing them to life. In the eleventh century,
relief carvings began to be used on façades and entrances, establish-
ing a sense of the symbolic substance of holy personages associated
with the buildings. Subsequently, the façade is made more prominent
as the site for setting the scene, making the first greeting, impressing
the onlooker with a sense of drama, and communicating the first
religious message.

In the context of the pilgrimage church the façade was developed
early in the twelfth century, at churches such as that of La Madeleine
at Vézelay, Sainte-Foy at Conques, and St James at Compostela,
where there were large crowds to be communicated with and who
were ready to be impressed.

By the mid-1130s, the entrance or façade was well established as
a site for monumental sculpture. The principal regional schools in the

first half of the twelfth century were in northern Italy, centring on Pavia and Modena, in southern France at Conques, Moissac, and Beaulieu, in western France at Poitiers, Angoulême, Saint-Jouin de Marnes, in Burgundy at Autun and Vézelay, and in Provence at Arles and Saint-Gilles.

A special case has been made for the façade of Saint-Gilles in Provence to play a kind of apotropaic role in warding off heresy in the Languedoc [**55**]. Peter of Bruys was a heretic who inveighed against church decoration and all forms of ceremonial pomp. He disbelieved in transubstantiation, the transformation of bread and wine into the actual body and blood of Christ, and condemned veneration of the Cross. He was lynched at Saint-Gilles by a mob enraged at his preaching against the crucifix and burned in front of the church. Scholars have pointed out the coincidence of the subjects on the new façade with issues that had arisen as a result of the Petrobrusian heresy, and a convincing case has been built up for it having been designed at least as a means of clarifying some precise issues of Church doctrine, if not as a more specific riposte to recent challenges to its authority.[21]

The sculpted portal was developed as a special feature of the abbey and cathedral façade in the Île de France, around Paris, from the middle of the twelfth century and into the thirteenth, as a kind of visual manifesto emphasizing the community of the Church, its

55

West façade, Saint-Gilles, Provence, late 1140s.

The inclusion of the crucifix, prominent on the south tympanum of the façade, has been associated with the suppression of the heresy of Peter of Bruys in *c*.1139 (although it is also consistent with other façade programmes). On the lintel the Last Supper was included either to refute the Petrobrusian heresy, which denied the sacrament of communion, or to be a general affirmation by the Church of its victory over heresy. Angels combating dragons at the outer edges may represent the fall of the rebel angels as the prototypes of all heretics.

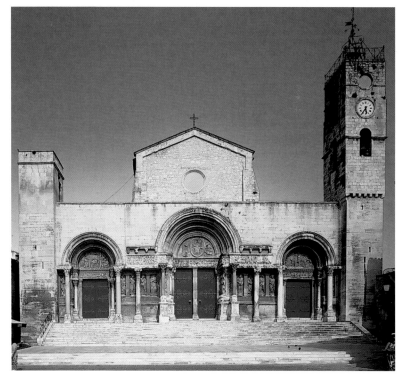

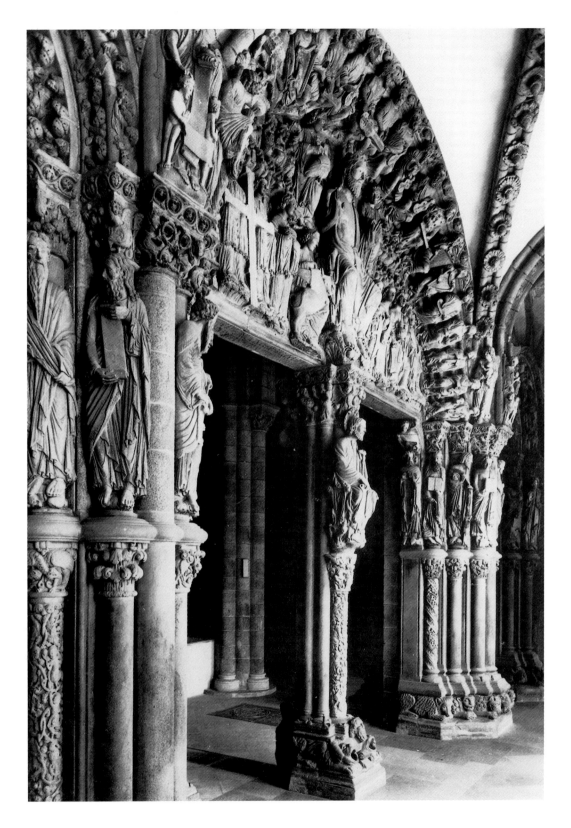

Portico de la Gloria, St James,
Compostela, c.1168.
Sculpture of the west narthex
façade of this pilgrimage
church was carved by a
workshop led by one Master
Mateo. The figures are
dramatic and compelling in
their expressiveness. The
scene is a Last Judgement.
On the tympanum is a Christ in
Majesty, four Evangelists, and
angels holding instruments of
the Passion. Around the
archivolts are the 24 elders of
the Apocalypse playing a
remarkable range of musical
instruments. Apostles and
prophets appear on the
jambs.

Innocent III (1198–1216)

Many of the most significant achievements of the papacy in the Middle Ages can be attributed to Innocent III. A brilliant administrator and negotiator, it was largely owing to his policies that the Church became highly centrally directed, very focused on conformity to correct religious observance, and vigilant against heresy. His purist attitude to Christianity caused him to be an energetic supporter of the Crusades, initiating the Fourth Crusade, which resulted in the Sack of Constantinople of 1204. His reforms allowed negotiation with heretics, but ultimately heresy was declared to be high treason against God and draconian counter-measures were taken against those who would not enter the Church. A period of heresy investigations in southern France between 1199 and 1209 led to excommunications, culminating in the violent Albigensian Crusade against the Cathars in 1209. The Fourth Lateran Council of 1215 was instigated by Innocent and its pronouncements were of profound importance. It confirmed the doctrine of transubstantiation, condemned all heresies, banned the founding of all new religious orders, ordered all Jews and Muslims to wear distinctive dress, and required that all Christians should confess sins annually and perform due penance. Each one of these resolutions refined what it meant to be Christian and had far-reaching consequences for religious practice and for the culture of persecution.

history, and its teaching. The carved tympanum surrounded by vous-soirs above the door and column figures flanking the doorways are important features of the design of these portals, all of which afforded opportunities for sculpture. From the best-known in France at Chartres (west façade, c.1150; transepts, c.1210–30), through to Amiens (c.1220)—and in Spain the only one by a named artist, the aptly named 'glorious' portal of Santiago di Compostela by Master Mateo (c.1190)—one can really gain a sense of sculpture being used to convey an impression of 'the Church' presenting itself as a monolithic institution that required obedience and adherence to strong principles of belief and codes of behaviour [56].[22] The theme of the Last Judge-ment, with its emphasis on Christ as Redeemer, continued as the dominant one, accompanied or closely followed by the Virgin Mary and exemplary images and lives of saints, prophets, and biblical kings. Images of damnation and transgression, which had been prominent in the tympana of earlier Judgement portals at Conques and Beaulieu, tended to be pushed to the periphery or organized into a sequence of voussoirs following the line of an arch. The dominant physical presence of images of upright holy personages and their adherence to the fabric of the building acted as a metaphor for their belonging, and for their role in stimulating faithful following. Closely allied to the centralizing orthodoxy of Innocent III's reign as pope, they also set the scene for the movement towards personal responsi-bility for salvation, which became dominant in the succeeding two centuries.

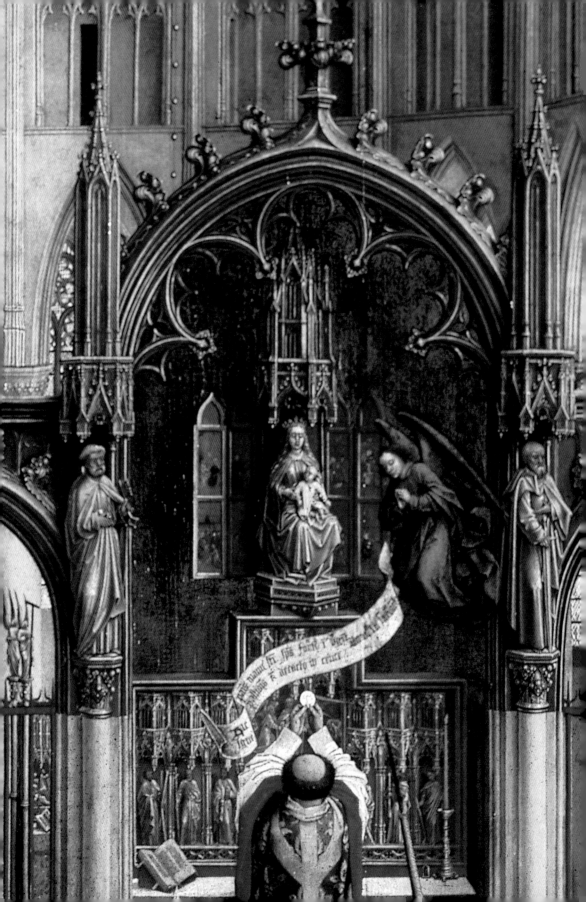

Design and Devotion

1200–1500

Detail of 79

4

The numbers of instititions and individuals contributing to the body of the Church's teaching and worship were still growing and developing at the beginning of the thirteenth century. They included enclosed orders of monks and nuns, the new 'public' orders of friars such as the Dominicans and Franciscans, cathedral chapters, local parish priests, and colleges of canons. As we shall see, the thirteenth century was a pivotal period during which the role of the Church was changed by forces that it had to embrace in order to respond to developments in society. The growth of towns and the emergence of a newly powerful crowd mentality, successfully manipulated by the friars, meant that the new institutions were populist and the new roles peripatetic.

But, overall, the necessity for maintenance of mass control and a strong administration meant that, for the time being, factions were united and had to be seen to be so. The frontier lands of Latin Christendom needed constant vigilance owing to fear of attack or penetration by different religions. The Muslims in Spain were still being fought well into the thirteenth century. Tartar invasions devastated parts of Silesia in 1241 and Hungary three times, the last being in 1287 [108]. In their wake, Cracow and Buda were in effect recolonized by German settlers. All over Europe there were regular pogroms against the Jews, resulting in their expulsion from England in 1290, from France in 1394, and from parts of Spain in 1492 [57]. New religious movements of the late fourteenth and fifteenth centuries, such as the Lollards in England, led by John Wyclif (1324–84) and the Hussites in Bohemia, led by Jan Hus (1369–1415), which were critical of excess, rejected aspects of doctrine, and called for more interaction with the laity, were ruthlessly suppressed as heresy. However, with a weak and divided papacy, split between Rome and Avignon from 1348 to 1377 and thereafter more or less unable to regain credibility and power, the way was more open for dissent to take hold. Rather than being condemned as heretics, subsequent reformers of the later fifteenth century offered a strong rationale for personal belief and initiated new waves of reform to cleanse the Church of its pomp and lavish display.

The figure

Among both the luxurious and the humble products of the late medieval Latin Church, extending from buildings to altar vessels, there is a perceptible unity of approach to design. It is manifest in a basic repertoire of motifs based on tracery forms, tabernacles, niches, turrets, and pinnacles, which could be applied using any medium and on monuments of different scales. There is no evidence of directives determining a corporate approach to imagery in the Church: no one was apparently told how anything should look, yet, with a few notable exceptions, there is widespread agreement about aesthetic appearance from the thirteenth to the fifteenth century in most of the countries of western Europe. One possible explanation may be phenomenological. Art traditions that have a strong basis in a centralized power or ideology—for example, the arts of the kingdom of Benin (Nigeria) in the sixteenth century, or those of pharaonic Egypt, or imperial Rome—have a tendency to show a marked predilection for orthodoxy, consistency, and unity, and the late medieval Church—at least until the middle of the fourteenth century—certainly conforms to this tendency. Other factors, more plausibly perhaps, may have been more specifically historical, governed by conjunctions of particular circumstances and networks of influence. One such example may have been the princely house of Anjou, which was in royal power during the thirteenth and fourteenth centuries in the Empire, in southern Italy, in Bohemia, and in Hungary, and some of whose members (notably the emperor and king of Bohemia, Charles IV (1347–78)) were active artistic patrons. More generally there might have been a tacit understanding that all the material products of the Church were instantly recognizable and identifiable as special. Physically, it meant that the Church was clearly differentiated from other kinds of institution. Above all, a strong unified aesthetic presented a visibly consistent front in the face of heresy, and doctrinally the Church was seen to behave as a concerted single body.

Fundamental to the development of a repertoire of forms in late medieval church art, and perhaps also to a kind of 'corporate identity', was the domination of the art of the church by the figure or small figure group which could be isolated in its own discrete space. The niche or tabernacle was the perfect means of honouring and hierarchizing the figure of a saint or setting a notional enshrinement around a holy scene. A figure could be further characterized and differentiated by means of the choice of supporting members and corbels for the gables and pedestals. While this started tentatively as a conceit, from the thirteenth century onwards it became a dominant characteristic common to the design of architecture, furnishings, and artefacts of religious use. On the façades of buildings as far apart geographically as Wells Cathedral in the west of England [58] and

57

Synagogue of the Transito, Toledo, fourteenth century. In Toledo it is still possible today to gain a sense of the polycultural and religious climate that existed in the Middle Ages, well beyond the time of its capture by the Christians in 1085 until the expulsion of the Jews in 1492. Mosques and defences survive from the pre-conquest period. Two medieval synagogues, as well as Christian churches and chapels, were built between the twelfth and sixteenth centuries. This synagogue was founded in 1366 by Samuel Levi, treasurer to King Pedro I of Castile. Spectacular non-figurative Mudejar stucco enriches the interior walls and arcades. This type of decoration, used in mosques, for example at Cordoba, from the eighth century, is traditionally associated with Arab craftsmen who may have continued to operate beyond the time of the conquest of their peoples. While there are examples of this kind of work in Christian churches in the city, the overall layout and concentration on non-figurative decoration in the synagogue is distinctly different from the Christian tradition.

the Benedictine abbey of Jak in Hungary, the cathedrals of Vienna and Siena, in Austria, and in Tuscany, life-size figures represented an awesome spectacle of the heavenly elite, making a very clear claim for the Church as a powerful site both of spiritual and social control.

The figure was foreign to the art of other religions. Scriptural vetoes in Islam and Judaism forbidding worship of graven images meant that figurative art had to be foresworn, so for Christianity it was a powerful differentiating tool [57].[1] Ironically, although this was also supposed to apply in Christianity, devotional practices came very close at times to image worship.[2] It is regularly testified in sermons and religious writings that communication about spiritual ideas was effected visually, through the corporeality that the buildings and

monuments were designed to enclose. In his treatise on images in churches, the English priest Walter Hilton of Thurgarton (d. *c*.1395) made the point: 'They judge of divine things from the analogy of corporeal things, imagining, for example, that God in his own nature has the body of man like their own, thinking that the three persons in the Trinity are separate beings like three men.'³ This tendency for individuals to identify physically with images of holy personages hints at one of the key factors that determined how the heavenly elite was to be represented in art and how it was responded to. It became increasingly important for lay people, that is any worshipper who was not clergy, to accept responsibility for living life according to Christian ideals and expectations. The decree concerning annual confession of sins in the Fourth Lateran Council of 1215 attempted to crystallize this practice, and the growing number of penance manuals and lay mass-books in the fourteenth and fifteenth centuries bears witness to an emphasis on individual responsibility for the path to salvation. Seen in this context, the emphasis on the holy personage, the saint, as role model and intercessor was not solely a question of changing fashion, but as much a response to need.

Cathedrals and communicative decoration

A great cathedral was a major focus for public devotion, attracting worshippers from the surrounding regions and beyond to attend masses, celebrate religious feasts, follow its processions, and visit its holy shrines. A cathedral had a responsibility to be a place of evident holiness and many achieved this by the lavish spectacle of their build-ings and worship. Approaching the principal west façade of the cathedral of Reims, where decorative carving extends from the ground to the summit, the viewer's eye is drawn upwards to the scene of the Coronation of the Virgin in the gable above the central west door, a favourite subject for portal sculpture but, additionally, in this case, a clue to the status of this church in state coronation ritual [59].⁴ Reims Cathedral was the seat of the archbishop and the coronation church for the kings of France. It thus performed a potent role at the pinnacle of an ecclesiastical hierarchy and for state ceremonial.

The scenes that the Virgin presides over include stories of her life in the archivolts and jambs, with the Passion and Judgement of Christ. Figures of prophets and saints occupy the side portals. But, for the first time in such a building, the entrances to the main west portals were surmounted by glazed tympana instead of sculpted ones. From the exterior, this space appears almost blank—a passage of flat geometry in an otherwise richly undulating, peopled exterior. It is only from the interior looking out that the full richness of the tympana, the colour, and the narratives of the stained glass are visible.⁵ From the inside the windows form an ensemble with an

58 (above)

Wells Cathedral, Somerset, west façade, c.1220.

Life-size figures of saints, confessors, patriarchs, prophets, and clerics increasingly proliferated in churches as individual images, or as part of altar furnishings. At Wells they form ranks on the façade, signalling to the worshipper that this holy place has its roots in human ancestry. The figures also display impressive virtuosity of carving and still inspire awe and wonder at the aesthetic achievement.

59 (page 92)

Reims Cathedral, west façade, c.1260.

Its exterior is the most highly decorated of all the thirteenth-century cathedrals in Europe, encrusted with sculpture at all three of its entrance façades at the west front and transepts, along the buttresses, and around the parapet. Reims Cathedral is unique in having stained glass set into the tympanum above each doorway rather than sculpture, which meant that this part was best viewed from the inside looking out.

60 (page 93)

Reims Cathedral, inner west façade, c.1260.

In the quantity and richness of its display of stained glass and sculpture of the inner west façade, the cathedral of Reims provides an extreme example of how the decoration of greater churches could be developed to ambitious communicative effect, to find new ways to extend the power and messages from the decoration from within the church into daily life.

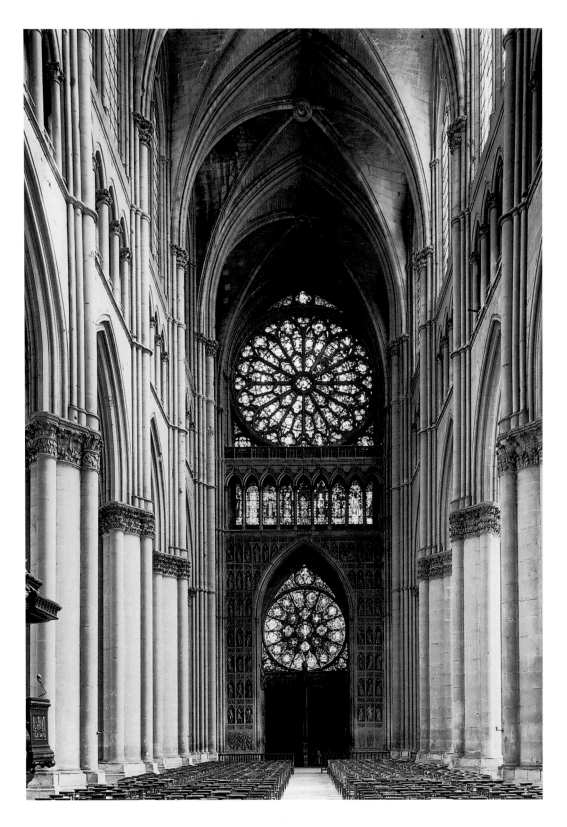

enormous interior façade of sculpture consisting of ranks of life-size figures in niches, rising from floor to vault [**60**]. Around the side doors, these figures continue the themes of Christ's Judgement and Passion begun outside, reminding viewers as they make their exit that these are the stories to carry away to guide them in their lives.

Even though it was in many ways prominent in the hierarchy of the Church in France, Reims would not have set specific standards for others to follow, except in as much as it would have been an obvious example to imitate. The arts of the Church operated on a very variable system of values and influences. The placing of imagery in a church in order to convey both general and directed messages and meanings must have been effected largely through collaboration between patrons and artists, establishing links between intention and reception. The way a monumental edifice on the scale of Reims ended up looking was a result of negotiation as well as artistic invention.

The aesthetic of preciousness

Glittering visions of heaven were only affordable by the super-rich. An elite notion of what constituted appropriate decoration for an atmosphere of extreme piety grew in the circle of the highly religious French monarchy under Louis IX and his mother, Blanche of Castile, and established an especially pervasive kind of aristocratic Parisian 'aesthetic of preciousness' that set a standard throughout Europe.[6] The Sainte-Chapelle, the palace chapel in Paris consecrated in 1248, is often invoked as the instigator of the trend for jewel-like architecture. It was commissioned by Louis IX as a giant reliquary glittering with tabernacle work, gilded figures of saints and angels, and stained glass, to honour his newly acquired relic of Christ's crown of thorns, a former treasure of the eastern Orthodox Church, which he had bought from the eastern Roman emperor in 1239. The taste for pinnacles, finials, gablets, gilded filigree, and the gorgeous glow of stained glass accorded perfectly with high prestige, appealing especially to royal and papal patrons who commissioned a number of variants on the theme, as for example at Saint-Urbain at Troyes and at the 'Capella Vitrea', the mid-fourteenth-century glazed choir added by the emperor Charles IV to Charlemagne's palace chapel at Aachen. Parisian metalworkers and ivory carvers quickly picked up on the style, and part of the reason for the spread of the 'aesthetic of preciousness' was the wide distribution of their work among elite patrons and recipients.

A typical example is the little silver-gilt reliquary for the instruments of the Passion, made in Paris in c.1280–1300, which was given to the treasury of S. Francesco at Assisi, most probably by Queen Jeanne of Navarre, and which managed to convey design and reli-

61

Reliquary of the Holy Corporal,
silver-gilt, treasury,
S. Francesco, Assisi,
c.1280–1300.

On the front of this reliquary
for the cloth used for wiping
mass vessels, a half-length
figure of the Resurrected
Christ showing his wounds
appears in a vision before St
Francis and St Clare and a
little group of praying nuns.
The form of this image, similar
to Christ as the Man of
Sorrows, which had originated
in Byzantine art, perfectly
conveyed the essence of the
pain of Christ. It became a
leitmotif for devotion to the
Passion and the Resurrection
simultaneously.

gious ideas simultaneously [**61**]. It was made in the form of a minia-
ture chapel-like tabernacle, echoing arcades and pierced decoration,
gablets, and pinnacles derived from architecture. It was one of a
number of reliquaries commissioned by the queen; another was given
to the cathedral at Pamplona, in Spain.

In a more prosaic way, the developing technology of design
processes also contributed to change in the decorative emphasis in
buildings in western Europe. Quite suddenly, around the middle of
the thirteenth century, appears a new kind of detailed and precise
architectural drawing, recording niches and canopies of façades in all
their fastidious complexity. Early examples are known from Reims
and Strasbourg [**62**]. It has been suggested that these large drawings,
making the components of architecture available in two dimensions
and at a smaller scale, influenced the inventive use of fictive archi-
tectural canopy forms in stained glass, and indeed in other media.[7]
Technology and artistic innovation may have been developing simul-
taneously here, as this integration of genres is exemplified especially
at Rouen, in Normandy, both at the cathedral and at the church of
Saint-Ouen, close to the centre of production and export of the best
and largest panels of glass. While this is a matter for speculation, the

62

Façade, Strasbourg
Cathedral, ink on parchment,
*c.*1270.

Drawings of a similar type are
known, dating from the
fourteenth and fifteenth
centuries, for the cathedrals of
Cologne and Vienna, and
elsewhere, and they probably
demonstrate options for the
designs prior to the start of
building.

impact of flat, graphic designs on niche and panel-work and their translation into both two- and three-dimensional aspects of decoration are notable and enduring features that lasted to the end of the Middle Ages.

The mendicants

63 Giotto (attrib.)

St Francis casting devils from
the city of Arezzo, fresco,
basilica of S. Francesco,
Assisi, 1290s.

The art commissioned in the
orbit of the mendicant
preachers, especially the
Franciscans, possesses highly
emotional and communicative
characteristics, evident in the
scenes from the life of St
Francis in the Upper Church
in Assisi. Recent scholarship
on some of the painters who
decorated their churches in
Italy, including Giotto, Simone
Martini, Bernardo Daddi, and
Taddeo and Agnolo Gaddi, has
highlighted the extent to which
the narrative is strengthened
by careful observation of
contemporary manners and
gestures.

The friars were the first of the religious orders who set out deliberately to mingle with the populace rather than to shut themselves away in cloistered seclusion. Both Franciscans and Dominicans were exempt from episcopal jurisdiction, and answerable directly to the pope. Their avowal of poverty meant that they were dependent on alms for survival and they therefore lived mainly in the towns [**63**]. Some friars always remained peripatetic, but within less than 30 years of their foundation both orders became established and settled in priory houses, where their churches, designed like great preaching barns, were paid for by wealthy adherents.

Through their preaching style, full of illustrative stories, their learning, but above all their accessibility, friars acquired the kind of charisma that the Church itself and the declining monasteries lacked. They showed the ways to new forms of devotion, with consequences for patterns of patronage, as well as for religious imagery.[8] Stimuli for the changing forms of art sometimes came through the force of a new philosophy, as much as an influential patron or talented artist.

The Order of Friars' Preachers was founded in 1220–1 by St Dominic (c.1170–1221), initially out of a need to combat heresy. He began as an Augustinian canon from Castile in Spain who had been enlisted by Pope Innocent III in the campaign in southern France to quell the Cathars. Catharism was a heretical movement which rejected the showy excesses of Catholicism, along with many aspects of doctrine and, among other things, the fate of the soul after death. It was through the force of their preaching, devotion to the sacrament, and the insistence on a simple life free of possessions, that he and his adherents quickly established a strong network of Dominican friars with a devoted following throughout France, Spain, Italy, and England, and beyond. The renunciation of worldly wealth by St Francis is one of the best-known stories of medieval Christendom. The return to the simplicity and poverty of the first Christian disciples was a guiding factor in the lives of the Franciscan friars, who were established as a religious order in 1223, advocating a life of simple devotion, study, and worship. Other mendicant friars followed, including female Franciscans, the Poor Clares, and the Carmelites. Dominican preachers became favoured advisers to French and English royalty and aristocracy. Both orders became well established in the universities and in powerful benefices in the Latin Church. Six of the greatest theologians of the entire Middle Ages were mendicants: Albertus Magnus, Thomas Aquinas, and Master Eckhart were Dominicans, and St Bonaventure, Duns Scotus, and William of Ockham were Franciscans.

The body of Christ

Abbot Hugh of Meaux commissioned a new crucifix in the 1340s for the choir of the lay brethren of his monastery. Believing, because it was both a beautiful and a miracle-working image, that it was likely to attract much sensational attention, especially from women, he requested special dispensation from the mother-house of Cîteaux for special licence to admit both men and women of good repute to view it. And how did the sculptor ensure that it would fulfil popular expectation? He carved only on Fridays and on those days he fasted on bread and water; 'moreover, he had a naked man before him to look at, that he might learn from his shapely form and carve the crucifix all the fairer'. Women did indeed flock to see the image but, to the abbot's disappointment, their 'devotion is but cold' and they were more interested in the church buildings.[9]

Had Abbot Hugh and his artist concentrated less on the beauty of the image and more on its violence, they would perhaps have touched a richer strain of popular devotion. Many feasts and cults of the late medieval Church took as a starting point empathy with Christ's suffering at the Crucifixion, isolating poignant images in order to evoke emotion. The appearance of the stigmata on the body of St Francis had been one manifestation of the extreme visual signs that mystics in the thirteenth century were appropriating to themselves in identifying with Christ's Passion.[10] The 'reinvention' of the crucifix to suit new expressions of piety was one example among many of new kinds of monument that redirected devotions to the body of Christ and the Resurrection. Under the auspices of the Franciscans, especially in Germany and Italy at the beginning of the fourteenth century, violent images of the wounded Christ started to be commis-

sioned, in order to express better the compassion of that order with Christ's suffering.[11] These images, known to students of Italian art as the *Christus patiens*, took various forms, German examples being on the whole more extreme in their signs of violence. Some such images provoked strong reactions and not all of the practices associated with devotion to Christ's suffering body were universally acceptable. The story of the bishop of London's banishment of Thydemann the German's 'crux horribilis', which had excited too much devotion among the populace who flocked to the city see it, may have been a sign of the Church's growing fear of popular piety as much as it was one among many of the Church's attacks against idolatry [**64**].[12]

At the heart of the medieval Church many things were shrouded in mystery. Most mysterious of all was the fact of Christ's Real Presence in the Eucharist. As a culmination of centuries of disputation on the matter, the Fourth Lateran Council of 1215 formalized this dogma by its confirmation of the doctrine of transubstantiation, which stated that during consecration the bread and wine of the Eucharist became the actual body and blood of Christ.[13]

In 1311, the feast of Corpus Christi—the body of Christ—was formally instituted at the Council of Vienne, having been founded more than half a century earlier by a group of nuns in Liège who had initiated a popular movement to honour the host as Christ's body.[14] During a similar period, and over the general terrain between the Low Countries, the Rhineland, and England, where the 'corporeal-

64

Forked crucifix (Gabelkreuz), wood, St Maria in Capitol, Cologne, 1304.

A new crucifix of this type made by Thydemann the German was displayed in London on Good Friday, 1305, attracting crowds of the faithful to venerate it. Because of this popular fervour, and because of its terrifying form, the crucifix was secretly removed and destroyed on the authority of the bishop of London. The 'crux horribilis' was believed to encourage idolatry.

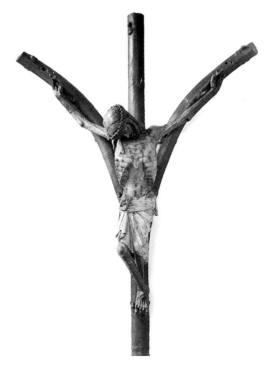

Sepulchre of Christ, stone, All Saints, Hawton, Nottinghamshire, *c*.1340.

In eastern England a small group of parish churches housed permanent monuments celebrating the Resurrection of Christ, which probably acted as proto-sacrament shrines for the permanent reservation of the consecrated host.

Within the central niche *(right)* is a representation of Christ's appearance to Mary Magdalen after the Resurrection. At the base *(below)* are four soldiers sleeping at the tomb.

ity' of Christ had initially become an important focus for devotion, new kinds of representation focusing attention on the body began to multiply [**65**]. Monuments that replicated the Tomb of Christ in Jerusalem, a tradition that harked back to the eighth century, increasingly changed their form from architectural evocations of the place of burial to frameworks for the body, which was often depicted in effigy within them. At Easter the host was ritually buried, either in a cavity on the chest of the figure of Christ or within a small niche, to be 'resurrected' on Easter morning.[15] Almost every church observed this ritual with a temporary structure. By the late fifteenth century in the Low Countries, the Rhineland, and Bavaria, giant sacrament houses up to the height of eight or nine metres, such as the giant pyramidal, pinnacled structure at Ulm, or the famous example by Adam Kraft in the church of St Lorenz at Nuremberg [**22**], attest to the near hysteria that veneration of the sacrament had reached, since many miracles and superstitions were associated with it, such as that the daily sight of it could keep evil or death at bay.[16]

Life and death

Annual confession of sins by all people, both secular and religious, was another injunction made by the Fourth Lateran Council and repeated regularly by local synodal decrees. Its purpose was always to have been an essential part of the spiritual cleansing process, although it was persistently imperfectly observed. Consequently, it was more rigorously to be associated with the imposition of numerous forms of penance appropriate to the sins that had been committed. The purpose of penance was to expiate the venial or lesser sins before death and to earn remission from purgatory. At the Council of Lyons in

1274, purgatory, belief in the existence of which had been acknowledged in essence for centuries, was offically declared a matter of faith.[17] As an interim resting place for the soul prior to the Last Judgement, purgatory was a place of purification, where penance in the form of torture could be exacted for the lesser sins that had not been fully atoned for during life (the committing of mortal or deadly sins would always condemn the sinner to eternal torture in hell). In early fourteenth-century Italy, Dante's *Divine Comedy*, and images based upon it, further shaped and formed the 'new' hell, providing a visionary topography of its many chambers, which greatly influenced the notion of the multifariousness of sin and the multiplication of horrors in specific locations. Purgatory, which took various representational forms, was for Dante a mountain with seven terraces, surmounted by Adam and Eve in the Garden of Eden, which almost touched the spheres of heaven [**66**].

66

Façade, Orvieto Cathedral, 1310–30.

The new church was built to commemorate a miracle of the holy corporal that had occurred during mass in 1260. The façade, a 'wall figured with beauty', according to the contract with Lorenzo Maitani (d. 1330), is a dramatic assembly of sculpture in stone relief and bronze, mosaics, and glass. Compelling images of the tortures of hell appear just at eye level next to the main portal. They are part of a sequence of marble carvings across the lower part of the façade, which also portrays scenes from the Old Testament and the life and genealogy of Christ.

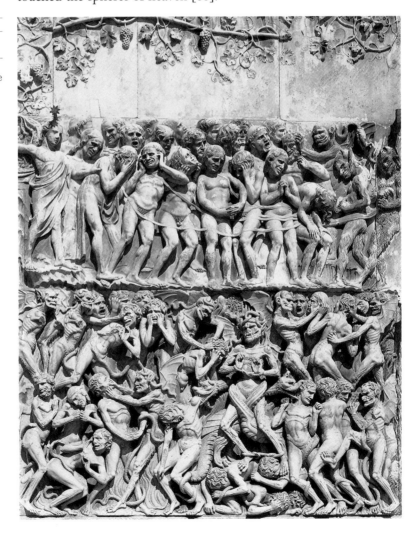

The need for the expiation of sins to be part of the permanent consciousness of every individual led to their ubiquitous portrayal as part of the fabric of a church. There were many new places to be exploited as carved decoration of church buildings increased and moved upwards and over entire structures, extending to foliate and figure-work, with much potential for their inclusion among gargoyles and corbel figures projecting from main roofs, pinnacle and turret rooflets, and gables. Such figures were decorative, but purposeful, being the repository of many different social, folkloric, unorthodox and orthodox, critical, and burlesque attitudes [132]. Artists took delight in their subversive possibilities, but clerics took advantage of opportunities to draw upon them for moral lessons on human weakness and folly.

Crusades and pilgrimages to the shrines of saints and benefactions to the fabric of the church could earn indulgences by which sinners would be entitled to a reduction in penance on earth and lessen the sentence of suffering in purgatory. On a person's death, remission from purgatorial torture could be effected by the living who undertook to pray for the well-being of his or her soul. It was through these systems that the Church ensured that an individual's preparation for death and afterlife was a permanent feature of life itself. The rich saw to it that prayers would be said on their behalf and in honour of their chosen kinsfolk and associates by setting up endowments to pay priests to say masses. With such memorials, devotion could determine design, and they were often associated with permanent alterations or additions to a church, such as a new chapel building, new altar furnishing, window glass, or a tomb [67].

The new urban rich, typified by Florentine banking families such as the Bardi and Peruzzi, who financed major enterprises from papacy and royalty to monastic farming all over Europe, founded memorial chapels in the Franciscan church of S. Croce in Florence, embellished with frescoes by Giotto. Churches in mercantile centres, such as Hull or Boston in eastern England, were entirely built anew or greatly augmented with chapels on the strength of endowments for chantries made by merchants and professional guilds and fraternities. For similar reasons, patrician and mercantile families in Germany and Austria contributed to the furnishing of altars with great wooden altarpieces in both major and parish churches in the late fourteenth and fifteenth centuries [68]. Winged altarpieces of the late fifteenth and early sixteenth centuries in Bavaria, Austria, and Silesia also played a part in the marking of their saints' feast days. According to the practice recorded in the verger's book for the parish church of St Lorenz in Nuremberg, it has been shown recently how the opening and shutting of great altarpieces was orchestrated almost as a dramatic display around the appropriate feast days throughout the

67

Central section of east
window, Gloucester Cathedral,
stained glass, c.1350–60.

A massive memorial window
filled with expensive coloured-
glass images of figures in tiers
dominates the east end of
Gloucester Cathedral.
Arranged around a panel
showing the Virgin and Christ
are Apostles, other saints, and
angels, lords temporal and
spiritual: kings and nobles,
bishops and abbots. The
window's history and donor
are both unknown, but the
lords temporal all fought with
King Edward III in the
Hundred Years War and it is
possibly a kind of glorious
collective war memorial.

68 Veit Stoss

Altar retable, painted wood, St Mary, Cracow, c.1477–9.

The driving force behind the commissioning of this altarpiece, with its dramatic rendering of the death, assumption, and coronation of the Virgin, was the large ex-patriot community of Germans in this Polish city. In the course of fundraising for subscriptions towards it, the native Poles not only refused to contribute, but mocked the Germans' presumption and were consequently 'vexed by the Blessed Virgin with many adversities'.

liturgical year.[18] A number of these were paid for by the parish or by subscribing groups of local patrician or merchant families as much out of a spirit of patriotism as from a desire to contribute to their communal salvation.

It was possible, above all, to focus concern for the posthumous welfare of the deceased around personal and family tombs. Tomb effigies, as life-size and frequently youthful recumbent figures, suggest very forcibly the continued presence of the person, whether he or she is represented in peaceful rest, as are most examples in Spain and Italy, or in wakeful activity. One of the various genres of tomb in northern Europe represented the dead in states of readiness for the Last Judgement and alert and, in some instances, already classifying themselves by representing their profession or good works. Imagery on tombs enabled the dead to reach back suggestively into life [**69**].

69 Masaccio

The Trinity with the Virgin and Two Donors, fresco, S. Maria Novella, Florence, 1425.

Masaccio's painting conflates several devotional traditions and is in effect a commemorative tomb painting as well as an evocation of the chapel over the rock of Golgotha in Jerusalem. The donors, members of the Lenzi family, are contemplating the Trinity while, below, the inscription over the cadaver is a memento mori which translates as: 'Which you are I was also, and that which I am you will become'. Above them, Mary and John flank the Cross. Mary looks towards the viewer to attract attention to her son's suffering while John exemplifies the grieving of the bereaved.

70 Vincent of Kastav

The Dance of Death, fresco, Beram, Istria, 1474.

The Dance of Death is often described as a macabre and strange fantasy, yet it is entirely consistent with the medieval acknowledgement of death and life as a continuum. The origin of the theme dates from a thirteenth-century legend of three young men who confront themselves as three cadavers one day while out hunting. It is vividly elaborated here in a typical parade of estates of society mingling with skeletons, highlighting the transitory nature of their mortal lives and vain pleasures.

In a number of ways it reinforced the continued importance of the dead to the living.

The Black Death in the middle of the fourteenth century was the worst of the many waves of pestilence that wiped out huge numbers of people all over Europe. It may have been a resultant anxiety that contributed towards an increasing resignation to the inevitability and finality of death, and to the greater emphasis in memorial art of the removal of life from the mortal body. This attitude was also reflected in cadaver tombs in England and France, which from the mid- to late fourteenth century onwards represented the flesh's decay, often as a skeleton beneath the effigy. It is also reflected in the increase after *c.*1300 of memento mori writings and imagery such as the genres deriving from the legend of the Three Living and the Three Dead, whereby three young men out hunting in a forest came across their mirror images as skeletons warning them of their mortality. According to the ghoulish rhythm of the Dance of Death, its late fifteenth-century variant, all classes of men, women, and children sway together in harmony as the dead reach back into life to snatch them [**70**].[19] As well as the anxiety occasioned by plague, there were, however, many other ideas conflated in these phenomena: in a broader context they were not unrelated to the penitential spirit in the devotions to the suffering and wounded body of Christ, mocking the vanity of the human condition and revelling in the finality of the body's decay.[20]

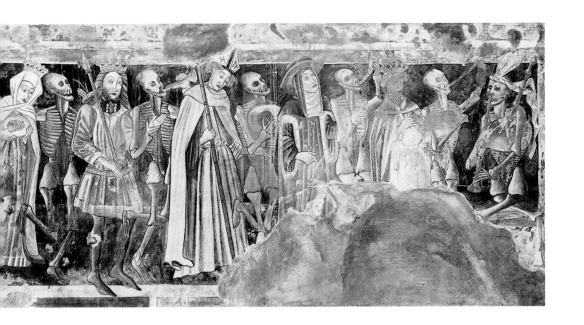

The Virgin Mary

The body of Christ was also represented in association with the tragic suffering of Mary in the form of the genre of the 'Our Lady of Pity'. The *Pietà*, first seen in Germany in the mid-fourteenth century, was one of the images that represented the 'Sorrows of the Virgin'. The Virgin was the principal holy intercessor, and devotion to her had steadily grown in the later Middle Ages and had developed many forms. There are numerous surviving life-size and polychromed images of her, especially with the Christ Child, and they appear to have been made in various centres and widely exported, for example from northern France around Paris and the Pas-de-Calais, from Bohemia—where the *Schöne Madonna* ('beautiful Madonna') originated [71]—and from the Low Countries, especially Brabant. In late fifteenth-century south German and Austrian examples, for instance in the work of Jakob Kaschauer of Vienna, the slender elegance of the earlier Virgins of France and Bohemia gives way to a vision of capable maternal serenity. Such images confirmed the Virgin's status as epitomizing a universal ideal of motherhood.[21]

Images of the Virgin provided comfort in life and death and were especially venerated by clerics, who were frequently shown in supplication to her on works of art they commissioned. In the later fifteenth century, on a leaf of a diptych, a breathtakingly mysterious and luminous painting by Geertgen tot Sint Jans (*c*.1455/65–*c*.1485/95?), which was commissioned by a cardinal, shows the Virgin ringed with light in a night sky riven with angels [72]. She is represented as another of her archetypes, the Woman of the Apocalypse 'clothed with sun, and

71

The Virgin and Child,
polychromed wood, Kruzlowa,
Bohemia, 1410.

The Virgin Mary was an
uncontested recipient of
praise for physical beauty,
goodness, and harmony. Both
poetry and images within
secular and religious
environments are witness to
her popularity and
importance. French
fourteenth-century Virgins or
the Bohemian *Schöne
Madonnas* of the fifteenth
century exemplify all those
qualities of harmony and
balance of proportion that
were described in
philosophical texts on
aesthetics. Not only were such
images ideal visions of beauty
for clerics, but they
exemplified modest
demeanour for women and
served as models for young
girls to follow.

Glorification of the Virgin, oil on wood panel, Haarlem, *c*.1480.

Some of the angels carry 'Arma Christi', the symbols of the Passion, and two carry rosaries. Angels in the outermost ring play musical instruments and the Christ child is playing a little bell back to them in a charming but poignant gesture which prefigures his own death knell. This painting has recently been identified as a pair with a panel in the National Gallery of Scotland that represents the Crucifixion adored by Sts Jerome and Dominic, the latter holding a rosary according to the tradition that originated in late fifteenth-century Haarlem that he had instituted the litany.

a moon under her feet and upon her head a crown of twelve stars'. She wears a crown of roses, indicating an association with the devotional prayers—the Ave Marias and paternosters—of the rosary.

Exemplary figures, demonstrating correct or desired behaviour, operated like personifications and were much employed by the Christian Church as educative tools. As well as being a model of diligent motherhood, the Virgin Mary was a paradigm of chastity, virginity, virtue, and humility, and for women especially she exemplified the values of obedience and piety, those values that male clerics— and husbands—were especially keen to see upheld [**73**]. Among the saints were many who performed exemplary roles, and although they were visible in images within churches, the conventional portrayals, standing with their attibutes, are much less various or affecting than

a

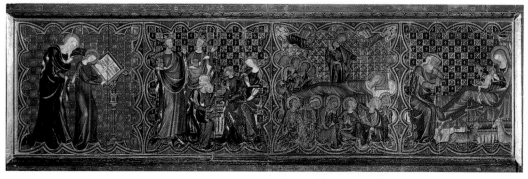

b

73

Crucifixion retable with saints, oil on oak panel, probably c.1335, and altar frontal, c.1335.

The painted altarpiece (**a**) depicts the Crucifixion flanked by the Virgin Mary and St John and, at either side, Sts Peter and Paul and Sts Catherine, Margaret, Dominic, and Peter Martyr. On the associated altar frontal (**b**) are scenes of the Nativity, Adoration of the Magi, and an image of St Anne teaching the Virgin to read (*detail*, *right*). This subject first appeared in manuscripts and altarpieces in the late thirteenth century in northern Europe. It has been associated with the Dominicans, who it has been suggested encouraged the education of noblewomen by putting forward this impeccable authority, and also promoted the notion of mothers teaching their offspring.

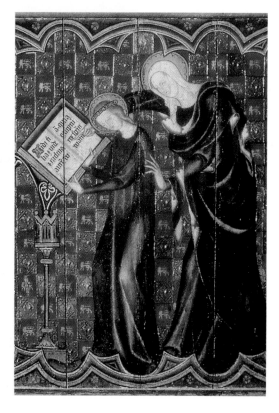

the images of the Virgin. One of the most important female saints, Mary Magdalen, appeared in medieval art most frequently in association with Christ in scenes of the Raising of Lazarus [**46**], the woman sinner who dried his feet with her hair in the house of the Pharisee, and the 'Noli me tangere', although she also had many localized genres of 'apotheosis' images.[22] Her role as the holy penitent, her modest demeanour, and the fact that she was the first to witness Christ's resurrected body [**65**] assured her status as a role model both for women and for men. Together, the Virgin and Mary Magdalen represented two polarities of Christian womanhood, perceived in sexual terms, the pure unsullied Virgin and the repentant whore.

Women and the Church

In many ways, to male clerics in any case, the representation of women's bodies in church was anathema. This did not prevent their appearing, but they were regarded as distractions and temptations from pious thoughts. Among corbels and gargoyles, in wall-paintings and stained glass, images that are critical of vanities, follies, and specifically the chattering of women are abundant [**74**]. Women were, however, also important patrons and benefactors. The Church at all levels depended on rich ladies of the manor, heiresses, and especially widows to pay for their buildings, windows, chapels, vestments, and

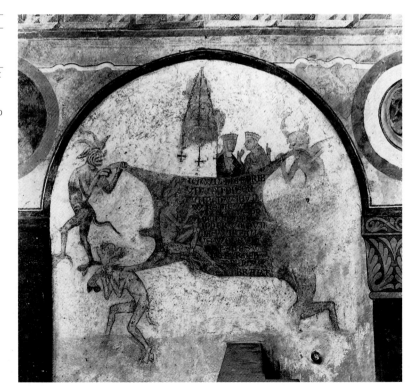

74

Tutivillus and Gossips, wall-painting, Reichenau Oberzell, Bodensee, c.1308.

Tutivillus was the devil who sat on the shoulders of women who chattered during mass and wrote down their words, to be presented to them later as evidence of their inattention and folly. Images of this scene are very common, appearing in sculpture, stained glass, and wall-painting. In this version, the verse quotes in German vernacular the devil documenting the women's transgressions by writing down everything they say.

Cloister, Jerpoint Abbey,
Ireland, *c.*1400.

This cloister has been
described as a 'rare and
spectacular rejection of
Cistercian austerity'. It is
particularly remarkable in that
it includes a large-scale
carving of a modestly dressed
woman on one of the cloister
piers beneath a corbel head of
a bishop. It may be a memorial
image of a benefactor.

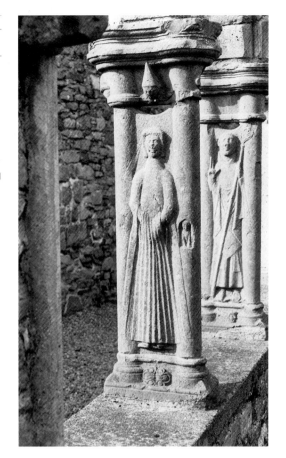

furnishings. Women's tombs and images were consequently allowed
into the holiest parts of churches, even into the churches of enclosed
orders of monks. It is most probable that the woman at Jerpoint was
a benefactor [**75**], and the image is possibly a tomb effigy but, as the
story quoted above from Meaux demonstrates, it was highly unusual
for a living woman to be allowed into such a sacrosanct area of a male
monastery, let alone have a permanent stone effigy.

Aristocratic women depended on clerics to guide them in their
devotions and in their duties to educate their children. Noble and
aristocratic women had often chosen to adopt overtly religious and
penitential roles, even taking the veil, as in the case of Blanche de
Champagne, daughter of Thibaut v, king of Navarre, who was shown
dressed in a Cistercian habit on her tomb, or Marie de Bourbon,
sister-in-law of Charles v of France, who was represented in effigy
as a Dominican prioress. An occasional convention for female tomb
effigies was for women to allude to their piety by showing themselves
reading, as in the case of the mid-fourteenth century effigy of
Maria Villalobos in Lisbon Cathedral [**76**]. Recent work concerning
medieval women has focused on their roles as teachers, readers, and

Tomb of Maria Villalobos,
stone, Lisbon Cathedral,
fourteenth century.

On tombs women are normally
shown in prayer. The tomb of
Maria Villalobos in Lisbon, like
that of Eleanor of Aquitaine
at Fontevrault, is one of very
few to represent a woman
reading. It is likely that her
studiousness represented
another desired quality
recommended by the
Church—piety and respect for
authority—and would thus
have acted as an example for
others to follow.

learners, for which exemplary images in many publicly available sources, including St Anne teaching the Virgin to read [73], throw light on what may have been widespread attitudes and practices.[23]

The altar

At the heart of religious observance and of absolutely crucial importance to the medieval Church was the sacrament of the altar, the celebration of mass centring on holy communion. Setting limitations to the practices and beliefs around the sacrament was also of central importance to the dissenting movements and eventually led to the Reformation. The grand and lavish late medieval altarpiece focused attention both on what was most dear to adherents of the high drama of sober religious devotion and what was most hated by its critics. Furnishing the need for aggrandizement of this holiest part of the church was almost an industry. Around Nottingham in the English Midlands, alabaster altarpieces were made in great numbers from the middle of the fourteenth to the end of the fifteenth century and exported all over Europe. Between c.1430 and 1470 wooden altar retables made in panels in the duchy of Brabant were sent to Germany, Spain, England, France, and Sweden. On the other hand, when it was required for a specially important site, the altarpiece could be an opportunity for the expression of individual virtuosity. The Italian sculptor Donatello's (1386–1466) response to the commission for an altar for the church dedicated to St Anthony in Padua was a blend of tradition and innovation, remarkably elegant, yet also a model of restraint [77].

The spectacle of the liturgy was enhanced by the very scale of altar furnishings and their intricate craftsmanship. Village artists of East Anglia excelled in the production of painted wooden altarpieces and rood screens to separate the altar from the nave. Through the

medium of newly available prints, they looked to artists from Nuremberg in the circle of Albrecht Dürer for models to guide them in figure styles of the saints and angels they painted on them.[24]

Priestly vestments too could echo the decorative lavishness of the altars they served, enhancing the general impression of the preciousness of the mass [**78**]. Splendid vestments were reserved for great feast days in the larger churches. Side panels of Rogier van der Weyden's (c.1399–1464) painting of the Seven Sacraments show the priest in more everyday attire [**79**]. It was the priest's task not only to perform the sacraments but to instruct the laity in the Ten Commandments and the paternoster, or Lord's Prayer. Many new prayers and religious feasts arose in the later Middle Ages. Part of the impetus for these was a wave of orthodoxy in the wake of the Wycliffite and Hus-

The priest

The priest was entitled by his ordination to celebrate the Eucharist, the central act of divine worship. He was invested with the power to administer sacraments: to celebrate holy communion, hear confession and forgive sins, perform the rites of baptism, marriage, confirmation, and last rites or extreme unction. In the later Middle Ages these were formalized as the Seven Sacraments. There was a hierarchy of the priesthood in the Middle Ages. The bishop was at the summit, in charge of administering a diocese and entitled to perform the highest sacrament of ordination. Below the bishop came the archdeacon, then the deacon, each of whom played a part in diocesan administration, and then the ordinary priest. After ordination a priest was entitled to receive a benefice in a parish, which would pay him enough to live on. There he had the responsibility of care of souls in the community. A senior parish priest was a rector and was entitled to a more valuable benefice.

site heresies of the late fourteenth and early fifteenth centuries, which had questioned the doctrine of transubstantiation. Some, like the feast of the Crown of Thorns, or the Five Wounds of Christ, reflected earlier monastic or friars' affective devotional practices now made accessible to the laity.[25] In 1479 Pope Sixtus IV granted indulgences to all who said the prayers of the rosary beads, a devotion that became ubiquitous and that had been initiated the year before by Dominican friars in Haarlem [**72**].[26]

Stir up my heart to seek you and rouse me from sleep and sloth. Visit me with Your salvation that my spirit may taste Your sweetness, which in this Sacrament lies richly concealed, as in a fountain. Give me light to reverence this great Mystery: give me strength, to believe with unshakeable faith . . . No one of himself is capable of grasping and understanding these things, which are beyond even the high knowledge of the Angels. How then shall I, an unworthy sinner, mere dust and ashes, search out and understand so deep and sacred a mystery?[27]

These words from the *Imitation of Christ* by the very influential German mystic Thomas à Kempis were written in 1441 under the heading 'On the many blessings granted to the Devout Communicant'. They allow a glimpse not only of the blessings, but of the humility and weakness of the communicant in the admission that there may be doubts to be assuaged: 'give me strength, to believe with unshakeable faith'. An Augustinian canon and member of the Brotherhood of the Common Life, an order dedicated to a return to simplicity in religious devotion, Thomas à Kempis showed the way to prayer and meditation through empathy with the worshipper. This approach was entirely different from the earlier mystical

writings of the mendicants. Thomas's valuing of the inner life, and his guidance for the internalizing of the experience of religious devotion through the contemplation of the qualities and strengths that prayer could bring, gave real meaning and purpose to the worshipper's responses. The inscription on the title-page read 'The act of beholding stimulates thought', and indeed Thomas's approach opened up new possible modes for the contemplation of imagery, holding out the possibility that the authority for interpretation was within the viewer.

79 Rogier van der Weyden

Altarpiece of the Seven Sacraments, oil on wood panel, c.1441.

This Flemish altarpiece depicts the observance of the sacraments around a Crucifixion at the centre, behind which the priest elevates the host in performing the sacrament of the altar. Each sacrament is accompanied by an angel wearing a different colour: white for baptism, yellow for confirmation, and red for confession in the left panel; green for the Eucharist in the centre; and purple for ordination, blue for matrimony, and black for extreme unction in the right panel. The altarpiece was commissioned in 1441 by Jan Chevrot, bishop of Tournai, for the altar of his private chapel.

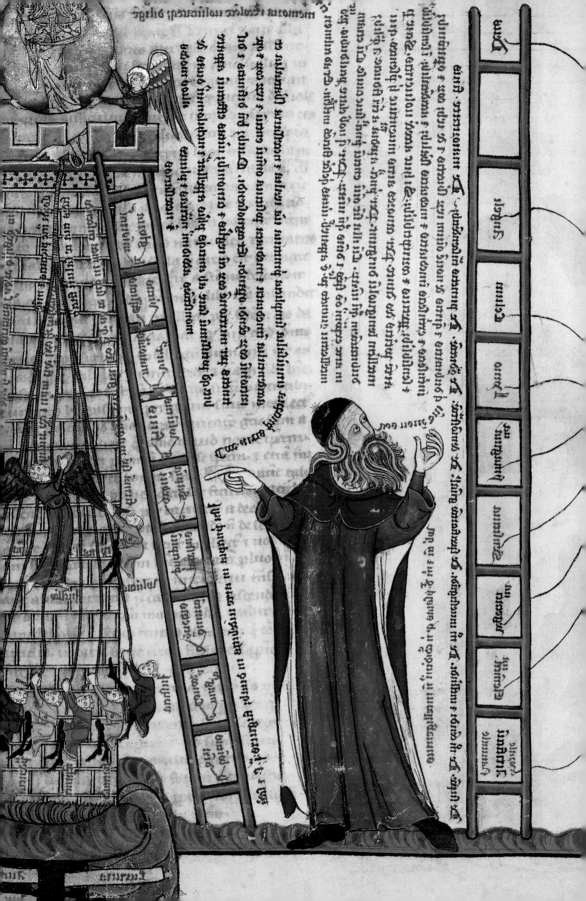

Image and Learning

5

The visual arts played a distinctive part in the intellectual history of the Middle Ages, not only as a means of demonstrating the shaping of ideas, but also in highlighting the connections between different branches of learning. Although the world of learning was focused around the written word and oral discourse, there was a number of genres of imagery that had the capacity to draw from these and allude to wider ideas with great subtlety and precision. Visual exegesis, or the exposition and clarification of ideas in visual form, was exploited through the diagram, especially during the twelfth century, as a means of conveying the relationships between the worlds of religion, logic, metaphysics, medicine, and astronomy.

As well as newly developed forms for displaying or exemplifying learning, there is much in this chapter that derives from earlier sources. The wisdom of the ancients, far from being rejected for being un-Christian, was recognized in the Middle Ages in some quarters and respected as being at the foundations of contemporary scholarship. Bernard of Chartres, a twelfth-century academic, was reported as having remarked upon the medieval debt to classical knowledge: 'as dwarves sitting on the shoulders of giants; they were able to see further not through their own stature but through the elevation to which the ancients had brought them'.[1] Allegory and symbolism, which had a venerable history reaching back to the classics and the Bible, were considerably deployed and extended in the Middle Ages as a means of representing complex ideas.

Images could convey ideas ready formed or they could act as a stimulus to thought. The capacity for the visual arts either to communicate directly or to explore oblique meanings and suggestive interpretations was realized in the medieval period more acutely than at any time previously in the history of western art. In order for the viewer to respond appropriately and to learn that visual messages might not be those that appeared most obvious, it was just as necessary then, as it is now, to be sensitive to scale and context. Equally, it helped if the artist had a clear idea of the level at which he or she was communicating, to whom and for what purpose. Through visual means a person or culture could display an interest in learning, and

there were a number of available strategies for ostentatious demonstration ranging beyond well-stocked library shelves through public schemes of decoration and adornment, tapestries, and the development of professional dress.

The cosmic body

'Illiterate men can contemplate in the lines of a picture what they cannot learn by means of the written word'.[2] This idea is based on a much reworked formulation of St Gregory to justify the usefulness of pictures in churches to represent stories for those who could not read them. From the frequency with which variations on these words were uttered by various clerics, the implication is that church art was justifiable as populist education, that pictures were aids in teaching, particularly in the case of the illiterate.

Painted on one of the vaults of the crypt of Anagni Cathedral, Italy, is just such an example of an image, dating from the late twelfth or early thirteenth century, of a translation into visual imagery of ideas derived from a deeply learned tradition [**80**]. Within a scheme of concentric circles is painted a figure of man as microcosm, as the centre of the universe and derived from its matter. Surrounding him is a diagram representing the quadripartite division of the cosmos in the form of the four elements, earth, air, fire, and water, and their associated properties and humours relating to the universe and all created things. The nature–man, macrocosm–microcosm image portrays the organization of universe with man at its centre, according to the rules of the natural sciences.

Scientific enquiry

Many significant developments in scientific enquiry, including astronomy, medicine, and geography, were concentrated outside the realms of the Christian Church or its institutions. There was, accordingly, a parallel tradition for the charting and visualization of the universe which derived from an alternative intellectual history and which continued to develop throughout the Middle Ages. Ancient Greek cosmological and medical writings by Hippocrates and Galen, and Euclid and Aristotle, were known in the West through the medical schools of southern Italy. Seminal works in astronomical and astrological history were written by Ptolemy in the second century BC—the *Almagest*, *Tetrabiblos*, and *Planisphaerum*. Such works were also extensively studied via Jewish and Islamic scholarship in Muslim Spain. Toledo was a centre from which they were disseminated principally through translations and commentaries made by Latin scholars such as Adelard of Bath and Gerard of Cremona, Michael Scot, and Herman the German who visited during the eleventh, twelfth, and thirteenth centuries and learned Arabic. Classical scholarship and traditions for picturing the cosmos also survived through Carolingian scholarship.

Man as microcosm, wall-painting, Anagni Cathedral (Lazio), crypt, c.1230.

The motif of 'man as microcosm' at the centre is a complex visual schema representing a body of learning derived from ancient Greek metaphysics. Galen and Hippocrates as its originators are duly represented with their texts below. Depicted in the same scheme are the Virgin and Child, the four evangelists and four angels bearing the crucifix, and scenes from the life of St Magnus. Nearby in the other vaults of the crypt are a Last Judgement programme and the Old Testament story of the Ark of the Covenant.

The Anagni 'cosmos' emerges from the same conceptual process as the series of *mappae mundi*, which similarly attempt to present a reconciliation of pagan and Christian thinking about the world and which were in some cases displayed as public art [2]. The fact that it is integrated, in this case within a scheme of religious subjects that includes the Last Judgement as a vision of the final days, gives it some status as an acceptable way in which the harmony of man's relationship with nature could be understood. Anagni was a centre of learning in the Middle Ages, and it is interesting that the cosmological imaging within this particular church ranges outside the Christian tradition.

The image of man as microcosm was usually more comfortably, and privately, located within the intellectual context of manuscripts. Among the images deriving from the revelations of the Rhenish nun Hildegard of Bingen (d. 1179), in a German manuscript of the second

81

Divine creation, the universe, and cosmic man, from Hildegard of Bingen, *Book of Divine Works*, tempera on parchment, *c.*1230.

In the corner Hildegard is shown at her desk writing her tablets, gazing up in wonder at her vision of 'cosmic man' encircled first by clouds, then water, then the flames of God, which are protective of those within and vengeful against enemies. Within the concentric zones are many symbols, of the burning love of Christ, the words of the Scriptures, and the evil works of the Devil.

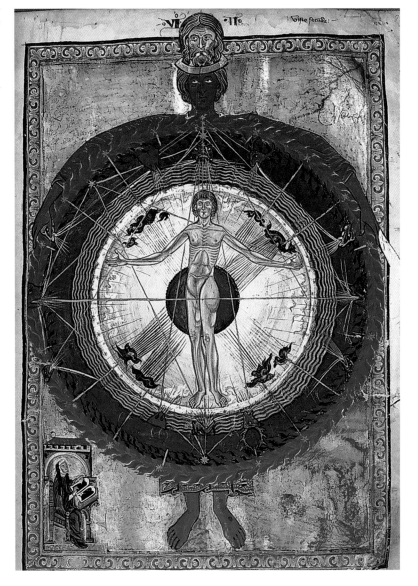

quarter of the thirteenth century, is a cosmic man, the product of an ecstatic vision, which reflects an intense individual response to art. Hildegard's visions were related in vivid, powerful terms, full of descriptive detail. An acute observer of natural phenomena, she wrote knowledgeably and passionately about medical and natural history. But there is also an interdependence in her visions between what she saw in her mind and the ways in which the cosmic phenomena she described had been portrayed in visual art. There is an extent to which her descriptions must have been derived from meditations upon visual images as well as what she saw in the world around her. The fact that she claimed no learning—'But what I do not see I do

not know, for I am not learned'[3]—suggests that her understanding of the structure of the world was experiential. It is also an interesting indication of the distinction between knowledge and learning: knowledge could be derived from vision. The Lucca manuscript of her *Book of Divine Works*, which was made after her death, retranslates her visions into a representation of 'cosmic man' that has recognizable authority within a culture of visual exegesis [**81**].

Making an entrance in another world entirely, an image of a 'zodiac man' appears in the *Très riches heures* of Jean, duc de Berry [**82**]. For the sake of its courtly audience this beautiful man is transformed into a veritable mannequin, reflecting his mirror image back to back. In each corner, the qualities of particular conjunctions of signs are identified with associated moods. Thus were identified the

82 Herman, Paul, and Jean de Limbourg

Zodiac man, from the *Trés riches heures* of Jean, duc de Berry, tempera on parchment, Flemish, 1413–16.

This extremely well-known manuscript is a prized jewel of a book, and zodiac man appears as part of a marked cosmological interest that is reflected also in the borders of the calendar pictures. Two beautiful naked figures shown front and back view are suspended in a blue sky studded with golden clouds. As well as having medical significance, the coincidence of time and beauty makes it very likely that this is a Vanitas image reflecting on the brevity and fragility of youth.

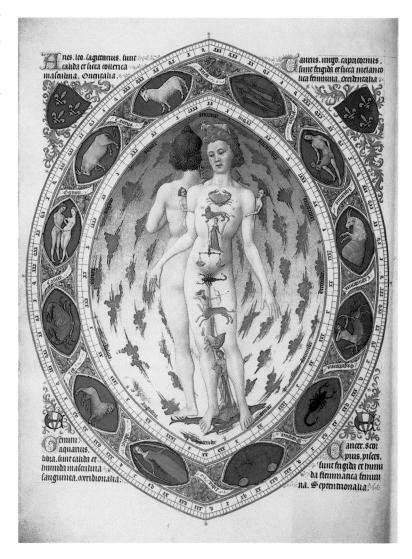

Wolf-Lupus, from Al Sufi, *Book of Fixed Stars*, tempera on parchment, Italian, *c.*1350.

This text was written by a leading tenth-century Arab astronomer whose definitions of over 1,000 star positions were founded on Greek scholarship, notably Ptolemy's *Almagest*. It is a good example of an object that represents transnational and cross-cultural interests, as this copy was illuminated in the Venice–Padua region, its illustrations drawing from Arab and classical sources. It was an especially prized addition to the library of the emperor Charles IV, a member of the French Valois family, resident in Prague as king of Bohemia.

planetary influences that would govern the state of his health. When the moon entered the sign, then medical treatment on that part of the body associated with it had to be avoided.[4] It dates from a time when astrology was a mainstream courtly interest (see below), and it is not unusual to find such learned and specialized illustration in a private devotional book. In the early fourteenth century an English baron, Robert de Lisle, had included a whole sequence of theological and moral diagrams in his psalter given in 1339 to two daughters who were nuns at Chicksands Priory.[5]

During the thirteenth and fourteenth centuries, research of inestimable importance by Jewish and Arab scientists working in Spain, southern Italy, and the Near East was filtering through to the West, producing practical outcomes such as precision instruments for surveying and measuring the universe [**83**].[6] The astrolabe for calculating positions of stars, the celestial globe for recording the plotting of the skies, and the armillary sphere for representing a stereographical projection of the heavens had placed Arab scholars at the forefront of the charting of the universe. Major interest in cosmological researches and the related (as it was then) discipline of astrology was shown in the fourteenth century by the Valois kings. Charles V of France (1364–80) had over 200 astronomical texts in his library. Christine de Pisan's father, Tommaso Pizzano (d. *c.*1385/90), a Bolognese Italian, was Charles's favourite court astrologer, whose predictions he is said to have believed implicitly, and he was one

The Astronomer Terzysko, astronomical book of Wenzel IV, king of Bohemia, tempera on parchment, *c.*1400.

This manuscript was owned by King Wenzel IV of Bohemia, who shared his father Charles IV's interest in astronomy. It shows the royal astronomer Terzysko using his quadrant to plot the annotated diagram of the heavens that surrounds him, ringed by signs of the zodiac.

Astrology and knowledge

The theory of matter, which formed the foundation of medieval medical knowledge, was based upon the interlinking of the quaternities, which governed the whole universe and which when taken to its logical conclusion meant that man's body was governed by the forces of the cosmos. Each of the four elements, air, water, fire, and earth, had tactile properties associated with the humours, the qualities of which determined behaviour. They also affected the four seasons, the grouping of the signs of the zodiac, and the four cardinal points. All the major forces were interdependent and met within man where the planetary influences were mapped with some precision by Arab astrologers, in particular in a treatise by Abu Ma'Shar, which became available in the West from the twelfth century. Images of 'zodiac man' appeared around the late fourteenth century in astrological and medical treatises locating the planetary positions appropriately along the body.

of the astrologers under whose influence he founded a college of astrology and medicine at the University of Paris in 1371.[7] Both the emperor Charles IV and king of Bohemia (1346–78) and his son Wenzeslaus IV (1378–1419) had collections of texts of Jewish–Arab scholarship [84]. It has been asserted that by the end of the fourteenth century and early fifteenth century, the courts of Europe, including those of bishops, were 'thickly strewn' with astrologers.[8]

Number symbolism and the diagram

Behold sky and earth and sea, and all in them that shines above, or creeps below, or flies or swims; all these things have forms, because they have numerical dimensions. Remove these, and the things will be nothing. From whom do they derive but from him who created number? And number is a condition of their existence. And human artists, who make material objects of all forms, use numbers in their works. So if you seek the strength which moves the hands of the artist, it will be number. (St Augustine, *On Free Will*, Book II, para. 42.)[9]

Plato's *Timaeus* described the visible world as an imperfect mirror of a real but invisible ideal world. St Augustine was the most important thinker to begin to reformulate the Platonic concept of a visible world, and to place it within a Christian framework. Medieval Neoplatonic philosophy provided a concept of measurable order for the universe. It was also recognized that the constituents of matter, such as the elements, could be comprehended in modules, as geometric and linear components, and that harmony, proportion, and measurement were fundamental for the appreciation of beauty in art.

Authority for a structure of number symbolism was provided above all by the Bible. Thus, in addition to the fourfold division of matter governed by the cardinal points and the winds, came the threefold division of the Trinity, the four rivers of Paradise, four evangelists, seven days for the creation of the world, twelve apostles, and so forth.

The effect of classical and biblical geometric and number symbolism on the visual repertoire of medieval religious art, especially in the way images were structured and measured, was enormous and well reflected in the eleventh and twelfth centuries in the ecclesiastical arts in the regions along the Rhine and Meuse rivers. Consciousness of the symbolism of number was very deep-seated and often theorized, for example in the influential writings of Honorius Augustodunensis (active 1106–35) and Rupert, abbot of Deutz (1120–30). The Benedictine monastic centres where number symbolism was thoroughly absorbed into the visual arts were also well placed geographically to operate as spheres of influence. Regensburg, and nearby Prüfening, were situated on a route to eastern Europe. Cologne, Liège, and nearby Stavelot were pivotal centres for the north.[10] An early eleventh-century gospel book made at St Emmeram, Regensburg, for the abbess of Niedermünster, is illustrated with a series of allegorized images bringing together the fruits of learning derived from various known Greek and Latin sources [85]. The scholar responsible for devising the complex iconography of the Uta Codex has been identified as a monk, Hartwic, and his career pattern, going abroad to

Classical ideas of beauty still dominated medieval aesthetic theory, and derived ultimately from the ideas of Pythagoras, mediated by a treatise written in the fifth century BC by the Greek sculptor Polykleitos. Visible beauty was characterized by balance and symmetry, measure, and the interrelationship of parts. Defined in relation to the body, the proportional relationship of each part to the next should be balanced, one finger relating to the next, the whole hand to the arm, the arm measured in relation to the torso, and so forth. Medieval thinkers added notions of harmony between form and context. Harmony and concord as essential positive qualities were extended to the wider context in which beauty was appreciated. Thus a beautiful thing might be rendered ugly when combined with other things in an inappropriate context. For some religious men and women, especially early in the period, there were necessary distinctions to be made between the beauties of nature and of artifice; moreover, the definition of visible beauty as relating principally to the body was problematic.

85

The Creation and Virtues, from the Uta Codex, tempera on parchment, St Emmeram, Regensburg, c.1002.

A schematic image showing an interplay between the force of God, whose hand is creating the world at the centre, and the four virgins who surround it and carry the gifts of the spirit to the world. At the corners are the four cardinal virtues.

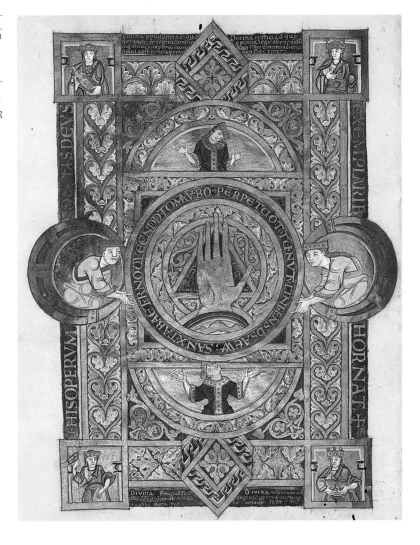

France for his higher education to study with Bishop Fulbert of Chartres, typifies the internationalism of scholarly and cultural life at this period.[11]

Schematic representation became a necessary part of the organization of knowledge of the universe, reflecting an understanding of its structure and relationships to humankind, informed by development of science, astronomy, astrology, medicine, and music. The diagram, or schematic drawing, was designed to express the harmony and balance and interlocking of ideas. In simplifying complexity and harmonizing opposites, it was taken to a new level of sophistication and beauty from the eleventh century onwards. Influential in developing new ways of presenting scientific knowledge diagrammatically

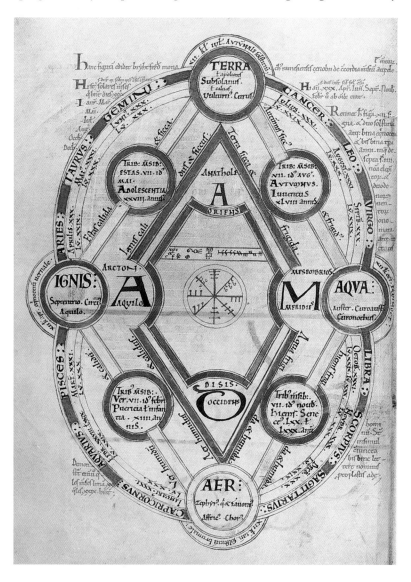

was a great scholar, Abbo of Fleury (*c.*945–1004), who spent two years at Ramsey Abbey from 985 teaching metrics and developing ideas towards his *Computus,* which were tables for calculating movable feasts of the Christian year. One of his pupils, the monk Byrhtferth (*c.*970–1020), wrote a manual that adopted many of his ideas and reproduced cosmological diagrams of particular clarity of design [**86**].[12]

Diagrammatic exposition was also of wider significance in the shaping of concepts of the ordered universe. Stained-glass windows carried the diagram very satisfactorily into the public sphere in an architectural context. Their ordered and symmetrical designs in themselves conveyed an idea of harmony, even if the imagery within them was obscure or required sharp eyes and subtle intellect to interpret [**87**].

In the context of teaching and scholarship the diagram also acted as a stimulus to thought and an aid to memory. Its suggestive capacity, the fact that it could schematize information as a means of condensing wider concepts, meant that it could be both a didactic and reflective tool. It was developed as an academic and pedagogic device in Paris in the context of the schools at the abbey of Saint-Victor in the twelfth century under the aegis of Hugh of St Victor and Peter of Poitiers. Information was organized in ladder or tree forms or geo-

Genealogy of the Children of Shem, ink on parchment, French, fourteenth century.

This illustration is from Peter of Poitier's *Compendium veteris testamenti*, used in this manuscript as a preface to a Bible. It is a compilation of secular and profane history presented diagrammatically. Here the artist places the genealogy within the framework of a complex piece of metalwork hung with suspended circular discs, enabling the family line to be shown in descent.

metric patterns. Peter of Poitiers presented the genealogy of Christ in the format of a sequence of linked circles, enabling the student to digest the information in his memory 'as in a treasure bag' [**88**].[13]

Memory

Specific kinds of images in books were designed to mark the text, to make it easy for the reader to find his or her way around, to signal important passages, and to be visual aids to remembering.[14] These might have been some of the guiding principles behind certain conventions, such as historiated initials—illustrations marking the beginnings of significant passages of texts in some manuscripts. In the psalter, a decorated initial often prefaced each group of psalms, forming a book mark for the passage to which it was attached. Cultivation of memory skills was a crucial part of learning, and there was an intermittent tradition of mnemonic skills derived ultimately from Cicero and devised originally for orators. These used visual forms, such as buildings with columns and figured capitals, around which the speaker took a mental journey in order to trigger the sequence of argument.[15] Imagination could create visual images more vivid than reality, and in a tour de force of descriptive skill, Hugh of St Victor's treatise on Noah's Ark proposed an archaeologically

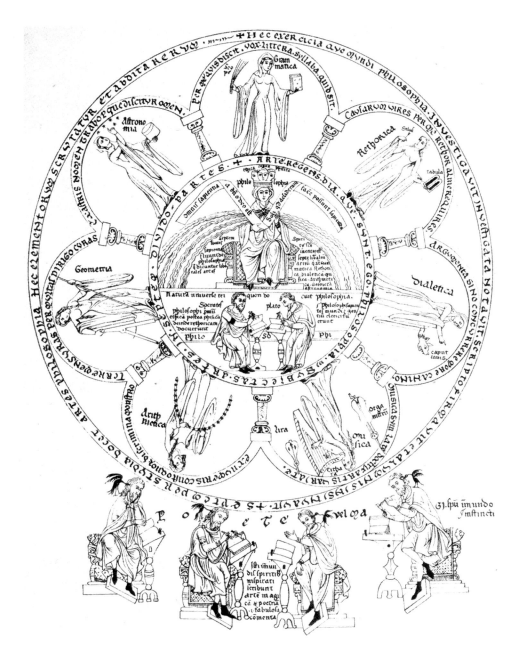

92

The Liberal Arts, *Hortus deliciarum*, *c.*1200, engraved copy, nineteenth century.

At the centre is seated Dame Philosophy wearing a triple-crown headdress (literally) of Ethics, Logic, and Physics; below her are Plato and Socrates in disputation.

Surrounding them are the seven figures of the Artes and below are four poets or 'magi' with black birds at their ears representing the doubtful sources of their inspiration.

91

Figures of Artes and writers, stone, Chartres Cathedral, south façade, c.1150.

At Chartres, in a demonstration of their inspirational role, the Artes, busy with their designated activities, are paired with industrious writers. Shown here are Music, playing the bells, and Grammar, who is instructing boys over their schoolbooks.

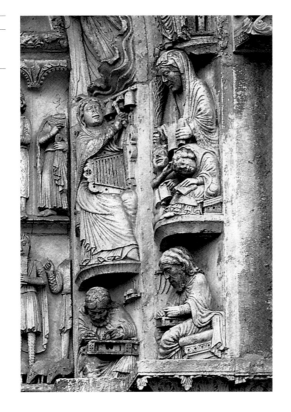

attributes of their subjects. In the Latin language, the Artes all took the feminine gender, and while in literature they are exclusively represented as female figures, in the visual arts independent traditions allowed their gender to be varied depending on their purpose and context [**91**].[20] The Artes, consisting of Geometry, Grammar, Arithmetic, Astronomy, Music, Logic, and Rhetoric (oratory), formed the core of the scholarly curriculum and it is probably not a coincidence that it was at about the time of the foundation of universities that representations began to multiply. Some of the earliest examples are to be found among the minor sculptures on the west façade of Chartres Cathedral, home of one of the foremost proto-university schools.

Allegorical encyclopaedias

The 'speculum' or mirror was a standard title image for a moralizing encyclopaedic work of learning. Another image for a work of compilation was the garden. Herrad of Landsberg (1167–95), abbess of the convent of Hohenburg in Alsace, and her predecessor Rilindis (d. 1167) created a work of reference about the world, salvation, philosophy, and learning—literally a 'garden of delights', the *Hortus deliciarum* [**92**]. For the benefit of the nuns at the convent at Mont-Saint-Odile, Herrad wrote that she had combed the world for its

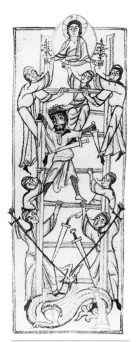

90

The Ladder of Virtue, from the *Speculum virginum* of Conrad of Hirsau, ink on parchment, *c*.1125–50.

The femaleness of virtue was sometimes exploited, as in this manual of moral instruction for nuns. Here the image of the ladder makes especially vivid the notion of ascent towards models of courage and heroism to which religious women might aspire.

Allegory and personification

Allegory and personification performed different teaching and learning roles in different circumstances. Their use in visual imagery could be suggestive rather then explicit, alluding to, rather than descriptive of, a body of ideas or beliefs. The *Psychomachia*, or 'Battle for Man's Soul', Prudentius's epic poem, written in the fifth century, gave rise to a body of allegorical illustration that very rapidly developed its own rationale. Female figures personifying good qualities such as Faith, Concord, Peace, Work, Sobriety, and Reason were engaged in mortal combat against their foes, Discord, Idleness, Pride, Luxury, Libido, and Avarice, in order to draw attention to the struggle between good and evil. The original story had the figures engaging in struggles of varying intensity, with the occasional mounting of tension as evil rallied, appearing to win. As visual figures they could be extracted from the narrative and rationalized into pairs in opposition, in order to highlight the victory of specific virtues over their opposite foes. By the twelfth century, the theme of Virtues Triumphant had emerged as the most common type and appeared in manuscripts, on church façades, as decoration on enamel and ivory reliquary caskets, and bishops' croziers.[18] Virtues were singled out as pivotal—the four 'cardinal virtues' of Prudence, Justice, Temperance, and Fortitude, or, as appropriate for religious life, the three theological virtues of Humility, Faith, and Charity, and in these groups they were incorporated into moralizing illustrations in manuscripts, treating the themes of the necessary virtues of temporal or spiritual rulership [**90**].

Perhaps in a society where opportunities for mass communication were limited, the lessons that underpinned civilized interaction needed regular and exemplary reinforcement. The *Psychomachia* was used not only in learned manuscript contexts, but episodically as part of public monuments, for example at the cathedral of Strasbourg (*c*.1300), 'where the trampled vices look like burghers' wives' to demonstrate that the battle against evil was not only an eternal one, but one that needed urgent local attention.[19] In the twelfth century clerical misogyny added the Wise and Foolish Virgins (Matthew 25: 1–13) to the repertoire of moral personifications, exemplifying both the virtue of prudence and the follies of its neglect. The fact that the specific quality of virtue was a desirable attainment for women, advertised as such in both religious and secular manuals of instruction, meant that the personified virtues and vices never quite lost their gender identity.

It was surprisingly late in the Middle Ages, not until towards the mid-twelfth century, that the disciplines that were considered to be at the root of all learning, the Seven Liberal Arts, started to make fitful appearances in the visual arts as personifications holding the

accurate reconstruction of its original form, described in great detail, some think, as a memory device, some as an elaborate fiction.[16]

Mnemonic systems could be turned around as a means of representing complicated ideas and aligning them within an ordered context. The Catalan philosopher Ramon Lull (*c.*1233–*c.*1315) had a visionary experience around the year 1272, whereby he suddenly perceived how he might develop an art that could represent systematically how the attributes of God infused the whole of creation [**89**].[17] Motivated by an overriding desire to convert the Muslims and Jews to Christianity, he believed he could do so by working with cosmological ideas common to all religions and proving that there was no distinction between faith and reason, that all mysteries had a rational basis. Lull's vision became manifest as a theoretical memory device, or series of metaphors and diagrams that ingeniously combined a complex organization of data with a means of shifting and recombining it in moving concepts, enabling him (as he thought) to argue irrefutably the rational case for the Christian faith.

89

Ramon Lull with the ladders of his art, ink and tempera on parchment, early fourteenth century.

In the *Ars magna* Ramon Lull created imaginary mechanical contraptions through which a multi-layered interpretation of nature and the divine issue of creation could be achieved as part of a movable system of levers, cranking handles, and revolving wheels. The image shows him orchestrating one part of it, whereby theological propositions are arranged on ladders in ascending order to God and descending order to the roots of evil.

This illustration is from the autograph copy of the *Liber floridus* by Lambert of Saint-Omer and prefaces a section of the book about the genealogy of the Norman counts. It shows the palm tree—a plant of paradise, rich in moral and symbolic associations—representing *Scientia* (Knowledge). The *Liber floridus* is an encyclopaedia of cosmology, history, and the physical universe set within a framework allegorizing the imagery of nature and plants in relation to the passage of time. It was both highly individual and much copied and may be numbered among the most important of the medieval encyclopaedias. For the computistical tables, schematic drawings, and cosmological material, Lambert drew upon earlier encyclopaedic works by Isidore of Seville and the Venerable Bede, and it is thought that Hrabanus Maurus's *De natura rerum* (ninth century) informed his natural history. He consulted such authorities in the monastic library at Saint-Bertin, where his notes have been found in some volumes. Illustrations include a self-portrait and several views of Saint-Omer. Among the historical material, the Flemish crusading hero Godfrey of Bouillon features prominently. It has been suggested that Lambert's overriding purpose was to place within a cosmic context the role of Flanders and Saint-Omer in the history of the Crusades.

93

Palm of Virtue, from Lambert of Saint-Omer, *Liber Floridus*, manuscript, coloured drawing, *c.*1120

The Liber Floridus of Lambert of Saint-Omer is an encyclopedia of history and science. Its purpose is more cosmic and scientific than that of the *Hortus deliciarum* and it allegorizes the imagery of nature and plants in relation to the passage of time.

The Lion, from the Ashmole
Bestiary, tempera on
parchment, English,
c.1200–10.

The lion is usually the first of
the animals to be discussed in
a bestiary and is seen as the
one closest to Christ, who was
identified with the 'Lion of
Judah' (Gen. 49:9). This
illustration shows three of the
lion's characteristics: the first
is that its young are born dead,
and on the third day the father
lion breathes life into the cubs;
the second shows the lion's
compassion in sparing the
prostrate; and the third shows
how the lion is afraid of
cockerels.

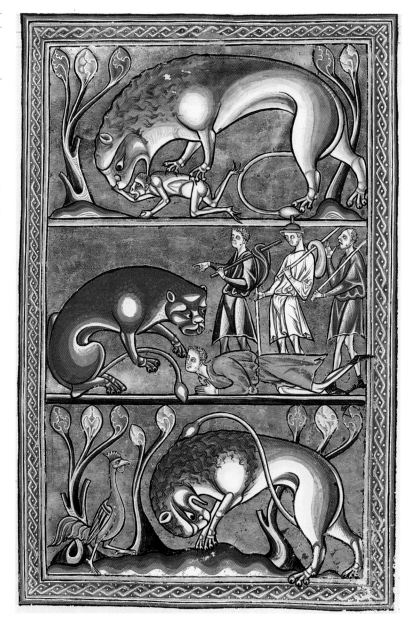

wisdom under God's guidance 'like a little bee gathering pollen from
the flowers of the scriptures and the philosophers'. Many symbolic
and allegorical images such as the Wheel of Fortune, the Artes, and
the Virtues are there, alongside typological comparisons between the
Old and New Testaments and Apocalyptic visions, and each image is
accompanied by careful explanatory inscriptions and scholarly text.[21]
The original manuscript was destroyed in a Prussian bombing raid on
Strasbourg in 1870, and it survives only in nineteenth-century copies
of a few pages. There has never been any doubt that the inception of

this book, its content, and its learning belong to the patrons, Herrad and Rilindis, and their colleagues, but the manuscript, originally comprising some 636 pictures on 325 folios, was commissioned from a team of professional artists.

Ever since the days of *Aesop's Fables*, allegories involving animals had been well known, and episodes from Aesop were occasionally to be found among illustrations in manuscript marginalia. The bestiary had its origins in the *Physiologus*, a text of Greek origin which was reproduced in the Middle Ages as a Christian moral tract. Most of the surviving manuscripts are of English origin and thirteenth century in date [**94**].[22] The moralizing core of the book was augmented from diverse encyclopaedic sources including Isidore of Seville's *Etymologiae*, Solinus's *Collectanea rerum memorabilium,* and Pliny's *Natural History*. As a result, it remained a hybrid. The organization of the text according to Christian ethical themes, the reliance on legend, and the anatomical oddities of the animal images indicate that overall the work should be interpreted as an allegorical treatise on virtue and vice. However, the encyclopaedic material has also caused it to be seen as a proto-scientific work of natural history.[23]

Schooling and professional scholarship

There was no universal education in the Middle Ages. Outside the Church, no organization existed to ensure that education was provided, let alone enforced, and the contexts within which learning took place are still very much a matter for conjecture. Teaching and learning for children, whether destined for religious or secular lives, took place in the context of monasteries, convents, cathedrals, and, especially in the later Middle Ages, in the towns. Aristocratic and bourgeois children could be taught at home, or could be sent away to be taught in other households where, presumably, tutors, books, and other resources were available.

The French king Louis VIII and his wife, Blanche of Castile, gave their son, the future St Louis, a moralized Bible containing illustrations comparing events from the Old and New Testaments. These kinds of book were almost exclusively made up of illustrations—one set of volumes now divided between Oxford, Paris, and London contains over 13,000 pictures rich in gold and expensive blues—and as such were almost certainly school books for wealthy households. Louis IX was said to have been educated and taught to read by his mother.[23] Another of the books they used survives, a psalter made at the end of the twelfth century in England for Geoffrey Plantagenet, archbishop of York. It must have been carefully handed down, or purposefully acquired, and as such it is testimony to the multiple purposes that precious illustrated manuscripts

had to serve even in these elevated circles. Designed as a devotional book for a high ecclesiastic, its clear script and many illustrations served well for teaching religious observance and, no doubt, reading to a boy king a generation later.

Certain branches of professional teaching were facilitated by the visual arts. Illustration was an essential component of medical textbooks, for example, making aspects of medical theory explicit through diagrams, by demonstrating the internal workings of the body [**95**]. The growth in numbers of textbooks also provided a ready market for visual embellishment for those who could afford it, and the Paris book trade was ready to supply this—there are accounts of

95

Anatomical illustration, English, *c.*1292.

This image, showing the veins, derives from a medical treatise and is one of a series showing the body's main circulatory and digestive systems. Technical information is the priority, but the illustration is also decorative, showing perhaps that medical practitioners, like lawyers, could afford fine books.

students squandering their money on illuminated manuscripts.[24]

From the mid-twelfth century Gratian's *Decretals* became the standard work on canon law, and Bologna became the centre for the production of manuscripts of the text, some of which were richly illustrated as presentation copies or made for wealthy patrons. Legal subjects required a whole new corpus of models for illustration. Legal disputations, papal councils, and learned assemblies codifying points of law were closely related to the pictorial and authoritative model of Christ disputing with the doctors in the Temple, which itself was reformed as an image to demonstrate lively and vigorous debate in academic chambers [**96**].

Around the universities of Paris and Oxford there was also a culture of disputation inherited from the pre-university pedagogic methods of the eleventh century. It had arisen from the ancient discipline of dialectics, whereby authorities were set against one another, compared, contrasted, and proved or disproved. Peter Abelard's (1079–1142) 'Sic et Non' (Yes and No), posing the argument in the form of 150 theological questions and their answers, exemplified the medieval version of this practice, and Peter Lombard's (d. 1160) four books of *Disputations* became a standard academic text. During the second half of the twelfth century, Aristotle's writings on logic, natural science, and metaphysics spawned new disputational

The medieval curriculum

The basic medieval curriculum was well established for clerics from the days of St Augustine, who considered the adaptation of the classical 'Trivium' and 'Quadrivium', based on the Seven Liberal Arts, appropriate for Christian teaching via the Scriptures. The Trivium consisted of the language-based subjects: grammar, rhetoric, and logic; and the Quadrivium the numerical sciences: geometry, arithmetic, astronomy, and music. It was already well developed in the Carolingian schools out of which grew a network of proto-scholarly institutions based at cathedrals and monasteries in northern France. Universities were starting to be formed by the late eleventh century, and within less than 100 years higher learning and scholarship had become professionalized in the universities of Paris and Oxford, which emerged from

the religious teaching tradition. The foremost professional school for teaching law became the university of Bologna in Italy from the mid-twelfth century, and at Salerno, in southern Italy, the most famous medical school in Europe was already in existence as early as the eleventh century.

Universities were vital international centres for intellectual activity, drawing many of the most notable thinkers of the age. During the thirteenth century, both Paris and Oxford were dominated by Franciscan and Dominican friars. While under such famous masters as St Bonaventure (1221–74) and St Thomas Aquinas (*c*.1225–74), theology was the dominant subject in Paris, and through scholars such as Robert Grosseteste (1175–1253) and Roger Bacon (*c*.1210–*c*.1292), Oxford became a centre for theoretical science, especially optics.

96 Master of 1328

Papal consistory court, tempera on parchment, Italian, Bologna, 1328.

The scene takes place in a lofty vaulted room, cut away at the front to allow viewing. The roof is supported by atlantes and the floor is upheld by another who forms the centre column dividing the text. The supreme authority of the pope is shown by his elevated position and the fact that he is flanked by angels. As he dispenses judgements, ranks of cardinals and secretaries are on hand to bear witness and codify the results.

methods of teaching and learning based on formulation and testing of hypotheses. As a way of producing a visual register of these kinds of scholarship, the glossed text became popular from the 1140s onwards [**97**]. The central authority, often the Vulgate edition of the Bible or another authoritative text, occupied the main body of the page, while various interpretations and illustrations were organized around it in blocks, forming glosses or running commentaries. A related phenomenon of marginal annotations or *scholia* arose in the scholarly world but developed beyond it. These were peripheral annotations to the manuscript page, which could take written or pictorial form. The topos partly gave rise to the later proliferation of marginalia, both framing and supplementing the main substance of the text.

97

Seated philosopher lecturing to pupils, manuscript painting, from Averroes, *In physicam aristotelis*, English, *c*.1250–75.

This glossed text, a typical university book, is an edition of Aristotle's writings on metaphysics by the Muslim scholar Averroes (1126–98), physician to the caliph in Spain, who held Aristotle in the highest regard as representing the pinnacle of human reason. The image shows a philosopher lecturing to a group of pupils.

The representation of the intellectual

Images of the four evangelists were principal exemplars for the depiction of the inspired scholar in the early Middle Ages. Themselves derived from classical author-portraits, they were usually shown seated at their desks, writing their texts. Despite being guided by the authority of divine inspiration, they were also depicted as diligent agents of the craft of writing. Most medieval scholars and scribes, while their portraits may derive from those of the evangelists, are represented more prosaically as artisans, bent over their tasks in concentrated activity [98]. Even the great Eadwine, who appears as the 'prince of scribes' and seated as a scholar in his study, is a craftsman driven by the duties of the task [99].[25]

Engagement with text as an inspirational medium and aid to thought was either directly or indirectly picked up by both Italian and Flemish artists of the fifteenth century as the appropriate mode for representing the saints Jerome and Augustine at their studies. As a kind of personification of learning itself, St Jerome is often depicted, for example in Antonello da Messina's painting (c.1475) now in the National Gallery, London, in a lofty hall-like study. His retreat into scholarship is interpreted as a task undertaken in splendid and comfortable isolation, unlike the St Jerome of Ferrer's Spanish altar piece in which he is an accessible and communicative intellectual dressed as a high-status church dignitary [100].

98 Pier Paolo dalle Masegne (active 1383–1403), also signed by his brother Jacobello

Panel from the tomb of Giovanni da Legnano, marble, originally in S. Domenico, Bologna, c.1386.

This panel from the tomb of Giovanni Legnano, a lawyer and lecturer at Bologna University who died in 1383, depicts scholars paying attention to a lecture. Those seated at the front consult their books. Behind them , one man is pointing to his eye as if informing us that there is something to watch. They wear various forms of academic dress—long flowing tunics closely buttoned to the elbow and hooded headgear, and one has a mortar board.

99

The scribe Eadwine, ink and tempera on calf vellum, from the Eadwine Psalter, English, c.1160.

The portrait of the scribe Eadwine is of unprecedented, and subsequently unmatched, scale and lavishness as though he were an author. In this manuscript, the scribe apparently took precedence over the other artists and oversaw and commissioned the rest of the work for the book. Around Eadwine's image are inscribed the words: 'I am the chief of scribes, and neither my praise nor my fame shall die' and 'By its fame your script proclaims you; Eadwine, whom the painted figure represents, alive through the ages, whose genius the beauty of this book demonstrates.' His portrait may have served as a memorial.

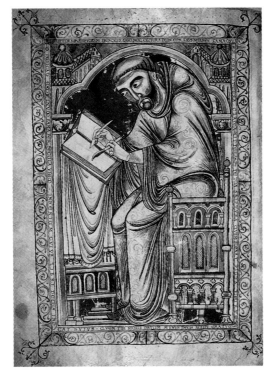

100 Jaume Ferrer and Pere Teixidor

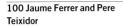

St Jerome in his Study, bound pigment in gilding on wood, panel from a retable, Catalonia, 1440–50.

The panel is of a type which depicts the scholar-saint (who lived c.342–420) anachronistically as a cardinal of the Catholic Church. As well as emphasizing his ecclesiastical status, it shows him as an intellectual, pen in hand, interested in his work. The restricted scale of the panel has necessitated telescoping the scene, but all the signs of learning are gathered around him. His Latin translations of the Bible and his Epistles are open and are displayed towards the viewer, and glasses are ready nearby. Jereme looks pointedly out at us, showing a model of the Church to indicate his role as doctor.

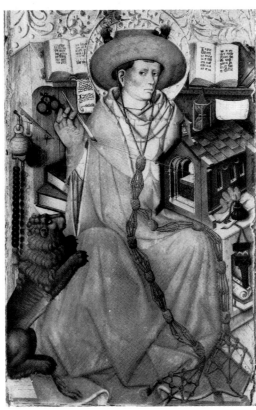

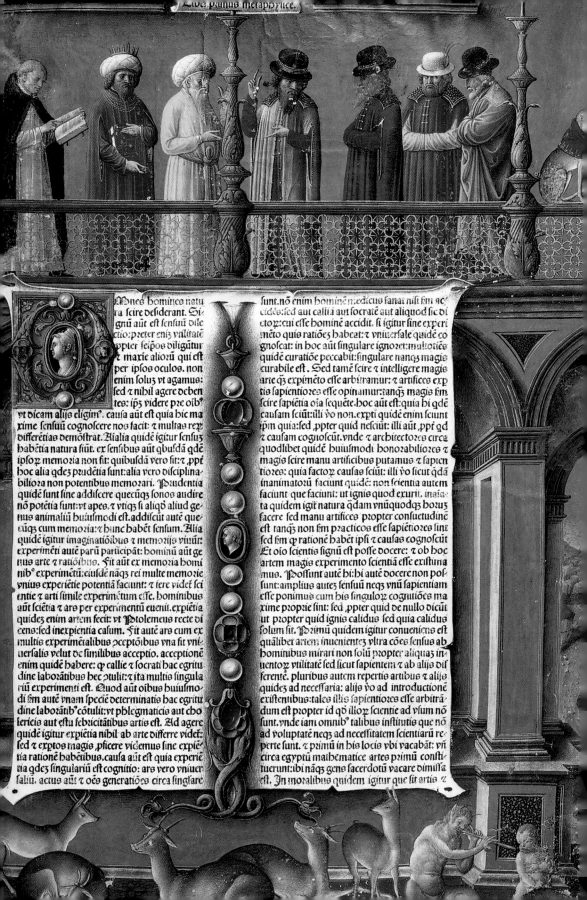



Omnes homines natu-
ra scire desiderant. Si-
gnum aut est sensuum dile-
ctio: preter eniz vtilitatez
propter seipos diligunt
& maxie aliozum qui est
per ipsos oculos. non
enim soluz vt agamus:
sed & nihil agere deben-
tes: ipz videre pre oibus
vt dicam alijs eligimus. causa aut est quia hic ma-
xime sensuum cognoscere nos facit: & multas rez
differentias demostrat. Alialia quidem igitur sensuz
habentia natura sunt. ex sensibus aut qbusdam qde
ipsoz memozia non fit: quibusdam vero fit: & ppter
hoc alia qdez prudentia sunt: alia vero disciplina-
biliora non potentibus memozari. Prudentia
quidem sunt sine addiscere quecuqs sonos audire
nō potentia sunt: vt apes. & vtiqs si aliqd aliud ge-
nus animaliu huiusmodi est. addiscunt aute que-
cuqs cum memozia: & hunc habet sensum. Alia
quide igitur imaginatiōibus & memorijs viuunt:
experimēti aute paru participāt: hominu aut ge-
nus arte & ratiōibus. Fit aut ex memoria homi-
nibus experimētu: eiusde naqs rei multe memozie
vnius experiētie potentia faciunt: & fere videt sci-
entie & arti simile experimētum esse. hominibus
aut scientia & ars per experimentu euenit. expiētia
quides enim artem fecit: vt Ptolomeus ait di-
cens: sed inexpientia casum. Fit aute ars cum ex
multis experimentalibus ꝑceptiōibus vna sit vni-
uersalis velut de similibus acceptio. acceptionē
enim quide habere: qp callie & socrati hac egritu-
dine laborātibus hec ꝑtulit & ita multis singula-
riu experimenti est. Quod aut oibus huiusmo-
di sm aute vnam speciē determinatis hac egritu-
dine laborātibus ꝑtulit: vt phlegmaticis aut cho-
lericis aut estu febricitātibus artis est. Ad agere
quide igitur expiētia nihil ab arte differre videt:
sed & exptos magis ꝑficere videmus sine expiē-
tia rationē habētibus. causa aut est quia experiē-
tia qdez singulariū est cognitio: ars vero vniuer-
saliu. actus aut & oēs generatiōes circa singulare



sunt. non enim hominē medicus sanat nisi sm ac-
cidēs: sed aut callia aut socratē aut aliquod sic di-
ctozum: cui esse hominē accidit. si igitur sine experi-
mēto quis ratiōez habeat: & vniuersale quidē co-
gnoscat: in hoc aut singulare ignozet: multotiēs
quidē curatiōe peccabit: singulare naqz magis
curabile est. Sed tamē scire & intelligere magis
arte qz expimēto esse arbitramur: & artifices exp-
tis sapientiores esse opinamur: tanqz magis sm
scire sapiētia oia sequēte. hoc aut est: quia hi qdē
causam sciut: illi vo non. expti quidē enim sciunt
ꝙm quia: sed ꝓpter quid nesciut: illi aut ꝓꝑ qd
& causam cognoscut. vnde & architectozes circa
quodlibet quidē huiusmodi honorabiliores &
magis scire manu artificibus putamus & sapien-
tiores: quia factoz causas sciut: illi vo sicut qdā
inanimatozum faciunt quidē: non scientia autem
faciunt que faciunt: vt ignis quod exurit. ina-
ta quidem igit natura qdam vnūquodqz bozuz
facere sed manu artifices propter consuetudinē
est tanqz non sm practicos esse sapiētiores sint
sed sm ꝗ rationē habēt ipsi & causas cognoscut
Et oīo scientis signū est posse docere: & ob hoc
artem magis experimento scientiā esse existima-
mus. Possunt aute hi: hi aute docere non pos-
sunt: amplius autez sensuū neqz vnū sapientiam
esse ponimus cum his singuloz cognitiōes ma-
xime proprie sint: sed ꝓpter quid de nullo dicut
vt propter quid ignis calidus sed quia calidus
solum sit. Primu quidem igitur conueniens est
quāliber artem inuenientes vltra cōes sensus ab
hominibus mirari non solu propter aliquaz in-
uentoz vtilitatē sed sicut sapientem & ab alijs dif-
ferente. pluribus autem repertis artibus & alijs
quidez ad necessaria: alijs vo ad introductionē
existentibus: tales illis sapientiozes esse arbitrā-
dum est propter id ꝙ illioz scientie ad vsum nō
sunt. vnde iam omnibus talibus institutis que nō
ad voluptatē neqz ad necessitatem scientiarū re-
perte sunt. & primū in his locis vbi vacabat: vn
circa egyptu mathematice artes primū consti-
tuerunt: ibi naqz gens sacerdotu vacare dimissa
est. In moralibus quidem igitur que sit artis &

101 Girolamo da Cremona or Jacometto Veneziano

Title-page of Aristotle, *Opera*, tempera on vellum, Venice, 1483.

This is a title-page for the second volume of a book printed in Venice by Andreas Torresanus de Absula. It shows the great philosophers from history gathered on a balcony.

Folly and ignorance were the antithesis of learning, and one of the unacknowledged but regularly exercised jobs of artists was to play devil's advocate and subvert high seriousness. Surrounding a *trompe l'œil* manuscript scroll on the title-page of a late fifteenth-century Venetian printed edition of the works of Aristotle is a collection of decorative allusions to antiquity—a sylvan glade with fauns and woodland animals, a cartouche of gems and cameos, and an arcaded building [**101**]. On the balcony above the arcade stands an imagined gathering of seven of the great philosophers from history, all solemnly engaged in conversation, or transported in deep thought, entirely convincing as a depiction of the giants of intellect. But just along from them at the end of the row a monkey crouches and turns its back on them, idly eating a piece of fruit. The jest here concerns the rarified nature of philosophical discourse and its incongruity with the mindless preoccupations of the world outside: these great men are so dull that even a monkey disdains their company.

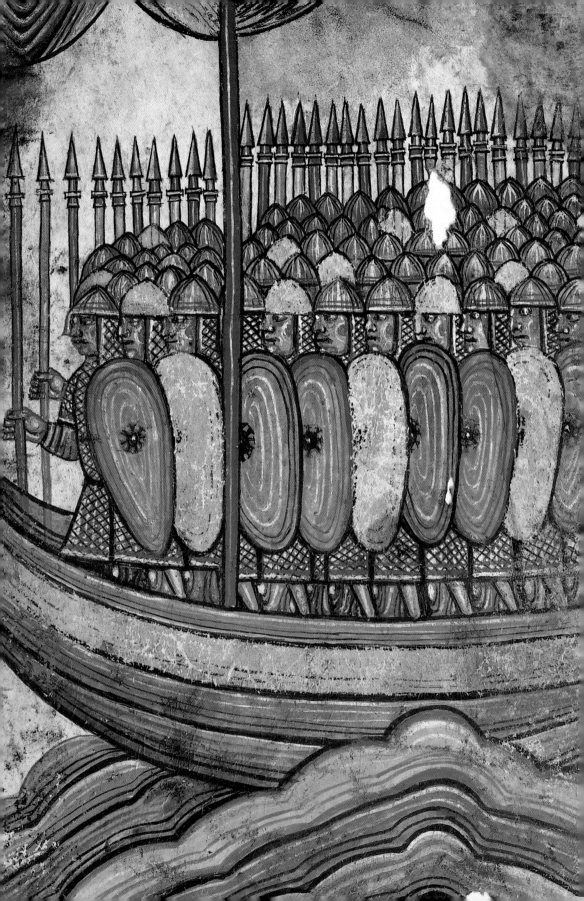

Art and War

6

On his rampaging, wealth-accumulating journey via Constantinople and Sicily to Jerusalem, Harald Hardrada of Norway spent several years in Russia before becoming king (reigned 1047–66). Together with King Jaroslav, whose daughter he later married, he fought against the Slavs and the Poles, the two men fighting side by side and 'shoulder to shoulder'. Notwithstanding his token benefactions to the holy shrines at Jerusalem, the motives for his onward journey seem not to have been especially spiritual. Nor, unlike the crusaders who came later, was his aggression directed specifically against the Saracens. He was a professional soldier in the service of the Byzantine emperors with an all-embracing ambition, apparently, to demonstrate his overwhelming prowess. In 'King Harald's Saga', written 170 years after Harald's death by the Icelandic writer Snorri Sturluson, as part of his epic history the *Heimskringla*, the poet Thjodolf wrote:

All men know that Harald
Fought eighteen savage battles;
Wherever the warrior went
All hope of peace was shattered.
The grey eagle's talons
You reddened with blood, great king;
On all your expeditions
The hungry wolves were feasted.[1]

Even over time and through translation, it is possible to detect how powerfully the rhythm of Nordic verse has immortalized these terrible violent journeys. The words and stories can still inspire awe, suspense, and fear. In very different ways, the visual culture surrounding the Viking wars and raids also has power to evoke a vivid impression of their presence [102].

War, though devastating and violent in its immediate effect, has many and surprising consequences, and art about or connected with war can be revealing of unexpected cultural factors. Large hoards of beautifully engraved silver necklaces, rings, bracelets, and cups still

intact in museum collections are poignant witness to the civilized and wealthy cultures that were disrupted, and the households and the women that were violated. But they also reveal a certain sensibility to fine things by these looters as they pillaged and then saved such treasures [135].

Sometimes fragmentary remains can hold the key to unlock a great story. A small iron parade axe richly inlaid with niello, now in Moscow, probably once belonged to a steppe nomad warrior [103]. According to the twelfth-century treatise on materials and techniques written by the goldsmith Theophilus, niello was invented in Russia. The imagery of the parade axe is likely, however, to have been derived from further afield, as it is thought that the style and subject matter of the decoration were influenced both by Byzantium and by Scandinavia. On one of its faces is depicted a Tree of Life flanked by two birds, a subject of Mediterranean origin, referring to the Christian message of spiritual replenishment and resurrection. Backing it is a subject altogether more sinister: a coiled and knotted serpent pierced by a great sword. This is probably Fafnir, the snake killed by Gram, the magical sword belonging to the Nordic hero Sigurd. The conquest of Fafnir echoes the theme of the celebration of valour and heroism, the defining values determining the use of this object, but paired with the Tree of Life, the emphasis of the message changes to one of renewal and optimism. Another way it could be interpreted is as a dual homage to life and death, reconciling conflicting Christian and pagan traditions, the irony being that the complex of cultures leading to this congruence of techniques and styles could only have come about as a result of conflict.

103

Parade axe, iron, silver, niello, Russia, Kazan region, first half of the fourteenth century.

A head of a small parade axe, now in Moscow, came originally from the central Volga, having belonged, perhaps, to a steppe nomad warrior living in the early eleventh century. Despite its small size, it is, like many high-status weapons, a complex object. It is made of iron and richly inlaid with gold and silver niello.

Palace decoration

It is hard to credit that the beautifully crafted little parade axe could be resonant with the kind of professional violence in which Harald Hardrada specialized. However, many of the arts of war, as well as the arts celebrating warlike exploits, are characterized by their exquisite care and attention to detail. Shortly after Harald Hardrada's attempts to capture England through the north, at the battle of Stamford Bridge in 1066, followed the invasion of southern England by Duke William of Normandy and defeat of the Anglo-Saxon army at the battle of Hastings. The Bayeux tapestry, or more correctly, the large embroidered wall-hanging now displayed in Bayeux, commemorates this famous conquest in 75 episodes [**104**]. It was probably embroidered in England within a generation of the battle of Hastings. Current opinions favour Odo of Bayeux (c.1036–97), half-brother of William the Conqueror, as its patron.[2] Attempts to read the embroidery as an equivalent to an historical chronicle have been frustrated by its occasional divergences from known fact and its occasional emphasis on minor events and characters. The significance, or prominence of some of its episodes, such as, for example, the emphasis on banquets, or the apparent discrediting of a mysterious Aelfgiva, is unclear. However, the embroidery was made as a piece of decorative art. From the late Middle Ages, it is known to have been displayed annually at Bayeux Cathedral on the Feast of Relics, but it may originally have been intended as a secular hanging, possibly for the great hall of Odo's palace.

While it relates the main events leading to the conquest of England, it does so with as much of an eye to dramatic visual effect as to accuracy of historical representation. With great skill, the artists have organized the compositions in such a way as to lead the eye

104

The Bayeux tapestry, wool embroidery on linen, probably English, last quarter of the eleventh century.

An emphasis on the drama of storytelling extends to the characterization of the main protagonists. It has been noted that the Normans are characterized as masterful and aggressive, whereas the Anglo-Saxons are feminized and made to appear submissive. The episode immediately after the death of Harold shows how an almost symmetrical grouping of clashing Norman and Anglo-Saxon soldiers is used as a visual device both to demonstrate the power of the event, but also to give this passage emphasis and a sense of energy following the confusion of the preceding scene.

through the narrative, making use of such devices as symmetry to arrest the viewer and centre the composition, or the linking together of scenes of movement to move onward. Border images of animals and people are used as devices to dip in and out of the narrative, to draw attention to important scenes, and to echo or mimic either their meaning or their spatial arrangement. Many other narrative traditions from manuscripts in book or roll form and from monumental reliefs have been drawn upon in order to underpin the depth of the story and its historical and mythical allusions. Understanding of the subtlety of the work has increased in recent years as more facets of these latter have been brought to light.[3] It has been proven that, in common with fairly standard practices by medieval artists, many of the main scenes were adapted from Old Testament images in Bible manuscripts illuminated at Canterbury. While according to the main written source, the biography of Duke William by William of Poitiers, written shortly after 1066, the invasion of England was likened to Caesar's conquest of 55 BC, the visual comparisons are stronger with illustrations of the Babylonian conquest of Judah from the Book of Daniel.[4] It has been suggested that this re-use of biblical imagery in visual form was partly intentional, in order to validate recent events within a Judaic tradition. Rather than being an inaccurate rendering of history, the narrative development, setting up the themes of betrayal, treachery, and retribution, derives more from the genre of the *chanson de geste*, and is thus consistent with the kind of storytelling one might expect after dinner in a lord's dining-room.[5]

The Bayeux tapestry is one of the most important sources for the study of early armour, even though details are conventionalized. At this period the main protection was afforded by a knee-length mail tunic and close-fitting hood. Leading figures wear mail leggings. Much of the work of the armourer in providing battle-worthy dress was not so much in metalwork, but in embroidery and textiles. Armour was supported by a layer of strong padded undergarments which were made in specialist armoury workshops. The pageantry of battle also depended on needlework, and indeed the correct identification of ally and foe relied on display of heraldic flags, horse coverings, surcoats, and banners [105, 106].[6]

A Latin poem by Baudri, abbot of Bourgeuil, addressed to William the Conqueror's daughter, Adela of Blois, describes the woven tapestries of her bed-chamber which glorified the military exploits of her father in the context of the histories of the Bible, Greece, and Rome. While these are thought to have been fantasies invented by Baudri for literary effect, the practice of commissioning works of art to celebrate the valiant warlike exploits of relatives was known throughout medieval Europe. In the English fenlands in the late tenth century, a wealthy widow, Aelflida, gave the abbey of Ely a

105

The siege of Mallorca, wall-paintings, from Palau Aguilar-Caldes, 1285-90.

This fragmentary series of wall-paintings depicts the conquest of Mallorca in 1229. Painted some 60 or 70 years after the event, they show the capture of Mallorca from the Muslims by the Christian king of Aragon, Jaime I. Jaime had died only in 1276, and many of the participants in the scene depicted in the Palau Aguilar-Caldes paintings are identifiable by their heraldry.

gift of hangings depicting the deeds of her late husband, Brihthnoth, killed at the battle of Maldon in 991.[7] Three hundred years later, Countess Mahaut d'Artois ordered a painted gallery at her chateau at Conflans to commemorate the deeds of her husband, Otto of Burgundy. At about the same date, in c.1320, Baldwin of Luxemburg, archbishop of Trier, had a chamber in his palace at Trier decorated with the warlike exploits of his brother, the emperor Henry VII.[8]

Pictures of the conquest of Mallorca from the Muslims in 1229, formerly in the Palau Aguilar-Caldes (now in the Museu Nacional d'Art de Catalunya) in Barcelona, show, in what has been described as a 'quasi-cinematographic' style, some of the quieter aspects of war—the amassing of troops and supplies, the encampment, the waiting, and the taking of the enemy by stealth [105]. Siege warfare called for careful and lengthy preparations, attention to detail, and sure judgement.[9] According to the account of Jaime I of Aragon (1213–76) in his *Book of Deeds*, the principal city of Mallorca, which was the finest he had seen, presented a lengthy challenge to the besieging army over the Christmas period. On New Year's Day, St George appeared in a vision, escorting an advance guard to bombard the walls, marking the beginning of the Spanish victory. The city was taken and 20,000 people killed in the process. The paintings have been related to a Catalan–Aragonese tradition in

palace decoration for the celebration of feats of arms and heroism, other examples being at the Palau Reial-Major in Barcelona, and at Cardona, depicting the defence of Gerona against the French in 1295.[10] Concentrated in frontier regions, it seems very likely that the necessity of war, to intercept opposing powers, and contrary religious beliefs, gave additonal motives for the use of paintings both to commemorate and celebrate these conquests.

In the context of public governmental palaces scenes of war, painted or hung on the walls, naturally elevated the genre of local history or dynastic homage to a status amounting to state propaganda. In Venice, in the Doge's Palace, this emphasis was highly developed in order, it seems, to provide visible evidence for increasing the honours due to the Venetian state. A long tradition of military wall decoration in the great council chamber began in *c*.1230 with paintings showing the history of conflict and battles between Pope Alexander III and Emperor Frederick Barbarossa, culminating in the Peace of Venice of 1177.[11] Historical accounts embellished the central peace-making role of Venice in restoring the pope's power during the period of resolution of this conflict, bringing the emperor to submission and helping to avert war across Europe. These paintings were reworked in the fourteenth century to reflect the details in a piece of blatant revisionist history, manipulating the evidence in order to portray the city in a pivotal role that in reality it had scarcely played. As if to emphasize the truth of this revised account, the paintings themselves were given an authenticating history, in the form of an inscription set centrally within them recording the existence of the earlier versions. Authority was thus established for a tradition of Venice as the site for reconciliation, and for the doge as a political equal to pope and emperor.

Chivalry

The association of the violence of armed combat with the harmony of righteousness and social order was a distinctive phenomenon of chivalric high culture of later medieval Europe as it appeared through the romance literature, art, and social organization. It was expected that the knight, the *chevalier*, usually an aristocrat, would fight both in battle and in sport to maintain order, his role being to defend the faith, protect the weak, uphold justice, and to combat all the possible disruptive and evil forces. The culture of knighthood depended on a shared set of values and aspirations toward chivalry, honour, prowess, and loyalty.

While there were certain differences in terminology between France, England, Spain, Italy, and Germany, the role models, traditions, and values were largely international, deriving from a constantly interweaving network of religious, secular, and historical sources that formed the backbone of its literature and mythology.

The arts of war typically reflected complex elements of knightly culture in their mingling of fact and fiction, exemplar and incident, decoration and realism. Illustrations to romance literature could highlight the extent to which fact and fiction were interwoven.

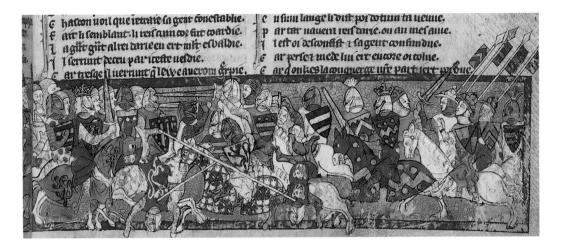

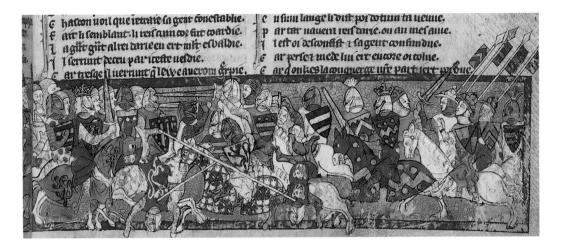

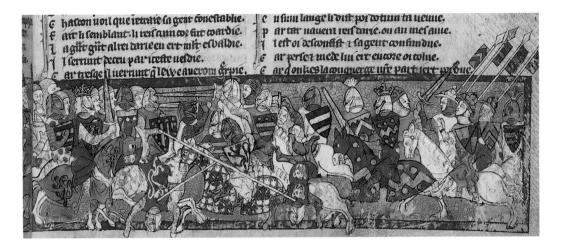

106

Third battle of Alexander and Darius, tempera on parchment, from Thomas Kent, *Roman de toute chevalerie*, 1308–12.

This confused mêlée of mounted knights is very different from the ordered symmetry of the Maciejowski Bible (**107**). There is another kind of order here, though, with each knight carrying a shield of arms bearing his heraldry. Although the illustration is from fictionalized history in a manuscript of romance literature, implicit in its interposing of real heraldry is a belief in the values of myth and of history in providing lessons for the living world. Various coats of arms are identifiable.

Running very deep in the genre of medieval depictions of war was the idea, reflected already in the Bayeux tapestry, of a living military tradition with a biblical, historical, or mythical context. Thus history, especially of the current era or recent past, could be viewed against ancestry of impeccable authority and justified by association with proven values of heroism, justice, or bravery. Depending on their situation, choices of historical, legendary, or biblical battle illustration not only indicated particular tastes for combat and victory, but validated them and set them within a new problematic context, rather as did Eisenstein's film *Alexander Nevsky* (1938) just before the conflict with Germany, or *Ivan the Terrible* in 1945 during the rule of Stalin— although these were both made from an independent critical position [**106**]. Edward I of England's (1272–1307) early years before he came to the throne were marked by the fighting of two battles against Simon de Montfort and the leading of a Crusade to the Holy Land in 1270. Between the 1270s and 1290s, he fought wars in Wales, in Scotland, and in France, and in 1293 intended to take another Crusade to liberate the East, but never did so. All these sites and situations of conflict only resulted in three battles. However, placing his tastes and personal history within a wider context, paintings that he commissioned for the upper walls of the king's chambers in the palace at Westminster (destroyed in the fire of 1834, but well documented) showed many battle scenes. These were drawn from the Old Testament, notably the history of Judas Maccabeus, and episodes from the books of Kings and Samuel. These paintings allowed him to be viewed as the inheritor of a patriotic conquering tradition. The allusion must have worked, as Judas Maccabeus was known as 'the hammer' and one popular tribute to Edward named him 'the hammer of the Scots'. Another contemporary account described him as the 'most Maccabeian of kings'.[12]

The aesthetics of violence

In an era of evangelical religion that emphasizes the virtues of humanitarian behaviour, it might seem surprising to find biblical illustration concerned with violent war scenes, but by the middle of the thirteenth century it was almost commonplace. Following two centuries of war in the Holy Land, the idea of warlike behaviour as just and right and pursued in defence of the one true religion was deeply internalized in Christian values and ethics. Nevertheless, even for that time, the Maciejowski Bible is unusual in having a very high proportion of illustrations that show fighting, rape, murder, or some kind of brutality and violence [**107**]. Made in France, it has, however, been cited as one of the possible sources for Edward I's palace paint-

107

Saul's body hung from the walls of Beth-Shan and the burning of the bodies of Saul and his three sons, tempera on parchment, from the Maciejowski Bible, c.1250.

Scenes of the display of Saul's headless and partly naked body from the walls of Beth-shan allow for some spectacular composition techniques, playing on the uses of symmetry, mirror images of opposing beams from siege machines, repetition of angles of elements that lead the eye in diagonals, and the balancing of group scenes.

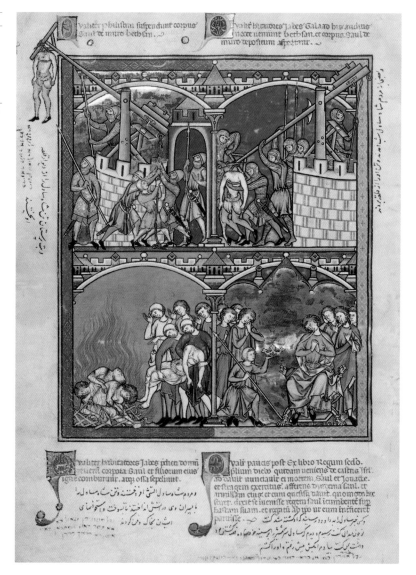

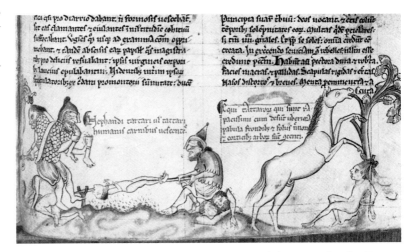

ings and its richness makes it clearly part of the same kind of combat-orientated courtly culture.[13] Demonstrated most strikingly in this book is the aestheticization of war. The tension between the disharmony of the subjects portrayed, and their dramatic and skilful visual presentation, creates for the viewer an uneasily pleasurable experience. There is something as disturbing as it is satisfying about the decorative arrangement of corpses back to back or face to face, about the pyramid formations of clashing adversaries who trample on them, and about the symmetrical balancing of enemies ripping each other's bodies apart against richly coloured, contrasting backgrounds.

Real and imagined battles

Working retrospectively from 1361, the date he arrived in England, Jean Froissart (*c.*1337–*c.*1410) researched and chronicled the events of the Hundred Years War between France and England. A canon of Valenciennes, he was also a poet and an historian in the employ of a succession of Flemish aristocratic patrons. His task was to tell a good and accurate but biased story—there was never any doubt that he should serve his patrons well and relate the events between 1327 and 1400 in such a way as to record the deeds of their relatives and associates. Froissart's chronicles survive in several variant editions, but those that are illustrated all date from long after the events they depict. In any case, drawings from life were rare and the phenomenon of the war artist was unknown. So, what we see, for example, of the battle of Crécy, in an illustration from a fifteenth-century manuscript, is a conventionalized battle scene set in a hilly landscape and relating more strongly to pictorial convention than to historical fact.

The main lines of the pictorial organization of the illustration for Froissart are devised according to symmetry. In this, the arrangement is not so different from that of the Bayeux tapestry of some 400 years

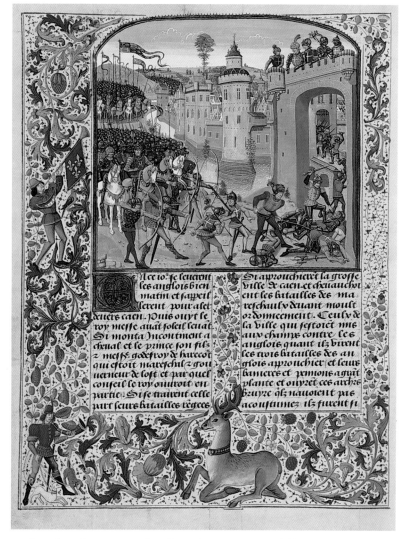

earlier. Another scene showing the storming of Caen shows one of
the more typical war tactics, a siege, during which the town was over-
whelmed by invading troops breaking down the gates and taking over
the battlements [**109**]. The care with which the composition has been
devised, following the sweeping diagonal across the picture from left
to right, derives as much from an attempt to create a good picture as
it does to portray events with accuracy.

Rather more terrible in the atmosphere of violence and bloodshed
are the illustrations from a mid-fifteenth-century Flemish manu-
script edition of the *Roman de Girart de Roussillon* [**110**]. Here a
crowded mass of mounted soldiers tramples bodies, limbs, and dis-
carded armour underfoot as they each tear into one another in confu-
sion. Countless bodies, lances, and pennants form the foreground and
lead the eye back in a horizontal plane through a limitless-seeming

crowd. This book was made for the duke of Burgundy, Philip the Good, a famous collector and bibliophile, and its illustrations were clearly directed at pleasing a discerning patron. Whether they related to fiction or to history, they were made to satisfy a taste for fine images and good stories with a biting edge of excitement and tension.

On a large scale, but operating with the same range of conventions, are Paolo Uccello's three panel paintings depicting the *Rout of San Romano* [111]. Painted for the chamber of a palace, very likely that of one of the principal protagonists, they show a battle between the Florentines and Sienese that took place in 1432. The pictures date from 1454 to 1457, so the battle was easily within living memory,

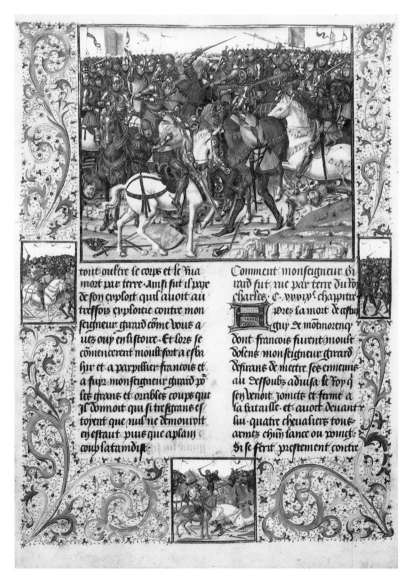

110
How Girart was grounded by King Charles, tempera on parchment, from Jean Wauquelin, *Roman de Girart de Roussillon*, Mons, 1448.
The violent battle scene is all the more powerful by comparison with its decorative setting on the page, surrounded by a margin of pretty acanthus painted scrollwork, punctured with glimpses of other horrific episodes in little vignettes. This manuscript is one of a group associated with Philip the Good, duke of Burgundy, which includes a 'Chronicle of Hainault', exploring similar conventions, with pictures of war arranged in decorative surroundings. Note the grid-like arrangement of discarded armour which, as in Ucello's painting, emphasizes the spatial recession.

and the paintings come very close to representing contemporary events. However, like the Froissart chronicle, the scene is set within a hilly landscape, in this case lush with vegetation and even somewhat pastoral. The battle, dominated by the equestrian figure of Niccolò da Tolentino, is played upon a field staked out with a grid of discarded armour and bodies, rather like that of the Girart de Roussillon manuscript.

111 Paolo Uccello

Rout of San Romano, oil on panel, 1454–7.

It has often been remarked how Uccello's paintings pay close attention to decoration and perspective design, but seen within the context of the traditions for battle imagery across Europe, they are entirely consistent with conventions of pictorial organization, which take precedence over a commitment to record what actually happened.

Warrior-heroes and super-heroes

The myth-making of the international culture of knighthood was concentrated on the construction of the warrior-hero. Judas Maccabeus, Alexander, Roland, El Cid, Parzifal, Sigurd, and King Arthur—seekers of truth, conquerors, adventurers, and rulers—were among the diverse role models [112]. These men were not merely warriors but had demonstrated by their superhuman prowess that they could lead and inspire. These were the heroes from mythology, from history, from fiction, from scripture, and from contemporary

The Nine Worthies, stone (restored), Rathaus, Cologne, north wall, *c.*1330.

This earliest surviving representation of the Nine Worthies appeared illusionistically in paint on the south wall of Cologne's civic hall and as corporeal presences in life-size sculpture on the north wall. There is a marked difference in the potential reading of these historic and militaristic figures in a civic, public situation from the gentler rendering of more decorative personae within the private privileged walls of a castle. Their presence implied that the city of Cologne was heir to this valiant tradition, bestowing power and protection on its citizenry.

The Nine Worthies

While contemporary personalities continued to be celebrated, by the early fourteenth century there had settled a more or less authoritative group of nine soldier-heroes whose appearances in the visual arts stood for the whole notion of heroism. Immensely influential in formalizing the canon was a poem, the 'Voeux du paon', written in 1312–13 by a Lotharingian, Jacques de Languyon, praising the virtues of 'neuf preux', or nine heroes, all distinguished by their strength and prowess. They formed three groups of three. The Jewish heroes were Joshua, David, and Judas Maccabeus; the pagans Hector, Caesar, and Alexander; and the Christians Arthur, Charlemagne, and Godfrey of Bouillon. These exemplary champions, known as the Nine Worthies, became a popular subject for representation in the decoration of great houses: they appeared in paintings, tapestries, glass, and sculpture in diverse locations: at the castle of Runkelstein in the Tyrol, at the castle of Craithes in Aberdeenshire, at La Manta near Turin (together with nine heroines from history), in tapestries owned by the French king Charles V, Duke Philip of Burgundy, and Jean, duc de Berry, the last of which survives in New York's Metropolitan Museum.

life, who knew no fear, who could when required demonstrate enormous feats of strength, endurance, leadership, and wisdom, and who were warlike, brave, and exemplary in their upholding of honour. Many of them were celebrated from the early Middle Ages by their own sagas and romances—stories popularizing their lives and deeds. But the visual arts played a particular role in formalizing those among the many potential heroes from mythology and romance who were to be celebrated and how they acted as exemplary role models whose actions needed to be seen.[14] The male heroic saviour, the medieval 'superman', was usually dressed as a soldier—indeed the 'arming of the hero' is a specific episode both in literature and the visual arts.[15]

Warrior-saints and angels

The enthusiastic acceptance of the Nine Worthies is especially striking, given that there already existed canonically recognized military heroes whose deeds earned them individual commemoration in the Church calendar: warrior-saints and angels. Among those

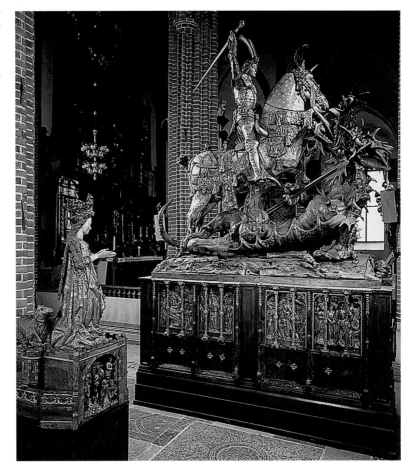

113 Bernt Notke

St George and the dragon, polychromed oak and mixed media, St Nicholas, Stockholm, 1489.

Following the popularity of the *Golden Legend* of Jacobus de Voragine, the story of St George's killing of the dragon became the episode most often depicted. The presence of the princess resonated with the chivalric culture of the Christian knight protecting and converting a vulnerable victim. St George's military presence was often invoked to guide Christian armies to victory. This group, containing relics of the saint, was commissioned by Governor Sten Sture the Elder (1470–1503) to commemorate such an assisted victory against the Scandinavian Union forces at the battle of Brunkenberg, October 10, 1471.

most widely venerated were Maurice, Sebastian, and Demetrius, but it was George who predominated as the exemplary hero in the later Middle Ages. From the time of his earliest legends in fourth- and fifth-century Palestine and the Middle East, St George's reputation was as an extraordinary and popular superman. He was allegedly killed three times—cut into pieces, buried in the earth, consumed by fire—and was each time revived by the power of God, milk rather than blood flowing from his head. One of the most imposing of all saints' images from the entire Middle Ages must be the immense late fifteenth-century wood-carving occupying almost the whole space of an arcade of the nave of Stockholm Cathedral. The sculpture was made by the Lübeck sculptor Bernt Notke (active 1483–1509) [**113**]. Saint and horse are richly clothed in armour. The dragon rears and writhes in a spiky, scaly mass while the princess prays earnestly to one side. Though many incidents from his life could have proved his valour, the depiction of St George as dragon-slayer was the ultimate accolade both of the super-hero of legend, such as Sigurd, and of the conqueror of evil, such as St Margaret.

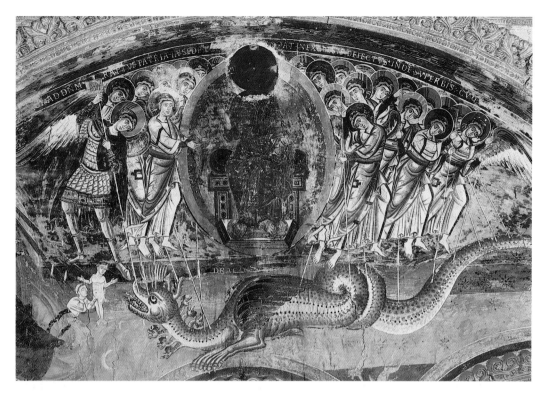

114

God of Revelation enthroned with St Michael and the angels fighting the seven-headed dragon, wall-painting, east wall, narthex, S. Pietro al Monte, Civate (Como), c.1100.

In a dramatic wall-painting from the narthex, or fore-building, leading into the nave at S. Pietro al Monte, Civate, St Michael, dressed in armour as a Roman soldier and assisted by his angels, plunges his lance into the seven-headed satanic dragon, the devil of the Apocalypse (Revelation 12).

The greatest and first of all dragon-slayers was beyond humanity, the archangel Michael, who epitomized the heavenly war against Satan. Both for the Jews and Christians, St Michael was the prince of the angels, protector of Israel. His name means in Hebrew 'who is like God', and in Greek 'supreme commander'. It became the war cry of the angels in their battle against Satan, recorded in the Apocrypha as St Michael fought to protect the body and tomb of Moses, and in the Book of Revelation or the Apocalypse of St John as he led the heavenly army. In medieval Christian art St Michael appeared in various guises, sometimes weighing the souls on the Day of Judgement, but more usually dressed in armour as a soldier ready for battle. His struggle against the evil seven-headed dragon of the Apocalypse stood for the fight against all evil [**114**]. Altars at the west ends of churches were often dedicated to St Michael as protector and defender of the holy edifice, and there were probably once many more images portraying him there.

Commemoration

In that the dead man stands, Peter Vischer's (active 1490s) bronze effigy of the Graf von Henneburg, who died in 1502, shows a striking variation on the common medieval monument of the armed knight ready for battle [**115**]. In almost every respect, the impression of life is remarkable. The armour is faultlessly accurate in its detail, being of

a characteristic late fifteenth-century German type with rippled fluting on all parts. The helmet or sallet is of the sou'wester shape distinctive of German armour after c.1460.[16] Here it is tipped back a little as if to allow the count vision to assess his next move, revealing his piercing eyes and the grim determination of his mouth. He holds his lance and sword in a convincing allusion to his preparedness to fight at any moment. Only his improbable stance, balanced on the back of an accommodating lion, hints that this is no ordinary statue and this is in fact the commemorative image of a corpse. We have here a military equivalent of the Vanitas figure; the effigy not only hints at its own spiritual eternity, but also demonstrates the loss of its vigour in its mortal decay.

A small number of effigies that showed the knight with legs apart and hand on sword in a 'lively martial attitude' (as described by Tummers), were made in England in the thirteenth century, but they were always recumbent, and apparently made specifically to appear in correct horizontal perspective.[17] Lying on their slabs in the heart of the judicial centre of modern London are eight armed knights whose lives had been devoted to killing and to gathering wealth for causes that they believed to be unworldly and entirely just [**116**].

Templars were based in Jerusalem at the beginning of the twelfth century and, under vows of chastity and obedience to God, dedicated themselves to protecting pilgrims and maintaining the church of the Holy Sepulchre. War waged by the Christians against Jews and Muslims in the Holy Land endured more or less continuously

115 Peter Vischer

Tomb effigy of Otto IV, Graf von Henneburg, bronze, church of Römhild, Thuringia, c.1490.

Otto IV commissioned a new church at Römhild, built in 1450 to 1470, as his family mausoleum. The bronze effigy was made by the Vischers of Nuremberg before his death.

116

Effigies in choir, Purbeck marble, Temple Church, London, c.1250–70.

These solemnly arrayed bodies were associates of the Knights Templars, the first of the quasi-monastic military orders devoted to liberation of the Holy Land from the Saracens.

for at least 200 years following Pope Urban II's preaching the First Crusade in 1095. With each new campaign, religious war was not only sanctioned by some of the most pious Christian men of Europe, but actively promoted. The military orders, including the Knights Templars and the Knights Hospitallers, who provided care for the sick, operated throughout Europe and were given privileges, properties, and gifts, and exemptions from ecclesiastical jurisdiction. During the course of the thirteenth century, the Templars in particular grew into very rich and worldly financiers, lending money to the royal exchequer, and in France even assisting in its administration. However, in a famous episode of retribution led by the French king Philip IV and his chancery between 1307 and 1312, the Templars were systematically accused of devil worship and institutionalized homosexuality, tried, and exterminated.

Women and war

Women only very rarely made interventions in the business of battle. Romance literature and illustrations in manuscripts and on ivory caskets and mirror backs from the fourteenth century made much of play-battles, as in the somewhat frivolous incident of the siege of the Castle of Love by armed knights who are pelted with roses by its female defendants [130]. The importance for the whole culture of chivalry of attachments between a knight and his female sponsor and for gains at tournament to be achieved in honour of a lady is well attested. Women did, however, have to defend their territories, and there are occasional records of their taking command of troops in order to do so. Froissart's chronicle of the Hundred Years War records an instance of his then patron, Edward III's queen, Philippa of Hainault, who, while highly pregnant, held off a rebellion against the king in Yorkshire by taking command of the royal troops at Neville's Cross while Edward was abroad in the Pas-de-Calais.[18] Anna Comnena (1083–1153), daughter of the Byzantine emperor Alexius I, wrote in the *Alexiad*, her history of her father's reign, that Gaita, wife of the Norman duke of Lombardy, Robert Guiscard, used to accompany her husband in battle, 'and when she donned armour she was a formidable sight'. Describing her in action fighting the troops of the Holy Roman Emperor in 1081, she does indeed sound fearsome:

like another Pallas, if not a second Athena, seeing the runaways and glaring fiercely at them, shouted in a very loud voice: 'How far will ye run? Halt! Be men!'—not quite in those Homeric words, but something very like them in her own dialect. As they continued to run she grasped a very long spear and charged at full gallop against them. It brought them to their senses and they went back to fight.[19]

Christine de Pisan, *Livre des faits des armes et de chevalerie*, tempera on parchment, 1409.

Christine is seated at her desk while the goddess Minerva is advising and guiding her in her task. Christine's words are conventionally humble: 'Lady and high goddess, may it not displease you that I a simple little woman should undertake at the present time to speak of such an elevated office as that of arms.' This manuscript belonged to Philip the Good, Duke of Burgundy (cf. **110**).

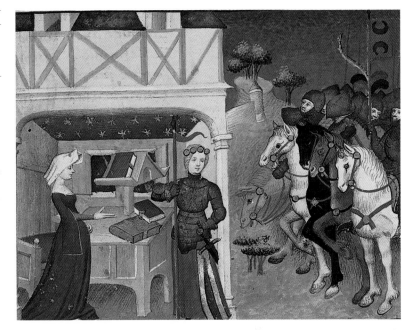

The most remarkable phenomenon of all in the history of women's participation in war was the rise to prominence of Joan of Arc (1412–31), who was only 16 years old and of peasant background, and still able to command troops on behalf of the French king.[20] Despite her importance and the extent to which she has captured the imagination of successive generations, no contemporary images survive of her and precious few from chronicles from the next generation. She was not from a class that commissioned art and her life ended by her being discredited by those who did.

Quite apart from her saintly character, Joan's credibility as a military leader may have gained greater currency thanks to the classical tradition that personified the authority of war in female form, as the goddess Minerva. The frontispiece to a manuscript of Christine de Pisan's *Livre des faits des armes et de chevalerie*, written in 1409, shows the author in consultation with the goddess Minerva, who wears an armed breastplate and has her hand resting on her sword [**117**]. Christine (1364–1430) was an admirer of Joan's achievements and her defender when she needed it, and also an adviser to royalty, the French king Charles v being her first patron. The treatise was a translation from Vegetius and other classic works of Roman law on the matter of the duties of a soldier and the tactics of war. Outside her little study, waiting to one side, or perhaps passing by, are the leaders of a group of cavalry. Christine derives her authority directly from Minerva in the approach she takes to the subject, modestly belittling her own status, according to normal literary convention:

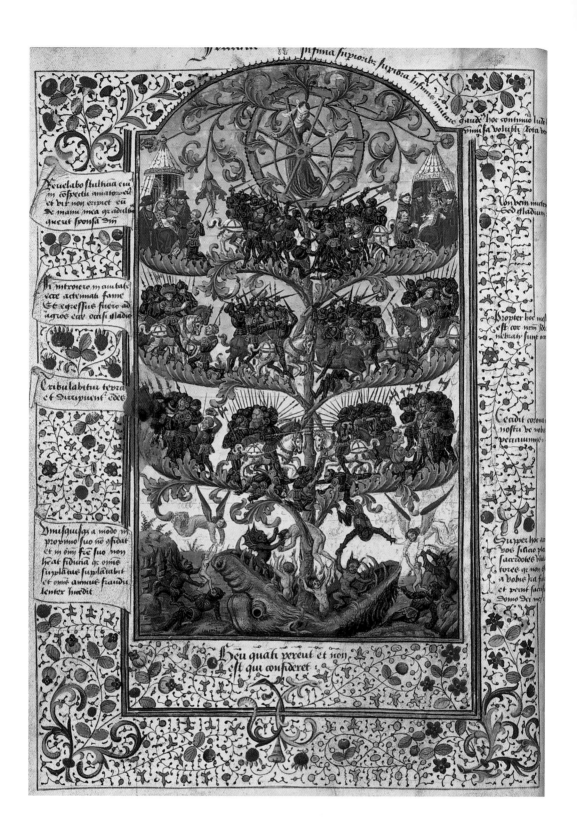

As this is unusual for women who generally are occupied in weaving, spinning and household duties, I humbly invoke in speaking of this very high office and noble chivalry, the wise lady Minerva, born in the land of Greece whom the ancients esteemed for her great wisdom . . . so let it not be held against me if I as a woman take it upon myself to treat of military matters.[21]

Treatises

Another authority that Christine consulted and included in her compilation was the *Tree of Battles* by Honoré Bouvet (sometimes written Bonet) [**118**]. This was also a work concerned with the legal aspects of war, with ethics, with military custom, and with the correct behaviour of a soldier. It was a theoretical treatise, not a practical manual, and yet it espoused attitudes that did eventually encourage reform. Written in the late fourteenth century, by the end of the following century it had been published in five languages and was widely read among the aristocracy of France, England, Scotland, and both Catalan and Castilian Spain.[22] Bouvet's opinion, partly also a synthesis of a number of authorities, was that the phenomenon of war was natural and in accordance with reason according to canon and civil law, and in accordance with divine law, as it had been sanctioned and encouraged by God in the Old Testament. The evils and injustices that stemmed from war did so as a result of abuse and misconduct. He was very critical of the idea of individual heroism, and the aggression implicit in the expectation that a knight would take individual initiative. He also promoted the idea that war should be waged according to just principles, and his ideas were very much in conformity with modern concepts of respect for authority, obedience to command, and duty to fellow soldiers.

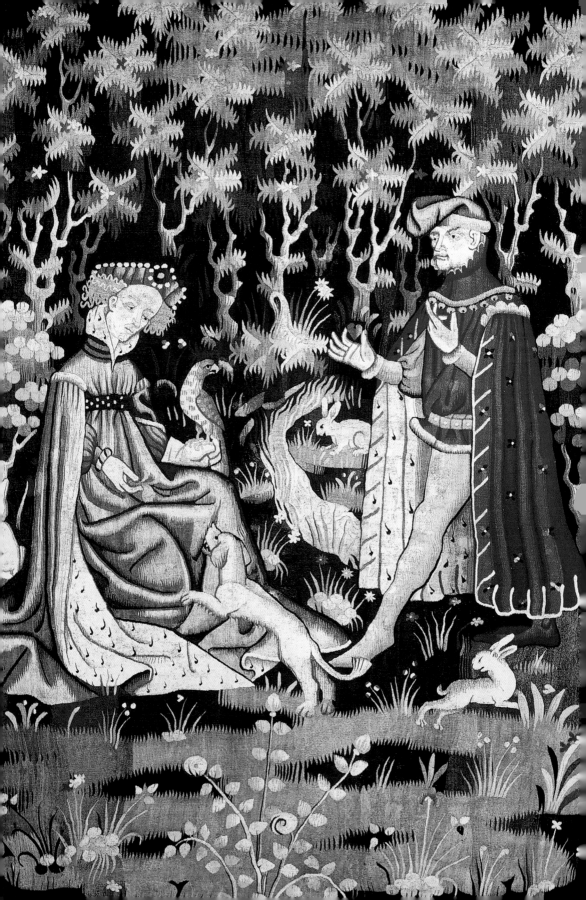

Pleasures

7

The expression of unalloyed pleasure is hard to find in medieval art. Almost everything mentioned in this chapter, while to some extent made for pleasurable use or reflecting pleasurable activity, is mediated by a context that gives it a serious or moral counterweight. Pleasure was often tempered by the watchful gaze of the forces of morality. If people did not monitor their own tastes and behaviour, then it was quickly done for them by the Church. Even in secular contexts, art was used in order to reinforce values demanded by religion. It would be wrong, however, to attribute to the Church all the means of restraint, just as it would be misguided to suppose that all pleasure was expressed in opposition to it. While the Church calendar regulated feasts and fasts, a check to overindulgence may have come from superstition, from local custom and habit, or from particular historical circumstances. After all, regardless of religious belief, celebrations involving feasting, dancing, joke-telling, and general merry-making are always more appropriate for celebratory occasions and invariably kept in check at times of war, poverty, or mourning. Nevertheless, to a very large extent it was the agencies of restraint and morality, from whichever source they came, against which pleasure was defined and itself given value. The knowledge that life is short and fraught with dangers makes its pleasures all the more desirable. Some of the sweetest pleasures are those that are forbidden, and it is precisely in the context of art mediated by morality that one can also find the greatest enjoyment and indulgence.

Transient beauty

The poignancy of the brevity of life's pleasures has always been a subject in art and poetry, but the medieval Church invested the genre with an additional moral force. Introducing the Vanitas theme of the later Middle Ages, according to which the transience of temporary physical beauty was contrasted with the decay of age, St Bernard of Clairvaux wrote of the superior inner beauty of the soul: 'No beauty of body can be compared with inner beauty, nor any dazzling complexion, which will yet wither, nor a rosy face, which is threatened with decay, nor costly dress which will be worn out, nor the beauty of

119

The Offering of the Heart, Flemish, *c.*1430.

An elegant lady, cloak lined with ermine, and with her falcon and dog, is approached by a fashionably dressed courtier offering a fruit, his left arm indicating the opening of a conversation. Hunting here is entirely decorative, and the whole scene focuses on the conquest of men by women, not the chase of bird or hound and prey. Decorative tapestries, especially from northern France and Flanders, were sought-after luxuries for noble households in England, France, and Flanders in the early fifteenth century.

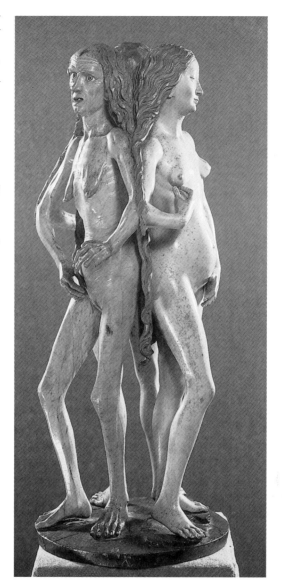

gold and the lustre of precious stones, or any things of this kind, which are all doomed to destruction.'[1]

Summing up in a beautifully hideous vision that all beauty must decay is Gregor Erhardt's limewood sculpture of the *Allegory of Vanity* of around 1500 [**120**]. Made for a monastery, the sculpture has an Adam and Eve-like beautiful young man and woman on one side and a withered old woman on the other. Intended as a graphic reminder of the transitory nature of human flesh and the folly of loving it too much, such a lovely object must indeed have stimulated some of those lustful thoughts it supposedly was intended to discourage.

The mingled pleasure and pain of enjoyment of youth's beauty while being conscious of its brevity was a powerful theme of the late Middle Ages and was common to tomb sculpture and lyric poetry:

The earth lies open breasted
In gentleness of spring
Who lay so close and frozen
In winter's blustering.
The northern winds are quiet,
The west wind winnowing,
In all this sweet renewing
How shall a man not sing?[2]

The opening verse of a love lyric that celebrates the burgeoning spring growth at the beginning of the year, this comes from the *Carmina Burana*, a manuscript anthology of lyrics probably written at the monastery of Benediktbeuern in Upper Bavaria in the early thirteenth century. The song 'Terram iam pandit gremium' is about the rising sap of new growth in spring when a young man's fancy turns to thoughts of love, but each verse carries with it a remnant of description of what had been left behind, tempering the joyous imagery with a chill note of another, more cautious, mood: 'Behold all things are springing with life come from the dead, the cold that wrought for evil is routed now and fled.' Illustrating this poem and perfectly capturing its mixture of celebration and foreboding is a rare image of pure landscape, luxuriantly filled with plant life, gambolling wild animals,

Beauty

Geoffrey of Vinsauf's *Ars poetica* (*c.*1200) contains one of the most elegant lyrical appreciations of a woman's body in medieval writing. Geoffrey was an English cleric and his work was dedicated to Pope Innocent III, proving that it was perfectly possible to express sensuous pleasures from within the Church even if it was not possible to experience them. Both his writing style and his aesthetic values have their roots in classical sources:

Smoother than polished marble let Nature fashion her chin—nature so potent a sculptor. Let her neck be a precious column of milk-white beauty, holding high the perfection of her countenance. From her crystal throat let radiance gleam, to enchant the eye of the viewer and enslave his heart. Let her shoulders, conforming to beauty's law, not slope in unlovely descent, nor jut out with an awkward rise; rather let them be gracefully straight. Let her arms be a joy to behold, charming in their grace and length. Let soft and slim loveliness, a form shapely and white, a line fine and straight, flow into her slender fingers. Let her beautiful hands take pride in those fingers. Let her breast, the image of snow, show side by side its twin virginal gems. Let her waist be close girt and so slim that a hand may encircle it. For the other parts, I am silent—here the mind's speech is more apt than the tongue's. Let her leg be of graceful length and her wonderfully tiny foot dance with joy at its smallness.

121

Spring landscape, tempera on parchment, from the *Carmina Burana*, early thirteenth century.

The lush vegetation is an extremely rare vision of landscape for such an early date. Almost certainly painted to echo the celebration of the beauty of nature in many of the poems of the *Carmina Burana*, it also has a slightly menacing, claustrophobic quality, and may, like the poems, be symbolic of the transitory nature of life on earth. The colours of the landscape correspond to the imagery in some of the poems:

> The woods are green with branches
> And sweet with nightingales,
> With gold and blue and scarlet
> All flowered are the dales.
> Sweet it is to wander
> In a place of trees,
> Sweeter to pluck roses
> And the fleur-de-lys,
> But dalliance with a lovely lass
> Far surpasseth these.

and birds [**121**]. Against the dense, flat background of blue and green, it is possible to sense both the intense heat of the sun and the residual chill hinted at by the closing lines:

> If she for whom I travail
> Should still be cold to me,
> The birds sing unavailing,
> 'Tis winter still for me.[3]

Sport and discipline

Bede's *Life of St Cuthbert* related how, as a boy, the saint received a message from God about his future vocation as bishop through the medium of a child sent to interrupt his sport [**122**]. Until then, the 8-year-old Cuthbert had

loved games and pranks, and as was natural at his age, loved to play with other children. He was naturally agile and quick witted and usually won the game. He would often be still fresh when the rest were tired and would look around in triumph, as though the game were in his hands, and ask who was willing to continue. He used to boast that he had beaten all those of his own age and many who were older at wrestling, jumping, running, and every other exercise.[4]

Lives of saints often give accounts of pleasures that have to be controlled or curtailed in order to make way for a life devoted to the serious purpose of religion. Art associated with pleasure can present the contrary view, showing precisely the enjoyment that was supposedly being checked. A twelfth-century illustration of this episode chooses the moment of Cuthbert's realization of his true vocation:

suddenly a child no more than three years old ran up to him and began to upbraid him, with all the solemnity of an old man, for his idleness and indulgence in games, saying he would do better to exercise a steady control over mind and body … Why most holy priest and bishop Cuthbert, do you persist in doing what is contrary both to your nature and your rank? How ill it befits you to play with children, you whom the Lord has marked out to instil virtue in your elders.

There were other contexts in which sport was a serious pleasure with its own controlling discipline, mastery of which was in itself a work of dedication. According to the Holy Roman Emperor Freder-

122

Cuthbert as a boy, from Bede, *Life of St Cuthbert*, from a manuscript made for Durham Cathedral Priory, *c*.1100–20.

The illustration of this episode shows a kind of cricket being played, conveying the jostling, tumbling enjoyment of the sport. Cuthbert, set to one side, points to himself in the recognition that he can no longer take part. Such was his talent for sport, his sacrifice in giving it up was seen as all the greater sign of his piety.

ick II of Hohenstaufen (1194–1250), king of Jerusalem and of Sicily, the pursuit of falconry 'enables nobles and rulers disturbed and worried by the cares of state to find relief in the pleasures of the chase'.[5] He had learned the art from Arabs in Syria while travelling on crusade to Palestine and then, frustrated at the inaccuracies of existing practical treatises, including works by Aristotle whom he criticized for not verifying his sources, wrote *The Art of Hunting with Birds* (*c*.1248), as a detailed work of scholarship. The book was a synthesis of the expertise of masters of falconry who were 'at great expense summoned from the four quarters of the earth', to enable Frederick to assess the importance of their knowledge while he was 'endeavouring to retain in memory the more valuable of their words and deeds'.[6] Chapters cover species of birds, their habitats, habits, food, their anatomies, including analysis of feathers, their care, and every aspect of the practice and methods of hunting, the duties of game-wardens, the layout and equipment of mews, and the treatment of illness. Frederick's son Manfred (d. 1266) shared his passion for falconry and prepared an edition of the book, now in the Vatican Library, which is full of lively and lifelike illustrations, many of which must have been made from direct observation.[7] Clearly, the illustrations in this edition do more than just highlight aspects of the text, and they enhance the sense of enjoyment in reading it and, hence, lure the reader more deeply into the subject. At their best, they also have a real sense of atmosphere. The famous illustration showing a man swimming across water to retrieve an escaped falcon manages to convey a wonderfully abandoned image, rare for the Middle Ages, of the union of man and nature [123]. Swimming was evidently a rare skill. A late medieval English text states that it was useful to swim in

123

Man swimming, tempera on parchment, from *De arte venandi cum avibus*, by Emperor Frederick II, 1260s.

The Vatican codex of *De arte venandi cum avibus* was the revised edition of the work prepared by Frederick's son Manfred, but unfinished at his death in 1266. This illustration shows the need for a falconer to know how to swim in order to save a falcon that has brought down its prey across an unfordable stretch of water.

126

King John cup, silver-gilt, enamel, English, *c*.1340.

The rich enamel decoration on the so-called 'King John' cup in Kings Lynn relates to the hunt. In each of five fields of enamel is a man and a woman, one over the other. Some pick the flowers, others are dressed as hunters, carrying bow and arrow. As a kind of metaphor for a virtual conquest, a female falconer is placed at the bottom of the cup, ready to be revealed with the last draught.

127 Circle of Conrad Witz

Schloss Ambras court playing cards, Upper Rhine, Vienna, *c*.1440–50.

Hunting provided the theme for a pack of playing cards destined for the Burgundian court. The four suits are herons, hounds, falcon-lures, and falcons, enabling players to enter the virtual world of the chase while indulging in the sport of the chamber. Until the invention of the four suits of the modern pack in the mid-fifteenth century, most medieval playing cards were organized in suits that echoed the classes of society. These derived from the *Tarocchi*, or Tarot, a game of divination of which there were many variations, and which came to Europe from the East via Italy in the fifteenth century.

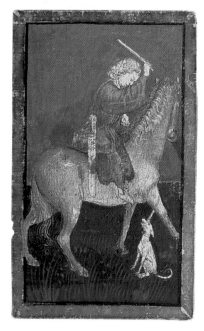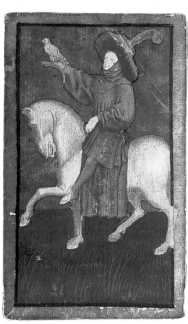

In medieval allegories, the hunt can be a multivocal metaphor referring to the spiritual or physical chase, to conquest or to rejection, or any shade in between. In both 'Le dit du cerf' and 'Le cerf amoreus', two French thirteenth-century poems, the wounded stag, lacerated by hounds, is a type for the martyred lover. In a lengthy German poem, 'Die Jagd' by Hadamar von Laber, dating from the second half of the fourteenth century, the hunter-lover pursues his stag-love along an arduous course, alternating encouragement and setback. The poem, playing on the dual conventions of the hunt and courtly romance, never quite allows the chase to reach its conclusion.

Knowledge of Clement's background and reputation immediately makes the choice of a very secular decorative scheme for the papal palace less surprising.

Proof of the young Tristan's nobility in Gottfried von Strassburg's epic poem *Tristan* of *c.*1210 came with his skill in 'excoriating' and displaying a hart after the kill. Having witnessed this lengthy and detailed process, King Mark's huntsmen declared him to be 'so marvellously well bred and accomplished ... Did you ever see anything so ingenious? ... Never did I hear of such refinements of the chase ... how perfect he was in the noble art of venery, and how he had set the quarry before the hounds.'[11] The description of the ritual dismemberment of a wild animal as a noble skill of a refined sensibility reads like a kind of pornography and clearly represented passionate and obsessive interest [125]. Gaston Phoebus, count of Foix, whose famous hunting book was widely read, led a life dominated by the kinds of pleasure that involved bloodshed either against men or animals. Gaston relates how, on return to their tents from a hunting expedition, ladies would help the men lace their sleeves with laces from their girdle bags and allow them to dry their hands on their white clothes, which 'thus afforded them amorous opportunities'.[12]

Hunting and sex

While the profession and expertise of hunting was claimed by men, women participated to some degree, especially in falconry. Images from a variety of artefacts witness their involvement. But interpretation of these kinds of image is never quite clear cut. Are we being shown images of events as they really happened, and are they entirely straightforward, or do their contexts, either in terms of their use or culture, suggest that they relate to allegory, or to additional layers of meaning? The other side to the courtly celebration of rural pursuits, or to the masculine culture of imperial falconry, is the image of the hunt in art and literature as part of the flirtatious culture of courtship [119, 126, 127]. There is plenty of evidence that the association in art and literature of women with hunting alluded to double pleasures, those of the sport itself and also to the pleasures of seduction. Since Dido and Aeneas or Diana and Actaeon of classical times, the stag chase had been a surrogate in literary imagery for seduction, enchantment, or the hunt of the imagination, while the boar was associated with raw sexuality.[13] Imagining his love being herself seduced by the prey, the hero Troilus in Chaucer's *Troilus and Criseyde* dreams of

> a boar with tusks great,
> That sleeps in the bright sun's heat.
> And with this boar, firmly in his arms enfolded,
> Lay kissing, his lady, bright Criseyde.

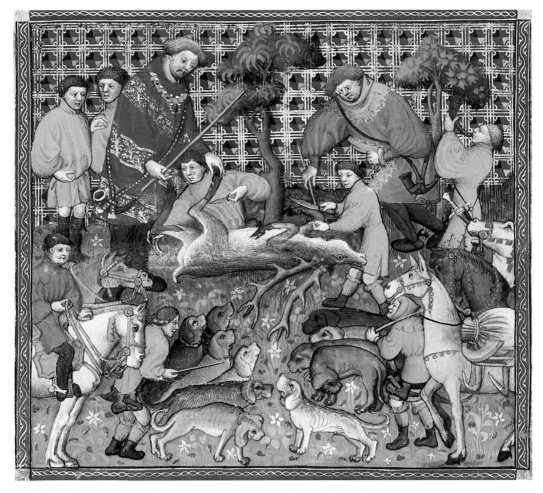

125

The master of the hunt quartering a stag, tempera on parchment, from Gaston Phoebus, *Le livre de la chasse*, c.1380.

Gaston Phoebus, count of Foix, in Béarn in south-western France, in the mid-fourteenth century, also wrote a standard work on hunting, lavishly illustrated with mouth-watering visions of verdant nature abounding with images of his henchmen freely displaying their cut-throat dismembering skills.

allegorical, highlighting the fragility of the balance between man and nature, there is no hint of dark content. Nor is there a sense of combat, or struggle between adversaries, or of the demonstration of mortal follies, like the hunting scenes that surround the *Beatus* page of the Peterborough Psalter [**8**]. The paintings only show huntsmen or fishermen at their tasks in a verdant landscape, and are more in tune with the notion of the pastoral conceit, the decorative use of rural pursuits and labour for aristocratic amusement.

Clement vi, who commissioned the decoration, was learned, a good diplomat and orator, and was indeed a patron of the arts. The younger son of minor nobility from the Corrèze, he was educated in monasteries from the age of ten and had risen in the rank of the ecclesiastical hierarchy in the service of the French king, having been previously chancellor of France and archbishop of Rouen upon his election in 1342. But he also had the reputation as a profligate lover of luxury, as being sexually active, and hosting banquets and festivities, and lavishing gifts and offices on members of his family and circle.

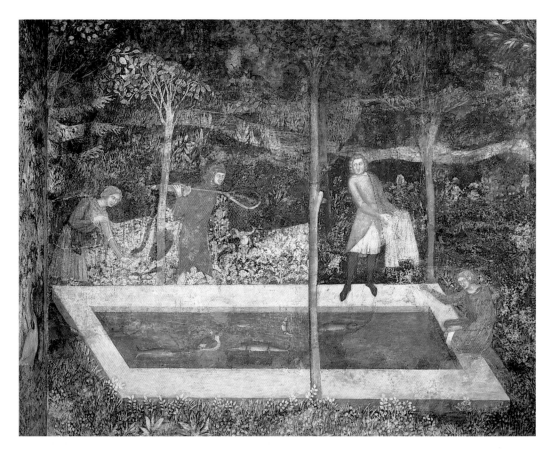

124 Matteo de Viterbo

Scene of fishing, wall-painting, Palais des Papes, Avignon, c.1356–64.

Clement VI's substantial enrichment of the palace at Avignon was one of the factors that signalled a firm move towards establishing the papacy permanently there rather than returning to Rome. It was likely also that it was a matter of personal and official prestige. Clement maintained that his predecessors had not known how to live like popes and that he was determined to run his household like that of a great prince.

case of need during wartime, advocating it for captains and men of arms, but adds: 'because there seemeth to be some peril in the learning thereof, and also it hath not been of long time much used, specially among noble men, perchance some reader will little esteem it, I mean swimming.'[8]

Game-hunting with hounds and with hawks was a universal aristocratic sport of the Middle Ages, described disparagingly in Robert of Bourne's moral handbook, *Handlyng Synne* (1303), as the fruits of idleness, 'pastimes not of clerks, but of emperors, kings, earls, barons and knights'.[9] It is all the more surprising therefore to find hunting scenes as a dominant theme of the wall-paintings in the so-called Chambre des Cerfs in the papal palace at Avignon [124]. The palace had been begun in 1335 as an austere fortress during the pontificate of Benedict XII, the third of the Avignonese popes, and completed as a great palace in 1351 during the succeeding reign of Clement VI. The paintings were situated in the pope's private apartments, so only visible to his immediate retinue.[10] They form the earliest surviving large-scale decorative scheme dominated by landscape, predating the popular Flemish *mille-fleurs* and hunting tapestries by about a hundred years. While it is possible that the scheme was meant to be

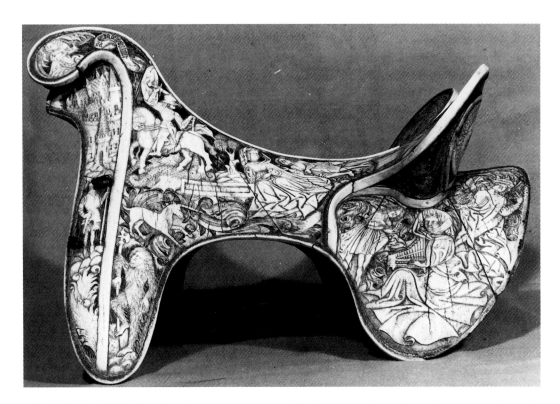

The hero grows grey while his love eludes him, thus preserving the safety and honour of his prey and retaining for him a perpetual sense of unfulfilled desire.

Visual images that dwell on the sexual aspects of hunting rarely echo these stories literally, but develop a parallel language of suggestion and double entendre. Playing on the imagination in a different way from literature, they also tend to offer more hope for the victorious conclusion of the chase. Romances, scenes of dalliance and of hunting, cover a type of wooden saddle overlaid with plaques of carved red-deer antler, known as a 'Hungarian' saddle, but probably common to Austria, Lombardy, and south Germany.[14] Three dating from the early fifteenth century in the Hungarian National Museum in Budapest are associated with King Sigismund (1387–1437), who presented one in 1431 as a ceremonial gift to the Romanian prince Vlad Drakul II, or Vlad the Impaler, otherwise known as Dracula [128].[15] Entirely at odds with Vlad's monstrous reputation as an obsessive torturer, these saddles picture a world full of dreamy princes and young huntsmen with roses, dragons and unicorns, long-haired princesses with flowing robes, male and female falconers, wild men capturing beasts, monsters, birds of prey, glorious foliage, and angels. Sexual allusions are indicated by embracing couples, often with very obvious suggestive overtones, such as the blatant emphasis of the folds of clothing between their legs.

Doing one thing while thinking of another

In a book of guidance on chaste and dutiful conduct written by the Ménagier de Paris for the benefit of his young wife, the author related a story from the *Romance of the Rose*, about the tragic Lucrece, incorporating in the course of the story a rare account of a range of popular pastimes.[16] Checking to see which of their wives had the 'best disposition of mind' worthy to lodge the emperor's son, Lucrece's husband and his friends took time off one evening from a siege that had been occupying them nearby. They found Lucrece sitting quietly alone reading her primer, while 'some ladies they found talking, others playing at bric, others at hot cockles, others at "pinch me", others playing at cards and other games of play with their neighbours; others who had supped together were singing songs and telling fables and tales and asking riddles; others were in the road with their neighbours playing at blind man's buff and at bric and so likewise at other games'. Lucrece was deemed the most virtuous and was chosen to host the emperor's son, only to be raped by him, which caused her such anguish that she committed suicide rather than endure the shame. The story was intended to teach a terrible lesson about the fragility of a wife's honour, but the method of testing it in the first place was to judge her susceptibility to games and distractions.

129

Game board, ivory and wood, Flemish, *c.*1430.

While an imaginary romantic board game might decorate a carved mirror frame, the real game provided a surrogate for seduction, and the chess board itself had its own distracting imagery. Around the perimeter of this Burgundian court artefact, a mixture of romantic, courtly, and fighting scenes is carved, including gardens with lovers at the fountain, musicians and dancing couples, fighting knights, and brave combats in a forest.

Casket, ivory, French, *c.*1350. This shows a tournament scene watched by admiring ladies and, next to it, the 'Chateau d'Amour', a romance episode showing castle walls defended against a siege by armed knights by maidens repelling their advances armed with roses. On the front are episodes from the 'Lay of Aristotle', such as are found illustrated in a wide variety of contexts from aquamaniles, tapestries, misericord seats, and marginal images in manuscripts.

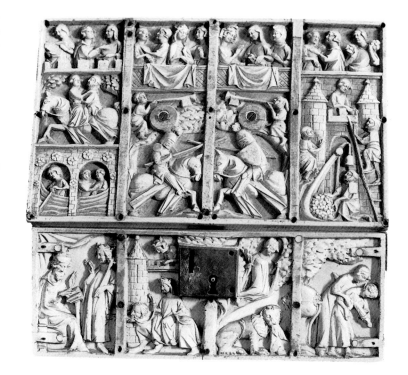

Images in the margins of manuscripts and on mirror backs sometimes show men and women playing at board games. An early fourteenth-century mirror case in the Louvre shows a man and woman at play, helped by two assistants, the woman's dress falling in the customary suggestive deep 'v' folds between her legs. One of the purposes of games is supposed to be to parody the values and behaviour of the real world, allowing space for levity and competition within a structure of rules of engagement. Evidently, one way in which couples could engage openly in flirtatious contact was by means of a game of draughts [**129**]. These scenes of couples at play have been related to romances—one such scene on an enamel belonging to Louis of Anjou was described as showing a game of chequers played by Tristan and Iseult to while away the hours on the boat journey from Ireland to Cornwall before the couple became lovers.

Combing, preening, gaming, hunting, dancing, fighting, and flirting—thus was the culture of courtly pleasure highly self-regarding and self-referential. Many objects on which one finds sporting and fighting imagery belonged to the boudoir and drew the combative knightly culture into a gentler domestic world. Caskets displaying tournament scenes were very popular, probably as bridal gifts, and must have been virtually mass-produced in Paris in the early fourteenth century [**130**]. Images are juxtaposed on these caskets with an element of satire and wry humour. A typical example of these in the Carrand Collection in Florence has a tournament on

the lid, a display of male sporting prowess admired by a balcony full of ladies. So, side by side we have women simultaneously encouraging and repelling male advances. Just to reinforce the message that neither men's physical strength nor intellect was a match for the will and power of women, Aristotle being bridled by Phyllis appears on the front. The story goes that Aristotle was Alexander the Great's teacher and reprimanded him for paying more attention to his mistress, Camaspe, than to his books. In revenge, Camaspe, otherwise known as Phyllis, seduced Aristotle and made him submit to being ridden by her in front of Alexander, who was watching from the windows of a tower.

Parody and humour

No precedent from an earlier date has yet been found in secular buildings for the muscle-bound, naked caryatid figures acting as vault rib corbels above the staircase of one of the eight towers around Frederick II's Castel del Monte in Apulia [131]. There is an aggressively male character to these figures, striking athletic poses as if supporting the roof is no effort, and showing off their genitals with what has been described as 'unrestrained openness'.[17] They rather underline the atmosphere of a male-dominated culture around the sporting pursuits of Frederick II's court.

'Atlas' figures as corbel supporters to roof and turret structures may have been widespread in secular buildings, but not enough complete examples survive for this to be known for certain. Corbels and gargoyles around the roofs of churches had been carved as atlantes since

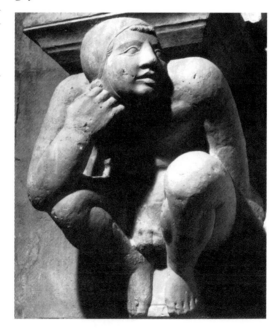

131

'Atlas' figure, stone corbel, from staircase to turret no. 7, Castel del Monte, Apulia, c.1250–60.

Castel del Monte, situated at the summit of a hill overlooking the plain between Cerignola and Bari, was designed for Emperor Frederick II not for defence, but for pleasure as a hunting lodge with eight rooms on each of two floors, just large enough to accommodate a hunting party and retinue. These figures in Apulia have been compared to semi-naked figure corbels in the transept of Strasbourg Cathedral, which share an element of the muscle-flexing show of strength that gives them a similar masculinity.

the twelfth century in northern Europe. Such figures have a long history in the plastic arts, reaching back to the ancient Greek figure of Atlas, shown supporting the world. In addition to the symbolism of the weight of responsibility, the medieval atlas becomes a figure that either invites pity by being clearly locked permanently into a situation of unbearable strain, or that threatens equilibrium by irresponsibly trying to upset the balance of the structure it is supposedly supporting. Playing on their fictive function as supporters, a Dominican preacher, John Bromyard, likened the image of the corbel straining to support its load to those people who noisily sympathize with others' misfortunes yet do nothing to help, or to slothful clergy who complain of the least imposition as if it were a great trial.[18]

Emphasizing the indignity of their predicament by acting in a ridiculous fashion is a pair of roof corbels about a century later than those at Castel del Monte, from a parish church at Heckington in Lincolnshire [132]. Under the illusion of supporting a small gable on a buttress, a half-clothed monkey is paired with a naked man who pulls his mouth and points to his bottom. The monkey is turning away with shock while the man is making a defiant gesture—pulling at the mouth was tantamount to an insult, while pulling at his bottom is self-evidently rude. The phenomenon, known as the 'world-turned-upside-down', of animals lampooning the antics of men while men behave with rampant bestiality, was thought to be hugely amusing, but also, characteristically, tinged with morality. In the context of a church, the message is more about pointing out human folly than celebrating male strength. Placed as this is at the

132

The world-turned-upside-down: a naked man and a clothed monkey, stone corbel, St Andrew, Heckington, Lincolnshire, c.1330.

The man pulls his mouth and points to his bottom in a form of insult, while the monkey purses its lips in contrast and apparent disapproval.

edge of a church, humour is harnessed in the interests of reinforcing orthodoxy. The image straddles the religious and secular worlds and performs within both, as a diverting distraction and enjoyable jest, and as a social corrective and grotesque parody. Dante describes the proud in purgatory as being bent, agonizing creatures, struggling to support great burdens of stone. They recall in their unfortunate servitude crouching corbel figures in medieval churches, which join knees to breast in a posture that 'though unreal begets real discomfort in him who sees it'.[19]

A spirit of pleasurable parody is licensed in the marginal illustrations of an early fourteenth-century Latin Bible made in Flanders [133]. The world-turned-upside-down is here in force, with a few salacious details, references to human follies, and drolleries, lampooning a number of conventions of secular and religious culture. Counterbalancing the seriousness of the main purpose of the book are animal chases, boar and hare hunts, made all the more ludic by their sober textual anchor. As if celebrating their conquests, a carnivalesque ball is taking place below them to the sounds of an orchestra composed of monkeys, dogs, goats, and hares, while a variety of dogs, hares, and rabbits join a vigorous dance. Although this manuscript was owned in the fifteenth century by the Burgundian royal family, the patron of this lively page is not known. It is fairly clear, however, that the drollery is being directed at a cleric.[20] Next to the illuminated initial of the main text, above a pair of angel musicians, a monkey holds up a urinal in parodic toast towards a bishop who kneels in front of the Virgin and Child. This little episode of caustic humour happens almost opposite the donkey and goat participating in a mass, so it is very likely that the bishop is either the donor or the original owner of the manuscript and that the imagery was somehow directed towards him. This puts a very interesting perspective on the whole interpretation. If he had been the kind of bishop who was lax in his morals, and who enjoyed hunting, he may have been the butt of the jokes. Or perhaps he disapproved of such things and had them represented in jocular form as examples of human follies to be avoided. Either way, there is a strong element of fun at the expense of higher clergy, which may indeed be intentional self-mockery, based on an understanding both of the pleasures and the critical force of the scenes being represented.

Another kind of object, a piece of witty tableware, also indulges in jokes at the expense of the clergy [134]. Two figures of bishops peep out from within a three-storeyed, arcaded house that forms the centre of the earliest known ceramic puzzle jug, made in thirteenth-century Saintonge in western France. Leaning out from lower windows are figures of girls straining to hear the music of two fiddlers playing below. In a kind of parody of richer vessels made of more

133

Marginal scenes from a Bible, manuscript painting, Flemish, first quarter of fourteenth century.

On the sides we have a hare tournament, a wolf swallowing a sheep, and a donkey singing the mass while a goat holds the cross. In the lower margin is a sequence of secular love scenes. A hunter with falcon bids farewell to his woman, a kneeling man is being crowned by another woman, and two young lovers are embracing while being serenaded by a violinist.

Puzzle jug, glazed ceramic,
Saintonge, western France,
*c.*1300.

This is probably the earliest
puzzle jug known, a virtuoso
piece of ceramic tableware
designed to amuse dinner
guests. Liquid was poured in
through the handle and out
through the long-necked mule
forming the spout.

precious materials, which would be emblazoned with family crests, the top is encircled by invented heraldry. There is little doubt that this is meant to represent a brothel, with the bishops trying to avoid being noticed. The spout is in the form of a long-eared, long-necked mule and it is from its head that liquid emerged, having been poured in along the hollowed-out handle. It is easy to imagine the increasing hilarity as this vessel was passed around at a dining table with guests being surprised at the route taken by the liquid, spotting the figures within and without, and exchanging ribald comments. Not only does this jug contain a whole story relating to its making, use, and imagery, but the real pleasure of the object lies in the fact that, in common with the best marginalia, it is a piece of enjoyable decoration that is both political and critical of the status quo.

Treasure

Images of a quite different drinking culture are conjured up by a highly decorated precious silver-gilt cup from Gotland [**135**]. Found among the treasures of a wealthy merchant-peasant from Dune in Gotland, it is one of those extraordinary objects that bear witness not only to wide-ranging cultural contact, but to the immense awe, puzzlement, and pleasure it inspired and continues to inspire. The little cup was part of a treasure hoard of 121 objects, the largest known

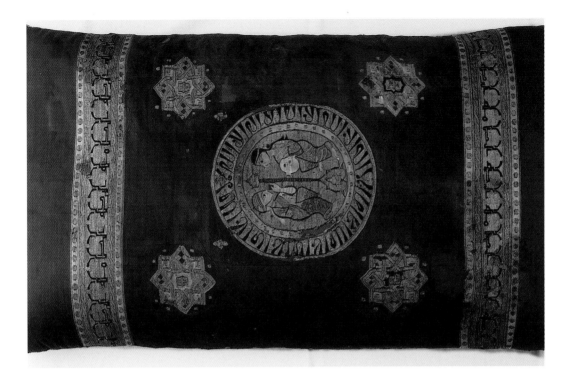

136

Funerary cushion of Berenguela, queen of Léon and of Castile, silk taffeta and gold thread, monastery of Santa Maria la Real de Huelgas, Burgos, *c.*1246.

Within a framework of Christian piety, these songs honoured the Virgin and her many compassionate and miraculous interventions to assist sinful mortals, combining elements of Arab and Jewish music with ribald secular storytelling and traditional terms of Christian prayer. Berenguela's mother is said to have loved music and dancing and to have enjoyed the performances of jongleurs. This cushion is perhaps witness to her daughter's continuation of those pleasures into her grave.

and use, and early history, might have turned to pain in the hands of its last owner.

Comfort

The gorgeous red silk cushion of Queen Berenguela of Léon is another of those objects at once extraordinarily simple and highly complex, witness to a union of ideas from more than one culture [**136**]. Designed to provide both spiritual and material comfort and luxury, in its way it is a considerable treasure, not least because despite its great fragility it has survived intact. The eldest daughter of Eleanor Plantagenet and Alphonso XIII of Castile, Berenguela's marriage to King Alphonso IX of Léon eventually led to the union of the two kingdoms of Léon and Castile. Berenguela had been active in rulership and politics, taking control of Castile as regent for the time of the brief minority rule of her younger brother Henrique from 1214 to 1217. She then continued as regent for her son Ferdinand, until the death of her husband in 1230, whereupon she ceded the throne formally to him as Ferdinand III. Towards the end of her life in 1246, Berenguela retired to the Cistercian convent of Las Huelgas at Burgos, which had been founded a quarter of a century earlier by her mother, Eleanor.[24] Although it was placed in her coffin, her cushion captures just the atmosphere of simple piety and restrained luxury that must have characterized this convent for queens, helping to make their declining years both pleasurable and restful. Its body is covered in silk taffeta and applied to it are tapestry silk stars and two encircling bands made in colours and gold thread with the words 'the perfect blessing' in kufic lettering woven into them. At the centre is a medallion around which is another kufic inscription, with the words 'there is no other god but God' (or 'there is no other god than Allah'), the opening words of the Q'ran. It surrounds a woven image, reminiscent of Coptic textiles, of two figures either side of a schematic Tree of Life, a woman playing a lute and a man in a turban dancing. The imagery of the cushion derives from a strongly religious culture tempered by cultural contact with Arab Muslims, whom Berenguela and her predecessors and successors had all conquered and driven south, but had clearly also learned from and respected. Mudejar, or Hispanic-Arab, craftsmen worked on many aspects of the fabric of Las Huelgas, notably the famous coffered plasterwork ceiling of the cloisters, which has been described as the finest example of such work outside the Alhambra Palace in Granada. Not only the style and fabric of its decoration, but the subject matter incorporates a number of other dimensions of this hybrid courtly–religious culture. At about this time, the future King Alphonso X was starting to compile what became a famous collection of songs, the 'Cantigas de Santa Maria', which straddled similar worlds of secular and religious life in Spain.[25]

135

Cup, silver gilt, from Dune treasure, Gotland, possibly made in Bulgaria, eleventh or twelfth century.

Its form and technique of manufacture, from repoussé-worked silver, with chased and punched decoration, conform to known classical Roman types. But the form also has a distinctly Chinese inspiration, especially the leaf-like thumb plate over the handle. An embossed frieze of paired lions, birds, palm trees, acanthus leaves, and volutes around the bowl has also been likened to Chinese prototypes, but may have a Sassanid or Persian origin. This harmonious combination of many different design elements indicates an Eastern Mediterranean, possibly Bulgarian origin.

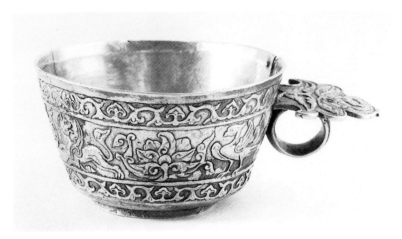

from the Middle Ages, which was buried in a wooden box at the time of the Danish invasion led by King Valdemar Atterdag in 1361. Its owner must have been afraid not only for its safety, but for his own and that of his family, justifiably as it turned out, as the invasion resulted in a massacre that devastated the male population of the island.

The design of the cup is complex, combining features from many disparate sources, and it is most likely that it was made in the eleventh or twelfth century in one of the areas of central or eastern Europe where eastern and western cultures were most entwined.[21] Indeed, a very similar example, the cup of Sivin, was found at Preslav in Bulgaria.[22] The eventual destination of the Dune cup, the area of Gotland at the northern edge of the Baltic Sea, was of strategic importance for trade between East and West, and in the course of the eleventh and twelfth centuries it grew into an increasingly active and contested commercial centre. Competing with the locals at the town of Visby were powerful German merchants who, formed into the Hanseatic League based in Lübeck in the fourteenth century, came to dominate the herring, spice, and cloth trades across Europe. At some point in the Scandinavian phase of its history, the cup was invested with magic properties. Its owner or one of his predecessors had inscribed in runes in the base a name, Vämund, and a magic formula, 'Sator Arepo tenet opera rotas'. These words, written one below the other, form a word-square and a palindrome based on the opening words of the Lord's Prayer, or 'Pater Noster', and translate roughly as 'The sower holds with labour the wheels of the plough'.[23] The palindrome was sometimes also used as a curative charm, or as an instrument to assist in childbirth, but perhaps in this instance as a kind of apotropaic charm to keep the hoard, its owners, or just the cup in safety. Whichever the case, it appears that the pleasurable overtones with which this object was associated through its making

Notes

Introduction

1. *The Travels of Sir John Mandeville*, trans. C. W. R. D. Moseley (Harmondsworth 1983), 45.

Chapter 1. A Sense of Place

1. J. Williams, 'Isidore, Orosius and the Beatus Map', *Imago Mundi* (1997), 49.
2. Pere de Palol, *El Tapis de la Creacio de la Catedral de Girona* (Barcelona 1986); J. Calzada i Oliveras, 'El Mosaic de la sinagoga de Beth-Alfa I el Tapis de la Creacio de la Catedral de Girona', *Revista de Girona*, 92, Tercer Trimestre 1980; Esteve Carbo Ponce, 'Reflexions sobre el simbolisme del 'Tapis de la Creacio' de la catedral de Girona s. XI' (doctoral thesis, University of Barcelona 1999).
3. J. Schulz, 'Jacopo de Barbari's *View of Venice*: Map Making, City Views and Moralized Geography before the Year 1500', *Art Bulletin* 60 (1978), 425–74.
4. J. B. Harley and D. Woodward (eds), *The History of Cartography* I (Chicago and London 1987), 286–370.
5. A. Wolf, 'News on the Ebsdorf World Map: Date, Origin, Authorship', in *Géographie du Monde au Moyen-Age et à la Renaissance*, ed. M. Pelletier (Paris 1989), 51–68.
6. P. D. A. Harvey, *Mappa Mundi: The Hereford World Map* (London 1996); G. Crowe, 'New light on the Hereford World Map', *Geographical Journal* 131, part 4 (Dec. 1965), 447–62.
7. H. Mayr-Harting, *Ottonian Book Illumination* vol. 1, (London 1991), 157–62.
8. R. W. Southern, *The Making of the Middle Ages* (London 1967), 20.
9. *The Pilgrim's Guide to Santiago de Compostela*, ed. W. Melczer (New York 1993), 90–6; M. L. Nolan, 'Shrine locations: Ideals and Realities in Continental Europe', in *Luoghi sacri e spazi della santita*, ed. S. B. Gajano and L. Scaraffia (Turin 1990), 23–35.
10. R. Mellinkoff, *Outcasts: Signs of Otherness in Northern European Art of the Late Middle Ages*, Berkeley 1993.
11. H. E. J. Cowdray, 'The Latin Kingdom of Jerusalem', in *Popes, Monks and Crusaders* (London 1984), XVII, 228–34.
12. V. Sekules, 'The Tomb of Christ at Lincoln and the Development of the Sacrament Shrine: Easter Sepulchres Reconsidered', *British Archaeological Association Conference Transactions* (Lincoln 1982), (1986), 118–31.
13. R. G. Ousterhout, 'The Church of Santo Stefano: a Jerusalem in Bologna', *Gesta* XX/2 (1981), 311–21.
14. J. Le Goff, *The Medieval Imagination* (Chicago 1992), 53–4.
15. G. R. Owst, *Literature and Pulpit in Medieval England* (Oxford 1961), 238.
16. R. Hilton, *Bond Men Made Free* (London 1973), 25–62.
17. G. Holmes, *Europe: Hierarchy and Revolt 1320–1450* (London 1975), 241.
18. *The Très Riches Heures of Jean, Duc of Berry* (New York 1969), intro. by J. Longon, 13–26.
19. J. M. Richard, *Mahaut comtesse d'Artois et de Bourgogne (1302–1329)* (Paris 1887), 48–60.
20. J. Alexander, 'Medieval Art and Modern Nationalism', in *Medieval Art: Recent Perspectives; a memorial tribute to C. R. Dodwell*, ed. G. R. Owen, N. Crocker and T. Graham, 209; T. A. Heslop, in *Age of Chivalry* (London 1987), cat. 193, 273.
21. P. D. A. Harvey, *Medieval Maps* (London 1991), 94–5.
22. *Andrea Mantegna*, ed. J. Martineau (London, Royal Academy exhibition catalogue, 1992), 258–72.
23. L. Jardine, *Worldly Goods* (London 1996), 295–300.

Chapter 2. Artists

1. R. Allen Brown, H. M. Colvin, A. J. Taylor, *The History of the King's Works*, I (London, HMSO 1963), 227; E. Welch, *Art and Society in Italy 1350–1500* (Oxford 1997), 94, fig. 43.
2. P. Lasko, *Ars Sacra* (London 1972/1994), 158; P. de Palol and M. Hirmer, *Early Medieval Art in Spain* (London 1967), 479–80, pls 80–1.
3. T. Tolley, 'John Siferwas: The Study of an English Dominican Illuminator', Ph.D.

thesis, University of East Anglia 1984, 2–93.

4. M. Mentré, 'L'enlumineur et son travail selon les manuscrits hispaniques du Haut Moyen-Age; in *Artistes, artisans et production artistique du Moyen-Age*, ed. X. Barral i Altet, vol. 1 (Paris 1986), 295–309.

5. Marcel Durliat, 'La Sculpture du XIᵉ Siècle en Occident', *Bulletin Monumental*, vol. 152 (1994), fig. 46.

6. J. Pope-Hennessy, *Italian Gothic Sculpture* (Oxford 1955/1986), 2–12, 169–72, 175–9, pls 1–10, 16–22.

7. Ibid., 177–8.

8. J. White, *Art and Architecture in Italy 1250–1400* (Harmondsworth 1966), 203.

9. T. G. Frisch, *Gothic Art 1140–c.1450: Sources and Documents* (Medieval Academy of America/Toronto 1987), 167–8; M. Baxandall, *Painting and Experience in Fifteenth-Century Italy* (Oxford 1985), 111–14.

10. R. H. Hilton, *English and French Towns in Feudal Society: A Comparative Study* (Cambridge 1992/5), 53–86; C. Dyer, *Standards of Living in the Later Middle Ages: Social Change in England c.1200–1520* (Cambridge 1989), 24–5; D. Nicholas, *The Later Medieval City 1300–1500* (London 1997), 80–4, 203–57, 266–74.

11. R. R. Sharpe, *Calendar of Letterbooks of the City of London* (1889), part 1, 194, 475; V. Sekules, 'Women and art in England in the thirteenth and fourteenth centuries' in *Age of Chivalry* (London, Royal Academy of Arts, 1987), 45.

12. *The Vision of Piers Plowman*, ed. A. V. C. Schmidt (London 1984), 49.

13. E. G. Holt, *Documentary History of Art*, 1 (Princeton 1957), 96–101; J. Harvey, *Medieval Craftsmen* (London and Sydney 1975), 87.

14. White, *Art* (1966), 291–302; N. Dawton, 'The Percy Tomb Workshop', in *Medieval Art and Architecture in the East Riding of Yorkshire*, ed. C. Wilson, British Archaeological Association Conference Transactions IX for 1983 (1989), 121–32.

15. Theophilus, *On Divers Arts*, trans. J. G. Hawthorne and C. Stanley Smith (New York 1979), 13.

16. C. Cennini, *The Craftsman's Handbook*, ed. D. V. Thompson (New York 1933).

17. F. Henry, *Irish Art* (New York 1970), 94–5.

18. Baxandall, *Painting and Experience*, 1972/1985), 8–9.

19. Ibid., 17.

Chapter 3. Art and Power in the Church

1. Quote from J. N. D. Kelly, *The Oxford Dictionary of Popes* (Oxford 1986), 186; see also B. Bolton, *Innocent III: Studies on Papal Authority and Pastoral Care* (Variorum 1995), and Bolton, *The Medieval Reformation* (London 1983).

2. R. Bartlett, *The Making of Europe: Conquest, Colonisation and Cultural Change 950-1350* (London 1994), 4–23.

3. H. J. Schuffels, 'Bernward Bischof von Hildesheim. Eine biographisches Skizze', in *Bernward von Hildesheim und das Zeitalter der Ottonen* (Hildesheim 1993), 29–43; P. Lasko, *Ars Sacra* (London 1994), 111–23.

4. Ibid., 154–6.

5. T. A. Heslop, 'Towards an iconology of croziers'; in *Studies in Medieval Art and Architecture presented to Peter Lasko*, ed. D. Buckton and T. A. Heslop (London 1994), 38.

6. J. Mitchell, 'The Crypt Reappraised', *San Vincenzo al Volturno* 1, *Archaeological Monographs of the British School at Rome*, 7, ed. R. Hodges (1993), 75–114; R. Hodges and J. Mitchell, 'The Assembly Room: part of the lower thoroughfare', *San Vincenzo al Volturno* 2, *Archaeological Monographs of the British School at Rome*, 9, ed. R. Hodges (1995), 26–64.

7. A. Abulafia, 'Bodies in the Jewish-Christian debate', in *Framing Medieval Bodies*, ed. S. Kay and M. Rubin (Manchester 1994), 123–37.

8. G. Zarnecki, *Studies in Romanesque Sculpture* (London 1979), 'The Chichester reliefs', 106–19.

9. O. Demus, *Romanesque Mural Painting* (London 1970), 629–30, pls 290–3.

10. J. Favières, 'La Nuit des Temps', *Berry Roman*, 32 (1970), 265.

11. Theophilus, *On Divers Arts*, ed. J. G. Hawthorne and C. Stanley Smith (New York 1979), 79.

12. E. Panofsky and G. Panofsky-Soergel (ed. and trans.) *Abbot Suger on the Abbey Church of St-Denis and its Art Treasures* (Princeton 1979), 41–3, 51.

13. W. Tatarkiewicz, *History of Aesthetics*, II (Warsaw 1970), 187.

14. *Cistercians and Cluniacs: The Case for Citeaux*, Cistercian Fathers Series, no. 33 (Kalamazoo 1977), 42.

15. C. Rudolph, *The Things of Greater Importance: St Bernard of Clairvaux's Apologia and the Medieval Attitude towards Art* (Pennsylvania 1990), 227–337.

16. Ibid., 20–56.

17. F. Gandolpho, 'Il Chiostro di Monreale', *I Normanni: Popolo d'Europa*, ed. M. d'Onofrio (Rome 1994), 237–43.

18. O. Demus, *The Mosaic Decoration of San Marco, Venice* (Chicago and London 1988),

108–14.

19. P. Brown, *The Cult of Saints: Its rise and function in Latin Christianity* (Chicago 1982), 88.

20. W. Cahn, 'Heresy and the Interpretation of Romanesque Art', in *Romanesque and Gothic: Essays for George Zarnecki*, 2 vols (Woodbridge 1987), 27–34; M. Lambert, *Medieval Heresy* (Oxford 1997), 46–8.

21. The standard work illustrating all the French examples is W. Sauerlander, *Gothic Sculpture in France 1140–1270* (London 1972).

Chapter 4. Design and Devotion

1. A. Abulafia, 'Bodies in the Jewish-Christian debate', in *Framing Medieval Bodies*, ed. S. Kay and Miri Rubin (Manchester 1994), 123–37.

2. M. Camille, *The Gothic Idol* (Cambridge 1989), 197–241.

3. G. R. Owst, *Literature and Pulpit in Medieval England* (Oxford 1961), 139.

4. E.g. Senlis, Mantes, Chartres, north transept. (W. Sauerlander, *Gothic Sculpture in France 1140–1270* (London 1972), pls 44–79.

5. P. Kurmann, *La Façade de la Cathédrale de Reims*, 2 vols (Lausanne 1987), vol. 1, 201–16.

6. R. Branner, *St Louis and the Court Style* (1965); N. Coldstream, *The Decorated Style* (London 1994), 7–59.

7. J. Bugslag, 'Early Fourteenth-Century Canopy Work in Rouen Stained Glass', in *Medieval Art and Architecture at Rouen*, ed. J. Stratford, British Archaeological Association Conference Transactions for 1986 (1993), 73–80.

8. L. Jacobus, 'Piety and Propriety in the Arena Chapel, Padua', *Renaissance Studies* 12/2 (1998), 177–205, and 'Giotto's Annunciation in the Arena Chapel, Padua', *Art Bulletin* 81/1 (1999), 93–107.

9. G. G. Coulton, *Life in the Middle Ages* (Cambridge 1967), vol. 1, 175, no. 102; T. A. Heslop, 'Attitudes to the visual arts: The evidence from Written Sources', in *Age of Chivalry* (London 1988), 26–32.

10. H. Belting, *Das Bild und sein Publikum im Mittelalter* (Berlin 1981), 204–51.

11. A. Derbes, *Picturing the Passion in Late Medieval Italy: Narrative Painting, Franciscan Ideologies, and the Levant* (Cambridge 1996), 1–34.

12. T. A. Heslop, 'Attitudes', 26; *Medieval Popular Religion, 1000–1500: A Reader*, ed. J. Shinners (Ontario 1997), 439–98.

13. Shinners, ibid., 6–12.

14. M. Rubin, *Corpus Christi: The Eucharist in late medieval culture* (Cambridge 1991), 164–85.

15. V. Sekules, 'The Tomb of Christ and the development of the sacrament shrine: Easter sepulchres reconsidered', *British Archaeological Association Conference Transactions, Lincoln 1982* (1986), 118–31; P. Sheingorn, *The Easter Sepulchre in England* (Kalamazoo 1987), 6–25.

16. E. Duffy, *The Stripping of the Altars* (New Haven and London 1992), 91–130.

17. J. Le Goff, *The Birth of Purgatory* (1981; London 1984), 289–333.

18. P. Crossley, 'The Man from Inner Space: Architecture and Meditation in the Choir of St Laurence in Nuremberg', in *Medieval Art Recent Perspectives*, ed. G. G. Owen-Crocker and T. Graham (Manchester and New York 1998), 165–82.

19. T. S. R. Boase, *Death in the Middle Ages* (London 1972), 104; P. Binski, *Medieval Death* (London 1996), 134–8, pl. 7.

20. Binski, *Medieval* (1996), 139–63.

21. The *Virgin and Child* by Jakob Kaschauer is illustrated in P. Volk, *Bayerisches Nationalmuseum München* (1991), pl. 17, 33.

22. S. Haskins, *Mary Magdalen: Myth and Metaphor* (London 1993), 3–191.

23. E.g. K. K. Jambeck, 'Patterns of women's literary patronage in England, 1200–c.1475', in *The Cultural Patronage of Medieval Women*, ed. J. Hall McCash (Georgia 1996), 228–65; M.-L. Ehrenschwendtner, 'Puellae Litteratae: The Use of Vernacular in the Dominican Convents of Southern Germany', in *Medieval Women in their Communities*, ed. D. Watt (Cardiff 1997), 49–71; C. Frugoni, 'La Femme sait lire', in *Histoire des Femmes en Occident*, ed. G. Duby and M. Perrot (Rome, Bari 1990), 412–39.

24. J. Mitchell, 'Painting in East Anglia around 1500: the continental connection' in J. Mitchell, ed., *England and the Continent: Essays in memory of Andrew Martindale*, (Harlaxton Medieval Studies VIII, Stamford 2000), 365–80.

25. Duffy, *Stripping* (1992), 11–52; J. Hamburger, *Nuns as Artists: The Visual Culture of a Medieval Convent* (Berkeley and London 1997), 102–36.

26. H. van Os, *The Art of Devotion in the Late Middle Ages in Europe 1300–1500* (London and Amsterdam 1994), 156; A. Eljenholm Nichols, *Seeable Signs: The Iconography of the Seven Sacraments 1350–1544* (Woodbridge 1994), 90–128.

27. Thomas à Kempis, *The Imitation of Christ*, ed. L. Shirley Price (Harmondsworth 1976), 192–5.

Chapter 5. Image and Learning

1. Bernard of Chartres's remark was cited by John of Salisbury in *c.*1159. G. Beaujouan,

'Transformation of the Quadrivium', in *Renaissance and Renewal in the Twelfth Century*, ed. R. L. Benson and G. Constable (Toronto, Medieval Academy of America 1991), 485.

2. Synod of Arras, 1025, derived from a letter written by St Gregory in the sixth century. In later formulations these were slightly transformed to state categorically that 'pictures were the books of the unlettered'.

3. P. Dronke, *Women Writers of the Middle Ages. A Critical Study from Perpetua to Margaret Porete* (Oxford 1984), 144–20.

4. C. Rawcliffe, *Medicine and Society* (Stroud 1995), pl. 9, 85–7.

5. Psalter of Robert de Lisle, British Library, Arundel MS 83/11, *c.*1310 and before 1339 (*Age of Chivalry*, cat. 569); Sandler (1986), cat. 38, vol. 2, 43–5.

6. E. Grant, *The Foundations of Modern Science in the Middle Ages* (Cambridge 1996), 127–67.

7. J. Tester, *A History of Western Astrology* (Woodbridge 1987), 197; Rawcliffe, *Medicine* (1995), 86.

8. Ibid., 196.

9. W. Tatarkiewicz, *History of Aesthetics* (Warsaw 1970), vol. 2, 60; A. Hyman and J. J. Walsh, *Philosophy in the Middle Ages* (Indianapolis 1974), 50.

10. A. C. Esmeijer, *Divina Quaternitas* (Amsterdam 1978), 55, discusses centres for exegesis.

11. H. Mayr Harting, *Ottonian Book Illumination* (London 1991) vol. 1, 126–9; B. Bischoff, 'Literarisches und künstlerisches Leben in St Emmeram (Regensburg) während des frühen und hohen Mittelalters', *Mittelalterlichen Studien* ii (Stuttgart 1967), 77–89; A. Katzenellenbogen, *Allegories of the Virtues and Vices* (Toronto, Medieval Academy of America, 1989), 35.

12. M. Lapidge, 'Byrhtferth', in *The Blackwell Encyclopaedia of Anglo-Saxon England*, ed. M. Lapidge, J. Blair, S. Keynes, D. Scragg (Oxford 1999), 78–9.

13. M. Carruthers, *The Book of Memory: A Study of Memory in Medieval Culture* (Cambridge 1990), 251.

14. C. de Hamel, *A History of Illuminated Manuscripts* (London 1986), 97–101; Carruthers, *Memory*, 242–50.

15. F. Yates, *The Art of Memory* (Harmondsworth 1966), 17–41.

16. Carruthers, *Memory*, 221–57; M. Evans, 'Fictive Painting in Twelfth-Century Paris', in *Sight and Insight; Essays in Honour of E. H. Gombrich at 85*, ed. J. Onians (London 1994), 73–87.

17. Yates, *Art* (1966), 175–96.

18. A. Katzenellenbogen, *Allegories of the Virtues and Vices*, (Toronto, Medieval Academy of America, 1989), 14–21.

19. Ibid., 19–20, pl. x, 19.

20. M. Evans, 'The Iconography of the Arts Reconsidered', in *Medieval Women*, ed. D. Baker (Padstow, 1978), 303–29.

21. A. Kruger and G. Runge, 'Lifting the Veil: Two Typological Diagrams in the *Hortus Deliciarum*', *Journal of the Warburg and Courtauld Institutes* 60, 1998, 1–22.

22. R. Baxter, *Bestiaries and their Users in the Middle Ages* (Stroud 1998), 29–82; X. Muratova, 'Bestiaries: an aspect of Medieval Patronage', in *Art and Patronage in the English Romanesque* (London 1986), 118–44.

23. R. Branner, *Manuscript Painting in Paris during the Reign of St Louis* (Berkeley 1977), 22–65; M. H. Caviness, 'Anchoress, Abbess, and Queen: Donors and Patrons or Intercessors and Matrons?', in J. Hall McCash, ed., *The Cultural Patronage of Medieval Women* (Georgia 1996), 105–54.

24. De Hamel, *History*, 107–35, n. 14.

25. T. A. Heslop, 'Eadwine and his Portrait', in *The Eadwine Psalter: Text Image and Monastic Culture in Twelfth-Century Canterbury* (London and University Park 1992), 178–85.

Chapter 6. Art and War

1. 'King Harald's Saga', Harald Hardrada of Norway (from Snorri Sturluson's *Heimskringla*), trans. and intro. M. Magnusson and H. Paesson, (Harmondsworth 1966/1982), 11.

2. D. J. Bernstein, *The Mystery of the Bayeux Tapestry* (London 1986), 31–6.

3. Ibid., 89–107.

4. Ibid., 166–78; S. Lewis, *The Rhetoric of Power in the Bayeux Tapestry* (Cambridge 199); *The Study of the Bayeux Tapestry*, ed. R. Gameson (Woodbridge 1997).

5. Bernstein, *The Mystery* (1986), 106–7; C. R. Dodwell, 'The Bayeux Tapestry and the French Secular Epic', *Burlington Magazine* CVIII (1966), 549–60.

6. K. Staniland, *Embroiderers* (London 1994), 22–3, 38.

7. C. R. Dodwell, *Anglo-Saxon Art: A New Perspective* (Manchester 1982), 134–6; E. van Houts, *Memory and Gender in Medieval Europe*, 900–1200 (Cambridge 1999), 102–3.

8. A. Martindale, 'Art in the Secular World', unpublished manuscript, University of East Anglia.

9. J. Bradbury, *The Medieval Siege*

(Woodbridge 1992), 206–13; R. Rogers, *Latin Siege Warfare in the Twelfth Century* (Oxford 1992), 154–92.

10. M. Pages i Paretas, 'Mestre de la conquesta de Mallorca', *Prefiguració del Museu Nacional d'Art de Catalunya* (Barcelona 1992), 201–3.

11. A. Martindale, 'The Venetian Sala del Gran Consilio and its Fourteenth-Century Decoration', in *Painting the Palace: Studies in the History of Medieval Secular Painting* (London, 1995), 144–93.

12. P. Binski, *The Painted Chamber at Westminster* (London 1986), 97.

13. Ibid., 87–94.

14. H. Schroeder, *Der Topos der Nine Worthies in Literature und Bildender Kunst* (Gottingen 1971) is the standard work.

15. J. M. Steadman, 'The Arming of an Archetype: Heroic Virtue and the Conventions of Literary Epic', in *Concepts of the Hero in the Middle Ages and the Renaissance*, ed. N. T. Burns and C. Reagan (London 1976), 147–96.

16. C. Blair, *European Armour* (London 1958), 92–107; M. Pfaffenbichler, *Armourers* (London 1991).

17. H. A. Tummers, *Early Secular Effigies in England* (Leiden 1980), 78–126.

18. Sir John Froissant, *Chronicles of England, France and Spain and the Adjoining Countries*, ed. T. Johnes (London 1839), 173–8.

19. *The Alexiad of Anna Comnena*, trans. E. R. A. Sewter (London 1969), 66.

20. M. Warner, *Joan of Arc* (London 1981), 13–31.

21. Christine de Pisan, *The Book of Deeds of Arms and of Chivalry*, trans. S. Willard, ed. C. Cannon Willard (Penn. State Press, 1999), 12–13.

22. N. A. R. Wright, 'The Tree of Battles of Honoré Bouvet and the Laws of War', in C. T. Allmand (ed.), *War, Literature and Politics in the Late Middle Ages* (Liverpool 1976), 12–31.

Chapter 7. Pleasures

1. St Bernard of Clairvaux, *Sermones in cantica cantiorum XXV*, 6, quoted in Tatarkiewicz, *Aesthetics* (1970), 187.

2. 'Terra iam pandit gremium, vernali lenitate', *Medieval Latin Lyrics*, trans. H. Waddell, (Harmondsworth 1929/52), 218–19.

3. Ibid., 220–1.

4. From Bede's *Life of St Cuthbert*, in *The Age of Bede*, ed. B. Radice (Harmondsworth 1965/83), 44.

5. *The Art of Falconry by Frederick II of Hohenstaufen*, ed. C. A. Wood and F. Marjorie Fyfe (Stanford 1943), general prologue, 4.

6. Ibid., 3.

7. Ibid., LXII–IXX; G. Orofino, 'Il rapporto con l'antico e l'osservazione della natura nell'illustrazione scientifica di età sveva in Italia meridionale', in *Intellectual life at the Court of Frederick Hohenstaufen*, ed. W. Tronzo (Washington 1994), 129–49.

8. '… by cause there semeth to be some perile in the lernynge thereof, and also it hath nat bene of long tyme moche used, specially amonge noble men, perchance some reder will litle esteme it, I mean swymmunge', from Thomas Elyot, *The Boke of the Governour*, reprinted in G. G. Coulton, *Social Life in Britain from the Conquest to the Reformation* (Cambridge 1918), 411.

9. Robert of Brunne's *Handlying Synne*, AD 1303, ed. F. J. Furnivall, *Early English Text Society* O.S. 119 (1901), 108.

10. B. Schimmelpfennig, 'Ad maiorem papae gloriam. La fonction des pièces dans le palais des papes d'Avignon', in *Architecture et vie sociale: L'organisation intérieure des grandes demeures à la fin du Moyen Age et la Renaissance* (Paris 1994), 25–43.

11. Gottfried von Strassburg, *Tristan*, ed. A. T. Hatto (Harmondsworth 1960/78), 85.

12. Marcelle Thiebaux, *The Stag of Love: The Chase in Medieval Literature* (Cornell 1974), 96–7.

13. J. Cummins, *The Hound and the Hawk: The Art of Medieval Hunting* (London 1988), 68–84, 96–110; Thiebaux, *Stag*, 144–228.

14. J. Eisler, 'Zu den Fragen der Beinsättel des Ungarischen Nationalmuseums I', *Folia Archaeologica* 28 (1977), 189–209; 30 (1979) 205–48; L. Gerevich, *The Art of Buda and Pest in the Middle Ages* (Budapest 1971), 96–7.

15. N. Davies, *Europe: A History* (Oxford 1996), 449.

16. *The Goodman of Paris*, ed. E. Power (Folio Society 1992), 68–9.

17. W. Sauerlander, 'Two Glances from the North: The Presence and Absence of Frederick II in the Art of the Empire: The Court Art of Frederick II and the *opus francigenum*', in *Intellectual Life at the Court of Frederick II Hohenstaufen*, ed. W. Tronzo (Washington 1994), 206.

18. G. R. Owst, *Literature and Pulpit in Medieval England* (Oxford 1961), 238.

19. Quoted from Dante in M. Schapiro, 'On the Aesthetic Attitude in Romanesque Art', in *Romanesque Art* (London 1977), 19–20.

20. By 1404 the book was owned by Philippe le Hardi, duke of Burgundy (C. Gaspar and F. Lyna, *Les Principaux Manuscrits à peintures de la Bibliothèque royale de Belgique*, 2ième partie

(Brussels 1984), cat. 126, 66).

21. A. Andersson, *Medieval Drinking Bowls of Silver Found in Sweden* (Stockholm 1983), 18–19, 56, 83–5. R. Wittkower, 'East and West: The Problem of Cultural Exchange', in *Allegory and the Migration of Symbols* (London 1977), 10–14.

22. Andersson, *Medieval Drinking Bowls* (1983) 18–19, 56, 83–5; G. Trotzig, 'Complementary Investigation of the Dune Cup – A Close Parallel to the Cup of Sivin', and O. Maniaeva, 'The Cup of Sivin from Preslav, Bulgaria', in *Laborativ arkeologi*, Stockholm University, Archaeological Research Laboratory vol. 9 (1996). I am grateful to Göran Tegnér for these references.

23. G. Henderson, *Early Medieval* (Harmondsworth 1972), 219–22.

24. M. Shadis, 'Piety, Politics, and Power: The Patronage of Leonor of England and her Daughters Berenguela of Léon and Blanche of Castile', in *The Cultural Patronage of Medieval Women*, ed. J. Hall McCash (Georgia 1996), 202–27.

Timeline
Museums and Websites
Further Reading
List of Illustrations
Index

Art and architecture		Historical and cultural events	
997			
997–1011	Crozier of Erkenbald, abbot of Fulda [39]		
998–1001	Gospels of Otto III [4]		
		1001	First Hungarian episcopal see founded at Estergom
c.1002	Uta Codex [85]		
1002–14	Aachen pulpit of Henry II [41]		
		1003–14	Danish invasions of England
		1016	Norman knights arrive in Sicily
		1022	Synod of Pavia calls for celibacy of higher clergy
1030s	Adhémar de Chabannes sketchbook [35]	1030s	First Norman lordship in Sicily
1050–70	Dune cup made [135]		
1054–67	Pantéon de los Reyes, Léon [10], built	1054	Schism between eastern Church at Constantinople and western Church at Rome
		1059–75	Start of quarrel between emperor and pope over lay investiture of bishops
		1061	Normans conquer Messina in Sicily
1066	Foundation of monastery of Fromista, Castile [45]	1066	**Battle of Stamford Bridge**: King **Harald Hardrada** of Norway defeated and killed; **Battle of Hastings**: King **Harold** of England defeated and killed; start of Norman rule in England
1066–71	New church at Monte Cassino		
1070–80	Shrine of San Millán de Cogolla [23]		
1070–1100	Bayeux tapestry records Norman invasion of England [104]		
c.1072–87	Wall-paintings at monastery of S. Angelo in Formis [40]	1072	Normans conquer Palermo in Sicily
		1073–85	Pontificate of Pope **Gregory VII** and period of Gregorian reform
1075–1100	Pulpit of S. Ambrogio, Milan [42]	1075	Dictatus papae: 27 propositions establishing sanctity and power of papacy
1078–1122	Church of Santiago de Compostela built		
		1080	Alphonso VI of Castile established Roman liturgy in place of Mozarabic rite
		1084	Foundation of Carthusian Order
		1085	Battle of Toledo
		1086	Domesday Book in England
1088	Third abbey church at Cluny begun		
1094–1105	Shrine of St Patrick's bell [37]	1094	Anselm of Laon wrote Cur deus homo
		1095	Council of Clermont—Pope Urban II preached the First Crusade
		1098	**Start of First Crusade** to Holy Land; Foundation of monastery of Cîteaux and beginnings of Cistercian Order
		1099	**Fall of Jerusalem** and establishment of Latin kingdom
c.1100	Manuscript Life of St Aubin (Viking raiders) [102]; Civate, apse wall-painting [114]; Manual of Byrhtferth [86]; Creation tapestry, Girona [1]		
c.1100–20	Life of St Cuthbert, Oxford MS [122]		
c.1108	Stone reliefs, Chichester [46]		
c.1110	Wiligelmo, Modena Cathedral [27]	1110–40	Theophilus De diversis artibus ('On Divers Arts')

1115

Art and architecture

1115	'Externsteine' stone at Horn, Westphalia [7]
c.1120	Tympanum at Autun by **Gislebertus** [25]; *Liber Floridus* of Lambert of St-Omer [93]; Wall-paintings at Nohant-Vicq [49]
c.1125–50	*Speculum virginum*, Conrad of Hirsau [90]
c.1130	Tympanum at La Madeleine, Vézelay [5]
1140	**Abbot Suger** begins to commission rebuilding of abbey church of Saint-Denis
1140s	New façade of abbey church of Saint-Gilles [55]
c.1150	South façade, Chartres Cathedral [91]; Portrait of artist **Hildebertus** in St Augustine, *Civitas dei* [21]; Imervard Cross, Brunswick [44]
c.1160	Eadwine Psalter [99]; Vault paintings, Pantéon de los Reyes, Léon [10]
1163–5	Pürgg, wall-paintings [47]
1165–70	Poitiers, Crucifixion window [50]
c.1168	Portico de la Gloria at Santiago de Compostela, by **Master Mateo** [56]
1170–80	Hague map of Jerusalem [6]
c.1170–90	Altar frontal of Avia [48]
c.1180	Monreale, cloister [51]
1180s	Door, Hurum church, Norway [43]
1181	Klosterneuburg pulpit (now altar), by Nicholas of Verdun [26]
1182–90	Shrine of Three Magi, Cologne, begun attributed to **Nicholas of Verdun** [53]
1194	Sarcophagus for royal infant of Castile [52]

Historical and cultural events

1115	Foundation of monastery of Clairvaux, **St Bernard** its abbot until his death in 1153
1118	Foundation of Order of Knights Templars
1122	Concordat of Worms resolved Investiture Crisis; **Peter Abelard** wrote *Sic et Non*
1123	**First Lateran Council** confirms Concordat of Worms and bans marriage of priests
1126	Burning of heretic Peter of Bruys in front of church of Saint-Gilles
1139	**Second Lateran Council** ends schism
c. 1140–5	Gratian's *Decretals*: textbook of canon law and case law
1146	**St Bernard** preaches at Vézelay, in favour of crusade to Holy Land
1147	Crusaders capture Lisbon
1147–9	**Second Crusade**
c. 1150–2	Peter Lombard wrote *Sentences*
1152	Establishment of archbishopric of Nidaros (Trondheim), Norway
1156	Foundation of Carmelite Order
c.1160	Latin translation of Ptolemy's *Almagest* brought to Palermo from Constantinople
1167–8	Foundation of Oxford University
1173	Canonization of **Thomas Becket**
1179	**Third Lateran Council**
1182	Jews banished from France
1187	End of Latin kingdom of Jerusalem
1189–93	**Third Crusade**
1190	Foundation of Order of German Hospitallers (Teutonic Knights)
1198–1216	Pontificate of **Pope Innocent III**

1200

Art and architecture

*c.*1200	*Hortus deliciarum* [**92**]
1200–10	Ashmole Bestiary [**94**]
*c.*1200–*c.*1230	
	Spring landscape, *Carmina Burana* [**121**]
1219	Seal of barons of London [**16**]
*c.*1220	Rose window, Lausanne Cathedral [**87**]
1220s	West façade, Wells Cathedral [**58**]
*c.*1230	Anagni crypt [**80**]
1230–40	**Villhard de Honnecourt**, sketchbook [**36**];
	Hildegard of Bingen, *Book of Divine Works*, Lucca MS [**81**];
	Hereford world map [**2**]
1241	**Matthew Paris**, *Chronica maiora* [**108**]
1246	Funerary cushion of Berenguela of Léon [**136**]
1248	Consecration of Sainte-Chapelle, Paris
*c.*1250	Maciejowski Bible [**107**]
*c.*1250–60	Atlas figure, Castel del Monte, Apulia [**131**]
*c.*1250–70	Temple Church, London, effigies [**116**]
*c.*1250–75	Averroes on Aristotle MS [**97**]
1253–68	S. Marco, Venice, mosaic showing rediscovery of St Mark's relics [**54**]
*c.*1260	*De arte venandi cum avibus* [**123**]; West façade, Reims Cathedral [**59**]
1260	**Nicola Pisano**, Pisa pulpit [**29**]

Historical and cultural events

1202–4	**Fourth Crusade**
1204	**Fall of Constantinople**
1204–61	Latin patriarchate of Constantinople
1209–18	Albigensian Crusade to combat Cathar heresy
1215	**Fourth Lateran Council**
1215–55	Aristotle's writings banned by arts faculty of the University of Paris
1220–1	Dominican rule established
1223	Franciscan rule approved by Pope Honorius III
1224	Foundation of University of Naples
1225–71	Albigensian Crusade, second phase
1226	Carmelite Order approved by Pope Honorius III
1229	Catalan capture of Mallorca from the Arabs; Foundation of University of Toulouse
1232	Canonization of St Anthony of Padua
1234	Canonization of St Dominic
*c.*1236	St Gothard pass opened from Switzerland to Italy over the Alps
1238	Aragon capture of Valencia
1238–41	Mongol invasions of eastern Europe
1243	Confirmation charter of University of Salamanca
1248	Castilian capture of Seville
1248–50	**Louis IX,** king of France, crusade to Damietta
1252–5	Franciscan William of Rubruck's journey to central Asia
1258–70	Jacobus de Voragine, *Golden Legend*

1266

Art and architecture

1268	Cosmati pavement, Westminster Abbey [28]
c.1270	Strasbourg façade, drawing [62]
c.1275	Saint-Blaise Monastery, choir cope [78]
c.1280–1300	Reliquary of Holy Corporal [61]
c.1285–90	Palau Aguilar-Caldes, wall-paintings [105]
1290s	Southwell Minster, chapter-house [15]; Assisi, Upper Church, wall-paintings [63]
c.1292	Medical illustration, Bodleian Library [95]
c.1300	Peterborough Psalter, Brussels [8]; Puzzle jug from Saintonge [134]
c.1300–1325	Flemish bible with marginalia [133]
c.1300–c.1350	Parade axe from Volga [103]
1304	'Gabelkreuz' (forked crucifix), Cologne [64]
c.1308	Reichenau Oberzell, wall-painting of Tutivillus and the Gossips [74]
1308–12	Copy of Thomas Kent, Roman de toute Chevalerie (version of Romance of Alexander) [106]
1310–30	Façade of Orvieto Cathedral [66]
c.1325	Ramon Lull, Breviculum ex artibus [89]
1328	Papal consistory court manuscript [96]
c.1330	Nine Worthies, civic hall, Cologne [112]
c.1335	Luttrell Psalter [11]; Crucifixion retable and altar frontal [73]
1338–40	**Lorenzetti**, frescoes, Siena Palazzo Pubblico [17]

Historical and cultural events

1266	Roger Bacon's Opus majus written
1267–70	Louis IX's crusade to Tunis (on which he died)
c.1268	Etienne Boileau, Livre des Metiers, written in Paris, documenting all the craft trades
1274	Council of Lyon confirmed doctrine of Purgatory
1282	French expelled from Sicily
1293–5	Lübeck made capital of Hanse towns
1297	Canonization of Louis IX, king of France
1303	Foundation of University of Rome
1306	King Philip VI banned Jews from royal domain in France
1307–14	Trial of the Templars
1309	Pope Clement V settled at Avignon, establishing papal court; Foundation of University of Orleans
1311	Council of Vienne confirmed Feast of Corpus Christi
1312–13	Jacques de Languyon wrote 'Voeux du Paon', one of the origins of the 'Nine Worthies'
1314–21	**Dante** wrote Divine Comedy
1323	Canonization of St Thomas Aquinas
1323–7	Flemish peasant uprising
1337–1453	**Hundred Years War** between England and France

1340

Art and architecture	Historical and cultural events
*c.*1340 Hawton tomb of Christ [65]; King John Cup [126]	
	1346 Foundation of University of Valladolid and Pembroke College, Cambridge
	1348 Foundation of University of Prague
	1348–9 **Black Death**—bubonic plague swept through central Europe, Italy, Germany, Austria, France, Flanders, and England
	1348–53 **Giovanni Boccaccio** wrote *The Decameron*
*c.*1350 Ivory casket with romance scenes (Bargello, Florence) [130]; Al Sufi, *Book of Fixed Stars,* belonging to Charles IV of Bohemia [83]	
*c.*1350–60 East window, Gloucester Cathedral [67]	
*c.*1356–64 Decoration of Palais des Papes, Avignon [124]	
	1358 'Jacquerie', peasant uprising in Paris region, France
	1362–*c.*1386 **William Langland** wrote *Piers Plowman*
	1364 Foundation of University of Cracow
	1365 Foundation of University of Vienna
1366 Foundation of Synagogue of the Transito, Toledo [57]	1366 Aristotle's works compulsory at the University of Paris
	1376 Pope Gregory XI left Avignon for Rome
1377 Dedication stone recording building of Ulm Cathedral [38]	
	1378 Clement VII elected anti-pope
	1378–1417 Papal schism
*c.*1380 Peter of Poitiers, *Compendium veteris testamenti,* bound with French 14th-century Bible [88]; Gaston Phoebus, *Livre de la Chasse* [125]	
	1381 **Peasants' Revolt** in England
*c.*1386 Tomb of Giovanni da Legnano in Bologna, by **Pier Paolo dalle Masegne** [98]	
	1387–1400 **Geoffrey Chaucer** wrote *The Canterbury Tales*
	1388 Start of Lollard persecution in England
	1394 Expulsion of Jews from France
*c.*1400 Illustrated chronicles of **Jean Froissart** [109]; Astronomical book of Wenzel IV of Bohemia [84]; Cloister of Jerpoint Abbey, Ireland [75]	
*c.*1400–*c.*1425 John Siferwas, Lovell Lectionary [24]	
	1403 **Jan Hus** began to preach Wycliffite ideas in Bohemia
	1406 First Latin translation of Ptolemy's *Geographia* available
1409 **Christine de Pisan**, *Livre des faits des armes et de chevalerie* [117]	
1410 Kruzlawa Virgin and Child [71]	

1413

Art and architecture

1413–16 and 1485
Très Riches Heures of **Jean, duc de Berry** [12, 82]

*c.*1420 Illustrated book of travels: *Livre des Merveilles* of **Sir John Mandeville** and **Marco Polo** [3, 34];
Jean Bourdichon, Le Travail [30]

1425 **Masaccio**, *Trinity*, painted in Florence [69]

*c.*1430 'Hungarian' saddle [128];
The Offering of the Heart, Flemish Tapestry [119];
Game board [129]

*c.*1435 **Jan van Eyck**, *The Virgin and Child and Chancellor Rolin* [14]

1440–50 Jaume Ferrer, St Jerome [100];
Schloss Ambras playing cards [127]

*c.*1441 **Rogier van der Weyden**, Seven Sacraments altarpiece [79]

1443–53 **Donatello**, Padua altar [77]

1448 Illustrated manuscript of Girart de Roussillon for duke of Burgundy [110]

1449–54 Tomb of Richard Beauchamp, earl of Warwick [33]

*c.*1450–70 Illustrated Boccaccio manuscripts [31, 32]

1454–7 **Paolo Uccello**, *Rout of San Romano* [111]

1460 Box with woodland scenes [9]

1473 Agricultural activities in Virgil's *Georgics* [13]

1474 **Vincent of Kastav**, Dance of Death, in Beram church, Istria [70]

1477–9 **Veit Stoss** altarpiece of St Mary, Cracow [68]

*c.*1480 **Geertgen tot Sint Jans**, *Virgin and Child* [72]

1483 **Girolamo da Cremona**, *Philosophers* [101]

1485 **Christoforo Buondelmonte**, *Liber insularum Cycladum atque aliarum in circuitu sparsarum* [18]

Historical and cultural events

1415 **Jan Hus** burned at stake as heretic;
Thomas à Kempis wrote *Imitatio Christi*;
Battle of Agincourt

1420–34 Hussite movement in Bohemia

1431 Foundation of universities of Caen and of Poitiers;
Joan of Arc burned at stake

1435 **Leon Battista Alberti** wrote *Della pittura*

1437 Foundation of All Souls College, Oxford

1443 First cargo of slaves arrived in Europe from Africa

1451 Foundation of University of Glasgow

1453 **Fall of Constantinople** to Ottoman Turks

1457 Foundation of University of Freiburg

1458 Foundation of Magdalen College, Oxford

1460s 'Remensas' Catalan peasant revolt

1463–79 War between Venice and Turks

1469–79 Portuguese exploration of Africa

1483 Spanish Inquisition

1488 Bartholomeu Dias the first European to round Cape of Good Hope

1489

Art and architecture

1489	**Bernt Notke**, St George, Stockholm [113]
1490	**Peter Vischer** effigy of Graf von Henneburg [115]
1492	**Andrea Mantegna**, *Descent into Limbo* [19]
1492–4	**Martin Behaim**'s globe [20]
1493-6	**Adam Kraft**, Sacrament tower for St Lorenz, Nuremberg [22]
*c.*1500	Gregor Erhardt, *Allegory of Vanity* [120]

Historical and cultural events

1491–8	**Girolamo Savonarola** preaching in Florence against luxury
1492	**Christopher Columbus** discovered San Salvador
1493	Columbus discovered Jamaica
1494	Treaty of Tordesillas confirmed division of New World between Spain (the Americas) and Portugal (Africa, Asia, and later Brazil)
1498	**Sebastian Cabot** discovered east coast of North America; Columbus discovered mainland South America
1499	**Amerigo Vespucci** discovered Guyana and Venezuela

Further Reading

*'... as dwarfs standing on the shoulders of giants
... we can see more and further than they could,
not indeed by the keenness of our vision or the size
of our bodies, but because we are raised up and
elevated by the greatness of giants ...'*

Bernard of Chartres's famous
acknowledgement to classical authority was
itself an early bibliographical reference,
surviving only in the work of John of
Salisbury.[1] Like both these medieval authors,
I owe a great debt to the existing body of
literature and hope that I have given it
adequate citation. This book has been guided
by particular stories and points of view,
although almost every object here has been
published before and discussed elsewhere in
the context of different approaches to the
subject. In a slim volume covering an
enormous amount of ground, many hard
choices have had to be made and much
interesting material has had to be excluded.
I have tried to maintain a balance between
illustrating and discussing famous monuments
and lesser-known, perhaps more surprising
ones. Rather than attempting anything like a
complete bibliography here for the very wide
span of time and subjects, I have concentrated
on listing authorities I have consulted and
especially those by which I have been inspired
and influenced. Most of this material therefore
relates fairly closely to what I have presented in
particular contexts, but there are also some
interesting publications here that adopt
similar thematic approaches to mine, but that I
have not been able to use directly. Lack of
space has prevented me from including as
much of this material as I would have liked,
either as part of the main text or as part of this
section.

There have been some excellent recent general
historical books covering very large areas of
the subject. Norman Davies's inspirational
Europe: A History covers a quite astonishing
range of material with an excellent balance
between the general and the particular and an
engaging rootedness in the present. David
Nicholas's general studies of medieval history
are interesting and extremely clear. Robert
Bartlett's new approaches to analysis of events
and the spread of ideas are very stimulating
and important. Prompted especially by R. I.
Moore's analyses of moral censorship and
persecution of heresy, I have looked more
carefully at the way in which imagery,
especially in the orbit of the Church,
reinforces orthodoxies at both conscious and
subliminal levels. A general understanding of
medieval thought is as indispensable for
coming to terms with the subject of medieval
art as a grasp of historical events. The books I
have listed give a good introduction, balancing
commentary with extracts from original texts,
and from there readers would be equipped to
search the original texts themselves. Most
books about art take only part of the period
covered by this book. Very few books take
strongly thematic approaches. Among the
exceptions are George Henderson's books
from the 1970s and Christopher de Hamel's
books on manuscripts which consider the
books from the point of view of their intended
and actual users. Organization of the material
is usually chronological and by style, or by
iconography. Despite the fact that
Romanesque and Gothic are the most usual
defining stylistic categories and feature in
countless book titles, the parameters of the
styles are notoriously difficult to define.[2]

Some of the most important new work has
appeared in the context of exhibition
catalogues. A remarkable series of major
exhibitions since the 1970s, covering different
aspects of medieval art, has done more than
anything to popularize the subject. These
exhibitions brought little-known objects to
light and occasioned some substantial
publications containing a vast amount of new
scholarly material. Since exhibitions and their

associated symposia are such exploratory and collective enterprises, the labours of assembling material and sharing and writing texts have engagingly mirrored medieval collaborative and disputational practice.

History

M. Barber, *The Two Cities: medieval Europe, 1050–1320* (London 1993)

R. Bartlett, *The Making of Europe: conquest, colonization and cultural change 950–1350* (London 1993)

R. L. Benson and G. Constable with C. D. Lanham, *Renaissance and Renewal in the Twelfth Century* (Cambridge, MA 1982/1991)

N. Davies, *Europe: A History* (Oxford 1996)

G. Holmes, *Europe: Hierarchy and Revolt 1320–1450* (London 1975)

J. Huizinga, *The Waning of the Middle Ages* (Harmondsworth 1924/1976)

H. Koenigsberger, *Medieval Europe 400–1500* (London 1987)

J. H. Mundy, *Europe in the High Middle Ages 1150–1309* (Harlow 1973)

D. Nicholas, *The Evolution of the Medieval World 312–1500* (Harlow 1992/1998)

D. Nicholas, *The Transformation of Europe 1300–1600* (Oxford 1999)

N. J. G. Pounds, *An Historical Geography of Europe* (Cambridge 1990)

J. Le Goff (ed.), *The Medieval World* (London 1990)

A. P. Smyth (ed.), *Medieval Europeans, Studies in Ethnic Identity and National Perspectives in Medieval Europe,* (London 1998).

Thought

P. Dronke, *A History of Twelfth-Century Western Philosophy* (Cambridge 1988)

A. Hyman and J. J. Walsh, *Philosophy in the Middle Ages: The Christian, Islamic and Jewish Traditions* (Indianapolis 1974)

G. A. Leff, *Medieval Thought from St Augustine to Ockham* (Chicago 1958)

A. Murray, *Reason and Society in the Middle Ages* (Oxford 1985)

A. Piltz, *The World of Medieval Learning* (Oxford 1981, first published in Swedish in 1978)

R. W. Southern, *Western Views of Islam in the Middle Ages* (Cambridge, MA, 1962/1978)

W. Tatarkiewicz, *History of Aesthetics*, 2 vols (Warsaw 1970)

General histories of art

X. Barral i Altet, F. Avril, D. Gaborit-Chopin, *Les royaumes d'Occident* (Paris 1983)

H. Beck and K. Hengevoss-Dürkop (eds), *Studien zur europäischen Skulptur im 12/13 Jahrhundert*, 2 vols (Frankfurt 1994)

J. Beckwith, *Early Medieval Art* (London 1964)

E. Bergendahl Hohler, *Norwegian Stave Church Sculpture*, 2 vols (Oslo 1999).

M. Blindheim, *Norwegian Romanesque Decorative Sculpture 1090–1210* (London 1965).

W. Cahn, *Romanesque Manuscripts: The Twelfth Century*, 2 vols (London 1996)

N. de Dalmases, A. José i Pitarch, *L'Art Romanic Catala I els seus Antecedents, s. IX–XII* (Barcelona 1983, 1986)

N. de Dalmases, A. José i Pitarch, *L'Epoca del Cister, s. XIII* (Barcelona 1985)

N. de Dalmases, A. José i Pitarch, *L'Art Gotic, Segles XIV–XV* (Barcelona 1987)

C. Davis-Weyer (ed.), *Early Medieval Art, 300–1150: sources and documents* (Toronto 1986)

H. Decker, *Romanesque Art in Italy* (London, Vienna 1958)

H. Decker, *Gotik in Italien* (Vienna 1964)

F. Deuchler, *Gothic Art* (London 1973)

R. Dodwell, *The Pictorial Arts of the West* (London 1993)

A. Erlande-Brandenburg, *Le Monde gothique: La Conquête de l'Europe 1260–1380* (Paris 1987)

L. Freeman Sandler, *Gothic Manuscripts 1285–1385*, 2 vols (London 1986)

T. G. Frisch, *Gothic Art 1140–c.1450: sources and documents* (Toronto 1987)

C. de Hamel, *A History of Illuminated Manuscripts* (London 1986)

M. F. Hearn, *Romanesque Sculpture: The Revival of Monumental Stone Sculpture in the Eleventh and Twelfth Centuries* (Oxford 1981)

G. Henderson, *Early Medieval* (Harmondsworth 1972)

G. Henderson, *Gothic* (Harmondsworth 1967)

A. Kampis, *A History of Art in Hungary* (London 1966)

C. M. Kauffmann, *Romanesque Manuscripts 1066–1190* (London 1975)

G. Künstler (ed.), *Romanesque Art in Europe* (Vienna 1968)

P. Lasko, *Ars Sacra* (London 1972–94)

A. Martindale, *Gothic Art* (London 1967)

M. Meiss, *Painting in Florence and Siena after the Black Death* (Princeton 1951)

N. J Morgan, *Early Gothic Illuminated Manuscripts*, 2 vols. (London 1988)

J. Pope-Hennessy, *Italian Gothic Sculpture*

(London 1955/1986)

W. Sauerlander, *Gothic Sculpture in France 1140–1270* (London 1972)

W. Sauerlander, *Le Monde gothique: Le Siècle des cathédrales, 1140–1260* (Paris 1989)

A. Schadler, *Deutsche Plastik der Spätgotik* (Stuttgart 1962)

M. Schapiro, *Romanesque Art* (London 1977)

H. Swarzenski, *Monuments of Romanesque Art* (London 1954)

A. Tulse, *Scandinavica Romanica: die hohe Kunst der Romanischen epoche in Danemark, Norwegen und Schweden* (Vienna 1968)

P. Williamson, *Gothic Sculpture 1140–1300* (London 1995)

G. Zarnecki, *Romanesque Art* (London 1971)

G. Zarnecki, *Studies in Romanesque Sculpture* (London 1979)

Exhibition catalogues

Age of Chivalry, Art in Plantagenet England 1200–1400, ed. J. Alexander and P. Binski (London, Royal Academy of Arts 1987)

Bernward von Hildesheim und das Zeitalter der Ottonen, ed. M. Brandt, R. Kahsnitz, D. Kötsche, H. J. Schuffels, 2 vols (Hildesheim 1993)

Art and the Courts: France and England from 1259 to 1328, ed. P. Verdier and P. Brieger, 2 vols. (Ottawa 1972)

Rhein und Maas/Rhin–Meuse Art et civilisation 800–1400, 2 vols. (Cologne/Brussels 1972)

The Secular Spirit: Life and Art at the End of the Middle Ages, ed. T. B. Husband and J. Hayward (Metropolitan Museum, New York, 1975)

Die Zeit der Staufer: Geschichte–Kunst–Kultur, ed. Reiner Haussherr, 3 vols (Stuttgart 1977)

Transformations of the Court Style: Gothic Art in Europe 1270–1330 (Brown University and Museum of Art, Rhode Island School of Design 1977)

Die Parler und der schöne Stil 1350–1400, ed. A. Legner et al., 5 vols (Cologne 1978)

Les fastes du gothique: le siècle de Charles V, ed. F. Baron et al. (Paris, Grand Palais 1981–2)

The Art of Medieval Spain 500–1200, ed. J. P. O'Neill (Metropolitan Museum, New York 1993)

L'Art au Temps des Rois maudits 1285–1328, ed. D. Gaborit-Chopin et al. (Paris, Grand Palais, 1998)

English Romanesque Art 1066–1200, ed. G. Zarnecki et al. (London, Hayward Gallery 1984)

Ornamenta ecclesiae: Kunst und Künstler der Romanik, ed. A. Legner et al., 3 vols (Cologne 1985)

L'Europe gothique XII–XIV siècles, (Paris, Louvre, 1968)

The Year 1200, ed. K. Hoffmann, 2 vols (New York 1970) and symposium volume, 1973

From Viking to Crusader: the Scandinavians and Europe 800–1200, ed. E. Roesdahl and D. M. Wilson (Paris, Berlin, Copenhagen 1992–3)

Splendours of Flanders, ed. A. Arnould and J. M. Massing (Fitzwilliam Museum, Cambridge 1993)

I Normanni: Popolo d'Europa 1030–1200, ed. M. d'Onofrio (Rome 1994)

Heinrich der Löwe und seiner Zeit, ed. J. Luckhardt, F. Niehoff, 3 vols (Munich 1995)

Chapter 1. A Sense of Place

No book on medieval art covers this subject, though there are some essential studies of some of the specialist areas covered here, such as maps and topographical material and some thought-provoking articles, such as that by Jonathan Alexander in *Medieval Art: Recent Perspectives*. I have listed here some influential books that consider questions of place and national identity in general, or from other periods.

J. Alexander, 'Medieval Art and Modern Nationalism', in *Medieval Art: Recent Perspectives. A Memorial Tribute to C. R. Dodwell*, ed. G. R. Owen-Crocker and T. Graham, 206–23 (with useful footnotes)

B. Anderson, *Imagined Communities* (London 1983)

L. Brubaker, 'Conclusion, Image, Audience and Place, Interaction and Reproduction', in *The Sacred Image East and West*, ed. R. Ousterhout and L. Brubaker (Illinois 1995), 204–20.

E. Burman, *The World before Columbus 1100–1492* (London 1989)

M. Camille, 'Labouring for the Lord: The Ploughman and the Social Order in the Luttrell Psalter', *Art History*, 10, no. 4, December 1987, 423–54.

M. Camille, *Mirror in Parchment: The Luttrell Psalter and the Making of Medieval England* (London 1988)

M. Camille, *The Gothic Idol: Ideology and Image-Making in Medieval Art* (Cambridge 1989)

M. Camille, 'The Image and the Self: Unwriting Late Medieval Bodies', in *Framing Medieval Bodies*, ed. S. Kay and M. Rubin (Manchester 1996), 62–99.

E. Edson, *Mapping Time and Space: How Medieval Mapmakers viewed their World* (London 1997)

J. B. Friedman, *The Monstrous Races in Medieval Art and Thought* (Cambridge, MA 1981)

A. J. Gurevich, *Categories of Medieval Culture* (London 1985; first published in Russian in 1972)

J. B. Harley and D. Woodward, *The History of Cartography* 1: *Cartography in Prehistoric, Ancient and Medieval Europe and the Mediterranean* (Chicago and London, 1987)

P. D. A. Harvey, *The History of Topographical Maps* (London 1980)

P. D. A. Harvey, *Medieval Maps* (London 1991)

P. D. A. Harvey, *Mappa Mundi: The Hereford World Map* (Hereford Cathedral, British Library 1996)

R. H. Hilton, *Bond Men Made Free: Medieval Peasant Movements and the English Rising of 1381* (London 1973)

J. M. Howe, 'The Conversion of the Physical World: The Creation of a Christian Landscape', in J. Muldoon (ed.), *Varieties of Religious Conversion in the Middle Ages* (Florida 1997), 63–80

L. Jardine, *Worldly Goods* (London 1996)

W. Kemp, 'Medieval Pictorial Systems', in *Iconography at the Crossroads,* ed. B. Cassidy (Princeton 1993), 121–33

M. Kupfer, 'Medieval World Maps: Embedded Images, Interpretive Frames', *Word and Image* X, no. 3 (Jul–Sept 1994), 262–88

J. Le Goff, *The Medieval Imagination* (Chicago 1985)

L. Lippard, *The Lure of the Local: Senses of Place in a Multicentred Society* (New York 1997)

D. Nicholas, *The Growth of the Medieval City from Late Antiquity to the Early Fourteenth Century* (New York and Harlow 1997)

D. Nicholas, *The Later Medieval City 1300–1500* (New York and Harlow 1997)

F. Rorig, *The Medieval Town* (Berkeley 1967)

R. D. Russell, 'A Similitude of Paradise: The City as Image of the city', in *The Iconography of Heaven,* ed. C. Davidson (Kalamazoo 1994)

S. Schama, *Landscape and Memory* (London 1996)

M. Warnke, *Political Landscape – The Art History of Nature* (London, 1994)

P. Whitfield, *The Image of the World* (London 1994/1997)

R. Wittkower, *Allegory and the Migration of Symbols* (London 1977)

Chapter 2. Artists

The potential bibliography on this subject is huge as there is a growing number of studies both of the practices of artists and the organizations of workshops. This list has been limited to the area immediately relevant to the article in this book and contains a number of useful studies of the role and practice of the artist and many individual works that consider case studies in a localized context.

Leon Battista Alberti: On Painting, trans. J. R. Spencer (New Haven and London 1970)

J. Alexander, *Medieval Illuminators and their Methods of Work* (Yale 1992)

X. Barral i Altet (ed.), *Artistes, artisans et production artistique au moyen-âge.* Actes du Colloque de Rennes, 3 vols (Paris 1987)

P. Basing, *Trades and Crafts in Medieval Manuscripts* (London, British Library 1990)

M. Baxandall, *Painting and Experience in Fifteenth-Century Italy* (Oxford 1972)

P. Binski, *Medieval Craftsmen: Painters* (London 1991)

J. Blair and N. Ramsay (eds), *English Medieval Industries* (London and Rio Grande 1991)

S. Brown and D. O'Connor, *Medieval Craftsmen: Glass-Painters* (London 1991)

E. Castelnuovo, 'The Artist', in J. Le Goff (ed.), *The Medieval World* (1990), 211–42.

Cennino Cennini: The Craftsman's Handbook, ed. D. V. Thompson (New York 1933)

C. R. Dodwell, *Theophilus: The Various Arts, De Diversibus Artibus* (Oxford 1986)

C. R. Dodwell, 'The Meaning of "Sculptor" in the Romanesque Period', *Romanesque and Gothic: Essays for George Zarnecki* (Woodbridge 1987), 1, 49–62

H. R. Hahnloser, *Villhard de Honnecourt* (Graz 1972)

J. Harvey, *Medieval Craftsmen* (London and Sydney 1975)

J. G. Hawthorne and C. Smith, *Theophilus: On Divers Arts* (New York 1979)

F. Henry, *Irish Art in the Romanesque Period* (New York 1970)

M. Hollingsworth, *Patronage in Renaissance Italy from 1400 to the Early Sixteenth Century* (London 1994)

J. Larner, 'The Artist and the Intellectuals in Fourteenth-Century Italy', *History* (1969), 42–60

J. Le Goff, *Time Work and Culture in the*

Middle Ages (Chicago 1980)

P. Lindley, *Gothic to Renaissance: Essays on Sculpture in England* (Stamford 1995)

A. Martindale, *The Rise of the Artist in the Middle Ages and the Early Renaissance* (London 1972)

B. Nolan, *The Gothic Visionary Perspective* (Princeton 1977)

J. Pope-Hennessy, *Italian Gothic Sculpture* (Oxford 1955/1986)

R. W. Scheller, *A Survey of Medieval Model Books* (Haarlem 1963)

K. Staniland, *Medieval Craftsmen: Embroiderers* (London 1991)

Chapter 3. Art and Power in the Church

An interesting perspective on the driving force of the Christian religion has been given by the recent attention to ethnicity and religious conformism in historical writing. Interest in this subject may have been sharpened by the atrocities in the name of national identity and ethnic cleansing of the latter part of the twentieth century in Europe.

A. Abulafia, *Christians and Jews in the Twelfth-Century Renaissance* (London 1995)

A. Abulafia, 'Bodies in the Jewish-Christian debate', in *Framing Medieval Bodies*, ed. S. Kay and M. Rubin (Manchester 1996), 123–37

M. H. Caviness, *The Windows of Christ Church Cathedral Canterbury*, Corpus Vitrearum Medii Aevi (London 1981)

R. Fletcher, *The Conversion of Europe: From paganism to Christianity, 371–1386 AD* (London 1997)

D. Freedburg, *Iconoclasts and their Motives* (Maarsen 1985)

Freedburg, *The Power of Images* (Chicago 1989)

J. Gage, *Colour and Culture: practice and meaning from antiquity to abstraction* (London 1993/1995)

L. Grant, *Abbot Suger of St-Denis: Church and state in Early Twelfth-century France* (London 1998)

L. Grodecki, *Le Vitrail roman* (Paris 1983)

B. Hamilton, *Religion in the Medieval West* (London and New York 1986)

T. A. Heslop, 'Towards an Iconology of Croziers', in *Studies in Medieval Art and Architecture presented to Peter Lasko*, ed. D. Buckton and T. A. Heslop (Stroud and British Museum 1994)

D. Kahn, *Canterbury Cathedral and its Romanesque Sculpture* (London, Austin 1991)

D. Knowles, *Christian Monasticism*
(London 1969)

G. B. Ladner, 'Medieval and Modern Understanding of Symbolism: A Comparison', in *Images and Ideas in the Middle Ages: selected studies in the history of art* (Rome 1983), 239–81

E. Mâle, *Religious Art in France. The Twelfth Century: a Study of the Origins of Medieval Iconography*, ed. H. Bober (Princeton 1978)

E. Mâle, *Religious Art in France. The Thirteenth Century: a Study of Medieval Iconography and its Sources*, ed. H. Bober (Princeton 1984)

R. I. Moore, *The Birth of Popular Heresy* (London 1975)

R. I Moore, *The Origins of European Dissent* (London 1977)

R. I Moore, *The Formation of a Persecuting Society: power and deviance in Western Europe 950-1250* (Oxford 1987)

C. Rudolph, *Artistic Change at St–Denis: Abbot Suger's program and the early twelfth-century controversy over art* (Princeton c.1990)

E. Panofsky (ed., trans., annot.), *Abbot Suger, on the Abbey Church of St–Denis and its Art Treasures* (Princeton 1946/1979)

R. W. Southern, *Western Society and the Church in the Middle Ages* (London 1970)

Chapter 4. Design and Devotion 1200–1500

There has been a growing interest since the early 1990s in the importance of liturgy and ritual in the Church and the impact on visual imagery.

P. Ariès, *Images of Man and Death*, trans. J. Lloyd (Cambridge, MA, London 1985)

G. Barraclough, *The Medieval Papacy* (London 1968/1975)

M. Baxandall, *The Limewood Sculptors of Renaissance Germany* (New Haven and London 1980)

H. Belting, *Das Bild und sein Publikum im Mittelalter* (Berlin 1981)

P. Binski, *Medieval Death: Ritual and Representation* (London 1996)

T. S. R. Boase, *Death in the Middle Ages: Mortality, Judgement and Remembrance* (London 1972)

C. W. Bynum, *The Resurrection of the Body in Western Christianity 200–1336* (New York 1995)

P. Crossley, 'The Man from Inner Space: Architecture and Meditation in the Choir of St Laurence in Nuremberg', in *Medieval Art Recent Perspectives: A Memorial Tribute to C. R.*

Dodwell, ed. G. R. Owen-Crocker and T. Graham, 165–182.

A. Derbes, *Picturing the Passion in Late Medieval Italy: narrative painting, Franciscan ideologies, and the Levant* (Cambridge 1996)

E. Duffy, *The Stripping of the Altars: Traditional Religion in England 1400–1580* (London 1992)

L. Grodecki, *Gothic Architecture* (London 1986; first published in Italy in 1976)

A. Gurevich, *Medieval Popular Culture: Problems of Belief and Perception* (Cambridge 1988)

T. Klauser, *A Short History of the Western Liturgy* (Oxford 1965/1979)

M. Lambert, *Medieval Heresy* (1977/1997)

A. Martindale, *Simone Martini* (London 1988)

J. T. McNeill and H. M. Gamer, *Medieval Handbooks of Penance* (Columbia 1938/1990)

H. van Os, *The Art of Devotion in the Late Middle Ages in Europe 1300–1500* (Amsterdam 1994)

G. R. Owst, *Literature and Pulpit in Medieval England* (Oxford 1961)

E. Panofsky, *Tomb Sculpture* (New York 1992)

H. Retzlaff and E. Lutze, *Schnitzaltare Altdeutscher Meister* (Stuttgart 1966)

M. Rubin, *Corpus Christi: The Eucharist in Late Medieval Culture* (Cambridge 1991)

W. Sauerlander, *Gothic Sculpture in France 1140–1270* (London 1972)

R. Schneider Berrenberg, *Studien zur monumentalen Kruzifix-Gestaltung im 13. Jarhundert.* 2 vols (Munich 1977)

J. Shinners (ed.), *Medieval Popular Religion 1000–1500: A Reader* (Ontario 1997)

R. N. Swanson, *Religion and Devotion in Europe c.1215–c.1515* (Cambridge 1995)

J. de Voragine, *The Golden Legend*, trans. and adapted by G. Ryan and H. Ripperger (New York 1969)

C. Wilson, *The Gothic Cathedral: The Architecture of the Great Church 1130–1530* (London 1990)

Chapter 5. Image and Learning

Although this is one area where there has been much interesting recent work, only a few books concentrate on discussing aspects of the imagery associated with learning. Anna Esmeijer's work is extremely useful and probably the most comprehensive in this respect. Michael Evans has many good examples of intellectual imagery in his book on medieval drawing. Frances Yates's work on memory remains of fundamental importance,

and Mary Carruthers' more recent work has very wide implications for the study of the visual arts.

J. G. Alexander, *Medieval Illuminators and their Methods of Work* (New Haven and London 1992)

R. Baxter, *Bestiaries and their Users in the Middle Ages* (Stroud 1998)

R. L. Benson, G. Constable (eds), *Renaissance and Renewal in the Twelfth Century* (Toronto 1982/1991)

J. A. Burrow, *The Ages of Man: A Study in Medieval Writing and Thought* (Oxford 1988)

G. Cames, *Allégories et symboles dans l'Hortus Deliciarum* (Leiden 1971)

M. Carruthers, *The Book of Memory* (Cambridge 1990)

M. H. Caviness, 'Anchoress, Abbess, and Queen: Donors and Patrons or Intercessors and Matrons?', in J. Hall McCash (ed.), *The Cultural Patronage of Medieval Women* (Georgia 1996), 105–54

M. T. Clanchy, *From Memory to Written Record* (London 1979)

A. B. Cobban, 'Reflections on the Role of the Medieval Universities in Contemporary Society'; in *Intellectual Life in the Middle Ages: Essays Presented to Margaret Gibson*, ed. L. Smith and B. Ward (London and Rio Grande 1992), 227–41

A. Conti, *La miniatura bolognese: scuole e botteghe 1270–1340* (Bologna 1981)

M. P. Cosman and B. Chandler, *Machaut's World: Science and Art in the Fourteenth Century* (New York 1978)

P. Cowen, *Rose Windows* (London 1979/1984)

M.-M. Davy, *Initiation à la Symbolique romane* (Poitiers 1982)

P. R. Doob, *The Idea of the Labyrinth from Classical Antiquity through the Middle Ages* (Ithaca and London 1992)

P. Dronke, *Fabula* (Leiden 1974)

P. Dronke, *Women Writers of the Middle Ages* (Cambridge 1984)

U. Eco, *Art and Beauty in the Middle Ages* (New Haven and London 1986)

A. C. Esmeijer, *Divina Quaternitas* (Amsterdam 1978)

M. Evans, *Medieval Drawings* (London 1969)

M. Evans, 'Allegorical Women and Practical Men: the Iconography of the Artes Reconsidered 305–329', in D. Baker (ed.), *Medieval Women* (Oxford 1978)

M. Evans, 'Fictive Painting in Twelfth-Century Paris', in *Sight and Insight: Essays on Art and Culture in Honour of E. H. Gombrich at*

85, ed. J. Onians (London 1994)

R. Gibbs, 'Images of Higher Education in Fourteenth-Century Bologna', in *Medieval Architecture and its Intellectual Context, Studies in Honour of Peter Kidson*, ed. E. Fernie and P. Crossley (London and Ronceverte 1990), 269–81

E. Grant, *The Foundations of Modern Science in the Middle Ages* (Cambridge 1996)

R. Green, M. Evans, C. Bischoff, M. Curschmann, *Herrad of Hohenberg: Hortus deliciarum* (London 1979)

C. de Hamel, *Glossed Books of the Bible* (London 1984)

H. M. Harting, *Ottonian Book Illumination* (London 1991)

T. A. Heslop, 'Brief in Words but Heavy in the Weight of its Mysteries', *Art History*, 9 (1986), 1–11; reprinted in *Romanesque and Gothic: Essays for George Zarnecki* (Woodbridge 1987), 111–18

A. Katzenellenbogen, *Allegories of the Virtues and Vices in Medieval Art* (Toronto 1989)

A. Kruger and G. Runge, 'Lifting the Veil: Two Typological Diagrams in the Hortus Deliciarum', *Journal of the Warburg and Courtauld Institutes*, 60, 1998, 1–22

G. B. Ladner, *Ad Imaginem Dei: the image of man in medieval art* (La Trobe, 1962)

G. A. Leff, *Medieval Thought from St Augustine to Ockham* (Chicago 1958)

C. S. Lewis, *The Discarded Image* (Cambridge 1964)

C. S. Lewis, *The Allegory of Love* (Oxford 1936)

M. Meiss, 'French and Italian Variations on an early Fifteenth-Century Theme: St Jerome and his Study', *Gazette des Beaux Arts* 62 (1963), 147–70

C. Morris, *The Discovery of the Individual 1050–1200* (Toronto/ Medieval Academy of America, 1972 /1991)

X. Muratova, 'Bestiaries: and aspects of Medieval Patronage', in *Art and Patronage in the English Romanesque*, ed. S. Macready and F. H. Thomson (London 1986), 118–44

S. H. Nasr, *Islamic Science: An Illustrated Study* (World of Islam 1976)

S. H. Nasr, *Science and Civilisation in Islam* (Cambridge, MA 1968)

Y. V. O'Neill, 'Diagrams of the Medieval Brain: A Study in Cerebral Localization', in *Iconography at the Crossroads*, ed. B. Cassidy (Princeton 1993), 91–105

A. Pilz, *The World of Medieval Learning* (revised edn, Oxford 1981)

C. Rawcliffe, *Medicine and Society in Later Medieval England* (Stroud 1995)

B. Ridderbos, *Saint and Symbol: Images of St Jerome in early Italian art* (Groningen 1984)

J. Seznec, *The Survival of the Pagan Gods* (Princeton 1972)

K. Stejskal, *European Art in the Fourteenth Century* (Prague, n.d.)

S. J. Tester, *A History of Western Astrology* (Woodbridge 1987)

D. L. Wagner, (ed.) *The Seven Liberal Arts in the Middle Ages* (Indiana 1983)

P. Whitfield, *The Mapping of the Heavens* (London 1995)

F. Yates, *The Art of Memory* (Harmondsworth 1966)

Chapter 6. Art and War

There is surprisingly little written on medieval art and warfare, although it is clearly a subject with enormous potential. While some of these books are illustrated, most of the authors are interested in evidence in the pictures for historical realism and assess them in terms of the accuracy of representations of various battles and war machines, rather than for artistic invention.

C. T. Allmand (ed.), *War, Literature and Politics in the Late Middle Ages* (Liverpool 1976)

M. Barber, *The New Knighthood: A History of the Order of the Temple* (Cambridge 1994)

C. Blair, *European Armour, c.1066– c.1700* (London 1958/1972)

R. R. Bolgar, 'Hero or Anti-hero? The Genesis and Development of the Miles Christianus', in *Concepts of the Hero in the Middle Ages and the Renaissance*, ed. N. T. Burns and C. Reagan (Albany 1975), 120–46

J. Bradbury, *The Medieval Siege* (Woodbridge 1992/1998)

S. A. Brown, *The Bayeux Tapestry: History and Bibliography* (Woodbridge 1998)

P. Coss, *The Knight in Medieval England 1000–1400* (Stroud 1993/1996)

N. Hooper and M. Bennett, *Warfare in the Middle Ages, 768–1487.* Cambridge Illustrated Atlas (Cambridge 1996)

M. Keen, *Chivalry* (London 1984)

A. Martindale, *Painting the Palace: Studies in the History of Medieval Secular Painting* (London 1995)

H. Nicholson (ed.), *The Military Orders*, 2 vols (London 1998)

R. Rogers, *Latin Siege Warfare in the Twelfth Century* (Oxford 1992/1997)

B. W. Wardroper, 'The Epic Hero Superseded', in *Concepts of the Hero in the Middle Ages and the Renaissance*, ed. N. T. Burns and C. Reagan (Albany 1975), 197–221

Chapter 7. Pleasures

R. Boase, *The Origin and Meaning of Courtly Love: A Critical Study of European Scholarship* (Manchester 1977)

M. Camille, *Image on the Edge: The Margins of Medieval Art* (London 1992)

M. Camille, *The Medieval Art* of Love (London 1998)

C. J. Campbell, *The Game of Courting and the Art of the Commune of San Gimignano 1290–1320* (Princeton 1997)

J. Cummins, *The Hound and the Hawk: The Art of Medieval Hunting* (London 1988)

U. Eco, *Art and Beauty in the Middle Ages* (New Haven and London 1986)

C. Frugoni, 'La Femme imaginée', *Histoire des Femmes*, 2: *Le Moyen Age*, ed. G. Duby, M.Perrot (Rome 1990), 357–437

C. S. Jaeger, *The Origins of Courtliness, Civilising Trends and the Formation of Courtly Ideals 939–1210* (Pennsylvania 1985)

H. W. Janson, *Apes and Ape Lore in the Middle Ages and the Renaissance* (London 1952)

R. Lightbown, *Medieval European Jewellery: with a catalogue of the collection in the Victoria & Albert Museum* (London, 1992)

L. Randall, *Images in the Margins of Gothic Manuscripts* (Berkeley 1966)

M. Thiébaux, *The Stag of Love: The Chase in Medieval Literature* (Cornell 1974)

Geoffrey of Vinsauf, *Poetria Nova*, ed. M. F. Nims (Toronto 1967)

Notes

1. A saying by Bernard of Chartres quoted by John of Salisbury *c.*1159 in *Metalogicon* 3.4, ed. C. J. Webb (Oxford 1929), 136; G. Beaujouan, 'The Transformation of the Quadrivium', in *Renaissance and Renewal in the Twelfth Century*, ed. R. L. Benson and G.Constable (Toronto 1991).

2. George Zarnecki's problem in defining Romanesque is a case in point (*Romanesque Art* (London 1981), 5.

Below is a list of museums that contain major collections of medieval art. It has not been possible to list important individual objects or smaller centres, some of which will be found in the List of Illustrations on p. 219.

United Kingdom

ENGLAND
Cambridge
Fitzwilliam Museum
Trumpington Street
Cambridge CB2 1RD
www.fitzmuseum.ca.ac.uk
Collection includes medieval paintings, decorative arts, and manuscripts.

London
British Library
96 Euston Road
London NW1 2DB
www.bl.uk
One of the world's best collections of medieval manuscripts, charters, seals, and maps.

British Museum
Great Russell Street
London WC1B 3DG
www.british-museum.ac.uk
Major collection of European medieval art, some sculpture, mainly metalwork, jewellery, ivories.

Victoria and Albert Museum
Cromwell Road
South Kensington
London SW7 2RL
www.vam.ac.uk
Includes significant collection of church art and domestic arts, major pieces displayed in medieval 'treasury'; many more, such as stained glass, metalwork, ironwork, and textiles in the relevant departments of the museum for those media.

Oxford
Ashmolean Museum of Art and Archaeology
Beaumont Street
Oxford OX1 2PM
www.ashmol.ox.ac.uk
Medieval painting, decorative arts.

Bodleian Library
University of Oxford
Broad Street
Oxford OX1 3BG
www.bodley.ox.ac.uk
Department of Special Collections and Western Manuscripts contains a great collection of medieval manuscripts. Good developing website with images on:
http://image.ox.ac.uk

SCOTLAND
Edinburgh
National Museums of Scotland
Chambers Street
Edinburgh EH11JF
www.nms.ac.uk
Good Scottish collections, archaeology, arms and armour, and ironwork.

Glasgow
Burrell Collection
Pollock Country Park
Glasgow G43 1AT
www.clyde-valley.com /glasgow /burrell. html
Important collections of tapestries and stained glass.

Western Europe

AUSTRIA
Vienna
Kunsthistorisches Museum
1010 Wien, Maria-Theresien-Platz
www.khm.at
One of the most important collections of medieval art in Europe. Includes the insignia, jewels, and coronation robes of the Holy Roman Empire.

BELGIUM
Bruges
Groëninge Museum
Dijver 12, 8000 Brugge
Paintings by Memling, Van der Goes, Van Eyck.

Western Europe

BELGIUM cont'd
Bruges
Musée Gruuthuse
Dijver 17, 8000 Brugge
A medieval building containing mainly
archaeology and decorative arts from the
region.

Memling Museum
Mariastraat 38, 8000 Brugge
Museum in St John's Hospital, contains
works by the artist including the Shrine of
St Ursula.

Brussels
Royal Museums of Fine Arts of Belgium:
Museum of Ancient Art
Rue de la Régence
1000 Bruxelles
www.fine-arts-museums.be
Includes Flemish medieval painting.

Musés Royaux d'Art et d'Histoire:
Musée du Cinquantenaire
Parc du Cinquantenaire 10
1000 Bruxelles
www.kmkg-mrah.be
The main collection of Mosan metalwork.

Liège
Musée d'Art Religieux et d'Art Mosan
Rue Mére Dieu
4000 Liège
www.netline.be/atlas/liege/musee/rel/
home_rel.htm
Metalwork and sculpture from the region of
the river Meuse.

Namur
Couvent des soeurs de Notre-Dame
Rue Julie Billiart 17
5000 Namur
Treasury of the priory of Oignies including
almost the complete collection of shrines
and reliquaries made by Hugo d'Oignies in
the early thirteenth century.

FRANCE
Paris
Musée du Louvre
75058 Paris, Cedex 01
www.louvre.fr
Major collection of sculpture and
decorative arts includes important
medieval arts.

Musée Nationale de Moyen-Age –Thermes
de Cluny
6 Place Painlevé
75005 Paris
www.musexpo.com/france/cluny
One of the world's best comprehensive
medieval art collections.

Bibliothèque Nationale
Quai François Mauriac
75013 Paris
www.bnf.fr
Extensive collections of medieval
manuscripts with a very good website
including virtual exhibitions and images.

Conques
L'Abbatiale Sainte-Foy de Conques
Aveyron
www.conques.com/visite.tresor.uk.html
Good treasury with famous gold reliquary
of Sainte-Foy. Good website promoting the
European Centre for Art and Medieval
Civilisation.

GERMANY
Berlin
Kunstgewerbe Museum
Matthäikirchplatz
Berlin-Tiergarten
www.smb.spk-berlin.de/kgm/s.html
One of the most important collections of
medieval arts, textiles, metalwork, and
ivories in Europe.

Cologne
Erzbischöfliches Diözesanmuseum
Roncalliplatz 2
50667 Köln
www.kolumba.de
Mixed collection includes medieval
painting and sculpture. Occasional
medieval exhibitions.

Schnütgen Museum
Cäcilienstrasse 29
50667 Köln
Collection of European medieval Christian
art, wood and stone sculpture, glass,
textiles, and treasury.

Western Europe

GERMANY cont'd
Freiburg-im-Breisgau
Augustinermuseum
Augustinerplatz 1-3
D-79098 Freiburg
Good collection of medieval art and
archaeology.

Munich
Bayerisches Nationalmuseum
Prinzregentenstrasse 3
80538, München
www.bayerisches-nationalmuseum.de
Large collection of medieval sculpture
including work by Hans Multscher, Gregor
Erhardt, and Tilman Riemenschneider.

Residenzmuseum und Schatzkammer der
Residenz
Residenzstrasse 1, 80333, München
www.museen-in-bayern.de/
Muenchen-Residenzmuseum.htm
The treasury from the Antiquarium of Duke
Albrecht V (created 1565), contains some
important medieval crowns, reliquaries,
and manuscripts.

Regensburg
Historisches Museum
Dachauplatz 2–4
Reflects the wealth and importance of this
town on the Danube on the route to eastern
Europe during the Middle Ages.

Diocezanmuseum St Ulrich
Domplatz 2
Domschatzmuseum (in the medieval
Bishop's Palace)
www.regensburg.de
Good collection of Church art, reliquaries,
and textiles from the eleventh century
onwards.

NETHERLANDS
Amsterdam
Rijksmuseum
Stadhouderskade 42
1071 ZD
Amsterdam
and:
PO Box 74888
1070DN
Amsterdam
www.rijksmuseum.nl
Contains collections of medieval painting,
sculpture, applied arts, and furniture.

Rotterdam
Museum Boijmans van Beuningen
Museumpark 18-20
3015 CX Rotterdam
www.boijmans.rotterdam.nl
Collection of ceramics and glass.
Fifteenth-century northern painting,
including the Geertgen tot Sint Jans
'Glorification of the Virgin'.

IRELAND
Dublin
National Museum of Ireland
Kildare Street
Dublin 2
Principal collection of early Irish art.

ITALY
Bologna
Museo Civico del' Medioevo e del
Rinascimento
Palazzo Ghislardi-Fava
Via Manzoni 4
Contains medieval church art and secular
art from Emilia Romagna area.

Florence
Museo Nazionale del Bargello
Via del Proconsolo 4
www.sbas.firenze.it/bargello/index.html
Contains important collection of medieval
sculpture, including the Carrand
Collection of ivories and metalwork.

Palazzo Davanzati
Via di Porta Rossa 9
Fourteenth-century palace with wall-
paintings and domestic arts collection.

Naples
Museo Nazionale di Capodimonte
Parco di Capodimonte
Includes important collection of Italian
and northern European painting from
fourteenth century onwards.

Rome
Vatican Museums
Viale Vaticoano 00165
Città del Vaticano
www.vatican.va
Important collection of books, book covers,
ivories, paintings. Information about the
collections and images is accessible via:
christusrex.org/wwwl/vaticano/0-
Musei.html

Western Europe

PORTUGAL
Calouste Gulbenkian Foundation
Av. Berna 45
1000 Lisboa
Originally a private collection. Includes
medieval paintings and decorative art.

SPAIN
Barcelona
Museu Nacional d'Art de Catalunya
Palacio Nacional
Parc de Monjuic
08038 Barcelona
www.gencat.es/mnac/c.fram_es.htm
Impressive collections of wall-paintings
and altarpieces from eleventh to fifteenth
century.

Burgos
Convent of Santa Maria la Real de las
Huelgas
Collection of royal tombs of Castile from
the twelfth century onwards. Museo das
Telas contains the dresses and textiles
removed from the tombs.

Eastern Europe

CZECH REPUBLIC
Prague
Národní Muzeum
Václavské námesti 68
11589 Praha
www.nm.cz
Collection of Bohemian art.

CROATIA
Zagreb
Museum of Arts and Crafts, Zagreb
Trg marsala Tital 0
1000 Zagreb
www.mdc.hr/muo/eng/opci.html
Strength is in metalwork, of which there
are 7,000 items, including bells; also
Croatian medieval sculpture and painting.

POLAND
Warsaw
Museum Narodowe
00–495 Warsaw
Al. Jerozolimskie 3
www.ddg.com.pl
Large collection Polish and Bohemian
medieval painting and sculpture.

Cracow
Museum Narodowe, Cracow
Al 3 Maja 1
Cracow
Collection of Polish art.

HUNGARY
Budapest
Hungarian National Museum (Magyar
Nemzeti Múzeum)
1088 Budapest
krt 14–16
http://origo.hnm.hu
Large collection of medieval artefacts from
Migration period onwards. Items
illustrated on website: *http:origo.hnm.
hu/gyutem /kozepkor/ekozepkor.html?*

Eztergom
Cathedral Treasury
Important fifteenth-century reliquaries and
textiles commissioned by the court of
Matthias Corvinus.

Scandinavia

DENMARK
Copenhagen
National Museum of Denmark
Ny Vestergade 10
København K
www.natmus.min.dk
Archaeology, church art, Danish medieval
art from mid-eleventh century onwards.

Nyköbing
Middelalder Centret (Medieval Centre)
Ved Hamborgskoven 2, 4800
Nyköbing F
www.middelaldercentret.dk
An experimental museum with
reconstructions of technology,
shipbuilding, and warfare. Good website
with images and research information.

Scandinavia

NORWAY
Oslo
Universitets Historisk Museum
Oldsaksamlingen
Fredericksgate 2
N-0164
Oslo
www.ukm.uio.no
University museum of national antiquities,
contains extensive collections of medieval
archaeology and art.

SWEDEN
Stockholm
Swedish Museum of National Antiquities
(Statens Historiska Museum)
Narvavagen 13-17
Stockholm
www.historiska.se
Swedish archaeology from prehistoric
periods onwards. One of the most
important collections of Viking treasures.

USA

New York
Metropolitan Museum of Art
1000 Fifth Avenue at 82nd Street
New York, NY 10028-0198
www.metmuseum.org
Stained glass, sculpture, Byzantine silver
and ivories, Limoges enamels. Highlights
illustrated on website (also for Cloisters
below).

The Cloisters
Fort Tryon Park
New York
NY 10046
www.metmuseum.org/collections/
department.asp?dep=7
Impressive branch museum of the
Metropolitan situated in four acres at Fort
Tryon, Manhattan. Based around five
reconstructed twelfth-century cloisters
from Spain and southern France. Wide-
ranging collection of medieval art in
Europe.

Morgan Library
29 East 36th St
New York, NY 10016
www.morganlibrary.org
Very good collection of manuscripts, some
illustrated on website.

Baltimore
Walters Art Gallery
600 North Charles Street
Baltimore, MD 2120
www.thewalters.org
Byzantine and medieval art, enamels,
ivories, bookcovers.

Washington, DC
National Gallery of Art
6th Street and Constitution Avenue, NW,
Washington, DC 20565
www.nga.gov
Italian thirteenth- and fourteenth-century
painting, sculpture from fourteenth
century. Collection of church treasures
includes chalice of Abbot Suger and
mainly Limoges enamels.

General websites

http://library.byu.edu/~rdh/eurodocs/
homepage.html
Eurodocs: a very useful and
comprehensive collection of transcriptions
and facsimiles and translations of
medieval primary manuscript sources. Put
together by Brigham Young University,
Utah.

http://lcweb.loc.gov/coll/nucmc/nucmc.html
Library of Congress National Union
catalogue of manuscript collections.

www.fotomr.unimarburg.de
Extensive picture library of German
monuments with on-line index at
http://bildindex.de/intro.htm

General websites

www.thais.it
Picture library of Italian sculpture and architecture.

http://www.ches.abdn.ac.uk:8080/besttest/alt/comment/best_toc.html
Pioneer website for the Aberdeen Bestiary with excellent introductory material and full text with translations.

Many universities with medieval studies courses and departments have good websites with links to the main sites for images, bibliographies, and teaching and resource materials. A selection will be found in the following websites. All secondary material should be checked for factual accuracy.

http://argos.evansville.edu
Search engine for medieval studies maintained by University of Evansville.

www.bc.edu.bc_org/avp/cas/fnart/links/medieval-links.html
University of Boston Fine Arts department's links to medieval resources.

www.lib.camb.ac.uk/MSS/Ee.3.59
Facsimile of the mid-thirteenth-century Life of St Edward the Confessor, with zoomable illustrations.

www.orb.rhodes.edu
On-line reference book for medieval studies. Useful bibliographies.

www.bris.ac.uk/Depts/Medieval
University of Bristol Centre for Medieval Studies, with links to medieval resources on the Internet.

www.georgetown.edu/labyrinth/index.html
The Labyrinth: resoures for medieval studies – one of the largest collections of linked resources, sponsored by Georgetown University.

http://www.rz.uni-karlsruhe.de
Includes good links to consortium of universities and a virtual library for resource materials for German medieval studies.

List of Illustrations

The publisher would like to thank the following individuals and institutions who have kindly given permission to reproduce the illustrations listed below.

1. Creation tapestry, wool embroidery, c.1100. 365 × 470 cm. Museu de la Catedral, Girona/photo Institut Amatller d'Art Hispànic, Barcelona.
2. The Hereford Cathedral World Map, facsimile (London: E. Stanford, 1872) of parchment original, black ink, gold leaf, and coloured pigment, c.1230. 158 × 133 cm. The Dean and Chapter of Hereford Cathedral and The Hereford Mappa Mundi Trust.
3. Three inhabitants of Siberia, *Livre de Merveilles*, parchment, early fifteenth century. Bibliothèque Nationale (MS fonds fr.2810, f.29v), Paris.
4. Two facing folios showing personifications of Rome and provinces of the empire approaching Otto III, and Otto III seated in majesty. Parchment, 998–1001. Bayerische StaatsBibliothek (MS Clm.4453, ff.23v–24r), Munich.
5. Tympanum of inner west doorway of the narthex, basilica of Sainte-Marie-Madeleine, Vézelay, c.1130. Photo A. F. Kersting, London.
6. The Hague map of Jerusalem, vellum, manuscript, Flemish, 1170-80. 255 × 165 mm. Koninklijke Bibliotheek (MS 76.F.5, f.1r), The Hague.
7. The 'Externsteine' Stone, Horn, Westphalia, c.1115. Photo AKG London.
8. Psalm 1, Peterborough Psalter, parchment, English, c.1300. 300 × 194 mm. Bibliothèque Royale de Belgique (MS 9961-62, f.14r), Brussels.
9. Box carved with wild folk in woodland scenes, boxwood (with jasper feet probably added in 16th century), Upper/Middle Rhineland, c.1460–70. 12 × 31 × 16 cm. Kunsthistorisches Museum (inv.no.118), Vienna.
10. The Annunciation to the Shepherds, vault painting, Panteón de los Reyes, Léon, Galicia, c.1160. Photo Institut Amatller d'Art

Hispànic, Barcelona.
11. Scene of harrowing, from the Psalter of Geoffrey Luttrell, parchment, English, c.1335. 354 × 244 mm. The British Library (MS Add.42130, f.171r), London.
12. Calendar illustration for September, from the *Très Riches Heures* of Jean, duc de Berry, parchment, painted by the Limbourg brothers, and Jean Colombe, 1413–16 and c.1485. 290 × 210 mm. Musée Condé, Chantilly (MS 65 [1284], f.9v)/photo Bridgeman Art Library, London/Giraudon, Paris.
13. Winter scenes, Virgil's *Georgics*, Bruges, 1473. 350 × 245 mm. Holkham Hall (MS 31, f.41v), Norfolk, by kind permission of the Earl of Leicester and Trustees of the Holkham Estate.
14. Jan van Eyck, *The Virgin and Child and Chancellor Rolin*, c.1435. Oil on panel.66 × 62 cm. Musée du Louvre (inv.no.1271), Paris/ photo Bridgeman Art Library, London.
15. Chapter-house of Southwell Minster, c.1290. Photo A. F. Kersting, London.
16. Seal of the barons of London, wax impression, 1219. Diameter 72 mm. Public Record Office (E.329/428), Kew.
17. Ambrogio Lorenzetti, *The Effects of Good Government*, fresco, Sala del Nove, Palazzo Pubblico, Siena, 1338–40. Photo Scala, Florence.
18. Picture map of Constantinople, from Christoforo Buondelmonte, *Liber insularum Cycladum atque aliarum in circuitu sparsarum*, tempera on parchment, Flemish, 1485. The British Library (MS Arundel 93, f.155r), London.
19. Andrea Mantegna, *Descent into Limbo*, tempera and gold on wood, c.1492. 40.3 × 43.7 cm. Barbara Piasecka Johnson Collection, Princeton, NJ.
20. World Globe, lime cement, parchment, painted paper, Nuremberg, 1492-4. Diameter 510 mm. Germanisches Nationalmuseum (inv.no.WI.1826), Nuremberg.
21. Hildebertus and assistant Everwinus, *Self-portrait*, from St Augustine, *Civitas dei*, ink on parchment, Bohemia, c.1150. 340 × 250 mm.

Library of the Metropolitan Chapter of St Vitus (sign.A 21/1,F.155R), Prague/photo Správa Pražského hradu.

22. Adam Kraft, Self-portrait (H. 90.5 cm.) and Sacrament shrine (H. 21 m.). Polychromed sandstone, 1493–6. St Lorenz, Nuremberg. Photos AKG London (right) and Scala, Florence (left).

23. Engelram and Redolpho panel, ivory, from the shrine of San Millán de Cogolla, Longroño, Spain, 1070–80. 60 x 45 mm. State Hermitage Museum, St Petersburg.

24. John Siferwas presenting his work to his patron, Lord Lovell. Lovell Lectionary, ink and tempera on parchment, early fifteenth century. The British Library (MS Harley 7026, f.4v), London.

25. Gislebertus, tympanum, west door, Saint-Lazare, Autun, signed by Gislebertus, c.1120. Photos Achim Bednorz, Cologne.

26. Nicholas of Verdun, panel from Klosterneuburg altar, bronze gilt, champlevé enamel, Stiftskirche, Klosterneuburg, c.1181. 205 x 165 mm. Photo AKG London.

27. Wiligelmo, dedication stone, façade, Modena Cathedral, c.1110. Photo School of World Art Studies, University of East Anglia, Norwich.

28. Cosmati pavement, limestone, marble, Westminster Abbey, 1268. Photo © Dean and Chapter of Westminster.

29. Nicola Pisano, pulpit, marble, Baptistery, Pisa, 1260. Photo Scala, Florence.

30. Jean Bourdichon, Le Travail, from Les Quatre Etats de la Société, tempera on parchment, French, fifteenth century. Ecole des Beaux-Arts, Paris/photo Bridgeman Art Library, London/Giraudon, Paris.

31. Irene, Pupil of Cratinus, painting, from Giovanni Bocaccio, De claris mulieribus, tempera on vellum. 405 x 207 mm. French, mid-fifteenth century. The British Library (MS Roy.16.G.V, f.73v), London.

32. Representatives of various workmen carrying the tools of their trades, tempera on vellum, from French fifteenth-century edition of Boccaccio, De cas des nobles malheureux hommes et femmes. The British Library (MS Add.18750, f.3r), London.

33. Effigy and tomb of Richard Beauchamp, Earl of Warwick, bronze, marble, iron, 1449–54. Beauchamp Chapel, St Mary's, Warwick. Photos A. F. Kersting, London.

34. Glass workers in Bohemia, from the Travels of Sir John Mandeville, ink and tempera on parchment, Flemish, early fifteenth century. The British Library (MS Add. 24189, f.16r), London.

35. Adhémar de Chabannes, sketchbook pages, ink on parchment, c.250 x 150 mm. St Martial, Limoges, first quarter of the eleventh century. Universiteitsbiblioteek (MS Voss.Lat.o.15, fasc.VIII, ff.42v–43r), Rijks Universiteit Leiden.

36. Villhard de Honnecourt, sketchbook, ink on parchment, c.160 x 240 mm. French, 1230–40.Bibliothèque Nationale (MS fonds fr.19093: f.38r (left), and f.88r (right)), Paris.

37. Shrine of St Patrick's bell, bronze with silver-gilt inlay and gold filigree. (H. 26.7 cm), Armagh, 1094–1105. National Museum of Ireland, Dublin.

38. Lutz Krafft, dedication stone, Ulm Cathedral, dated June 1377. Münsterbauamt Ulm/photo Ingrid Rommel.

39. Crozier head of Abbot Erkenbald of Fulda, silver, 997–1011. Dom-Museum, Hildesheim. Bildarchiv Foto Marburg.

40. Entombment of Christ, wall-paintings, 1072–87. S. Angelo in Formis, Campania. Photo © G. Dagli Orti, Paris.

41. Pulpit of Henry II, silver, bronze-gilt, gems, ivory, enamel, 1002–14. H. 146 cm. Aachen Palace Chapel. © Domkapitel Aachen/photo A. Münchow.

42. Pulpit, marble, late eleventh century. S. Ambrogio, Milan. Photo Alinari, Florence.

43. Doorway, wood, Hurum church, Valdres, Oppland, Norway, 1180s. Oldsaksamling, Universitets Oslo/photo Martin Blindheim.

44. Crucifix, painted wood, c.1150. 277 x 266 cm. Brunswick Cathedral, Lower Saxony. Photo School of World Art Studies, University of East Anglia, Norwich.

45. St Martin at Fromista, Castile, founded 1066 by Dona Muñia, widow of Sancho el Major, King of Navarre. Photos Achim Bednorz, Cologne.

46. The Raising of Lazarus, stone relief, c.1108. Chichester Cathedral. Photos: Sonia Halliday Photographs, Weston Turville/F. H. C. Birch (general view) and A. F. Kersting, London (detail).

47. Wall-paintings around chancel arch, 1160s. Chapel of St John, Pürgg, Styria. Photo AKG London.

48. Altar frontal (or retable), tempera on panel, c.1170–90. 105 x 176 cm. Santa Maria d'Avia, Catalonia. Museu Nacional d'Art de Catalunya, Barcelona/photo Institut Amatller d'Art Hispànic.

49. Wall-paintings, second quarter of the twelfth century. Saint-Martin, Nohant-Vicq, Indre. Photo Bridgeman Art Library, London.

50. Crucifixion window, stained glass, 1165–70.

Poitiers Cathedral. Sonia Halliday Photographs, Weston Turville.

51. King William II of Sicily presenting the church to the Virgin Mary, cloister capital, Monreale Cathedral, c.1180. Photo Alinari, Florence.

52. Stone sarcophagus for one of the children of Alphonso VIII of Castile and Eleanor Plantagenet, 1194. Museo de Telas Medievales, Real Monasterio de las Huelgas, Burgos/photo © Patrimonia Nacional, Madrid.

53. Shrine of the Three Magi, gold, silver-gilt, bronze-gilt, gems, enamels, pearls, begun c.1182–90. H. 170 cm. Domschatzkammer, Cologne/AKG London/photo Erich Lessing.

54. The miraculous revelation of the relics of St Mark, mosaic, c.1260, south-west pier below central dome, San Marco, Venice. Photo Scala, Florence.

55. West façade, Saint-Gilles, Provence, late 1140s. Photo Achim Bednorz, Cologne.

56. Portico de la Gloria, St James, Compostela, c.1168. Photo Institut Amatller d'Art Hispànic, Barcelona.

57. Synagogue of the Transito, Toledo, founded 1366. Photo Institut Amatller d'Art Hispànic, Barcelona.

58. Wells Cathedral, Somerset, west façade, c.1220. Photo A. F. Kersting, London.

59. Reims Cathedral, west façade, c.1260. Photo Achim Bednorz, Cologne.

60. Reims Cathedral, inner west façade, c.1260. Photo Bridgeman Art Library, London.

61. Reliquary of the Holy Corporal, silver-gilt, c.1280–1300. 292 x 267mm. Museo-Tesoro S. Francesco, Assisi. Photo Scala, Florence.

62. Façade, Strasbourg Cathedral, ink on parchment, c.1270. Musée de l'Oeuvre Notre Dame de Strasbourg (project 'A').

63. Giotto (attrib.), St Francis casting devils from the city of Arezzo, fresco, 1290s. S. Francesco, Assisi. Photo Scala, Florence.

64. Forked crucifix (Gabelkreuz), wood, 1304. H. 150 cm. St Maria in Capitol, Cologne. Photo Rheinisches Bildarchiv, Cologne.

65. Sepulchre of Christ, stone, c.1340. All Saints, Hawton, Nottinghamshire. Photos Michael Brandon-Jones.

66. Façade, Orvieto Cathedral, 1310–30. Photo Scala, Florence.

67. East window (central section), stained glass, c.1350–60. Gloucester Cathedral. Sonia Halliday Photographs, Weston Turville.

68. Veit Stoss, altar retable, painted wood, c.1477–9. H. 13 m. St Mary, Cracow. Bildarchiv Foto Marburg.

69. Masaccio, The Trinity with the Virgin and Two Donors, fresco, 1425. S. Maria Novella, Florence. Photo Scala, Florence.

70. Vincent of Kastav, The Dance of Death, fresco, 1474. Beram, Istria. Photo Conway Library, Courtauld Institute of Art, University of London.

71. The Virgin and Child, polychromed limewood, 1410. Kruzlowa, Bohemia. H. 118 cm. Muzeum Narodowego, Cracow/photo Marek Studnicki.

72. Geertgen tot Sint Jans, Glorification of the Virgin, Haarlem, c.1480. Oil on wood panel. 26.8 x 20.5 cm. Museum Boijmans van Beuningen (inv.no.2450), Rotterdam.

73. (a) Crucifixion retable with saints, oil on oak panel, probably c.1335. 94 x 381 cm. Thornham Parva, Suffolk/photo Hamilton Kerr Institute, University of Cambridge; (b) Altar frontal, c.1335. Musée National du Moyen Age, Paris/photo Bridgeman Art Library, London/Giraudon, Paris.

74. Tutivillus and Gossips, wall-painting, c.1308, Reichenau Oberzell, Bodensee. Bildarchiv Foto Marburg.

75. Cloister, Jerpoint Abbey, Ireland, c.1400. Photo Roger Stalley, Trinity College, Dublin.

76. Tomb of Maria Villalobos, stone, fourteenth century. Lisbon Cathedral. Arquivo Fotográfico Municipal, Lisbon.

77. Donatello, Lamentation over the Dead Christ, stone relief, 1443–53, from the high altar, S. Antonio, Padua. Photo Alinari, Florence.

78. Choir cope, linen, silk, abbey of Saint-Blaise, Upper Rhine, c.1275. 150 x 310 cm. MAK-Österreichische Museum für Angewandte Kunst (inv.no.T.9125), Vienna.

79. Rogier van der Weyden, Altarpiece of the Seven Sacraments, oil on wood panel, c.1441. Centre panel 200 x 97 cm; side panels 119 x 63 cm. Koninklijk Museum voor Schone Kunsten (inv.no.393/4/5), Antwerp.

80. Man as Microcosm, wall-painting, c.1230, Anagni Cathedral (Lazio). Photo Alinari, Florence.

81. Divine Creation, the Universe, and Cosmic Man, from Hildegard of Bingen, Book of Divine Works, tempera on parchment, c.1230. 390 x 255 mm. Biblioteca Statale (MS 1942, f.9r), Lucca, su concessione del Ministero per I Beni e le Attività Culturali.

82. Herman, Paul, and Jean de Limbourg, Zodiac Man, tempera on parchment, from the Trés Riches Heures of Jean, duc de Berry, Flemish, 1413-16. 290 x 210 mm. Musée Condé, Chantilly (MS 65 [1284], f.14v)/photo Bridgeman Art Library, London/ Giraudon,

Paris.

83. Wolf-Lupus, from Al Sufi, *Book of Fixed Stars*, tempera on parchment, Italian, *c*.1350. Museum of National Literature (Památník Národního Písemnictví), Prague.

84. The Astronomer Terzysko, astronomical book of Wenzel IV, king of Bohemia, tempera on parchment, *c*.1400. 467 × 346 mm. Bayerische StaatsBibliothek (MS Clm.826, f.8v), Munich.

85. The Creation and Virtues, from the *Uta Codex*, tempera on parchment, St Emmeram, Regensburg, *c*.1002. Bayerische Staats-Bibliothek (MS Clm.13601, f.IV), Munich.

86. Byrhtferth's diagram of the Elements from a Natural Science textbook miscellany, ink and tempera on parchment, English, *c*.1100. 342 × 242 mm. St John's College (MS 17, f.17v), University of Oxford.

87. Rose window, stained glass, early thirteenth century, Lausanne Cathedral. Photo Achim Bednorz, Cologne.

88. Genealogy of the Children of Shem, from Peter of Poitiers, ink on parchment, French, fourteenth century. The British Library (MS Roy.I.B.X, f.10v), London.

89. Ramon Lull with the ladders of his art, ink and tempera on parchment, early fourteenth century. 345 × 280 mm. Badische Landes-bibliothek (MS St.Peter.perg.92, f.5r), Karlsruhe.

90. The Ladder of Virtue, from the *Speculum virginum* of Conrad of Hirsau, ink on parchment, *c*.1125–50. The British Library (MS Arundel 44, f.93v), London.

91. Figures of Artes and writers, stone, *c*.1150, south façade, Chartres Cathedral. Photo Bridgeman Art Library, London.

92. The Liberal Arts, *Hortus deliciarum*, *c*.1200 (engraved copy, nineteenth century).

93. Palm of Virtue, from Lambert of Saint-Omer, *Liber Floridus*, coloured drawing on parchment, *c*.1120. 310 × 210 mm. Universiteits-bibliothek (MS 90.f.76v), Ghent.

94. The Lion, from the Ashmole Bestiary, tempera on parchment, English, *c*.1200–10. 276 × 183 mm. The Bodleian Library (MS Ashmole 1511, f.10r), University of Oxford.

95. Anatomical illustration, from a Medical and Calendrical Miscellany. English. *c*.1292. 269 × 192 mm. The Bodleian Library (MS Ashmole 399, f.18r), University of Oxford.

96. Master of 1328, papal consistory court, tempera on parchment, Italian, Bologna, 1328. 327 × 212 mm. Pierpont Morgan Library (MS M.716, f.1r), New York/photo Art Resource.

97. Seated philosopher lecturing to pupils, manuscript painting, from Averroes, *In physicam aristotelis*, English, *c*.1250–75. Bibliothèque Nationale (MS lat.6505, f.49r), Paris.

98. Pier Paolo dalle Masegne (active 1383–1403), also signed by his brother Jacobello, panel from the tomb of Giovanni da Legnano, marble, *c*.1386, originally in S. Domenico, Bologna. 760 × 620 mm. Museo Civico, Bologna/photo Scala, Florence.

99. The scribe Eadwine, ink and tempera on calf vellum, from the Eadwine Psalter, English, *c*.1160. 460 × 330 mm. Trinity College Library (MS R.17.1, f.283v), Cambridge.

100. Jaume Ferrer and Pere Teixidor, St Jerome in his Study, bound pigment in gilding on wood, panel (151 × 86 cm) from a retable, Catalonia, 1440–50. Museu Nacional d'Art Catalunya (inv.no.114743), Barcelona/photo Institut Amatller d'Art Hispànic.

101. Girolamo da Cremona or Jacometto Veneziano, title-page of Aristotle, *Opera*, volume 2 (Venice: A. Torresanus de Absula, 1483), tempera on vellum. 413 × 273 mm. Pierpont Morgan Library (inv.no.21195), New York/photo Art Resource.

102. Viking raiders, Scenes from the Life of St Aubin, Abbaye de Saint-Aubin. Tempera on parchment, French, *c*.1100. 295 × 205 mm. Bibliothèque Nationale (MS nouv.acq.lat.1390, f.7r), Paris.

103. Parade axe, iron, silver, niello, Russia, Kazan region, first half of the fourteenth century. Gosudarstvennyj Istoricaskij Muzej, Moscow.

104. The Bayeux tapestry, wool embroidery on linen, probably English, last quarter of the eleventh century. Musée de la Tapisserie, Centre Guillaume-le-Conquerant, by special permission of the City of Bayeux.

105. The Siege of Mallorca, wall-paintings, from Palau Aguilar-Caldes, 1285–90. 175 × 532 cm. Museu Nacional d'Art Catalunya, Barcelona/photo Institut Amatller d'Art Hispànic.

106. Third battle of Alexander and Darius, tempera on parchment, from Thomas Kent, *Roman de toute chevalerie*, 1308–12. 322 × 220 mm. Bibliothèque Nationale (MS fonds fr.24364, f.43r), Paris.

107. Saul's body hung from the walls of Beth-Shan and the burning of the bodies of Saul and his three sons, tempera on parchment, from the Maciejowski Bible, *c*.1250. 390 × 304 mm. Pierpont Morgan Library (M.638, f.35v), New York/photo Art Resource.

108. Matthew Paris, a Tartar cannibal feast, ink drawing, with colours, from the *Chronica maiora*, 1241. 362 × 248 mm. The Parker Library

(MS 16, f.166r), by permission of the Master and Fellows of Corpus Christi College, Cambridge/photo Conway Library, Courtauld Institute of Art, University of London.

109. The Storming of Caen by Edward III in 1346, manuscript painting, from Froissart's *Chronicles*, Bruges, c.1400. 440 x 330 mm. Bibliothèque Nationale (MS fonds fr.2643, f.157v), Paris.

110. How Girart was grounded by King Charles, tempera on parchment, from the *Roman de Girart de Roussillon*, Mons, 1448. 400 x 300 mm. Österreichisches National-bibliothek (MS 2549, f.152v), Vienna/photo Felix Leutner.

111. Paulo Uccello, *Rout of San Romano*, oil on panel, 1454–7. 182 x 320 cm. The National Gallery (inv.no.583), London.

112. The Nine Worthies, stone, c.1330, north wall, Rathaus, Cologne. Bildarchiv Foto Marburg.

113. Bernt Notke, St George and the Dragon, carved oak, polychromed and gilded over gesso, horsehair, linen, leather, iron, parchment, elk antler, 1489. H. 3.09 x W. 2.28 m. St Nicholas, Stockholm. Photo Anders Qwarnström, Stockholm.

114. God of Revelation, enthroned with St Michael and the Angels fighting the Seven-Headed Dragon, wall painting, c.1100, east wall, narthex, S. Pietro al Monte, Civate (Como). Photo Scala, Florence.

115. Peter Vischer, tomb effigy of Otto IV, Graf von Henneburg, bronze, c.1490. Church of Römhild, Thuringia. Bildarchiv Foto Marburg.

116. Effigies in choir, Purbeck marble, c.1250–70. Temple Church, London. Photo A. F. Kersting, London.

117. Christine de Pisan, *Livre des faits des armes et de chevalerie*, tempera on parchment, 1409. 297 x 212 mm. Bibliothèque Royale de Belgique (MS 10476, f.3r), Brussels.

118. Honoré Bouvet, *Tree of Battles*, tempera on parchment, French, c.1470. Musée Condé (MS 346/1561, f.10v), Chantilly/photo Bridgeman Art Library, London/Giraudon, Paris.

119. Lovers in a garden (*The Offering of the Heart*), wool tapestry, Flemish, c.1430. 208.3 x 256.5 cm. Musée National de Moyen Age, Paris/photo Bridgeman Art Library, London.

120. Gregor Erhardt, *Allegory of Vanity*, limewood with original polychromy, attributed to Hans Holbein the Elder, Augsburg, c.1500. H. 46 cm. Kunsthistorisches Museum (inv.no.1), Vienna.

121. Spring landscape, tempera on parchment, from the *Carmina Burana*, early thirteenth century. 180 x 120 mm. Bayerische StaatsBibliothek (MS Clm.4660, f.64v), Munich.

122. Cuthbert as a boy, from Bede, *Life of St Cuthbert*, from a manuscript made for Durham Cathedral Priory, c.1100–20. 197 x 122 mm. By permission of the Master and Fellows of University College (MS 165, f.8r), Oxford/photo the Bodleian Library, University of Oxford.

123. Man swimming, tempera on parchment, *De arte venandi cum avibus*, by Emperor Frederick II, 1260s. 360 x 250 mm. Biblioteca Apostolica Vaticana (MS Pal.Lat.1071, f.69r), Vatican City, Rome.

124. Matteo de Viterbo, scene of fishing, wall painting, c.1356–64, Chambre des Cerfs, Palais des Papes, Avignon. Photo © G. Dagli Orti, Paris.

125. The Master of the hunt quartering a stag, tempera on parchment, from Gaston Phoebus, *Le livre de la chasse*, c.1380. Bibliothèque Nationale (MS fonds fr.616, f.70r), Paris.

126. King John cup, silver-gilt, enamel, English, c.1340. H. 395 mm. Borough Council of King's Lynn and Norfolk/photo School of World Art Studies, University of East Anglia, Norwich.

127. Circle of Conrad Witz, Schloss Ambras court playing cards, Upper Rhine, Vienna, c.1440–50. 156 x 95 mm. Kunsthistorisches Museum (inv.nos.5018-5071), Vienna.

128. 'Hungarian saddle', early to mid-fifteenth century. Red deer antler, wood, leather. L. 56 cm. Magyar Nemzeti Múzeum (inv.no.55.3119), Budapest.

129. Game board, ivory and wood, Flemish, c.1430. 66.2 x 65.6 cm. Museo Nazionale del Bargello, Florence/photo Scala, Florence.

130. Casket, ivory, Flemish, c.1350. 65 x 190 x 116 mm. Museo Nazionale del Bargello, Florence/photo Scala, Florence.

131. Atlas figure, stone corbel, c.1250–60, from staircase to turret no. 7, Castel del Monte, Apulia/photo Sopraintendenza ai Monumenti e alle Gallerie, Bari.

132. The world-turned-upside-down: a man points to his bottom and a clothed monkey, stone corbel, c.1330, St Andrew, Heckington, Lincolnshire. Photo Michael Brandon Jones, School of World Art Studies, University of East Anglia, Norwich.

133. Marginal scenes from a Bible, manuscript painting, Flemish, first quarter of fourteenth century. 360 x 252 mm. Bibliothèque Royale de Belgique (MS 9157, f.1r), Brussels.

134. Puzzle jug, Saintonge, glazed ceramic, western France, c.1300. H.46 cm. Royal Albert Memorial Museum and Art Gallery, Exeter/photo Exeter City Museums.
135. Cup, silver-gilt, from Dune treasure, Gotland, possibly made in Bulgaria, eleventh or twelfth century. Diameter (at rim) 106 mm. Statens Historiska Museet (inv.no.6849:5), Stockholm/photo ATA Riksantik-varieämbetet.

136. Funerary cushion of Berenguela, Queen of Léon and Castile, silk taffeta and gold thread, c.1246. 85 × 50 cm. Museo de Telas Medievales, Monasterio de Santa Maria La Real de Huelgas (inv.no.00650512), Burgos/photo © Patrimonia Nacional, Madrid.

The publisher and author apologize for any errors or omissions in the above list. If contacted they will be pleased to rectify these at the earliest opportunity.

Index

Note: References to illustrations and captions are in italic. There may also be textual references on the same page.

Abbo of Fleury 129
Abelard, Peter 139, 199
Abu Ma'Shar 125
Adelard of Bath 120
Adhémar de Chabannes *54*, 198
Aeneid (Virgil) *32*
Aesop's Fables 137
Aguilar-Caldes, Palau 151, *105*
Al Sufi *124*, 201
Albertus Magnus 98
Alexander III, Pope 152
Alexander the Great 12
allegory 119, 177–8
 Allegory of Vanity (Erhardt) *170*
 encyclopaedias 133–7
 and personification 132–3
Almagest (Ptolemy) 120, *124*, 199
Alphonso x 188–9
altarpieces 43, 113, 201
 Altarpiece of the Seven Sacraments (Weyden) 114, *116–17*, 203
 Catalonia *143*
 Crucifixion *110*
 Klosterneuburg *42*, 199
 S. Antonio, Padua *114*
 Santa Maria d'Avia, Catalonia *74*
 St Mary, Cracow *104*
altars 58, 102, 113–17, 199, 201, 203
Anagni Cathedral 120, *121*, 200
Annunciation to the Shepherds, The 22, 23
Aquinas, St Thomas 40, 98, 139, 201
Arab influences 9, *124*, 125, 188, 189
architecture, significance of representation 13
Aristotle 120, 139, *141*, 174, 182, 200, 202
 Opera 144, 145
Ars magna (Lull) *131*
Art of Hunting with Birds, The (Frederick II) *174*
artists 35
 and anonymity 40–2
 career 46–51
 collaboration between 50
 commissions 58–9
 as entertainers 36–8
 as loyal servants 38–40

manuals 49, 52–4
 and patrons 56–9
 reputation of 43–6
 sketchbooks 54–6, 198, 200
 women 46, *48*
Ashmole Bestiary *136*, 200
astrology 120, 124–5
astronomy 120, *124*, *125*, *133*
atlases 30
'Atlas' figures ('atlantes') *see* corbel figures
Augustine, St *36*, 126, 139, 199
Austen, William 50
Averlino, Antonio (Filarete) 37
Averroes *141*, 200

Bacon, Roger 139, 200
Barbari, Jacopo de' 30
Bataille, Nicholas 50
Baudri, abbot of Bourgueil 150
Bayeux tapestry *149*, 150, 153, 198
Beatus of Liebana 8
Beauchamp, Richard, earl of Warwick 50, *51*, 203
beauty
 theories of 127
 transience of 169–72
Bede, the Venerable 135, 172, *173*
Behaim's globe *33*, 203
Benedict XII, Pope 175
Benedictines 126
Berenguela of León 188–9, 200
Bernard of Chartres 119
Bernard of Clairvaux, St 15, 78, 169, 199
Bernward of Hildesheim, St 63, *71*, 72
Berry, Jean, duc de *24*, *49*, 160, 202
bestiaries *136*, 137, 200
Bible
 Flemish *184, 185*
 Maciejowski *153*, *154*, 155, 200
Black Death 106, 201
Blanche de Champagne 112
Blanche of Castile 137
Bloch, Marc 19
board games *180*, 181, 202
Boccaccio, Giovanni 44, *48*, 49, 201
body of Christ 98–100
Boethius 58
Boileau, Etienne 48, 200
Bonaventure, St 98, 139

Bonet, Honoré *see* Bouvet, Honoré
Book of Divine Works (Hildegard of Bingen) *122*, *123*, 200
Book of Fixed Stars (Al Sufi) *124*, 201
Bourdichon, Jean *46*, *47*, 202
Bourgot (woman artist) 48
Bouvet, Honoré *166*, *167*
boxes
 gittern *21*
 troubadour's 21
Bromyard, John 183
Buondelmonte, Christoforo *31*, 203
Byrhtferth *128*, 129, 198

Caesar Augustus 11
Carmelite friars 98
Carmina Burana 171, *172*
caskets *181*, 182, 201
Catalan Atlas 10–11
Cathars 98, 200
cathedrals 90–4: *see also* individual entries
Cennini, Cennino 45–6, 53–4
Charlemagne 10, 65–6, 94
Charles IV, King of Bohemia 88, *124*, 125, 201
Charles V, King of France 10, 124–5, *160*, 165
Charles VI, King of France 24
Chartres Cathedral *133*, 199
Chaucer, Geoffrey 177, 202
Chevrot, Jan *117*
Chichester Cathedral *71*, 72
chivalry 152, 164
Christine de Pisan *165*, 167, 202
Chronica maiora (Matthew Paris) *155*
Chronicles (Froissart) *156*
Cimabue, Giovanni 45
Cistercians 77–8, 80
Civitas dei (St Augustine) *36*, 199
Clement VI, Pope *175*, 176–7
cloister capital, Monreale Cathedral *79*
Collectanea rerum memorabilium (Solinus) 12, 137
Colombe, Jean 24
commissioning of works of art 150–1
Comnena, Anna 164
Compendium veteris testamenti (Peter of Poitiers) *130*
Computus (Abbo of Fleury) 129

Conrad of Hirsau *132*
corbel figures 182–4
 Castel del Monte, Apulia *182*
 St Andrew, Heckington *183*
Corpus Christi 99, 201
Cosmati pavement *44*, 200
cosmic man *122, 123*
Council of Lyons 101, 200
Council of Vienne 99, 201
craft guilds 48–9
Creation tapestry, Girona *9*
crozier of Abbot Erkenwald *64*, 198
crucifixes 98
 Brunswick Cathedral *69*
 St Maria in Capitol, Cologne 99,
 201
Crucifixion window, Poitiers Cathedral
 76, 77
Crusades 4–5, 15, 17, 85, 153, 164, 198, 199,
 200
cups
 Dune treasure, Gotland 4, 186, *187*,
 198
 King John *178*, 201

Daddi, Bernado *96*
Dance of Death (Vincent of Kastav)
 106–7
Dante Alighieri 44, 101, 184, 201
De cas des nobles malheureux hommes et
 femmes (Boccaccio) *49*
De diversibus artibus (*On the Various Arts*)
 (Theophilus) 52, 198
de la Longe, Dionysia *46*
De natura rerum (Hrabanus Maurus) *135*
death, art and preparation for 100–6
Decretals (Gratian) 139, 199
dedication stones 202
 Modena *43*
 Ulm Cathedral *58*
Descent into Limbo (Mantegna) *31, 32*,
 203
Desiderius, Abbot of Montecassino
 56–7, 64
Diagram of the Elements (Byrhtferth)
 128
diagrams *9*
 Manual (Byrhtferth) *128, 129*
Dialogue between a Cluniac and a
 Cistercian monk 78
Disputations (Lombard) 139
Dominic, St 98, 200
Dominican friars (Order of Friars'
 Preachers) 95, 96, 98, 115, 139,
 200
Donatello 113, *114*
Dune treasure, Gotland 186–8
 cup 4, 186, *187*, 198
Duns Scotus, Johannes 98

Eadwine 142, *143*
Eadwine Psalter 28, 56, *143*, 199
Ebsdorf map 11
education 137–41
 scholarship 142–5

Edward I, King of England 10, 153, 154–5
Effects of Good Government, The
 (Lorenzetti) 29, *30*
encyclopaedias, allegorical 133–7
Engelram *38, 39*
Entombment of Christ 65
entrances 82–5
Erhardt, Gregor *170*, 203
Erkenbald, Abbot of Fulda 63
 crozier *64*, 198
Etymologiae (Isidore of Seville) 8, 137
Euclid 120
Everwinus *36*
'Externsteine' stone, Horn *18*, 199

Ferrer, Jaume 142, *143*, 203
figures in religious art 88–90
Filarete *see* Averlino, Antonio
Fourth Lateran Council 85, 90, 99, 100,
 200
Francis, St *96, 97*, 98
Franciscan friars 96, 98–9, 139, 200
Frederick Barbarossa 81, 152
Frederick II, Holy Roman Emperor *174*,
 182
frescoes
 Assisi *96, 97*
 Florence *105*
 Istria *106–7*
 Siena *30*
Froissart, Jean 155–6, 158, 164, 202
funerary cushion 188, *189*, 200

Gaddi, Taddeo and Agnolo *96*
Gaita, duchess of Lombardy 164
Galen 120, *121*
gameboards *180*, 202
gardens 24, 26, 29, 133
Gaston Phoebus *176, 177*, 202
Geertgen tot Sint Jans 107, *109*, 203
Genealogy of the Children of Shem
 (Peter of Poitiers) *130*
Geoffrey of Vinsauf 171
Geoffrey Plantagenet 137
Geographia (Ptolemy) *32, 33*, 202
geometry 55
George, St 161
Georgics (Virgil) 24, *26*
Gerard of Cremona 120
Ghiberti, Lorenzo 40, 53
Giotto 44–6, *96, 97*, 102
Girolamo da Cremona 144, *145*, 203
Gislebertus *41*, 199
globes *33*, 203
Glorification of the Virgin (Geetgen tot
 Sint Jans) *109*
Gloucester Cathedral *103*, 202
gold 65, *66, 77*
Gospels of Otto III 13, 198
Gothic, as all-embracing art term 2
Gottfried von Strassburg 177
Gottfried, Abbot 72, 74
Gratian 139, 199
Gregory the Great, St *3*, 120
Gregory VII, Pope 61, 62, 67, 198

Grosseteste, Robert 139
Guibert of Nogent 14
Guillaume de Machaut 21

Hadamar von Laber 178
Hague map of Jerusalem *17*, 199
Harald Hardrada 147, *149*, 198
Hartwic, monk 126, 128
hell, representations of 101
Henry II, emperor 65, *66*, 198
Henry IV, emperor 67
Henry III, King of England 10
Hereford Cathedral map *10*, 11–12, 200
Herman the German 120
Herrad of Landsberg 133, 136, 137
Hildebertus *36, 37*, 199
Hildegard of Bingen 121–3, 200
Hilton, Rodney 46
Hilton, Walter 90
Hippocrates 120, *121*
Honorius Augustodunensis 126
Hortus deliciarum 133, *134*, 136–7, 199
Hrabanus Maurus *135*
Hugh of St Victor 129, *130*–1
Hugh, abbot of Meaux 98
Hungarian saddle *179*, 202
hunting 169, 174, *175*–6, *177*
 and sex 177–9
Hurum Church, Valdres *68*, 199
Hus, Jan 87, 202

idolatry 99
Imitation of Christ (Thomas à Kempis)
 115, *117*
In physicam aristotelis (Averroes) *141*
Innocent III, Pope 61, 85, 98, 199
Irene, Pupil of Cratinus, Painting 48
Isidore of Seville 8, 12, 17, *135, 137*
ivories 4, 19, 65, *66*, 94, 202
 caskets *181*, 201
 panels *38, 39*

Jacometto Veneziano 144, *145*
Jaime I *151*
Jean le Noir 48
Jerome, St 142, *143*
Jerpoint Abbey, Ireland *112*, 202
Jerusalem 198
 Hague map *17*, 199
 reproduced elsewhere 15–19
 in world maps 11
jewels 65, *66*
Jews 85, 199, 201, 202
 influence of 9, 11, 124, 125, 189
 pogroms 87
 synagogues 89, 202
Joan of Arc 165, 203
John of St Albans 37
Judgement tympanum *41*
Kaschauer, Jakob 107
Kent, Thomas *153*, 201
King John cup *178*, 201
Knights Hospitallers 164, 199
Knights Templars *163*, 199, 201
Kraft, Adam *37, 38*, 203

Ladder of Virtue (Conrad of Hirsau) *132*

Lambert of Saint-Omer *135*, 199

Lambespringe, Bartholomew 50

Lamentation over the dead Christ, Padua (Donatello) *114*

landscape 21–6

Langland, William 22, 46, 202

Latin Church: *see also* monasteries
altars *58*, 102, 113–17, 199, 201, 203: *see also* altarpieces
asceticism in 77–9
bishops' contribution to art 63–5
and the body of Christ 98–100
cathedrals 90–4: *see also* individual entries
entrances 82–5
expiation of sins 100–6
figures in art of 88–90
hierarchy in 114
mendicant friars 96–8
monumental art 67–72
organization of 61–2, 63
parish churches 72–6
pulpits *45*, 65–7, 198, 199, 200
reform 62, 87
relics 17–18, 42, 79–82
reliquaries 43, 56, 94–5, 200
wealth displayed in 77
and women 111–13

Lausanne Cathedral *129*, 200

law 139, *140*, *141*

Le Goff, Jacques 19

Leo IX, Pope 61, 62

Leo of Ostia 56, 64

Levi, Samuel 89

Liber Floridus (Lambert of Saint-Omer) *135*, 199

Liber insularum Cycladum atque aliarum in circuitu sparsarum (Buondelmonte) *31*, 203

Liber sancti Jacobi 14

Life of St Aubin *146*, *147*, 198

Life of St Cuthbert (Bede) 172, *173*

Limbourg brothers 24, 25, *123*

Lives of Florentine Men, The (Villani) 45

livre de la chasse, Le (Gaston Phoebus) 176, *177*

Livre des faits des armes et de chevalerie (Christine de Pisan) *165*, *167*

Livre des Merveilles *12*, 202

Livre des Métiers (Boileau) 48, 200

Lombard, Peter 129, 199

Lorenzetti, Ambroglio 29–30

Louis VIII, King of France 137

Louis IX, St 94, 137, 200, 201

Lovell Lectionary *39*, 202

Lovers in a garden (tapestry) 168, *169*, 202

Lull, Ramon *131*, 201

Luttrell Psalter 23, 24, 201

Lyghtefote, Katherine 48

Maciejowski Bible *153*, *154*, *155*, 200

Maitani, Lorenzo *101*

man as microcosm 120, *121*

Mandeville, Sir John 1, *12*, 202

Manfred, son of Frederick II *174*

Mantegna, Andrea 31, *32*, 59, 203

Manual (Byrhtferth) *128*, 129

manuscripts 3–4, 11, 41, 37–8

mappae mundi *see* world maps

maps *17*, *31*, 199: *see also* world maps

Marie de Bourbon 112

Martini, Simone 96

Mary Magdalen, images of 111

Masaccio *105*, 202

Masegne, Pier Paolo dalle *142*, 202

Massingham, John 50

Master Eckhart 98

Master Guzmin 40

Master Mateo *84*, *85*, 199

Matthew Paris *155*

medicine 120, *123*, 124, 125, *138*, 139, 201

memory skills 129–32

Ménagier de Paris 180

mendicant friars 95–6, 98

Messina, Antonello da 142

Michael, St 162

Michael Scot 120

monasteries 61, 62, 199, 201
asceticism in 77–9
Cistercian 77–8
Cîteaux 77–8, 98, 198
Cluniac 69–70, 71, 78

Monreale Cathedral 78, *79*

Monstrous Races 11, *12*, 14, 15, *16*, 17, *129*

monumental art 67–72

mosaics 56–7, 64, 78, *79*
Orvieto Cathedral *101*
revelation of the relics of St Mark 81, *82*, 200

Muslims 85, 87
mosques 89

Natural History (Pliny) *12*, 137

nature rampant 19–21

Nicholas of Verdun 42, *81*, 199

Nicodemus 43

Nine Worthies 160, 201, 202

Notke, Bernt *161*

Ockham, William of 98

Odo of Bayeux 149

Olaf Haroldsson 67

On Free Will (St Augustine) 126

Opera (Aristotle) *144*, *145*

Orvieto Cathedral *101*, 201

Otto III, Holy Roman Emperor *13*

Otto IV, Graf von Henneburg 162, *163*, 203

Ottokar III, Count, of Traungau 72

Palm of Virtue (Lambert of Saint-Omer) *135*

Pantéon de los Reyes, Léon 22, 198

Papal consistory court *140*, *141*, 201

parade axe *148*, 149, 198

Paris Psalter 56

parish churches 61, 62

parody in art 182–4

patronage, by women 111–12

Paul, St 29

Peace of Venice 152

peasants 21–4

Pedro I, King of Castile 89

Pedro IV, King of Aragon 10

personification
and allegory 132–3
of place 13–15

Peter of Bruys *83*, 199

Peter of Poitiers 129, *130*, 202

Peterborough Psalter 19, 20, 176, 201

Philip Augustus, of France 15

Philip IV, King of France 164

Philip the Good, Duke of Burgundy *157*, 160

Philippa of Hainault 164

Physiologus 137

Picaud, Amery 14

Pisano, Giovanni 43–4, *45*

Pisano, Nicola 43, 44, *45*, 200

Pizigano, Francesco 30

Pizzano, Tommaso 124–5

Plato 126

playing cards *178*, 203

Pliny *12*, 137

Poitiers Cathedral *76*, 77, 199

Polo, Marco 11, *12*, 202

Polykleitos 127

Poor Clares 98

priesthood, hierarchy of 114

Prudentius 132

psalters 124, 130, 137
Eadwine 28, 56, *143*, 199
Luttrell 23, 24, 201
Paris 56
Peterborough 19, 20, 176, 201

Psychomachia (Prudentius) 132

Ptolemy
Almagest 120, *124*, 199
Geographia 32, *33*, 202

pulpits 199
Aachen 65, 66, 198
Milan 67
Pisa *45*, 200

puzzle jug 184, *186*, 201

Pythagoras 127

Raising of Lazarus, The, Chichester Cathedral *71*, 72

Ralf de Luffa *71*

Ramiro I, of Aragon 39

Ranieri Zen 81

realism 31, 32–3

Redolpho *38*, 39

reform and authority 62

Reims Cathedral 28, 90, *91*, *92*, *93*, 94, 95

Reinald van Dassel, archbishop of Cologne 81

relics 17–18, 79–82
Three kings, Cologne 42

reliquaries 43, 56, 200
Reliquary of the Holy Corporal 94, *95*

Sainte-Chapelle 94
Richard I, King of England 15
Richard of Holdingham and Lafford 11
Richard of St Victor 52
Rilindis 133, 137
Robert de Lisle 124
Robert of Basevorn 20
Robert of Bourne 175
Roman de Girart de Roussillon 156, *157*
Roman de toute chevalerie (Kent) *153*, 201
Romance of the Rose 24, 26, 180
Roritzer, Matthew 49
Rout of San Romano (Uccello) 157, *158*–9
Rupert, abbot of Deutz 126

S. Antonio altarpiece, Padua 113, *114*
sacrament houses 37–8, 100
Saint-Gilles, Provence, west façade *83*, 199
San Martin, Fromista 70, 71
Santi, Giovanni 46
sarcophagi *80*
Scala Pilati 15
scholarship 142–5
scientific enquiry 120, 124–5
Seal of Barons of London 29, 200
sense of place
 concepts of place 8–12
 conditioned by experience 7–8
 culture of 27–33
 Jerusalem reproduced 15–19
 and landscape 21–6
 and nature 19–21
 personification of place 13–15
 stereotypes of place 14
Sepulchre of Christ, All Saints, Hawton *100*
Seven Liberal Arts 132, *133*, *134*, 139
Seven Sacraments 114, *117*, 203
Sherborne Missal 39
shrines 43, 198
 Shrine of St Patrick's bell 56, *57*, 198
 Shrine of the Three Magi *81*, 199
Siferwas, John *39*, 202
Sigismund, King of Hungary 179
silk 4, 48
Sixtus IV, Pope 115
sketchbooks 54–6, 198, 203
Snorri Sturluson 147
Solinus 12, 137
Southwell Minster 19, *28*, 29, 201
Speculum virginum (Conrad of Hirsau) *132*
Spring landscape, *Carmina Burana 172*
St George and the dragon (Notke) *161*
St James, Compostela, portico *84*, *85*
St Jerome in his Study (Ferrer and Teixidor) 142, *143*
stained glass 90, *91*, *93*, 94, 95, 111
 Crucifixion window, Poitiers Cathedral *76*, 77
 Gloucester Cathedral *103*, 201
 Lausanne Cathedral *129*, 200
Stoss, Veit *104*, 203
Strasbourg Cathedral 95, *96*, 132, *182*,

200
Suger, Abbot of Saint-Denis 57–8, 77, 199
symbolism 119
 number 126–30

tapestries 3, *21*, 49–50, 150–1, *168*, *169*, 202
 Apocalypse series 50
 Bayeux *149*, 150, 153
 Creation tapestry 9
Teixidor, Pere *143*
Terzysko, royal astronomer *125*
Thangmar 63
Theophilus 52, 77, 148, 198
Thjodolf 147
Thomas à Kempis 115, 117, 202
Thomasse (woman book illustrator) 46
Three Living and the Three Dead, legend of 106
Thydeman the German 99
Timaeus (Plato) 126
tombs 104, *105*, 112, *113*, *142*
Torresanus de Absula, Andreas *144*, *145*
Travail, Le (Bourdichon) 46, *47*, 202
travel 4–5, 7, 14
Travels of Sir John Mandeville 53
treatises 167
Tree of Battles (Bouvet) *166*, *167*
Très riches heures 24, *25*, *123*, 202
Trinity with the Virgin and Two Donors (Masaccio) *105*
Troilus and Criseyde (Chaucer) 177
Tutivillus and Gossips, Reichenau Oberzell *111*, 201

Uccello, Paolo 157, *158*–9, 203
universities 139, *142*
Urban II, pope 163–4, 198
Uta Codex 126, *127*, 198
Utrecht Psalter 56

van Eyck, Jan 26, *27*, 46
vestments 114, *115*
Vézelay 15, *16*, *17*, *41*, 82, 199
Villalobos, Maria 112, *113*
Villani, Filippo 45
Villhard de Honnecourt 28, 54, *55*, 200
Vincent of Kastav *106*–7, 203
Virgil
 Aeneid 32
 Georgics 24, *26*, 203
Virgin and Child, Bohemia *108*
Virgin and Child and Chancellor Rollin, The (van Eyck) 26, *27*
Virgin Mary, images of 107–11
Vischer, Peter 162, *163*, 203
Vision of Piers Plowman (Langland) 22, 46, 202
visual art
 interpretation of 3–4
 role of, in medieval society 2–3
Vlad Drakul 179
Volto Santo, Lucca 43, *69*

wall-paintings 74–5, 151–2, 153, 198, 201
 Anagni Cathedral 120, *121*
 Chambre des cerfs, Palais des Papes *175*, 176
 Doge's Palace, Venice 152
 God of Revelation enthroned with St Michael *162*
 Saint-Martin, Nohant-Vicq *75*, 199
 St John, Pürgg *72*, *73*, 199
 siege of Mallorca *151*, 201
 Tutivillus and Gossips *111*
war
 aesthetics of violence 154–5
 battles 155–8
 commemoration of 162–4
 heroes 159–60
 palace decoration 149–53, 154–5
 treatises 167
 warrior-saints and angels 160–2
 women and 164–7
Wells Cathedral *91*
Wenzel (Wenzeslaus) IV *125*, 202
Weston, Matilda 46
Weyden, Rogier van der 46, 114, *116*, *117*, 203
White, John 44
Wiligelmo *43*, 198
William II, King of Sicily 78, *79*
William of Poitiers 150
women
 artists 46, *48*
 and the Church 111–13
 and patronage 111–12
 and war 164–7
woodcuts, Jacopo de' Barbari 30
world maps (*mappae mundi*) 8, 9–12, 32–3, *121*
 Ebsdorf 11
 Hereford Cathedral *10*, 11–12, 200
world-turned-upside-down 183–4
Wyclif, John 87

Yevele, Henry 48

zodiac man *123*, 125